Illustrated Letters

Artists and Writers
Correspond

ACKNOWLEDGMENTS

This book was conceived and realized by Roselyne de Ayala and Jean-Pierre Guéno, who would like to express their gratitude to: Claude Nabokov, who kindly made the results of his own research available to them; Édouard and Christian Bernadac, who generously opened the treasures of their own collection; Thierry Bodin, who lent many documents from his private collection; Georges Fessy, who took many of the photographs under sometimes difficult conditions; as well as to all those who offered us advice, helped us to select the illustrated letters, lent documents to us, or authorized us to produce them: Mmes Valentine de Chillaz, Élisabeth David, Sylvie Durbet-Giono, Aube Elléouët-Breton, Marquise de Ganay, Pascale Heurtel, Michelle Le Pavec, Laure Murat, Marie-Laure Prévost, Hélène Védrine, MM Frédéric d'Agay, Hughes Bachelot, Éric Buffetaud, Olivier Debré, Yves Gérard, Claude Lévi-Strauss, Alain Nazare-Aga, Claude Pichois, Paul Renaud. We would like to thank the libraries, museums, and institutions that kindly opened their doors and made their collections available to us, especially: in Paris: the Archives Nationales de France, the Bibliothèque d'Art et d'Archéologie Jacques Doucet, the Bibliothèque Centrale du Muséum National d'Histoire Naturelle, the Bibliothèque de l'Institut de France, the Bibliothèque Littéraire Jacques Doucet, the Bibliothèque Nationale de France, the Collection Frits Lugt/Fondation Custodia/Institut Néerlandais, the Département des Arts Graphiques of the Musée du Louvre and the Musée d'Orsay, the Fondation Le Corbusier, the Musée d'Histoire Contemporaine—BDIC (Hôtel National des Invalides), the Musée de la Poste, the Musée National d'Art Moderne/Centre Georges-Pompidou, the Musée Picasso, the Musée Rodin; the Musée d'Art et d'Archéologie de Besançon; the Musée des Beaux-Arts de Chartres; the Médiathèque Jean Renoir and the Musée-Château de Dieppe; the Musée de Grenoble; the Musée Ziem de Martiques; the Musée des Jacobins de Morlaix; the Musée des Beaux-Arts de Nantes; the Bibliothèque Municipale de Valognes; the Musée Félicien-Rops de Namur (Belgium); the Musée d'Art et d'Histoire de Genève (Switzerland); Éditions Flammarion, Librairie Gallimard, Librairie Plon. We would also like to express our gratitude to Renaud Bezombes, Jeanne Castoriano, Séverine Hache, Aurélien Moline, and Benoit Nacci of Éditions de La Martinière, who designed and edited the book.

Editor, English-language edition: Ellen Nidy
Design Coordinator, English-language edition: Raymond P. Hooper

Library of Congress Cataloguing-in-Publication Data

Plus belles lettres illustrées. English
Illustrated letters : artists and writers correspond / [edited] by
Roselyne de Ayala and Jean-Pierre Guéno ; translated by John Goodman.
p. cm.
Includes bibliographical references and index.
ISBN 0–8109–0653–8
1. French letters—Manuscripts—Facsimiles. 2. Manuscripts, French Facsimiles. 3. French letters—Illustrations.
4. Authors, French Correspondence. 5. Artists—French Correspondence.
I. Ayala, Roselyne de. II. Guéno, Jean-Pierre. III. Goodman, John. 1952 Sept. 19– IV. Title.
PQ1286.P5713 1999
846'.708—dc21 99–22310

Printed and bound in France

Harry N. Abrams, Inc.
100 Fifth Avenue
New York, N.Y. 10011
www.abramsbooks.com

Opposite: Egyptian pottery fragment bearing an inscription. Paris, Musée du Louvre.

Illustrated Letters

Artists and Writers Correspond

Roselyne de Ayala

Jean-Pierre Guéno

Foreword by Francine Prose

Translated from the French by John Goodman

Harry N. Abrams, Inc., Publishers

CONTENTS

Paul Gauguin, signed autograph letter with sketch (ink and watercolor) of Gauguin's painting Te Arii Vahine. *Bérès collection.*

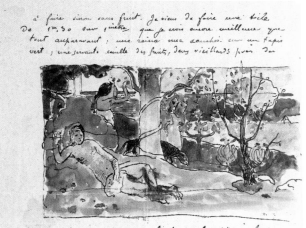

Charles Giraud, signed autograph letter with sketch of two Tahitian women, dated September 15, 1846. Paris, Musée du Louvre.

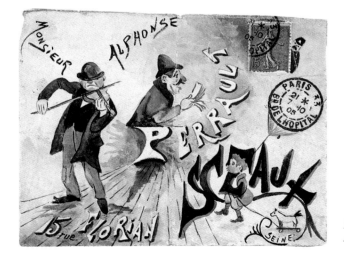

Envelope from the postman Frédéric Pioche to Alphonse Perrault, 1901. Paris, Musée de la Poste.

André Dignimont, signed autograph letter.
Paris, Librairie "Les Autographes."

Félix Buhot, print with "symphonic margins."
Paris, Bibliothèque d'Art et d'Archéologie Jacques Doucet.

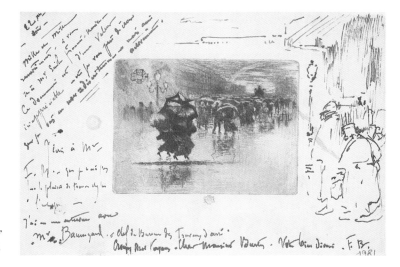

Gaston Chaissac, signed autograph letter, illustrated with a color drawing (magic marker). Paris, Musée National d'Art Moderne/Centre Georges-Pompidou.

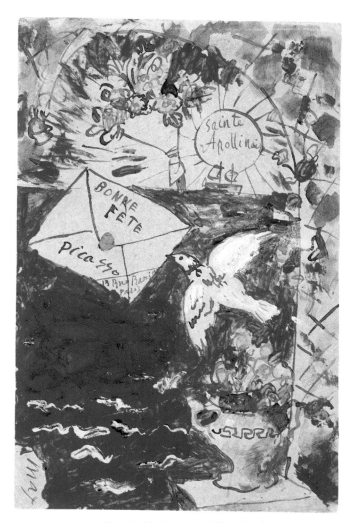

Card from Pablo Picasso and Max Jacob to Guillaume Apollinaire. Paris, Musée Picasso.

Ce 21 Février 1890

Monsieur

Désirant aller au
Bal des Incohérents
cette année je vous prie
Monsieur le Président d'être
assez aimable de m'envoyer
3 entrées qui me sont ab-
solument nécessaires pour
l'effet de mon costume
Je crois pouvoir vous
remercier d'a-
vance et
vous
prie d'accepter Monsieur
toutes mes salutations

Risse

11 Rue Fontaine

FOREWORD

In a letter to his dear friend Madame Jaubert, Alfred de Musset describes a performance of Beaumarchais's *The Barber of Seville* that took place in the spring of 1836 at the Théâtre Français. At the end of one of the acts, Rosine, played by the actress Mademoiselle Plessy, received a letter from her suitor, Lindor. As the orchestra struck up a waltz to signal the intermission, Rosine remained alone on stage, pacing as she read and reread Lindor's impassioned love note.

Illustrated Letters: Artists and Writers Correspond helps us understand the transfixed fascination that Rosine was miming, as well as the sympathetic identification that kept the audience members in their seats for almost five minutes admiring the actress's daring in portraying a woman so engrossed in words on paper that the rest of the world dropped away. Paging through this volume of revealing, witty, beautiful, and often brilliant dispatches from artists and writers such as marquis de Sade, Camille Corot, Charles Baudelaire, Colette, Cocteau, Picasso, and Miro, we become such readers, lost to our surroundings, transported to an earlier era, before modern technology began to blunt the generosity and inventiveness with which we communicate.

The fact that these letters are illustrated adds another dimension—reading them is like watching a speaker perfectly fluent in two languages effortlessly translating back and forth from one to another in a way that illustrates, paradoxically, the endless possibilities and the finite limitations of word and image.

Letter from Avisse, February 21, 1890.

BONTÉ SENSIBILITÉ

Couplet.

When language proves insufficient, inadequate for the purposes of intricate and accurate description, even the most articulate of these writers abandon the word for the line and begin to draw. Ivan Turgenev, sending Gustave Flaubert his (notably brief) condolences on the death of George Sand, winds up sketching the Russian estate at Spasskoye that he inherited from his mother. Eugène Delacroix depicts a Moorish gate in Meknes (the former capital of Morocco), while Victor Hugo, whose letters are among the most exquisite, renders in ink and wash the town square of Ghent with its prodigious cannon. Georges Mniszech, the husband of the daughter of Balzac's mistress, could not possibly have conveyed with mere words the gorgeousness of the rare butterfly that he reproduces, in full color, in his letter to the novelist. Antoine de Saint-Exupéry mails his mother a drawing of a dog he saw in Casablanca, while van Gogh sends his brother Theo an extraordinary rendering of the sort of Brabant peasant woman who would soon appear in *The Potato Eaters*.

Many of these images are more beautiful than anything the artist can hope to say, reminding us of the reason many of them became painters in the first place. Manet's glorious apple communicates far more than his words in his hasty note to his beautiful young model, Isabelle Lemonnier. Corot's fluid landscape, a "souvenir de Bourgogne," offers a striking contrast to the rather stiff formality of his message to a woman whose name has been lost to us. Paul Delvaux declares his admiration and gratitude to Claude Levi-Strauss with a minimal expression of thanks—and a far more expansive drawing of two nudes. Picasso greets Apollinaire on his name day also with few words—and an exuberant painting of flowers, a vase, the open sea, and a letter-carrying bird.

But just as often there are occasions on which pictures simply will not do and the painters and writers of this volume remember how useful—and necessary—language is when one wants to express all the possible nuances of emotion and experience: love, loneliness, irritation, homesickness, longing for the person to whom the letter is addressed.

Among the most engaging examples are the letters in which artists use words to reflect on the subject of art. In a letter decorated with a marvelously

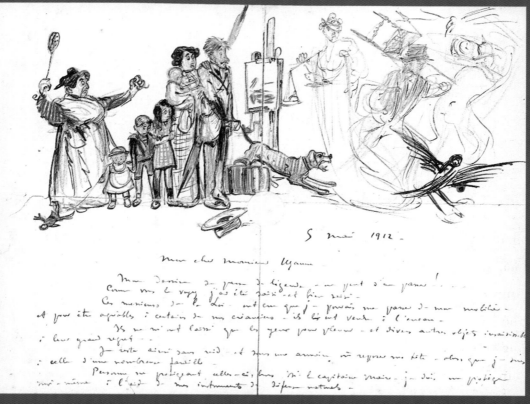

5 mai 1912.

Mon cher monsieur Uganne

energized drawing of a horse, Raoul Dufy tells the writer Fernand Fleuret, "A day of work is a day of astonishing adventure and exploration." Alongside a drawing of a totemic figure, André Derain complains of the "nerve-wracking" effort involved in "what's generally known as painting." Apollinaire sends Picasso one of his shaped pictorial poems together with a terse reflection on the process of writing them.

In several surprising letters, language and line operate at cross-purposes, contradicting each other in provocative and illuminating ways. In some cases, the humor of a drawing undercuts (or attempts to mediate) the seriousness of what the letter writer is saying. The self-mocking caricature of the cigarette-smoking virago seems intended to defuse the stridency of George Sand's urgent plea for money. Hospitalized by recurrent, painful attacks of arthritis, Verlaine, writing to his friend Irénée Decroix, adds a self-portrait of himself confined to bed but still vigorous, even imperious, brandishing his pen and debating a matter of word choice. The paradisical scenes of tropical ease and delight that we see in Gauguin's art are all the more poignant here in their proximity to his written account

of his deteriorating health, physical agony, and the "cruel life" that he was enduring.

When language and decoration cooperate and work together harmoniously (whether the effect has been created consciously or unconsciously), the illustrated letter is the perfect vehicle for expressing the range and depth of the individual personality. It is hard to avoid being struck by the intensity of self-involvement that permeates Rodin's letter to Rose Beuret—his mistress, servant, and eventually his wife—as he makes the most perfunctory inquiry about her well-being ("I don't know how you're getting on in Brussels") and immediately goes on to give her precise and elaborate directions for the execution and display of his work; he even sketches, for her benefit, a base to be used for one of his sculptures. Rimbaud's letter to his friend Ernest Delahaye is a thrilling expression of youthful high spirits and sexual arrogance, a wicked boast about the speed with which he subverted Verlaine's newfound piety ("Verlaine arrived here the other day, gripping a rosary . . . Three hours later he'd renounced his god and made the 98 wounds of Our Lord bleed.") that includes a cartoon of Verlaine

Letter from Mariano Fortuny, May 5, 1912.

Ma délicieuse

Je te fais porter ce casaquin
qui vient de moi
Il est absolument propre mon chérie. Le
jauni est la marque du temps —
Petite fille chérie
je t'embrasse
Ta Marie

Les fleurs Tombent
comme tu vois

descending from his coach into the heart of Rimbaud's hellish neighborhood in Stuttgart. The irony, humor, and lightheartedness that emerge from Gustave Doré's illustrated description of his travels in Spain are a revelation, and not at all what one would expect from having seen only his highly romantic and stylized engravings. Rosa Bonheur and Colette conclude their letters with humorous self-portraits—Bonheur with her palette, Colette as a mischievous rat—that function, in context, like little grace notes of friendship and affection.

In the most integrated, most eloquent of the letters, word and image combine to achieve what neither mode of expression could manage on its own. Writing to a prospective client, Le Corbusier offers her a series of architectural drawings that expand, via the text, to provide a coherent vision of a pleasing, serene, and integrated daily domestic life. Robert Desnos's charming rebus is intended to function—and it did, we learn—as a means of enchanting and seducing his beloved Youki, who, at the time she received the letter, was married to someone else.

It is too simple, I think, to see these letters merely as relics of a bygone era—of a time that existed before the telephone, before e-mail—and to lament the fact that communications as eloquent and glorious as these may never be created again. For what *Illustrated Letters* gives us, in addition to pleasure, is a kind of faith in the playfulness and generosity of artists and writers who create this art merely out of a motivation to give it—to send it—to someone else.

Personalized, individualized, unique, meant for only one reader, letters are the opposite of the commodity, of the object of mass production. These letters are like missiles aimed from one heart to another, or like messages in bottles that reach us from a great distance, across lost and far-off seas. Their words and images continue to hold us in their grasp long after we have closed the book—even as the intermission begins and the orchestra strikes up its waltz.

Letter from Marie Laurencin to Carmen Tessier.

The Abbé de La Haye

"Le Dondon. Parish of the Mountains bordering the French cape." Such is the description of the vicarage of the abbé de La Haye in *L'Histoire de l'isle espagnole ou de S. Domingue*, written in 1731 by Father Pierre-François-Xavier de Charlevoix. Aside from these indications, the abbé de La Haye is a mysterious figure. It may be assumed, however, that the severe judgments issued by visitors to the island of Santo Domingo—now the Dominican Republic—of God's representatives who were stationed there were also applicable to him. According to Father Labat, in 1681 the clergy there was "as debauched as the others, the greater number being apostates who left their convents with libertine intentions."

Although the situation on the island improved somewhat with the arrival of the Jesuits, who replaced the Capuchin friars as administrators, according to the *Essai sur l'administration de Saint-Domingue*, the systematic expulsion of the Jesuits from dependent territories of the French crown in 1762 entailed the arrival en masse of "secular priests who were the worst assemblage of bad subjects yet to appear in the colony." In all likelihood, the abbé de La Haye was among their number. One thing we can be sure of, however, is that the obligations of his ministry left the vicar of Le Dondon (French slang for "the plump lady") time to pursue his interest in herbs and plants.

The question as to whether the abbé de La Haye was a good priest was of little concern to the "Areopagus of men of letters [and] scientists" to which he sent two descriptive texts and five illustrations of plants from the Antilles. Here it was the abbé de La Haye's botanical skills that were in question, which is why the academy asked two of its members, the celebrated naturalists Antoine-Laurent de Jussieu and René-Louiche Desfontaines, to assess the abbé's materials. Their judgment must have been severe, for his descriptions are nowhere mentioned in the academy's proceedings. The texts were nonetheless preserved by Jussieu, who annotated the abbé's memoir with the scientific names of the species described, changing "Aërostat"—a name commemorating the "mania for aerostats and hot-air balloons that amused France and England during the years immediately following the peace of 1783"—to "Theophrastia," and changing "Fraisière"—a name inspired by "the form and figure of its fruit" (*fraise* is French for strawberry)—to "Marcgravia." The result was science's gain but poetry's loss.

Beyond such taxonomic considerations, this letter, written by an obscure abbé and sent to the very famous Académie Royale des Sciences in Paris, offers further evidence—if such be needed—that nature enjoyed a privileged status in the eighteenth century.

To the Académie Royale des Sciences,

To the gentlemen of the Académie Royale des Sciences June 21, 1787

Areopagus of men of letters, scientists, academicians, citizens, enthusiasts, brought together by love of philosophy, animated by a desire to expand the empire of the sciences, wise depositories of human knowledge of useful discoveries, fruit of the immense effort of several studious generations, receive the literary homage of an observer who, far from his country, confined in the mountains of the New World, has devoted his days to the study of nature. To begin with commendations, with flattering praise, this would be, sirs, to offend you. Flattery dishonors equally those who offer it and those to whom it is directed. True glory consists in being useful to one's fellow citizens, in doing good for them, in being worthy of one's country. Such are our ambitions. Please deign to accept my work and to accord it whatever degree of consideration you deem appropriate. Only the precious benefit of being encouraged by your approbation can make one brave the many obstacles confronting those who desire to devote themselves peaceably to study under a burning sun, in a voracious climate, in a colony hitherto subject to the tyrannical yoke of cupidity. . . .

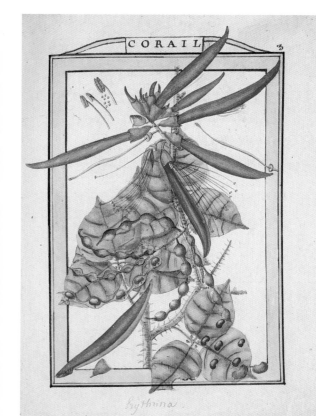

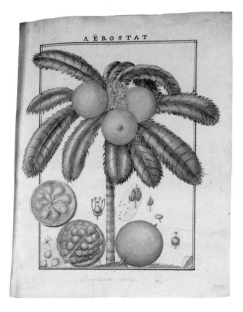

To supplement his descriptions, the abbé de La Haye sent the Académie Royale des Sciences drawings of several samples of plants on Santo Domingo that interested him. Left: Le Corail (coral plant). Right: L'Aërostat à aiguillons (prickled aerostat). Paris, Muséum National d'Histoire Naturelle.

A MESSIEURS
DE L'ACADEMIE ROYALE
DES SCIENCES

MESSIEURS

AREOPAGE de lettrés, sçavans Académiciens, ci-
toyens Zélés, que l'amour de la Philosophie rassemble,
que le désir d'étendre l'empire des Sciences, anime.
Sages dépositaires des Connaissances humaines, des
découvertes utiles, fruits des travaux immenses de
plusieurs générations studieuses; recevez l'homage
littéraire, d'un observateur, qui loin de sa patrie, confi-
né dans les montagnes du nouveau monde, a consacré
ses jours à l'étude de la nature. De buter par des louan-
ges, par des éloges flatteurs, ce serait, Messieurs, vous
offenser. La flatterie deshonore également celui qui
la prodigue et celui qui en est l'objet. La vraie gloire
consiste à être utile à ses concitoyens, à leur faire
du bien, à bien mériter de sa patrie. Telle est celle que
vous ambitionnez. Daignés agréer, accueillir, mes
travaux, et leur donner le degré de considération
qu'ils vous paraitront mériter. L'avantage précieux
d'être encouragé par vos suffrages, peut seul faire
braver les obstacles multipliés, qu'opposent à celui
qui désire paisiblement se livrer à l'étude; un
ciel brulant, un climat dévorant, une colonie jus-
qu'ici asservie au joug tyrannique de la Super-

Marquis de Sade (1740–1814)

Man Ray, Portrait of the Marquis de Sade.
Houston, The Menil Collection.

In considering the correspondence of the marquis de Sade, one would expect to find a letter addressed to Satan rather than a prayer addressed to God. However, the man who in his writings explored all aspects of sexuality and evil indeed addressed this letter, discovered only after his death, to the Creator. On the envelope, he wrote: "Paper concerning / mademoiselle de Launay / which is to say family matters / to be burned unread if / found after my death." The woman in question is Anne-Prospère de Launay, Sade's sister-in-law and a secular canoness, with whom he fled in 1772 after various sexual escapades had led to his being condemned to death.

The marquis de Sade spent thirty of his seventy-four years in prison. During his detentions at Vincennes, the Bastille, and Charenton, he wrote incessantly. Among his works, one dark literary jewel stands out: an all but unreadable catalogue of perversions entitled *Les Cent Vingt Journées de Sodome* (*The 120 Days of Sodom*), characterized by Jean Paulhan as a veritable "gospel of evil." It is set in a château of terror, an "impenetrable citadel," where the women are already "dead to the world."

Is the sketch that the marquis attached to his evening prayer a plan of this place? And what is the significance of the meandering line inscribed on the verso, suggestive of a gigantic intestine? In any event, the hellish world represented in the sketch on the right—featuring rooms titled "house of detention" and "pavilion of exaction," which open onto corridors and torture chambers labeled "here one torments to excess," "here one whips with rods," "here one fucks the ass and the mouth," and "here one whips with all kinds of instruments," which in turn open into circular rooms with the grisly titles "here one torments pregnant women," "here one cripples," and "here one commits murder"—includes all the elements of setting and sexual criminality essential to the Sadean "philosophical" system.

The conclusion of this horrific process, as the sketch indicates, could only be death: the two final doors lead to the "cemetery." As for the marquis himself, he received—against his express wishes—a religious burial. By contrast, his stipulation that no name be inscribed on his tombstone was respected.

To God

Evening Prayer

Oh my God, I have but one grace to ask of you and you won't want to grant it to me however pressing my entreaty; this grace, this exceptional favor, would be, oh my God, that you not choose for my keepers men who are even more wicked than I, that you not deliver he who is guilty only of quite ordinary and quite trivial lapses to rogues hardened by crime who mock your laws [and] make sport of transgressing them at every moment of the day. Place my destiny, oh my God, in the hands of virtue, it is your image on earth, and only those who respect it should concern themselves with reforming vice. Oh best of beings, do not choose for my regents a manipulator, a taker from the poor, a bankrupt, a sodomite, a robber, a Spanish policeman of the Madrid Inquisition, a defrocked priest, and a brothelkeeper. Since I must be sacrificed, oh my God, since it is written in your great book that you ordained my birth to provide support for boys and food for pigs, and that you knew better than anyone that the only fruit I could derive from this was to become worse than I was, due to the supplement of hate that I would be obliged to feel toward my brothers; that my example, at least, through your holy power, might serve my compatriots, and that the vile scoundrels I have just named, perceiving through the scant success of their remedies on me the impossibility of veiling henceforth their horrors under the mark of such an illusory equity, end by imagining other means to subject their fellowmen to the prodigious disorders of their vengeance and their cupidity.

Amen

Left to right: Envelope with seal; text of the prayer; identifying note on the front of the envelope.

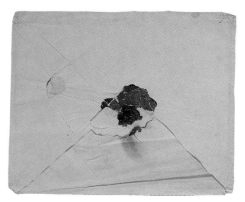

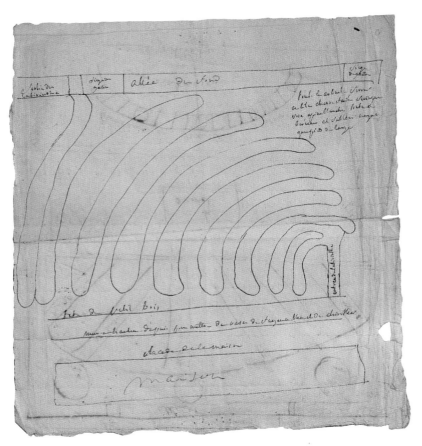

Above left and right: The piece of paper with sketches on either side that was enclosed with the prayer in the envelope.

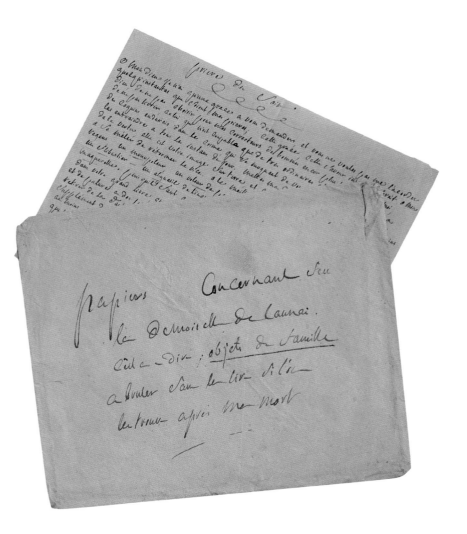

HONORÉ DE BALZAC (1799–1850)

Achille Devéria, Portrait of the Young Balzac.
Paris, Bibliothèque de l'Institut.

Anonymous, Portrait of Laure de Balzac
as a Child. *Paris, Maison de Balzac.*

To his sister, Laure Surville

Of all the portraits we have of Balzac, a man who fascinated his contemporaries, posterity has favored caricatural descriptions of him as an exaggeration of nature: a work-monster of unprecedented vitality; a pleasure seeker whom his secretary Léon Gozlan called "superb in his Pantegruelism" (a reference to Rabelais meaning: "a certain gaeity of spirit steeped in disregard of things fortuitous"), who ate with his knife and blew his nose into his napkin; an extrovert who laughed fiercely and loudly at off-color jokes and who was "a bit tiring with his words," as George Sand delicately phrased it; a man with "the bulk of Mirabeau" (a reference to the president of the Constituent Assembly during the French Revolution), per the poet Alphonse de Lamartine; and who, according to Théophile Gautier, had "eyes that could stare down an eagle."

At age twenty-two, when Balzac wrote to his sister and confidante Laure, almost all of the above descriptions applied in spades. Judging from his flattering self-portrait as a dandy, he was still thin, but his capacity for work was already colossal: he anticipated "selling a novel a month," a quota he almost met, for over the next year he produced no less than twelve small volumes under various pseudonyms. His professed volubility is evident in his voluminous letter writing ("If I listened only to my desire to babble, I'd write reams to you"). His major preoccupations, glory and money, which resound throughout *La Comédie humaine*, surface in every line of this private missive concerning the marriage of his second sister, Laurence, to Armand de Montzaigle, who proved a wretched husband, first accumulating debts and then abandoning his wife and two children.

Himself an arriviste who begged his sister to find him some "rich widows" and borrowed against anticipated inheritances (he "would one day have an income of thirty thousand livres") as well as his own nonexistent fortune ("it will come, I haven't the slightest doubt"), Balzac did not need to look far to find a model for Rastignac, one of his best-known characters, who appeared in his novels *Le Père Goriot* (1834) and *La Cousine Bette* (1847) and who came to symbolize ruthless ambition. The difference was that Balzac's ambition was literary. As to the main focus of the letter (Laurence's impending marriage), we might view it as an occasion for the future author of *The Physiology of Marriage* (1829) and *The Petty Annoyances of Married Life* (1846) to express his views concerning a fundamental institution of nineteenth-century society that he was soon to chronicle in many of his novels.

[Paris, July 1821]

It is very difficult, when writing you, to avoid the subject of *il troubadouro*, and you must have as many versions [of him] as you have letters. So lend me your pretty little ear: we've seen the whole family, even a niece who is charming. Let's proceed in proper order: the grandmother is a gaunt little old lady who is said to be quite amiable. Imagine a woman somewhere between Mme de Fétan and grandmama, with qualities of both, and you'll have a pretty good idea of her. As for the mother, I didn't see her with my own eyes, but it seems she's a woman of the highest breeding, manner, etc., as live as gunpowder: she embraced Laurence with a cordiality rare for a mother-in-law. I would ask no more of my own. She told [her son], he said, that, while his accounts were flattering, she found [Laurence] above them. Judging from what I've been told, I'd say she's the nervous type, and, after nervous types, what I fear most, I dare say even more, are their intimates. There's a sister-in-law who is past the age of passion and who, by consequence, is pious up to her neck, and of whom it is said she is younger than she looks and quite amiable. There's a second one who married an auditor for the Council of State who one day will have an yearly income of thirty thousand livres; who (the sister-in-law) is very pretty, amiable, not at all ill-natured. . . .

(continued in the appendix, page 207)

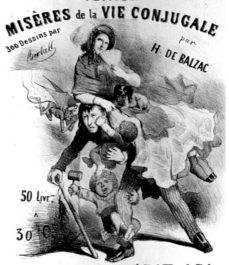

Bertall, poster for Les Petites Misères de la vie conjugale
(The Petty Annoyances of Married Life)
by Balzac. Paris, Maison de Balzac.

pardonné excepté à Mamans qui est à couteau tiré avec lui et
avec l'éditeur, le grand machinateur de l'aventure = nous ignorons
encore ce qui va devenir ce malheureux ménage = selon moi vaudra
qu'à se voir heureux et marier. = Mouillard fait les robes, et marie
les drapes, et moi les bavettes.

Je fais mille vœux pour vous voir marier à Paris travailler à en causer
et Martin que Dieu confonde ! à n'est pas la ville qui en ait l'ingénieux
= j'espère que tu me diras tout ce qui est à Bayeux = achève tout en
comptes sommaire de toutes les jolies femmes, de toutes celles qui sont
ou ne sont pas jolie tu, pour tous les mariage; pour en avoir
pour ton oncle tu sauras que depuis 10 grands mois je fais
l'amour et j'aurai mai très, et cependant je pense à
comme le Corrège ! c'est moi aussi, je suis peintre !

a été Ballay et le soir, a fait l'aquarelle au peintre
esprit en anglais m'a dit n'aura mai Elise la tout ma
passion, a marié à l'ensemble de qui ? j'ai mis nom = garder
la malfaisance est en aînée = Honorine Marthe comme un
ange a été aidé de voyager et elle s'étonne ! et très
l'aide de sa mère.

j'aimerai que mon âme de l'avarice j'écrirai
l'amour, il fait fleurir par j'ai toujours été en porte à
à toutes mes entreprises. adieu.

j'entends que absolument comme dans ma dernière lettre
ohé écrire lettre à Pierville et au port du vai = il y a bien
longtemps que nous n'avons reçu sa main mais lire

adieu donc
ton frère qui t'aime

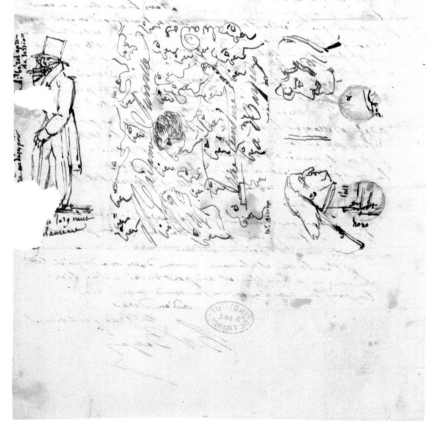

Eugène Delacroix (1798–1863)

Eugène Delacroix, Self-Portrait with Green Vest,
1837. Paris, Musée du Louvre.

Delacroix was in North Africa from January to June of 1832 serving as painter-attaché to a diplomatic mission sent by King Louis-Philippe to the emperor of Morocco.

From the moment he arrived in Tangier, his painter's sensibility was excited by the city's streets and inhabitants and the profusion of new forms and colors. He wrote long letters to two of his childhood friends, Jean-Baptiste Pierret and Félix Guillemachet, and he accumulated sketches and observations in small notebooks in which, at night, when all was calm, he painted delicate watercolors. "One would need twenty arms and forty-eight-hour days to convey even a middling idea of all this," he confided in one of his first letters.

On March 15, he described the delegation's arrival in Meknes (the former capital of Morocco) and the reception the French received: crowds, disorder, flags, music, deafening uproar, blank rifle fire. "It is furiously Africa at present," he wrote by way of summary.

But by March 20, the date he resumed writing the same letter after a brief hiatus, the excitement was on hold. The French were cloistered while waiting for their audience, and inactivity weighed heavily on them. The artist himself was experiencing a surfeit of the picturesque and was also a bit homesick, for he had yet to receive any news. "A word from you others would have charmed me more than all Africa," he writes.

The local architecture attracted his attention: in his letter he refers to the house in which they were lodged, illustrating the Moorish gate through which he had entered Meknes. A similar sketch appears in one of his notebooks with the indication "very high gate of the city." It also appears in a watercolor now in the Louvre. With Delacroix, narration and drawing complemented one another to compose an invaluable illustrated diary and sourcebook. The artist would draw upon this "Oriental dream" throughout his long career.

To Jean-Baptiste Pierret

In the midst of my transport, I noticed some very curious buildings in the city, always in the Moorish style but more imposing than in Tangier.

March 20

At the moment, we've been held prisoner in a house in the city for about five or six days, until the moment of our audience. Being constantly together, we are less disposed to gaiety, and the hours seem very long, although the house where we are is very curious for its Moorish architecture, which is that of all the palaces in Granada you've seen in prints. But I find that the sensations are wearing thin over time, for the picturesque assaults your eyes to such an extent at every step that in the end one grows insensitive to it. The day before yesterday they brought a packet of letters. It was a postman specially dispatched on foot from Tangier. For there are no regular means of communication in this country, where there are neither roads nor bridges nor boats nor rivers. My heart beat fast at the thought of something being in it for me; but you are severe with me and I swear to you that a word from you others would have charmed me more than all Africa. I suppose we'll be staying here about ten more days. I'll write you from Tangier to tell you about the probable date of my return.

A thousand regards to you and yours. I still love you despite your silence.

Eugène

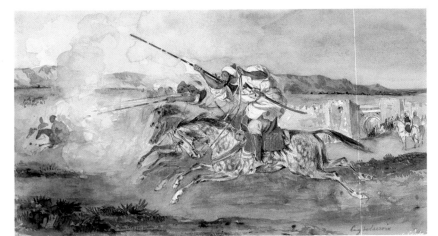

Eugène Delacroix, Arab Fantasia Outside the
Gates of Meknes, *1832. Paris, Musée du Louvre.
Inspired by his Moroccan sojourn, Delacroix
incorporates the same gate that he sketched in
the letter opposite.*

Cela n'était rien au prix de notre réception dans leur capitale. On nous a d'abord fait prendre le plus long pour nous faire tourner alentour, nous faire juger de son importance. L'empereur avait ordonné à tout le monde de s'armer et d'aller nous faire fête sous les peines les plus sévères, de sorte que la foule et le désordre étaient extrêmes. Nous pensons qu'à la réception des autrichiens qui sont venus il y a 6 mois il y avait en 12 hommes et 14 chevaux tués par divers accidents. Notre petite troupe avait donc beaucoup de peine à se maintenir ensemble et à se retrouver au milieu des milliers de coups de fusil qu'on nous tirait dans la figure. Nous avions la musique en tête et plus de vingt drapeaux portés par des hommes à cheval. La musique est également à cheval; elle consiste dans des espèces de musettes et des tambours pendus au cou du cavalier sur lesquels il frappe alternativement et de chaque côté avec un bâton et une petite baguette. Cela fait un vacarme extrêmement assourdissant qui se mêlent aux décharges de la cavalerie et de l'infanterie et des gens enragés qui perçaient tout autour de nous pour nous tirer à la figure. Tout cela nous donnait une colère mêlée de comique que je me rappelle à présent avec moins d'humeur. Le triomphe qui ressemblait au supplice de quelques malheureux qu'on mènerait pendre

durera depuis le matin jusqu'à 4 h de l'après midi. Notez bien que nous avions à peine pris un léger à compte fin de déjeuner à 7 h du matin sous notre tente. Au milieu de ma fureur, j'ai remarqué dans cette ville des édifices fort curieux toujours dans le style mauresque mais peu imposant que Tanger.

20 mai

dans ce moment nous sommes prisonniers dans une maison de la ville environ depuis son 6 jours jusqu'au moment où nous aurons notre audience. Étant toujours en présence les uns des autres, nous en sommes moins disposés à la gaité et les heures paraissent fort longues, quoique la maison où nous soyons soit très curieuse pour l'architecture mauresque qui est celle de tous les palais de Grenade dont vous avez vu les gravures. Mais j'éprouve que les sensations s'usent à la longue et le pittoresque vous crève tellement les yeux à chaque pas qu'on finit par y être insensible. On a apporté avant hier un paquet de lettres. C'était un piéton expédié exprès de Tanger, car on n'a aucun moyen régulier de communiquer dans ce pays où il n'y a ni routes, ni ponts, ni bateaux sur les rivières. Peu s'en est battu en passant qu'il y aurait quelque chose pour moi. Mais vous me tenez rigueur et je vous jure cependant qu'un mot de vous autres m'eût plus charmé que toute l'Afrique. Je suppose que nous avons à rester ici environ une dizaine de jours encore je vous écrirai de Tanger pour vous parler de l'époque probable de mon retour. Mille choses à tous les vôtres. Je vous aime toujours malgré votre silence.

Eugène

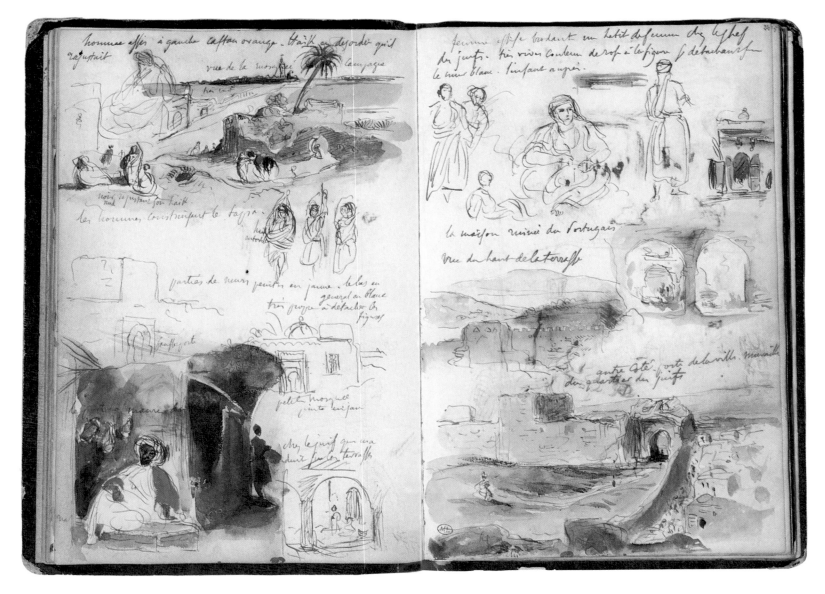

Delacroix brought back from his Moroccan
trip a North African and Spanish Album
(1832, Paris, Museé du Louvre), from which
some pages of his watercolor sketches are
reproduced here.

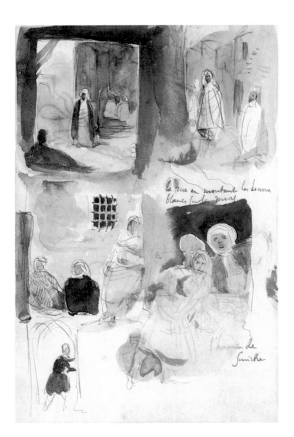

EUGÈNE ISABEY (1803–1886)

This seemingly banal letter in fact reveals two fundamental facets of the painter Eugène Isabey's personality. First, his great kindness toward his students. This letter to one Monsieur Porte, responsible for issuing passports to travelers, is not the only one of its kind. Another such note is illustrated with an administrative office bearing a sign that reads "Passports." Everyone who frequented Isabey's Paris town house on avenue Frochot was struck by the way he helped and encouraged young talent. In 1845 his beneficiary was the young Dutch painter Johann Barthold Jongkind, whom he met in Holland and took to Normandy and encouraged him to take up watercolor. In Honfleur Isabey met the young Eugène Boudin, whom he urged to place greater emphasis on the skies in his marines, to paint beach scenes, and to make a name for himself in Trouville, the seaside resort frequented by Second Empire high society where Isabey himself also painted.

The second important trait of Isabey's revealed by this letter is his love for the sea and boats. As a youngster, he had dreamed of becoming a sailor, but, influenced by his father, the miniaturist Jean-Baptiste Isabey, he took up painting, specializing in landscapes and marines. In 1825 he joined Delacroix and Bonington in England and set about mastering watercolor. He was among the first artists to paint the Normandy coast. He turned out many scenes of seaside resorts and fishing ports, but he also rendered shipwrecks and storms, which he imbued with a romantic theatricality. He so excelled in the genre that in 1830 he was named official painter to the French navy, a status that enabled him to sail on warships. The year of his appointment, he accompanied a colonial expedition to Algeria. Isabey devoted the last years of his life to watercolor and the rendition of light. In his freedom of handling, he heralds Impressionism.

To M. Porte

Tuesday, August 28, 1832

My good friend Porte,

This is one of my students, Mr J. Dubois, who is going to Tréport in Normandy. Be so kind as to issue him a [passport].

Regards,

E. Isabey

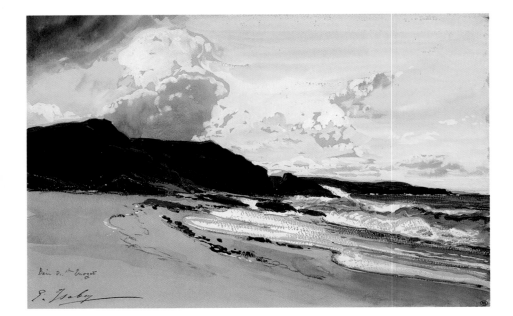

Above: Eugène Isabey, Marine at Étretat. *Paris, Musée du Louvre. Left: Eugène Isabey,* The Bay of Saint-Énogat. *Paris, Musée du Louvre.*

2

Mon bon ami Porte c'est un
de mes élèves Mr L. Dubois
qui part pour Treport en Normandie.
Soyez assez bon pour lui
faire donner un passeport

tout a vous
L. Wahen

Mardi 28 aoùt 1832

ALFRED DE MUSSET (1810–1857)

Charles Lancelle, Portrait of Alfred de Musset,
1854. Paris, Musée d'Orsay.

What was the nature of the relationship between Musset and Madame Jaubert? The poet presented his own view of this question to the other party concerned in the following fine passage: "You have found the true name of the feeling that unites us by calling it a feeling without a name. This is not a paradox, your remark is true and full of charm. It reminds me of another, rather funny one (you well know that we also share a taste for mixing up comedy with high seriousness), it was, I think, a friend of mine who said to a woman: 'We are on the back road of love and friendship.'"

To his beloved friend, Musset opened his heart and confided his joy and pain. Their amorous liaison of several weeks in 1836 did nothing to compromise their subsequent relations, which were rooted in profound mutual affection.

On May 20 of that same year, Musset hastened to write his confidante about a little event: The actress Mademoiselle Plessy, whom he had just seen in the role of Rosine in Beaumarchais's *The Barber of Seville* at the Théâtre Français, had surprised the audience by dramatically remaining on stage during the musical interlude between scenes to read and reread a letter from her smitten suitor Lindor, alias Almaviva. This theatrical effect so moved Musset that he devoted his entire letter to it, illustrating it with a drawing in which he pictured himself contemplating the audacious actress's performance from a box seat. The letter scene re-created within a letter: such is the conceit contrived by the poet in this wonderfully vivid communication.

Musset's correspondence with Madame Jaubert also features many accounts of the writer's eventful love life, from his disappointments with the actress Rachel (caricatured without mercy) to his courtship of the singer Pauline Viardot (who doesn't come off much better). Musset's visual barbs could be as sharp as his verbal ones. Only George Sand escaped relatively unscathed: even as a caricature, the author of *Lélia* remains beautiful. But then, as the French say, one doesn't trifle with love.

To Madame Jaubert

[Paris] Tuesday evening [May 24 (?), 1836]

You made a big mistake, madame, in not coming to the Théâtre Français this evening. This Rosine was not Spanish, but she was witty and something of a flirt, indeed quite the flirt. She made a charming exit. Here's how it went. She had just finished reading Lindor's letter: the act was over and she was alone on stage (I think it's the second act); the letter read and the last word uttered, the actress had only to leave: indeed, she began to move, the orchestra started to play—a waltz, I don't know why, probably to get me excited, but there it is—when, instead of making a normal exit, in other words leaving the theater empty for intermission, here is what Rosine did tonight. She began to move very slowly, holding Lindor's letter in her hand, rereading it, circling the stage, not uttering a word, this lasted almost five minutes—everyone in the orchestra seats stayed put, they kept their eyes on the girl, which didn't make her move any faster, still circling and rereading despite the intermission and the music. Finally she exited and was applauded. What do you make of that? How bold, calculating, affected, and perfectly true, how feminine it is!—"But," you say, "it's a tradition; perhaps it's always done that way."—No, madame: I've seen, with God's help, *The Barber of Seville* a hundred times, and I've never seen this exit. "So!" you say again, "It was Mlle Mars's idea." Well, what's that to me? It was charming, and bear in mind that to dare doing it, to dare holding the spectator's attention at the start of intermission, to dare remain when everyone's about to get up, when there aren't any more lines, when the café vendors are anxious to start hawking their lemonade—My faith, to dare to do that, to do it and make it a success of it, is quite something.

I forgot to ask you about the SECRET of my PASSION for Mlle P[lessy]—In all seriousness, don't treat this like the pear of St G. For the first time in my life, I was afraid you might tell me a little too much. Farewell, madame. How is your headache?

Alfd Mt

[Address]
Madame Jaubert
15 rue Taitbout

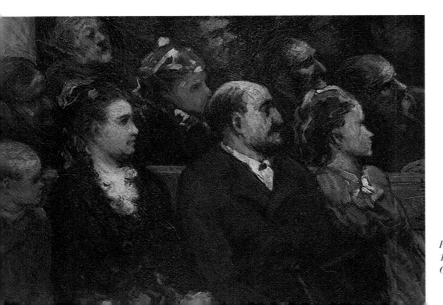

Honoré Daumier, Le Théâtre Français,
*1857–60. Washington, D.C., The National
Gallery of Art.*

Madame
Madame Jaubert
15 rue Taitbout

Mardi soir

Vous avez eu grand tort, madame, de n'être pas venue le soir au théâtre français. Rosine n'a pas été espagnole, mais elle a été spirituelle et assez coquette, fort coquette même. Il y a eu une sortie charmante. Voici comment. Elle vient de lire le billet de Lindor, l'acte finit, elle est seule en scène (c'est je crois le 2d acte) le billet lu et le dernier mot dit, l'actrice n'a plus qu'à s'en aller; elle s'en va donc, l'orchestre se met à jouer — une valse, je ne sais pourquoi, probablement pour me monter la tête; mais c'est réel — or, au lieu de sortir comme on sort, c.a.d. de laisser le théâtre vide pour l'entracte, voici ce qu'a fait Rosine ce soir. Elle s'en est allée à pas lent, tenant à la main le billet de Lindor, le relisant, tournant sur la scène, seule, sans mot dire, cela a duré près de cinq minutes, — le parterre n'a pas bougé, il a suivi des yeux la demoiselle qui n'en a pas été plus vite, tournant et relisant toujours en dépit de l'entracte et de l'orchestre,

enfin elle est sortie et on a applaudi. Que dites vous de cela? comme c'est hardi, calculé, affecté et parfaitement vrai, comme c'est féminin! — mais direz-vous, c'est une tradition, cela se fait peut-être toujours — non pas, madame, j'ai vu, dieu aidant, une centaine de fois le barbier de Séville, et je n'ai jamais vu cette sortie; eh bien! direz vous encore, c'est une idée de Mlle Mars; eh! que m'importe? c'est charmant, et songez que d'oser le faire, d'oser tenir ainsi le spectateur en haleine au moment où l'entracte commence, d'oser rester quand tout le monde va se lever, quand on n'a plus rien à dire, quand les garçons de café brûlent de crier leur limonade, — ma foi; oser cela, le faire, et réussir, c'est quelque chose.

J'ai oublié de vous demander le secret sur ma passion pour Mlle b. — sérieusement parlant ne faites pas pour cela comme pour la foire de St G. c'est la première fois de ma vie que j'ai eu peur que vous n'eussiez dit un mot de trop — adieu madame. comment va la migraine?

les compliments que vous savez

Alfd Mt

GEORGE SAND (1804–1876)

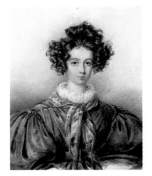

Alfred du Musset, Portrait of George Sand,
1833. Paris, Bibliothèque de l'Institut.

Maurice Dudevant, Caricature of
François Buloz, *1834. Private collection.*

To François Buloz

Like a tax collector demanding "Money! More Money!," Aurore Dupin, alias George Sand, insisted emphatically that François Buloz, editor of the *Revue des Deux Mondes*, listen to her tragicomic pleas. Times were hard for authors of the Romantic generation who were struggling to eke out a precarious living with their pens by writing serial novels for periodicals. Not surprisingly, all the surviving correspondence from the authors of the period concurs on one point: publishers are pigs who take advantage of needy authors.

While not impoverished, George Sand was certainly in no position to adopt a lavish lifestyle. She had fled her husband, Baron Dudevant, and then sued him for divorce, eventually obtaining an annual income of 3,000 francs (roughly $7,000 in today's currency); however, these funds were earmarked for the education of their two children. The earnings from her first novels, *Indiana, Valentine, Lélia* (1831–33), had been swallowed up in short order. For *Jacques* (1834), Buloz had advanced her four thousand francs, which made possible her trip to Italy with Alfred de Musset. She had subsequently submitted her *Lettres d'un voyageur* (1835–36) and was not about to let up on her demands to be paid.

What could Buloz do but smile and surrender when confronted with this self-mocking caricature of the writer-as-shrew, cigarette dangling from her lips, powerless before her creditors thanks to a publisher deaf to her pleas? She also considers him blind since—here she adds injury to insult—he had the bad taste to publish Lherminier, a writer who did not have the luck of pleasing George Sand (*caecut* is Latin for "blind," hence "caetlherminier"). Her sense of humor brought results: on December 24, five thousand francs were deposited in her account.

In 1841 George Sand had a falling out with Buloz, but they reconciled eighteen years later. Thereafter he served as publisher for almost all her books; however, judging from Sand's vituperative remarks to Gustave Flaubert, written in February 1867, their relations were still far from tranquil: "I say only that if anyone should lend me money it is Lord Buloz, who has purchased châteaux and estates with my novels."

[Paris,
December 13, 1836]

Buloz!—Huh?—Buloz!!
—Huh?—Damned Buloz!!!
—What?—Money!—I can't hear you—Five hundred francs!—What did you say?—The devil take you! You promised me six thousand francs within a few days, and I ask you for 500 francs for tomorrow.—I said no such thing.—Ah! You're not deaf, then! Very well, give me 500 francs, 500 francs, 500 francs.—I can't hear you.

My dear friend, if you're deaf, you can at least read, I presume, although there's room for doubt, given the quality of the articles you put into the *Revue* by the likes of Mrs. George Sand, XXXX etc. etc. etc. and caetlherminier etc.

I've written you six letters now, but apparently your eyes are deaf, a strange illness that has never yet been described.

(500 francs) George (*500 francs*)

[Address]
Monsieur Buloz
man of means and landowner
rue des Beaux-Arts, 10

Auguste Charpentier and George Sand,
George Sand and Her Friends. *Paris,
Musée de la Vie Romantique.*

Mon cher ami, si vous
êtes sourd, du moins vous
saurez lire cette personne
quoique ne se contentant guère
à la qualité des lettres de
vous collègues. es - mrs George
Sand, X , X , X , X etc. etc. etc.
Et Coetterminius L

Voilà six lettres que je vous
écris, mais il paraît que
vous êtes sourd par les
yeux, maladie étrange
et qui jusqu'à ce jour n'a
pas été décrite.

(500 francs) George (500 francs)

Juste que la vie !!

ANATOLE DE SÉGUR (1823–1902)

Portrait of the young Anatole de Ségur, detail of The Ségur
Children on a Boating Party. *Paris, Musée Carnavalet.*

Like all the sons of the comtesse de Ségur (she had four, followed by four daughters), Anatole, the third, enrolled at age seven in the boarding school at Fontenay-aux-Roses, whose prospectus specified: "This establishment does not resort to corporal punishment." Sophie de Ségur, née Rostopchine, whose upbringing in her native Russia had been brutally severe, intended to protect her children from the suffering and humiliation pervasive in schools of the day.

The family lived for vacations, when they all would gather at the Château de Nouettes on the Orne River, where the comtesse devised a thousand games and distractions. She was an attentive mother who recounted scintillating tales to her children but did not yet write—she published her first book only at the age of fifty-six.

This meant that Anatole, who was consumed by writing, was able to pursue a literary career before his mother had one of her own, although he enjoyed less success and was certainly less talented. His first—dreadful—volume of poems appeared in 1848, followed in 1853 by his first novel, *Les Mémoires d'un troupier* (Memoirs of a soldier). He studied law and became a prefect and a member of the Council of State, but this did not prevent him from writing, especially about his family, the subject of his most interesting works. It is worthwhile consulting his *Biographie nouvelle de Monseigneur de Ségur* (about his elder brother Gaston, his mother's favorite, who opted for the priesthood in 1847), which was followed by a *Biographie de la comtesse de Ségur* and *L'Été de la Saint-Martin, souvenirs et rêveries du soir* (The Saint-Martin summer, evening memories and reveries). Another entertaining and useful resource is Anatole's correspondence with the members of his family, including this letter—"truly illustrated," as he put it—in which the fourteen-year-old adolescent, serious and diligent, sought to amuse his well-loved mother with a few antics until the family could once more be united.

To his mother, the comtesse de Ségur

Oreste Kiprinsky,
The Comtesse de Ségur.
Paris, Musée Carnavalet.

[Fontenay-aux-Roses]
April 18, 1837,
at 2 o'clock

Dear Mama,

I write you a letter that might truly be described as illustrated. I already wrote Papa this morning, but I must write you again to tell you that while eating, my dental apparatus turned completely upside down and I took it off because it wasn't holding anymore, and I saw that the wires were broken and bent upwards inside so they pricked me. I put it in my desk and I won't touch it again until Papa comes to see me. Paul and Albert came to tell us good-bye during the recreation period. They leave tonight at 6 o'clock. All three of us are well. I hope my sisters enjoyed themselves at the party Saturday night at Madame de Brigodas' [?].

Farewell, dear mama, I embrace you with all my heart along with papa and my sisters. A thousand regards to Mademoiselle [illegible].

Anatole

Addressed to:
Madame la Comtesse de Ségur
rue de Grenelle no. 91, Paris

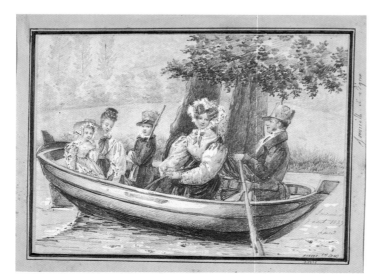

The Ségur Children on a Boating Party.
Paris, Musée Carnavalet.

ce 13 avril 1837 à 2 heures

Chère Maman

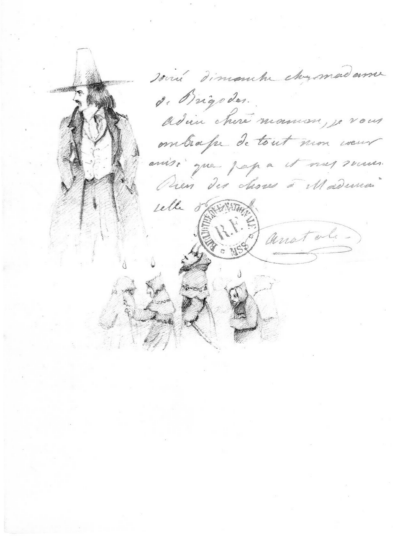

e vous écris une lettre que l'on peut
véritablement appeler illustre. J'ai
déja écrit ce matin a papa mais
il faut que je vous écrive encore pour
vous dire qu'en mangeant mon appa
reil, il est tout-à-fait renversé ma visi
re je l'ai ôté car il ne tenait plus
et j'ai vu que les fils étaient cassés
et rebroussés en dedans ce qui me
piquait. je l'ai mis dans mon pupi-
tre et je n'y toucherai pas que
papa ne vienne me voir. Paul
et Albert sont venus nous dire
adieu dans la récréation. ils
partiront ce soir à six heures.
Nous nous portons tous trois
bien. J'espère que mes sœurs
se sont bien amusées à leur

soirée dimanche chez madame
de Brigodes.
Adieu chère maman, je vous
embrasse de tout mon cœur
ainsi que papa et mes sœurs.
Bien des choses à Mademoi
selle S

Anatole.

VICTOR HUGO (1802–1885)

Auguste de Chatillon, Victor Hugo and His Son Victor
(detail), 1836. Paris, Musée Victor Hugo.

To Adèle Hugo

Louis Boulanger, Adèle Hugo, *1839.*
Paris, Musée Victor Hugo.

Caricature, landscape, and portraiture, pen and pencil, amorphous blots and delicate arabesques, wash and line: Victor Hugo seems to have explored all of ink's possibilities. His countless drawings, as well as the hundreds of letters in which his script frames a sketch, encompasses a view, or is complemented by the detail of a capital in the margin, unquestionably place him among the greatest writer-draftsmen of all time.

One of his favorite subjects was architecture, and during his travels he often scribbled between the lines of his letters images of churches or town squares that he wanted to remember. A case in point is this letter, written during a sojourn in Belgium and northern France from August 11 to September 13, 1837. He wrote his childhood sweetheart Adèle Foucher, now his wife and the mother of his five children, almost every day, recounting everything that had transpired. He admired the paintings of Rubens and Van Eyck, but it was the Flemish monuments and the "tormented and bizarre taste that here results from the encounter of North and South, Flanders and Spain" (letter of August 18, 1837) that spurred him to draw.

Some days after Hugo penned this letter, with its sketch of the town square and its "enormous" cannon in Ghent, the painter Louis Boulanger wrote to him: "The other day I went to see the excellent Madame Hugo, who showed me part of a letter with a ravishing drawing by you of a town square, the one in Ghent, I think. I assure you that it piqued my curiosity, it's drawn with infinite taste and appears to be quite accurate. Make many more for those of us unable to follow you."

Hugo had no need of encouragement: in addition to his illustrated correspondence, he left at his death dozens of albums and notebooks containing more than 1,300 drawings that were inseparable from the accompanying text.

Audenaerde,
August 24 [1837]
7 P.M.

. . . I saw the large cannon of Ghent, of which I provide you with a small drawing. It's an enormous tube made from sheets of cast iron, a real fifteenth-century machine. The inhabitants of Ghent take few pains with it. They've stuck rococo stonework with garlands on three sides, and the mouth of the bombard is just a trash receptacle. This cannon is eighteen feet long and weighs thirty-six thousand livres. One can readily make out on the inside the grooves made by the iron sheets. The mouth is two and a half feet in diameter. It fired large balls or tons of grapeshot. It's enormous. It's nothing, however, beside the bombards of Mohammed II, drawn by four thousand men and two thousand oxen and which vomited immense stone blocks. They were kinds of volcanoes that the Turk aimed at Constantinople.

There are beautiful paintings in Saint Bavo, especially two: one by Rubens, the other by Jan van Eyck, the inventor of oil painting. The one by Rubens, which represents the entry of Saint Amand into the monastery of Saint Bavo, is admirable. The group at the bottom is superb. The other, in a totally different style, is no less marvelous. Van Eyck is as calm as Rubens is violent. There is also a beautiful painting by a student of van Eyck, and another, likewise beautiful, by Rubens's master. In Paris we scarcely know this Otto-Venius [Otto van Veen] who was the master of Rubens. A remarkable thing! He, too, is a calm painter.

Moreover, every Flemish church is a museum. . . .

(continued in the appendix, page 208)

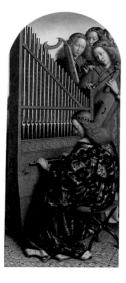

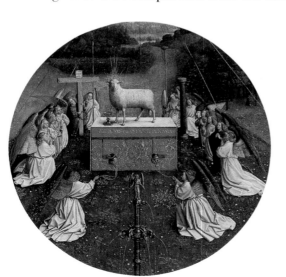

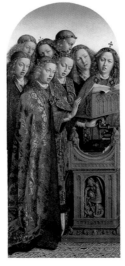

Jan Van Eyck, The Ghent Altarpiece: The Mystic Lamb
(detail of central panel), and two side panels.
Ghent, Cathedral of Saint Bavo. Hugo saw this
altarpiece in the cathedral, where it remains today.

GÉRARD DE NERVAL (1808–1855)

Nadar, Portrait of Gérard de Nerval,
1855. Paris, private collection.

Jean-Baptiste Clesinger, Portrait of Théophile Gautier.
Château de Versailles et de Trianon.

In December 1842, after his first internment with Dr. Blanche and a rather fallow literary period, Gérard de Nerval left Paris for the Levant in the company of Joseph de Fonfride, an amateur Orientalist. For the poet, this trip was not only an intellectual challenge thrown down to his prestigious predecessors (Chateaubriand, Lamartine, etc.); it was also a trial during which he would eventually have to cope with the failure of his reason. Théophile Gautier, who shared with him the happy times of *La Bohème galante*, was the first recipient of the letters that Nerval wrote from Cairo and is doubtless the mysterious dedicatee of the introduction to *Voyage en Orient*, which reads, "To a friend."

Despite gaps resulting from damage, this letter teems with information for historians, as well as for readers of the weighty *Voyage:* it alludes to the work undertaken by Gautier for his scenario for the Egyptian ballet *La Péri*, first performed at the Paris Opéra on July 17, 1843; it attests to Nerval's friendship for his brother in literature (throughout the text he refers to him as "My poor cat," "I've missed you terribly," "I dream about you," "without you, I'm like an idiot," etc.); and it casts light on the poet's life in Cairo and evokes his activity as a photographer, of which, unfortunately, no trace has ever been found. It also offers what are, in effect, first drafts of passages in "Women of Cairo" and "Harem" (in which he writes that a "Coptic marriage" is "much simpler and less costly" than the purchase of a slave).

To detail his thoughts lucidly and precisely and to complement his chiseled descriptions, Nerval drew rapid thumbnail sketches in his free and assured hand, which he inserted in the text like supporting illustrations. The same day Nerval wrote this letter, he wrote to his father: "I leave today from Cairo for Syria . . . I spent the entire season in Egypt without experiencing the slightest problem with my health."

To Théophile Gautier

[Cairo, May 2, 1843]

My poor cat, I am indeed in Cairo, in the great Cairo and nowhere else, near the Nile and the pyramids. I say, that's not bad, but the place's charms aren't inexhaustible, and it's two months now that I miss you essentially. Since the consul's departure, I've stopped seeing *La Presse*, where you spoke to me a little, very little, yourself; then I haven't received any letters; I count on finding some in Beirut. It's true that here you have to write three before one arrives; it's probably the same at the other end. I want to try not to describe the landscape to you: as you'll surely come here, and probably talk about it much more than I, it's important that you not have ideas in advance that are too precise. The city of the Thousand and One Nights is a bit dilapidated, a bit dusty, yet something can still be done with it. You're right to do a ballet about Cairo before seeing it. Set it in the period of the Mamluks instead of in the present, otherwise you'll have to have extras at the Opéra dressed as Englishmen in mackintoshes, with cotton piqué hats and green veils, marvelous Frenchmen proudly wearing the fashions of 1816 in tatters, ridiculous Turks decked out in the uniforms of Istanbul, etc. You mustn't neglect [gap] [seen from?] Mokattam, a mountain that [gap] if you need gardens, there are some on the banks of the Nile and those in Rodda [are?] delicious: Arab gardens are quite distinctive and you probably won't find any prints of them.
[drawing]
I'd like to paint for you a kiosk that's in Rodda but I can't: it's a stairway of terraces with green arbors one surmounting the other, culminating in a pavilion on the top, a bit like the Isola Bella in Lago Maggiore but lighter, then lots of cypresses to sad and charming effect with doves perching on their tips. But what's marvelous and what I'm even less capable of rendering [drawing] are the plant beds tracing carpet patterns, flowers, patterns of very tall tamarind trees. There's something funereal about this that makes one feel women should be strolling about in the moonlight, around the pools. . . .

(continued in the appendix, page 211)

Gérard de Nerval, Cairo Notebook, drawing in ink and watercolor representing the island of Shubrâ.
Paris, Bibliothèque National de France.

particulier dont tu te trouveras par des gravures probablement.

Je voudrais te peindre un kiosque qui est à Rhodda mais je ne peux pas c'est un escalier de terrasses avec des berceaux de verdure se surmontant par étages jusqu'au pavillon placé en haut, à peu près comme l'Isola bella du lac Majeur mais plus léger, puis force cyprès d'un effet triste et charmant avec des colombes qui se perchent sur la pointe — mais ce qui est merveilleux et que je puis encore moins rendre ce sont des plates bandes formant des dessins des tapis des fleurs des dessins en tamarins très hauts — cela a quelque chose de funèbre où l'on sent que les femmes doivent se promener au clair de lune, autour des bassins. Il y a des bosquets de ... jasmin, ou de myrtes taillés ainsi et circulaires des citronniers ... taillés uniformément en quenouilles, des orangers chargés de fruits, mais non taillés. De grands galeries peintes formant volières, un pavillon de marbre à colonnes où les femmes se baignent sous les yeux du maître. Je regrette de ne pouvoir t'envoyer mon épreuve daguerréotypés de ce serait que ... et à Schoubra; quelque peintre t'en donnera le dessin; il y a des crocodiles et des lions qui versent de l'eau, c'est illuminé pour les fêtes — tout cela peut se faire en effet de nuit avec la lune, je regrette bien de n'être pas près de toi pour t'expliquer tout mais en prenant pour motif les jardins de Schoubra on ferait quelque chose de ravissant — Comme mœurs j'ai vu de très curieux — la paye des Coptes et la fête de la naissance du prophète puis le retour des pèlerins où le cheikh monté des hadjis passe à cheval sur le dos d'une foule de croyants — puis les mariages dont tu trouveras la description exacte dans les deux volumes d'un anglais nommé Lane, intitulés mœurs des Egyptiens Il y a aussi quelque chose très beau pour l'opéra dans laquelle des nubiennes font ... pendant que d'autres ... sur ... qu'elles portent sur l'épaule en ... mais conduit la danse en faisant ... et une femme la tête couverte d' ... en allant dans ... et ...

voici de sa main, avec une grande robe ... dirige le tout avec un sabre recourbé, dansant une sorte de pyrrhique avançant reculant devant la marche La ... dans les mariages chacun tient une bougie si c'est la nuit et l'on porte ... quelque du bougies de dix pieds à peu — Il y a des costumes de femmes fellahs très graciaux l'opéra en aura facilement Un verras ... peut être un peintre sous qui ... parti avant nous et à qui j'ai dit tô 'alew ti bou' —

mon ami je suis une mazette je t'écris toujours au moment où la poste part et de plus aujourd'hui je pars moi-même — Le ... est assez convenable Il a acheté une esclave indienne et comme il voulait me la faire baiser je n'ai pas voulu alors il ne l'a pas baisé non plus nous en sommes là cette femme coûte très cher et nous ne savons plus qu'en faire — On a d'autres femmes tant qu'on veut ... — à la copte, à la grecque et c'est beaucoup moins cher que d'acheter des femmes comme mon compagnon a eu la ... de le faire. Elles sont ... dans des habitudes de harem et il faut les servir c'est fatiguant.

Voici donc l'Affaire nous partons aujourd'hui pour Damiette avec la femme et tout un ménage de là nous irons à Beyrouth — Le voyage sera terminé cet automne je pense bien souvent à toi — je rêve de toi; je n'en fais rien — On est très ... par le climat, j'ai beaucoup lu — je ne ferai guère qu'un ou deux articles ... les mœurs que je t'enverrai — mais il y aurait énormément à faire pour toi! J'écris mais absolument à Beyrouth tâcher de m'y rejoindre et ... pays après la Grèce sans toi je hais comme un ... Adieu — Dis moi si Henriette a réussi et ... tu en as fait — dis bonjour à Serruau à ...

CHARLES GIRAUD (1819–1886)

Detail of illustration on opposite page.

The custom of enlisting painter-draftsmen to accompany military and scientific expeditions—those famous maritime painters who were, in effect, the ancestors of today's photojournalists—is a venerable one. It lies behind this remarkable, abundantly illustrated, twenty-one-page torrent of a letter.

In 1842 King Louis-Philippe, in the interest of safeguarding French interests in Polynesia, responded to a request by Queen Pomaré IV of Tahiti for protection by despatching an expeditionary force to the island. Giraud, who was twenty-two at the time accompanied the expedition and took part in the military operations, notably the attack on the stronghold of Fautuhua in 1846.

"Because illustrations give you pleasure," our artist informs his correspondent, "I'll scatter some throughout my letter to strengthen my narrative."

On the first page, Charles Giraud represents himself in his garden, a pickax and a rake at his feet, consuming a letter in the shade of a palm tree. The ensuing text, however, makes it clear that the painter's horticultural activities, while diligently pursued, were relegated to breaks between military initiatives in which he participated eagerly. Giraud made many sketches of the island's vegetation, dwellings, and population and, like Paul Gauguin some fifty years later, enjoyed the local wahines, taking one of them as his mistress.

Upon returning to Paris, he exhibited an immense canvas at the Salon, the annual exhibition of artworks presented to the public by the French Academy, entitled *Souvenir of Tahiti*. He was nicknamed the Tahitian and became a regular guest of Princess Mathilde Bonaparte, whose salon was an important gathering place for artists and writers during the Second Empire. As a result of his connections, in 1855 he accompanied a scientific expedition organized by Prince Napoléon (cousin of Napoleon III) to Greenland.

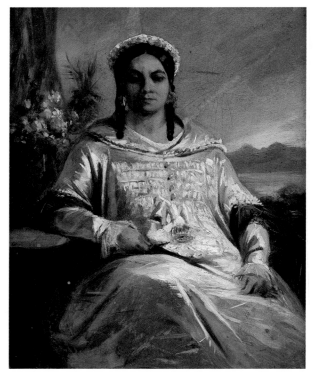

Charles Giraud, Portrait of Queen Pomaré IV. *Paris, Musée des Arts d'Afrique et d'Océanie.*

To Hardin

September 15, 1846

My dear Hardin

It was very kind of you to think about the exile. Your letter found me in the middle of my garden: I was giving myself over to husbandry. I immediately dropped my pickax and rake to devour your letter beneath the shade of a palm tree. Its length didn't frighten me, quite the contrary. When I got to the end, I set about rereading it to make sure I hadn't forgotten anything. My brother persists in not sending me any news. Gibert has forgotten me. Only you think about me. Not only because I'm very grateful to you, but because illustrations give you pleasure, I'll scatter some throughout my letter to strengthen my narrative.

Before telling you about myself, I must report the death of J. Bovy. Things are not going well in this family. Is Daniel, of whom you say nothing, doing better? Did you replace Leleu with Gibert? This enchants me: we could enjoy ourselves together: you who love strolling would come and get me at my house and we'd have at one another until we got to your place, walking all the while (it's not far). So Élisa has gotten into preserves: what luck! I'd embrace her; are there sweeter circumstances? For her everything is milk and honey. How I'd like to be there to give her advice and encouragement! Remember, my dear Élisa, that there's no pleasure in life without a little work: it's Monsieur Florian who said that. Another prankster said: Work, exert yourself, the background [*fond*] is more finished than the rest (he said nothing about funds [*fonds*]). My advice to you is: Courage, perseverance: you already have my business, and you could put on your shop sign: Licensed by the Painter of Queen Pomaré. I'll make drawings for your candies and Hardin will make up some slogans for you. Isn't your fortune already assured? I'm annoyed that this poor Henriette sees you only rarely. You could give her some good advice. I'd like to know she's on the path of good fortune like you. I'd like to have heard a word from her as well, even a simple greeting. For a moment, I'd have thought I was surrounded by all my friends on rue du Sabot. I haven't forgotten the wild times we had together and Henriette's laugh. It's all present in my memory, but that's over now. We've become grave, serious. We think about the future, fools that we are! Isn't life in the present? So you're painting. Good, all the better: but don't have the vain desire to paint finished paintings, make studies, good and serious ones that you can exhibit. . . .

(continued in the appendix, page 209)

Papeete 15 7bre 1846 —

Mon cher Hardin

C'est bien aimable à vous d'avoir
pensé à Venila. Votre lettre m'a
trouvé au milieu de mon jardin,
j'étais en train de me livrer
à la culture, j'ai laissé
aussitôt la pioche et le rateau
pour dévorer votre lettre à
l'ombre de mon cocotier. La
longueur ne m'a pas effrayé
au contraire lorsque je suis
arrivé à la fin je me suis
mis à la relire afin de
voir si je n'avais rien oublié.
Mon frère persiste à ne pas
m'envoyer de nouvelles, Gebert
m'oublie. Vous seul pensez
à moi aussi je vous en
suis très reconnaissant, puisque
les illustrations vous plaisent
je vais en peindre une
à plus forte raison de donner plus
... à ma narration
il faut que je vous
... mobilité ...
Avant de ...
j'irai que m'a ...la nouvelle de la monde je ...

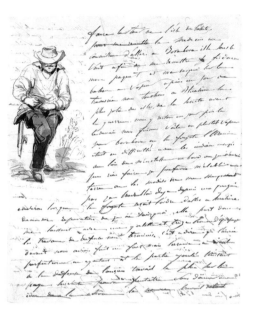

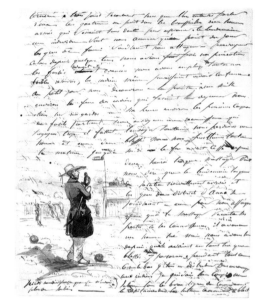

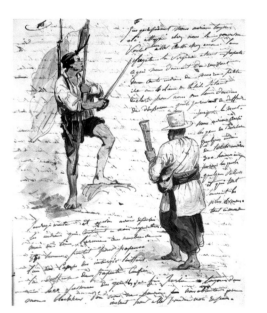

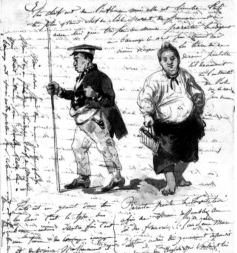

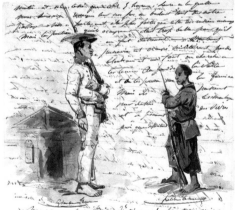

GEORGES MNISZECH (1822–1881)

Portrait of Count Mniszech. *Paris, Maison de Balzac.*

Louis Boulanger, Portrait of Balzac, *1842.*
Tours, Musée des Beaux-Arts.

To Honoré de Balzac

[Frankfurt,
October 18, 1846]

Sphinx
Saltimboquorum /
of Gringelet.
country /
planet
of Leverrier

In 1845, in Dresden, Balzac met Comte Georges Mniszech, suitor for the hand of Anna Hanska, the daughter of Balzac's mistress, Ève Hanska. He quickly grew attached to Mniszech, an avid lepidopterist, whom he called, doubtless to please Ève, "my good and only male friend." This small band dubbed itself the Saltimbanques (itinerant performers)—a name inspired by a popular production at the Théâtre des Variétés—and embarked on a series of trips throughout Europe in which everyone had a specific vaudevillian identity: Balzac, under the name Bilboquet, was the head of the troupe, Madame Hanska was Atala, Georges was known as Gringelet, and Anna, the young romantic lead, went by the pseudonym Zéphirine.

On October 11, Georges and Anna were married in Wiesbaden. Balzac, who was among those present, had a notice published in *Le Messager*, specifying that "through her mother, the bride is the great niece of the Marie Leczinska, queen of France" (wife of King Louis XV), and that the groom was the "great nephew of the last king of Poland." On the seventeenth, the novelist set off for Paris, and Mniszech immediately wrote him this affectionate letter, which gives the extent of their mutual affection. One recognizes Mniszech's portrait of the dandy, "magnificently attired in a beautiful housecoat of white cashmere" (Balzac's preferred dress when writing); the passionate collector amassing things for his town house on rue Fortunée; and the brilliant author of *Cousine Bette* (the first chapters of which were appearing at this very moment in *Le Constitutionnel*) and *Cousin Pons* (which was not published until the following year). Clearly, Balzac had either read passages to Mniszech or showed him the manuscript, which features the author's characteristic phonetic evocations of French words pronounced with a German accent phonetically—as when Schmucke deforms *bric-à-braquer* (shopping for curios) into *"pricàpraker."*

In Paris Balzac spent a fortune decorating his new apartments to make them worthy of receiving Madame Hanska, his *"loulou trésor"* (treasured lapdog). He finally married her in 1852, a union actively encouraged by Georges and Anna. Unfortunately, the couple's domestic happiness was short-lived: Balzac died some weeks later, at age fifty-one.

We had not expected, my very dear Bilboquet, to hear from you so soon. It is charming of the head of the troupe to be so thoughtful of his friends and to profit from the slightest moment to send them news: we are enchanted to know that your vases will soon be in Paris and I hope that you'll be satisfied with the way your saltimbanques carried out your instructions. How did you reach Paris? Not too tired? Write us about all this quickly, for we [are] uneasy and very impatient to know that you are already comfortably installed in the rich apartments of Hôtel Bilboquet, surrounded by all the masterpieces of indigenous and exotic art and magnificently attired in a beautiful housecoat of white cashmere while holding your morning cup of chocolate, after having spent the whole night writing masterpieces like the wicked old cousin, or the friends Pons and Schmucke who went "prickàpraking" together. I've made some magnificent purchases here in the way of sphinxes, which as you know are my great passion in butterflies. I bought one, above all, that's the rarest in Europe and comes from Crete. We will remain here until Wednesday because of the mailboats. The conveyance that will carry the brave saltimbanques to Dresden is magnificent and causes riots in our hotel, which, as you can imagine, makes us quite proud of this distinction. Farewell, my very dear Bilboquet, write us soon, for we think of you always, and the question "What's dear Bilboquet doing?" is on our agenda morning and evening and every hour of the day. Farewell, then, hoping that we will still be seeing, dear and good Bilboquet, our excellent and unique friend.

[Gringelet]

(continued in the appendix, page 212)

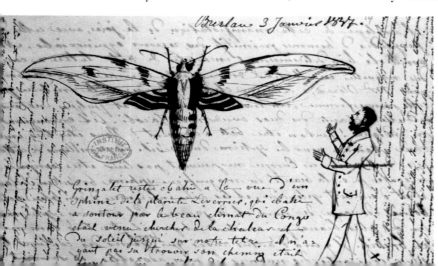

A letter from Georges Mniszech to Balzac in which he depicts himself chasing butterflies.

Francfort, 18 Octobre 1846

9

Sphinx Saltimbanquorum
de Gringalet—
patrie / la planète Leverrier.

Nous ne nous attendions pas, mon très cher
Bilboquet de recevoir de vos nouvelles de si
bonne heure c'est charmant de la part du
chef de la troupe de penser ainsi a ses amis.
et de profiter ainsi du moindre moment
pour leur donner de ses nouvelles, nous
Sommes

ADOLPHE ARMAND (DATES UNKNOWN)

Detail of illustration on opposite page.

To his friend Délègue

On board the frigate *Uranie*,
anchored in Brest,
December 15, 1848

My dear Délègue,

This letter is of a particular type known as a *lettre de ponton*. It was written in a *ponton*, the hull of an old ship anchored in a river or harbor and used for barracks storage, as a landing stage, or, quite often, as a prison. In the first half of the nineteenth century, the mere mention of the word made French sailors tremble, evoking frightful misery, unspeakable punishments, and cruel death. Such hulls were grouped in twos or threes and secured by cables to create what were, in effect, floating buildings. Their interiors were furnished only with a perimeter bench and four more benches placed in their centers. On arrival, each prisoner received a hammock, a very thin wool blanket, and a flock mattress.

One evocative testimony of such an imprisonment was written—and attractively illustrated—by Adolphe Armand, who took part in the revolutionary uprisings of June 1848. Violently suppressed, they resulted in the arrest of some 15,000 insurgents, 3,000 of whom were deported to the North African Territories, which the Republic had conquered in 1830 and decided to colonize. On board the frigate *Uranie*, the young Parisian tried to pass the time by describing to one of his friends his slow descent into a hell of boredom, small talk, and plotting (he had apparently been disavowed by his family, which in any case would have been compromised by corresponding with him). But our man, although transported "150 leagues from his stomping ground" by this "political hurricane," remained an optimist: convinced that he would eventually return to Paris, he ardently pleaded for news of his relatives and friends. Several of the latter were companions in his misfortune, resigned to their fate, resourceful in the game of survival, weary like him at the thought of their pending one-way voyage to North Africa.

Doubtless you're quite surprised to receive, unexpectedly, news from a poor philosopher who's been carried 150 leagues from his stomping ground by the political hurricane of June. I've long reflected in my *ponton* as to what course I should pursue regarding this letter, and you would have already received it if I hadn't judged it appropriate to begin it over again to cut short any grounds for delay. So I address myself to you, to your old friendship for the family, to beg you to give me some news of it as well as of yourself, and a short word about the quarter, and above all about the family. When I was in the faubourg or in Paris, I had it when I wanted it, but distanced as I am and always uncertain of going or coming I know not where, to Algeria, they say, all that I've suffered has not completely stifled in me the feelings of natural interest I bear toward persons who are so far from returning them, and it seems to me, of course, very cruel to be the *only one* deprived of all ties with his relations. There are people of all sorts among us, and there's not a single one even among the most destitute of the lowest class who doesn't receive, almost as often as the most distinguished men in the *ponton*, their share of consolation and solace. This last item is, to be sure, the one that least concerns me, but a line, a word from someone in the family or from a friendly hand telling me about them—I'd pay for it with anything that might be inflicted on me. It is difficult to imagine the joy and eagerness with which everyone on the *ponton* rushes forward at the signal of the distribution of mail, and myself, I follow suit only to witness the contentment of others. . . .

(continued in the appendix, page 212)

*Watercolor illustration from the five-page letter that
is shown opposite.*

Vue de Brest, ... et de l'entrée du port prise du ponton l'Uranie)

est un homme trop libre de sa personne et d'un caractère trop solide pour que je puisse supposer chez lui un changement sans motif. Je n'y comprends donc absolument rien. — D'un autre côté, je te dirai que je ne suis pas sans inquiétude = Il ne s'est guère passé de jour que je ne pense à ce qu'il m'a dit des pertes qu'il a éprouvées = Je m'efforce à croire que les coups portés à sa position n'ont pas été de force à la renverser totalement cependant j'ignore ce qui a pu lui survenir depuis cette époque, et je m'inquiète plus sur ce point, que je ne me suis jamais inquiété pour moi-même. Je te serai donc bien obligé de me rassurer autant que possible sur toutes ces choses, n'oublie pas surtout, en commençant, pour maman, bien entendu, de me donner des nouvelles. Des nouvelles des neveux et nièces Mr et Mme Lolaguer Eugénie Léon Mr et Mme Dauban, Amélie, les petits neveux, nièces &&c le ban et l'arrière ban. — Par les motifs qui m'ont éloigné de tout ce monde que j'aimais j'ai du éviter de les importuner depuis longtemps en les occupant de ma personne, mais si j'ai encouru leur désaffection, leur mépris même, je suis toujours resté maître de les aimer parce que je suis certain qu'ils m'eussent toujours aimé eux même s'ils m'eussent toujours connu. Cette conviction a presque toujours suffi à mon cœur pour le dédommager de tout ce qu'il a souffert injustement = C'est pourquoi mon cher Délégué je te prie de me donner des nouvelles aussi promptes que possible, j'attends ta réponse avec confiance, et je la bénirai mille fois surtout si elle répond à mes souhaits.

Pour ce qui est de moi, je me porte toujours bien, la captivité du ponton, pas plus que tout autre événement du même genre ne saurait influer sur moi si accoutumé aux vicissitudes = La santé des détenus sur notre navire comme sur les trois autres qui sont en rade, est généralement bonne le temps assez beau dans les commencements est devenu plus mauvais à cause de la saison, bien entendu et la mer ne nous permet pas toujours de garder aisément la perpendiculaire, mais nous y sommes assez habitués maintenant pour pouvoir marcher en trébuchant plus ou moins, ce dont les matelots eux même ne sont pas exempts = Les jours sont devenus si courts qu'il nous faut abandonner le pont vers quatre heures et rentrer dans l'intérieur du navire pour y tendre nos hamacs qui une fois tendus ne permettent plus la circulation qu'à quatre pattes. Aussi le plus grand nombre qui se couchent de suite, restent-ils jusqu'au réveil c'est à dire de 4 hre du soir jusqu'à 8 heures du matin

EUGÈNE ROGER, KNOWN AS ROGER DE BEAUVOIR (1807–1866)

Nadar, Portrait of Roger de Beauvoir.
Paris, Musée d'Orsay.

"Monsieur Roger de Beauvoir whose real name is neither Roger nor Beauvoir," wrote Balzac; in point of fact, Roger was his real name, but he took the pseudonym Roger de Beauvoir, after the name of a family estate in Normandy. Having abandoned a diplomatic career, he redefined himself as a dandy, becoming one of the most celebrated pleasure seekers of the "jeunesse dorée" of the 1830s. "Roger de Beauvoir," wrote Alexandre Dumas, "was born with all nature's gifts. He was handsome, he was well proportioned, he was a poet, he was an artist, he was elegant." He made his literary debut with a novel, *L'Écolier de Cluny* (The student from Cluny) in 1832, which Dumas and Frédéric Gailardet adapted into their famous play *La Tour de Nesle*. He contributed to many newspapers and periodicals in addition to publishing quite a few stories, poetry, and plays. His gifts as a draftsman, however, were known only to his friends.

Roger de Beauvoir had married the actress Léocadie Doze, and the couple's 1850 divorce occasioned a high-profile trial. In this letter to the poet Alfred Asseline, a friend, we find him vacationing with his two children in Dieppe, Normandy, in the rain. The commanding view of Dieppe, executed in blue ink on blue paper, has a picturesque allure. The second page (not shown here) is illustrated with a domestic scene picturing himself embraced by his sons, and the final page depicts a rather unfrightening ghost. In 1862 Roger be Beauvoir published his last collection of poems under the title *Les Meilleurs Fruits de mon panier* (The best fruit from my basket). This letter is worthy of figuring under such a rubric.

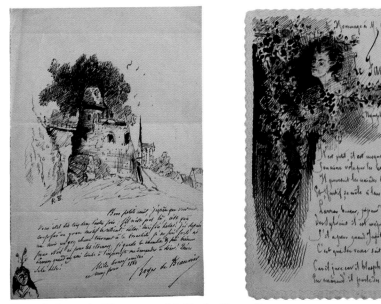

Roger de Beauvoir, "Hommage to M. Charles Vincent,"
signed autograph letter with illustrations, 1865.
Paris, Private collection.

To his friend Alfred Asseline

Dieppe, August 12, 1852
My dear friend Asseline!

Arrived here at 9:30 in the evening on Monday on the 3 o'clock train. I've taken the measure of the region like a veritable engineer, it's deplorable! . . . Torrential rain every morning, lodgings extravagantly expensive, innkeepers with whom one converses only with the aid of a justice of the peace or a police commissioner! The children and I haven't been able to go swimming yet. I think the city's emblem must be an umbrella.
[view of Dieppe as seen from the author's bedroom]
I offer you however the panorama from my window, with a maid taking Eugène and Henri for a walk. These two messieurs literally pass their time making me curse myself. I've just been brought for their account a young sixteen-year-old maid formerly in the employ of Mme Bosco. Bosco, the famous Bosco, who is performing here! I have yet to discover the domestic virtues of this Iris; only during the day does she take them for walks, at night she goes to her parents' house in Le Pollet so the brats can make trouble for their papa to their heart's content!—Candy!—A watch!—A three-deck ship! Thus am I awakened in a bed where I sleep very badly. Poor Roger! But one has to act the father!
[drawing of the author in bed being pestered by his two children]
I found Henri with a cooking spoon and Eugène with a windmill waking me up at 6 in the morning after a night spent in bloody combat with fleas . . .
As for the house where I live, it's impossible to describe, it's frightful . . . and still I pay very dearly.
Come all the same with Anaïs but I think that I'll be leaving soon. I've found few people here except for Gouy, Mrs de Gourcy, de Brigges. Mme Godefroid dines with us almost every evening. The Maison de la Flouait has received express orders from the noble vicomte de Waresquiel, I was unable to take lodgings there for gold or silver despite my pleas. On the other hand, there are the most extraordinary rumors about that building, they say that by night one of the old Waresquiels comes back, sets the table, takes two sous from a gold platter, and returns to the kingdom of the shades . . . It makes your hair stand on end! He doesn't touch a single plate. He has a key and won't give it even to Comte Hugo Sigismond!!!!
What more to tell you? Perhaps that Papon decorated with his cross (Gonzague) and his chain *en crisocale* still hasn't left his card for Bosco.
Come quickly for I'm leaving on the 15th! I'm as bored as the Odéon of Altaroche!
Regards to you and a thousand kind words to the Comtesse Anaïs de Waresquiel, to Sigismond, etc. etc.

Your friend,
R. de Beauvoir
Address all letters to me *poste restante*

maison de la dame Flouait a reçu des ordres exprès du noble Vicomte de Varesguiel, je n'ai pu m'y loger ni pour or, ni pour argent malgré mes supplications! En revanche les bruits les plus inouïs courent sur le logis, on dit que la nuit l'âme d'un ancien Varesguiel y revient, il met le couvert lui même, se donne deux sous dans un plateau d'or, & repart pour le royaume des ombres ... c'est à faire dresser les cheveux! Il ne touche à aucun plat! Il a sa clef et ne la donnerait pas même au Comte Hugo Sigismond !!!!

Que te dire de plus? Si de ses croix (Gonzague) crinoline n'a pas encore Bolio.

a n'est que la sororité et de sa chaîne en mir sa carte à

Arrive vite car le 1er je m'en vais! Je m'ennuie comme l'Odéon d'Altaroche!

À toi de cœur, et mille choses à la Comtesse Anaïs de Varesguiel & à Sigismond, &c

Ton ami:
R. de Beauvoir

Toutes mes lettres sont adressées poste restante.

Dieppe 12 août 1852.

Mon cher ami Alteline!

Arrivé ici à 9 h. 1/2 du soir lundi par le train de 3 heures j'ai levé en véritable ingénieur la carte de ce pays, elle est déplorable! Une pluie torrentielle chaque matin, des logements hors de prix, des hôteliers avec qui l'on ne converse qu'à l'aide d'un juge de paix ou d'un commissaire de police! Les enfants et moi nous n'avons pu nous baigner encore, je crois que cette ville a pour armes un parapluie

Je t'en tire cependant le panorama de ma bonne promenant Eugène et Henry.

Pénétré avec une de deux Messieurs

Théodule Devéria (1831–1871)

Portrait of Théodule Devéria, *engraving.*
Paris, Bibliothèque de l'Institut.

To François Chabas

Palais du Louvre, December 24, 1854

My dear Monsieur,

As the copy of Rossellini in the library of the institute was at the bindery, I had to wait until today to answer you. The word placed next to a fisherman is [hieroglyphics], at the indicated place: in the explanatory text, Rossellini breaks it down into [hieroglyphics], which he doesn't translate, and [hieroglyphics], analogous to [hieroglyphics]— which strikes me as highly problematic! It seems to me the bas-relief is better reproduced in Lepsius, II, bl. I send you a sketch:

[sketch of two young fishermen alongside a stream] + [hieroglyphics]

Fish, and perhaps fishing and fishermen, are in question in several places in the *Select Papyri* of the British Museum, particularly in *Anastasia* III and IV. I have unfortunately not had time to study them deeply but I find the word to be plural [hieroglyphics]. I think it's the same as the one in M. Cailliaud's pottery fragment, which he also interprets as "fishermen." It's in a passage that is analyzed but not translated by Mr. Heath, perhaps I'll find other examples in the rest of his book, for looking through I noticed that fishermen are discussed in several passages. But lacking precise indications, I was unable to find the portions of the text he was talking about: this could be done only by following his translation with the text, the one beside the other. In any case, I nowhere saw the word [hieroglyphs] used to mean fisherman. I totally agree with you about the phrase that you cite: your translation is much more literal and consequently better than that of Mr. Birch. In his dictionary, Champollion gives the sign [hieroglyphics] as expressing the general idea "shepherd, driver of a herd of quadrupeds, of whatever species." But he doesn't give its true phonetics [hieroglyphics], and he cites the word [hieroglyphics] "doorkeeper, guardian of a door." Furthermore, the verb *ari* is used, I think, in the sense of "to guard, to conserve, to reserve," whatever the object *cf.* T 81.1. "I am the Lotus pure issue of a splendid [?] reserved for the nostril of the sun god, reserved for the nose of the goddess Hathor" (the variants give [hieroglyphics]). This meaning has no relation to a herd of quadrupeds, and I see no example where this word used substantively and in isolation would obviously mean "shepherd," but wouldn't other examples be needed before advancing that of "prisoner"? . . .

(continued in the appendix, page 214)

Too little attention has been paid to Théodule Devéria, who, although one of the great Egyptologists of the second half of the nineteenth century, died too young to complete a single book.

He first became interested in Egypt while listening to the venerable Egyptologist Achille Constant Théodore Emile Prisse d'Avennes, attired in Oriental dress, whose portrait his father Achille Devéria was painting. But it was the revolutionary days of June 1848 that decided him on his vocation. After being wounded during the street fighting in Paris, he met Jules Feuquières, who introduced him to Auguste Mariette, then a curator at the Louvre, Charles Lenorment, future professor at the Collège de France, and Emmanuel de Rougé, all brilliant Egyptologists who helped him get his bearings in their discipline, with which he was already enamored. Hired as a curatorial assistant in the Department of Egyptian Antiquities at the Louvre in 1855, he visited museums in London and Dublin before making his first trip to Egypt in 1858. When Mariette settled in Cairo in 1860, Devéria succeeded him as adjunct curator of the Louvre's Egyptian collection.

His letters to François Chabas, who was initiated into Egyptology at the age of 35, are the sole portion of his correspondence to survive. These letters are devoted almost completely to the discussion of lectures and textual interpretations. In some of them, Devéria reveals irritation at Chabas's glibness about philological questions. "The farther I advance, the more I distance myself from your opinion regarding the vague system that you adopt, which prevents us from seeing the Egyptian language clearly," Devéria wrote him at one point, to which Chabas responded: "We differ in our estimation of a few philological rules that you consider important, whereas I think them imprecise and useless in any case." Patiently, Devéria urges Chabas to adopt his method of translating and understanding ancient texts, which consisted of accumulating examples and multiplying comparisons, submitting one's intuitions to others for assessment, and reopening questions that had been dealt with precipitously.

Devéria's death was an indirect result of the Franco-Prussian War. His fragile health obliged him to spend every winter in Nice, but he did not want to leave Paris during hostilities. He died there at age 40 in January 1871, having succumbed to a chest infection aggravated by a severe cold spell that had gripped the capital.

Théodule Devéria, Edfu, Facade of the Great Hall of the Temple of Horus, *photograph, 1859. Paris, Musée d'Orsay.*

MINISTÈRE.

DE LA

AISON DE L'EMPEREUR.

DIRECTION GÉNÉRALE

DES

JSÉES IMPÉRIAUX.

Palais du Louvre, le 24 Décembre 1855.

Mon Cher Monsieur,

L'exemplaire du Rosellini de la Bibl. de l'Institut étant à la reliure, j'ai dû attendre jusqu'à ce jour pour vous répondre — Le mot placé auprès d'un pêcheur et 𓊨𓏤𓎡𓇋, à l'endroit indiqué; dans le texte explicatif, Rosellini le décompose en CNXX, qu'il ne traduit pas, et XX, analogue à OPOPS .— cela me paraît fort problématique...! Le bas-relief me paraît mieux reproduit dans Lepsius, II, bl. .— Je vous en envoie un croquis :

une barque etc.

Il est question de poissons, et peut être de pêche et de pêcheurs dans plusieurs endroits

CHARLES-ALBERT D'ARNOUX, KNOWN AS BERTALL (1820–1882)

Photograph of Bertall.

To Monsieur Émile Péreire

When one's name is Charles-Albert, vicomte d'Arnoux, comte de Limoges-Saint-Saëns, and when one has abandoned the École Polytechnique to devote oneself to drawing and caricature, the family insists upon a name change. Reversing the syllables of one of his given names, in 1843 he published under the psuedonym Bertal *Les Buses graves* (The solemn blockheads), a send-up of Victor Hugo's *Les Burgraves* (The Burgraves). At about the same time, he was commissioned to sketch the character of Madame Vauquer in *Le Père Goriot* for the large edition of Balzac's *La Comédie humaine*. Shortly thereafter, Balzac chose him to translate *Les Petites Misères de la vie conjugale* (*The Petty Annoyances of Married Life*) into visual terms (see pages 22–23). He was to become one of Balzac's finest illustrators, and it was Balzac who advised him to add a second "l" to his pseudonym.

An indefatigable contributor to many periodicals, notably *Le Journal pour rire* and *L'Illustration*, he produced thousands of humorous images concerning events of the day, occasionally even writing the texts for his illustrated albums called "La Comédie de Notre Temps" (The comedy of our time). He also illustrated quite a few books, notably by the comtesse de Ségur, as well as several published in the Bibliothèque Rose series.

Here he reminds the great financier and entrepreneur Émile Péreire about his drawings for the *Journal pour rire*, and, knowing that the banker is also a collector, sends him some of his original drawings, hoping to obtain in exchange a few shares of stock. By way of a signature, he draws himself respectfully tipping his hat to his correspondent and presenting him with a visiting card, its corner folded over as was customary when one left them in person. Deftly executed, witty and elegant, this little pen drawing exemplifies the art of Bertall to perfection.

June 8, 1856

Monsieur,

At the instigation of my friend, M. Édouard Lebey, I have had the pleasure of figuring often in the *Journal pour rire* and in the form I deemed most appropriate to draw attention to the various enterprises that you have managed so capably and successfully. I don't have in hand a collection of the many things I've drawn with the intention of being agreeable to you. Permit me to send you in this mailing one or two concerning the Rivolis and the Crédit Mobilier affair: this latter above all turning to account the issue of the Crédit Mobilier Espagnol, the stock for which is to be distributed shortly.

Monsieur Lebey having emboldened me to ask you for some by way of exchange, I would be grateful to you for whatever number of shares you might see fit to grant me.

My pencil and my pen charge me with offering you their respectful homage, and I think they firmly intend to continue being agreeable to you whenever the occasion might present itself.

Accept, I beg you, this expression of the feelings of high regard with which their owner has

the honor of being
Your entirely devoted
[on the *carte de visite*]

Bertall
16 rue de Fleurus

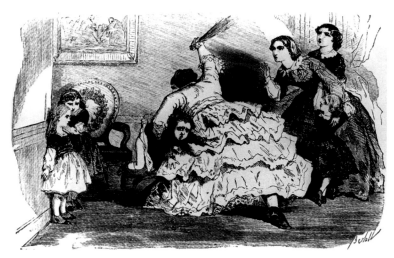

Bertall, illustration for Le Général Dourakine *by the Comtesse de Ségur.*

8 Juin 1856. A. Monsieur Emile Péreire

Monsieur

À l'instigation de mon ami — Mr. Edouard Lebey, j'ai eu le plaisir de faire figurer souvent dans le journal pour rire, et sous la forme que je croyais le plus propre à attirer l'attention, les diverses entreprises que vous avez patronées avec tant de mérite et de succès. Je n'ai point sous la main une collection des nombreuses choses que j'ai dessinées dans l'intention de vous être agréable; permettez moi de vous en adresser sous ce pli une ou deux ayant trait aux Rivoli, et à l'affaire du crédit mobilier; ce dernier surtout empruntant quelque opportunité à l'émission du Crédit mobilier Espagnol dont les actions doivent être réparties prochainement.

Monsieur Lebey m'ayant enhardi à vous en demander quelques unes au pair, je serai reconnaissant du nombre quel qu'il soit des actions que vous voudrez bien m'accorder.

Mon crayon et ma plume me chargent de vous présenter leurs hommages respectueux, et je les crois dans l'intention la plus arrêtée de continuer à vous être agréable lorsque l'occasion pourra s'en présenter.

Agréez, je vous prie l'expression des sentiments de haute considération avec lesquels leur propriétaire a l'honneur d'être.

Votre tout dévoué

Bertall
16 rue de Fleurus

CHARLES BAUDELAIRE (1821–1867)

Nadar, Portrait of Baudelaire.

In correspondence between an author and his or her publisher. questions are often raised concerning a manuscript that occasion heated discussion. thereby casting new light on a work's genesis and meaning. The letters exchanged between Charles Baudelaire and Auguste Poulet-Malassis regarding *Les Fleurs du Mal* in 1857 certainly number among these jewels of literary history. In the face of Baudelaire's utter intractability. Poulet-Malassis. whom the poet nicknamed "Coco mal perché," or "ill-perched chap" (a play on his real name, which literally rendered would yield "badly seated chicken"). manifested extraordinary patience. In this letter. written a month before the book's publication. Baudelaire takes issue with the proofs from the printer. De Broise. who was an associate of the publisher. Baudelaire is unsparing in his reproaches. expressing concern about the smallest typographical details, revealing himself to be obsessed with precision. attentive to every editorial decision, and intransigent regarding insignificant as well as substantive issues. He encloses the now famous poem "Vin des chiffoniers" ("The Ragpicker's Wine"), duly transcribed in fine copy for the typesetters, and concludes with a series of exclamation points indicative of his agitated state of mind.

Consisting of a hundred poems, *Les Fleurs du Mal*—originally to have been entitled *Les Lesbiennes* (The lesbians). then *Les Limbes* (Limbo)—had a first printing of one thousand copies and went on sale in Paris at the end of June. By August Baudelaire was on trial for obscenity. The recommendation of the prosecutor Ernest Pinard, who had become famous a few months earlier during the analogous trial of Gustave Flaubert for *Madame Bovary*, was as follows: "Show leniency toward Baudelaire, who is anxious and unbalanced by nature. Likewise toward the printers, shielded by the author. But condemn at least some pieces in the book so as to issue a warning that has become necessary." The sixth court of the Tribunal de la Seine levied a fine of three-hundred francs against Baudelaire: Poulet-Malassis and De Broise were each fined one-hundred francs, and six poems judged licentious were ordered suppressed. Publication and sale of these "condemned poems" were prohibited in France until 1949.

To Auguste Poulet-Malassis

Nadar, Portrait of August Poulet-Malassis *(detail)*, *c. 1857. Private collection.*

[roughly February 20, 1857]

But, my dear friend, since I make you so unhappy and you are so impatient to come to Paris, come, then, without worrying about the last sheet. The meticulous care with which I correct is a fine safeguard: I'll submit my proofs to you first, before sending them back to M. De Broise with my authorization to print.

With regard to what you wrote me yesterday when you sent me a bit of the proofs, it's unintelligible. You must have a typesetter who's quite obstinate or quite dense. All of my roman numerals are accurate. The new order indicated by these numbers must be followed. What's more, at the end of one of my letters I wrote out the end of the table of contents for you, with the ordering numbers. You can consult this letter if your typesetter persists in retaining the original order.

Today. I send you "Le Vin des chiffoniers," which I copied over to make things easier for your workers, who would have found the proof much too overwritten.

Now you owe me a final proof, the ninth.

Come to Paris with the table of contents. but don't have it printed until I've read it over. I don't think that would be possible for you anyway, since the last or the two last sonnets will be set on the same sheet.

Yours truly.

You took what I wrote you about the health of my brain for a Joke.

Ch. Baudelaire

So you don't want to show me the cover! !!!!!!!!!!!!!!!!!!!!!!!!!!!!!!!!!!!! !!! !!!!!!!!!!!!!!!!!!!!!!!!!!!!!!!!!!!!!!!

C. B.

Emblem of the publishing house of Auguste Poulet-Malassis.

Lettre écrite à propos d'une
des dernières feuilles du volume.
Lettre de Poulet-Malassis

Mais, mon cher ami, puisque je vous rends si
malheureux et que vous êtes si impatient de
venir à Paris, venez donc, sans vous
inquiéter de la dernière feuille. Le soin mi-
nutieux avec lequel je corrige est une bonne
garantie; D'ailleurs, je vous soumettrais mon
épreuve avant de la renvoyer avec Bon à
tirer à M. De Broise.

Quant à ce que vous m'avez écrit hier
en me renvoyant un bout de placard, c'est
inintelligible. Il faut que vous ayez un metteur
en pages bien entêté ou bien étourdi. Mes
chiffres romains sont toujours exacts. Il faut
suivre l'ordre nouveau qui est indiqué par
les chiffres. D'ailleurs à la fin d'une de mes
lettres, je vous avais écrit la fin de la
table des matières, avec les ~~chiffres~~ numéros d'ordre.
vous pouvez donc en référer à cette lettre. si le
metteur en pages s'est obstiné à suivre
l'ordre primitif.

Aujourd'hui, je vous envoie
des chiffonniers, que j'ai recopiés

Commodité de vos ouvriers qui auraient
trouvé le placard vraiment trop surchargé!

Maintenant vous me devez une
bonne feuille la 9ᵉ.

Arrivé à Paris, on la table
des matières, mais on la faites que tu sais
dans que je l'aie lue. D'ailleurs je crois
que cela ne vous est pas possible parce que
le dernier ou les deux derniers chapitres seront
composés sur le même fragment de feuille.

Bien à vous,
vous aurez pris pour une blague ce que
je vous ai écrit sur la santé de mon cerveau.

Ch. Baudelaire

Vous ne voulez donc pas me
montrer la Couverture !!!!!!!!!

vous aurez l'obligeance de
me renvoyer toute la copie, et si vous
de la dernière feuille, à M. De Broise
dès à Paris. Ils voudra bien les garder.

Proofs of Les Fleurs du Mal *with autograph corrections, comments, and "ready to print" authorization sent by Baudelaire to Poulet-Malassis. Above: Baudelaire's corrections to the proof of the dedication page to Théophile Gautier. Paris, Bibliothèque Nationale de France.*

Left: Transcription of Baudelaire's annotations on the proof of the dedication page:

It seems to me it would be better to lower the dedication a little so it would be in the center of the page, but I leave that to your taste. Then, I think it would be good to have *Fleurs* in italics—in leaning capitals since it's a punning reference to the title. Finally, although each of these lines and letters are well proportioned (relative to one another), I find them too large: I think that the whole would gain in elegance if you used a slightly smaller typeface for each line, retaining their relative proportions. Only the *C. B.* seems to me a bit small—

—I note that your pagination excludes the title page and the dummy title page. Again, I leave this to your taste—Please be so kind as to set the final proof aside for me.—I give you my

Ready to print

Ch. Baudelaire

Manuscript of the dedication page to Théophile Gautier.

Title and copyright page proofs with Baudelaire's corrections.

The page proofs for the poem "Spleen" with Baudelaire's corrections and authorization to print.

CHARLES-FRANÇOIS DAUBIGNY (1817–1878)

Nadar, Portrait of Charles Daubigny.
Private collection.

In 1857 an important event took place in the life of the painter Daubigny: he purchased a boat and outfitted it himself so that he could live and paint in it as he pleased, for he thought the most beautiful landscapes were to be found along riverbanks.

This vessel, christened *Le Bottin*, was an old flat-bottomed ferryboat roughly twenty-eight by six feet, outfitted with sails and oars. Daubigny built a pine cabin on it that served simultaneously as studio, kitchen, and bedroom. Inside were chests containing kitchen implements, easels, and paint boxes, as well as provisions and a demijohn of wine. Daubigny was joyous and sociable by nature, and he didn't hesitate to invite his friends to share his escapades on the Seine, the Oise, and the Yonne rivers: Camille Corot (see pages 66–69) was dubbed the "honorary admiral"; the sculptor Geoffroy Dechaume the "sailor"; and Daubigny's young son, Charles, the "cabin boy." Their nautical voyages were punctuated by amusing incidents: an encounter with a steamboat that almost capsized them, a broken oar, an absurdity uttered by the "cabin boy," an excursion by lantern light when the night was pitch black ("the effect was very amusing"). Daubigny represented these events in drawings, which he then translated into prints that were published in 1862 by Cadart under the title *Le Voyage en bateau*.

Water was an essential element of Daubigny's pictorial universe, and these trips were a great source of inspiration for him. His paintings *The Banks of the Oise*, *Village and Bridge by a River*, *River Landscape with Herd of Cattle*, and *Houses on a Riverbank* were directly inspired by observations he made on board *Le Bottin*.

Seduced by the banks of the Oise, Daubigny acquired a house and garden in Auvers-sur-Oise, north of Paris, in 1859. It was here that, in 1867, the boat described in this letter found its final berth, transformed into a refreshment barge.

To Geoffroy Dechaume

Wednesday evening, October 28, 1857

My old friend,

Good evening, I waited to write you about the regular progress of *Le Bottin*, I could say irregular, for now that we know the country better, it's a bit by whim. But we're beginning to get used to this nautical voyage and we really encounter only good people. You must know from my wife that I returned to L'Afferte. Unfortunately, you took the good weather away with you, such that we haven't seen the Herblay countryside in anything but gray weather. We went by the islands, and we had a bit of a scare getting past the two fragments of the bridge that we saw together. We no longer sleep on the boat. We even made a gift of our two bales of hay to Neptune so he'll look kindly on us. However, this old beggar made us break an oar in the middle of the water below Triel, such that we returned to father Creté and a wheelwright repaired it for us. We consoled ourselves by drinking some new wine with father Creté, who gave us some very good information. He's a very brave man with scads of medals for having saved eleven people from the water. He told us not to navigate when the water's high, but until now the water has been rather low and I'm instead afraid of rocks in the currents. We've already sailed twice in the dark of night but we knew the way: once going to Triel, the other time returning to Meudan. We hung our lantern, which lit up the whole Seine: the effect was very amusing. As you see, we're moving in short stages, the days are so short now, especially when you want to make sketches along the way. You have to see the grrreat sketching commotion on board *Le Bottin*, what diligence. All that's lacking is the teacher!!!

Alas, cabin boy No. 1 performs his duty well since I bought him a dishcloth. We're very lucky, for the weather this morning, October 29, is superb. As you see, we're in Mantes. If I'm not afraid of wasting too much time, I'll seek out a man named Félix Cartier whom I haven't seen for thirty-nine years and who's supposed to be established as a clockmaker here. In Meulan I met a certain Bignon, an actor. He's supposed to come to see me in Paris. I refused to have lunch with him to avoid losing time, for the good weather might not last long. . . .

(continued in the appendix, page 214)

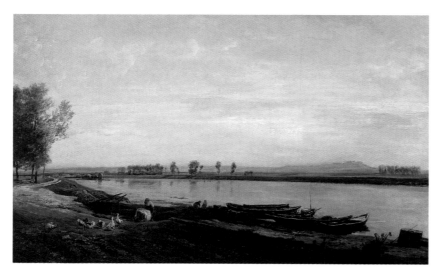

Charles Daubigny, The Seine at Bezons.
Val d'Oise. *Paris, Musée d'Orsay.*

t'y attendrais tu as oublié ton carnier
dans le bateau adieu mon
vieux je vais boire dans ta goutte
à ta vente une bonne poignée
de main ton ami C. Daubigny
Embrasse ta femme
pour moi et tous les enfants

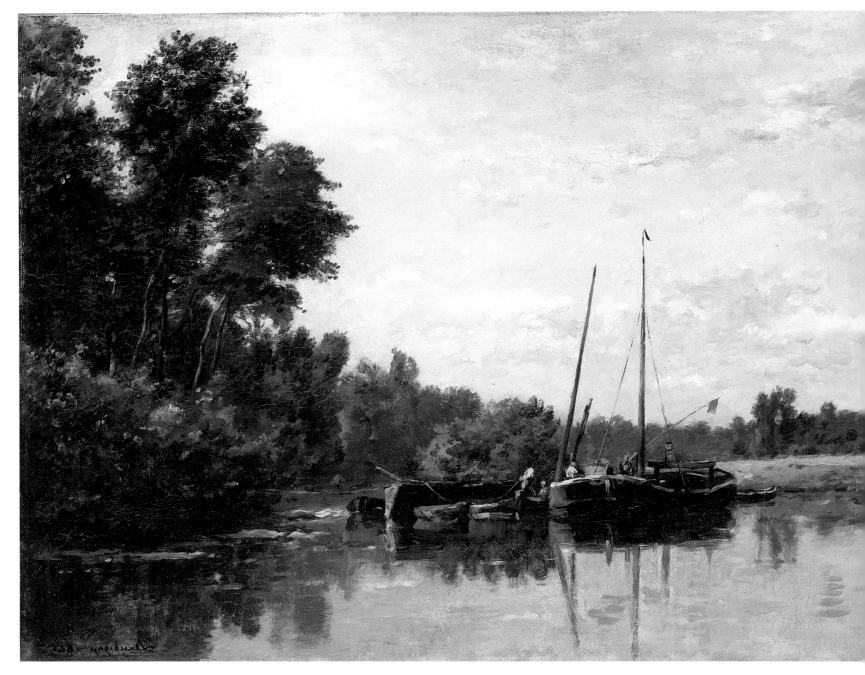

Charles Daubigny, Barges. Paris, Musée du Louvre.

Charles Daubigny, Luncheon on the Floating Atelier, Paris, Musée d'Orsay.

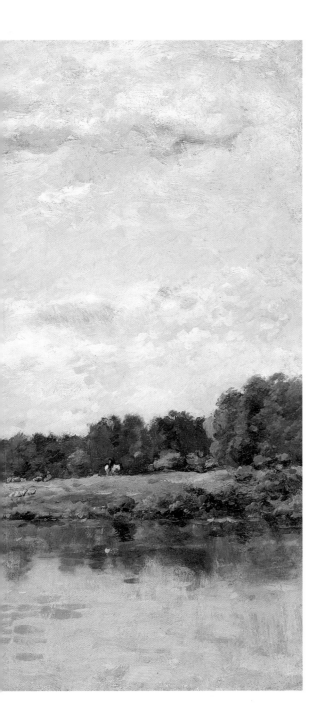

Charles Daubigny, The Floating Atelier. Paris, Musée d'Orsay.

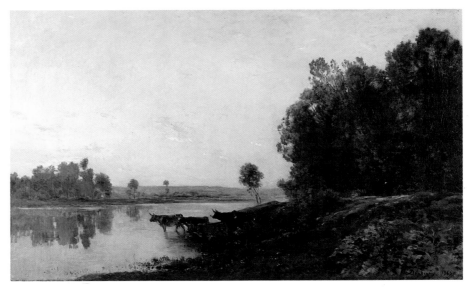

Charles Daubigny, Rising Sun, Banks of the Oise. Lille, Musée des Beaux-Arts.

CÉLESTIN NANTEUIL (1813–1873)

What could be more mysterious and affecting than an incomplete letter—undated, to an unknown recipient—that contains professions of love as well as crisp, elegant illustrations? This document has escaped history, but it is signed with the name of a superb artist who is too little known, whose letters are extremely rare, and whose works are prized by collectors: Célestin Nanteuil.

A student of Ingres and a friend to poets (most notably Victor Hugo), an engraver, a lithographer, and an etcher, Nanteuil is widely regarded as the pre-eminent illustrator of the French Romantic school. He devised vignettes for Hugo's *Bug-Jargal, Dernier Jour d'un condamné à mort,* and *Notre-Dame de Paris;* he also provided illustrations for texts by Théophile Gautier, Alfred de Musset, Alexandre Dumas, and Roger de Beauvoir, designing in addition the title pages for many musical scores. Thus it is not surprising to discover in the present letter—despite the fact that the author was clearly in a port city at the time of writing—descriptions of a performance of scenes from *Fernand Cortez,* an opera by Spontini to a libretto by D'Esménard and Étienne de Jouy, and *Robert le diable,* an opera by Meyerbeer to a libretto by Scribe and Delavigne. These two works, with their complicated plots and exalted heroic sentiments, had been hugely successful in Paris. With a few deft strokes of the pen, Nanteuil renders the heads of two of the principals: Fernando Cortéz, the conquering Spanish hero of the title, and Bertram, the mysterious figure who eventually reveals himself to be the father of Robert le Diable. The concision of his art is exemplified by these spontaneous sketches, which can only have delighted their intended recipient.

To a lady

. . . or medieval sculpture. But I perceive, madame, that if I continue, I'll end by giving you a course in architecture, which wouldn't amuse you; that's better left for our promenades with St. Audouin, the great expert on Gothic architecture. I'd much prefer, madame, instead of speaking to you about old churches and old reliefs, to be able to tell you that I love you, to try to express to you how unhappy I am at being unable to see you, but you forbid it, which is very cruel of you, madame.

[drawing]

Here's a sailor's wife in a port. They are very beautiful in costume, with their scarlet aprons, blue corsets, and exposed legs. Sometimes I look at them a long time, and they have no idea why I'm looking at them with such interest. A few days ago we saw a performance as charming and funny as they come, however greatly I regret, madame, that you couldn't enjoy the[se] performances *Fernand Cortez* and *Robert le Diable* at the *cirque.* You couldn't imagine anything funnier than the costumes and burlesque poses of these honorable squires, who played with an admirable seriousness, but what surpassed everything, what really made my laugh, although I'm not prone to, were the two admirable eyebrows glued to the man playing Bertram. The rest of his figure went very well with his head, and the whole constituted, I assure you, an ensemble that was utterly ravishing. If only you'd been there.

I think, madame, that you are still in Dunkirk; I haven't had news of you for quite some time. I wrote you several letters poste restante, I don't know if they reached you. After Dunkirk, I think Brussels is your next stop. As for me, I'll return to Paris to look after your apartment and await whatever orders you see fit to give me.

Your devoted
Célestin Nanteuil

Célestin Nanteuil, The Ray of Sunlight.
Valenciennes, Musée des Beaux-Arts.

qui sont à des côtés tout de la sculpture du
moyen age. mais je m'apperçois, madame que
si je continue je vous ferai un cours d'architecture
ce qui ne vous amusera pas. c'est bon pour
nos promenades avec Mr Ledouix, le grand
amateur d'architecture gothique. j'aimerais
bien mieux, madame, au lieu de vous
parler de

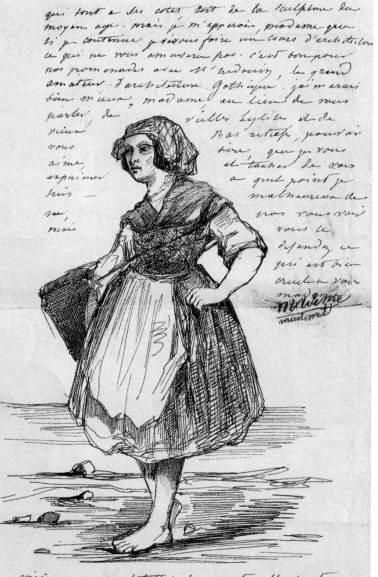

vieille église et de
vos retief, pouvais
dire, que je vous
aime, et tâcher de vous
exprimer à quel point je
suis — malheureux de
me, ne vous voir
mais vous le
défendre ce
qui est bien
cruel à vous
madame

vois, une malétotte du port. elles sont
bien belles de costumes avec leur jupons
écarlate, leurs corset bleu et leur jambes nues

quelquefois je me mets à les regarder —
pendant longtemps, et elle ne comprennent pas
surtout ce que jai à les regarder avec tant
d'intérêt. nous avons vu il y a quelques
jours, le spectacle le plus charmant et
le plus dramatique que se puisse voir. je
bien sûrement regrette madame, que
vous ne puis ici jouer de la
représentation de fernand cortès
et de robert le diable au
cirque. vous ne pourriez vous
figurer rien de plus amusant
que les costumes et les poses

FERNAND-CORTES

burlesque. de ces honorable écuyers, qui
jouent cela avec un sérieux admirable
mais ce qui surpassait tout, ce qui
vraiment m'a fait rire, quoi que je ne
sois pas très en train, au sont les
deux admirable sourcils que s'était
collé celui qui représentait
bertram. le reste du
personnage était fort bien —
avec la tête et le
tout françois je vous
jure un ensemble des plus
rarissants BERTRAM que si étiez vous la.

je pense, madame, que je vous sais
toujours à dunkerque je n'ai pas reçu
de vos nouvelle depuis bien longtems —
je vous ai écrit plusieurs lettres poste
restante je ne sai, si elles vous seront
parvenues. après dunkerque c'est je crois
à Bruxelles que vous allez. alors moi
je reviendrai à paris pour m'occuper de
votre appartement et recevoir les ordres
que vous voudrez bien me donner.

votre dévoué
adolphe mantout

THÉOPHILE GAUTIER (1811–1872)

Nadar, Portrait of Théophile Gautier *(detail). Private collection.*

To Jean-Auguste-Dominique Ingres

Jean-Auguste-Dominique Ingres, Self-Portrait. *1806. Cambridge, Mass., The Fogg Museum.*

Théophile Gautier is undoubtedly one of the most misunderstood person-alities of the nineteenth century. His novels *Mademoiselle de Maupin, Le Capitaine Fracasse,* and *Le roman de la momie* (*The Romance of a Mummy*) are well known, but how often is it remembered that Baudelaire dedicated *Les Fleurs du Mal* to him, calling him "the impeccable poet" and the "perfect magician of French letters"; or that he was on friendly terms with all the great figures of the period, such as Flaubert, Balzac, and Hugo; or that he was a sen-sitive travel writer who wrote about his trips to Spain, the Orient, and Russia; or that he extolled "art for art's sake" and was a forerunner of the Parnassian school of poetry; or, finally, that he rehabilitated Goya and defended Delacroix?

For a time an aspiring painter, throughout his life Théophile Gautier—who opted to retain the designation "man of letters and painter" on his passport—placed his journalistic talents at the service of artists he admired. Ingres figures prominently among them. When he wrote this letter to the "dear and venerated master" (a customary way of addressing him at the time), Gautier was nearing the end of his sojourn in St. Petersburg, Russia, where he spent six months gathering material for his book *Voyage en Russie.*

What is this "miraculous painting" that Gautier attributes to Ingres, apologiz-ing for the awkwardness of his copy of it? We do not know. The master's response is lost, and the publication of this letter in *L'Intermédiaire des chercheurs et des curieux* (May 25, 1885), in hopes of solving the mystery, proved fruitless. To sat-isfy a commission from the future Tsar Alexander II, Ingres had delivered a *Virgin with the Host* to the Academy of Fine Arts in St. Petersburg in 1842 (now at the Pushkin Museum in Moscow), but it clearly bears no relation to the Madonna described and drawn by Gautier. The critic's interpretations were probably extravagant. In 1862 Ingres paid homage to Gautier by including a portrait of him in *Jesus among the Doctors.* The friendly relations between the two men continued until Ingres's death in 1867.

St. Petersburg
February 7, 1859

Dear and venerated master,

I have just discovered in St. Petersburg a miraculous painting that can only be by you or by Raphael. It is not by Raphael, as indi-cated by its too-perfect state of preservation, yet I haven't seen this sublime composition among the line engravings of your work. Is it one of the three or four paintings that, gone astray, lost, passed into the hands of unknown owners, have regrettably been lost track of? I have recourse to your benevolence to find out. This canvas represents the Virgin and the infant Jesus life-size. The celestial mother presents to the world her divine infant, whose little arms and perpendicular body simulate the resemblance of a cross as if in anticipation of the Passion. The Virgin, with her beautiful hands, holds the bambino by the armpits as if she wanted to have him take his first step on her knees and this first step presaged Calvary. The expression of maternal tenderness on Mary's face is tinged with a prophetic melan-choly, she vaguely foresees the anguish of Golgotha. The little Jesus, too, is serious, sad, his head inclined to one shoulder already sug-gesting his agonized movement on the cross, recalling the . . . *ponant caput expiravit.* The two heads of the child and the Virgin touch one another; with a boldness that is pleasing and charming, the halo of Jesus traces its gold circle over the cheek of Mary, whose nimbus entwines with her son's rather like the rings of an open wedding ring. The Virgin's tunic is red, her mantel an intense blue. The drawing is yours, enough said, the modeling is of a strength and finesse that belongs to you alone, the color of a powerful harmony, a veiled warmth in the gilded and brown register of the Roman school. . . .

(continued in the appendix, page 214)

Théophile Gautier, Carlotta Grisi in "Giselle." *1841. Private collection.*

Cher et vénéré Maître

Je viens de découvrir à St pétersbourg un tableau miraculeux qui ne peut être que de vous ou de Raphaël. il n'en pas de Raphaël. sa conservation trop parfaite le dit et pourtant je n'ai pas vu dans votre œuvre gravé au trait cette composition sublime. fait elle partie des trois ou quatre tableaux égarés, perdus, passés à des possesseurs inconnus dont on regrette de n'avoir pu retrouver la trace? j'ai recours à votre bonté pour le savoir — cette toile représente la vierge et l'enfant Jésus de grandeur naturelle. la céleste mère offre au monde son enfant divin dont les petits bras et le corps perpendiculaire simulent la ressemblance d'une croix comme par un pressentiment de la passion. La vierge de ses belles mains, soutient le bambino par les aisselles comme si elle voulait lui faire essayer sur ses genoux le premier pas et ce premier pas présage le calvaire. à l'expression de tendresse maternelle sur le visage de Marie se mêle une mélancolie prophétique elle devine confusément les angoisses du Golgotha. le petit Jésus aussi est sérieux, triste; sa tête penche sur l'épaule

Gautier

CAMILLE COROT (1796–1875)

Nadar, Portrait of Camille Corot *(detail)*.
Paris, Musée d'Orsay.

To Madame X

Paris, September 21, 1860

Madame,

I arrive from Burgundy.
I went to visit my little niece.
I found her quite well like her little boy whom I found very kind.
She should come next year to show him to her sister who still hasn't seen him. I'll be paying you my autumn visit in the company of Ferdinand and M. Menetrier.
Until I have the pleasure of seeing you, accept, madame, assurances of my affectionate thoughts

Camille Corot

Turn the page, you'll see a little *souvenir* of Burgundy.

How can one not be startled by the contrast between the text of this letter and the drawing on its verso? After returning to Paris from a trip to Burgundy, Corot penned this note to a Swiss woman friend whom he planned to visit in the fall. There's nothing poetic about the text, written in the terse, no-nonsense style that Corot favored in his correspondence: he briefly refers to a visit to his niece, her "very kind" little boy, and a forthcoming visit.

By contrast, the beautiful pen sketch boasts features dear to the landscape painter: large trees framing the scene, a small, solitary figure (here on horseback), and, finally, a cluster of buildings on a distant hill. This *Souvenir de Semur* is a poetic reverie nourished by the painter's memories of his trips to Italy. During his first stay there in 1826–27, he made his first strides as a landscape painter and resolved to devote himself to painting: "I have but one goal in life that I want to pursue steadfastly," he confided to his friend Abel Osmond, "that is to make landscapes. This firm resolution will prevent me from becoming seriously attached. I mean from marrying."

During his second Italian sojourn in 1834, he painted several plein air studies of Volterra that inspired later compositions and that reveal his taste for panoramic views with buildings perched on distant hills.

These same themes recur in his travel sketchbooks, where they seem not so much to record specific sites as to answer the vicissitudes of memory. Indeed, in 1855 Corot began to use *souvenirs*, the French word for "memories," in his titles: *Souvenir de Marcoussis* (1855), *Souvenir de Ville-d'Avray* (1857), and the celebrated *Souvenir de Mortefontaine* (1864).

Corot's landscapes, then, are poetic reminiscences: to paraphrase one contemporary critic, while they are not landscapes we have seen, they correspond to our dreams.

Camille Corot, Rider on a Sunken Road *(detail), c. 1870. Paris, Musée du Louvre.*

Camille Corot, The Roman Campagna, *also called* La Cervara. *Paris, Musée du Louvre.*

Camille Corot, Souvenir de Mortefontaine. *Paris, Musée du Louvre.*

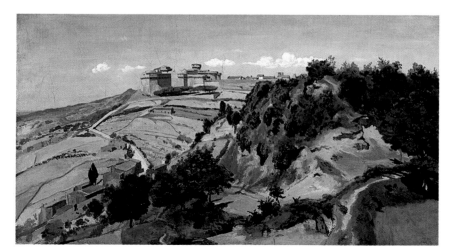

Camille Corot, Volterra: The Citadel. *Paris, Musée du Louvre.*

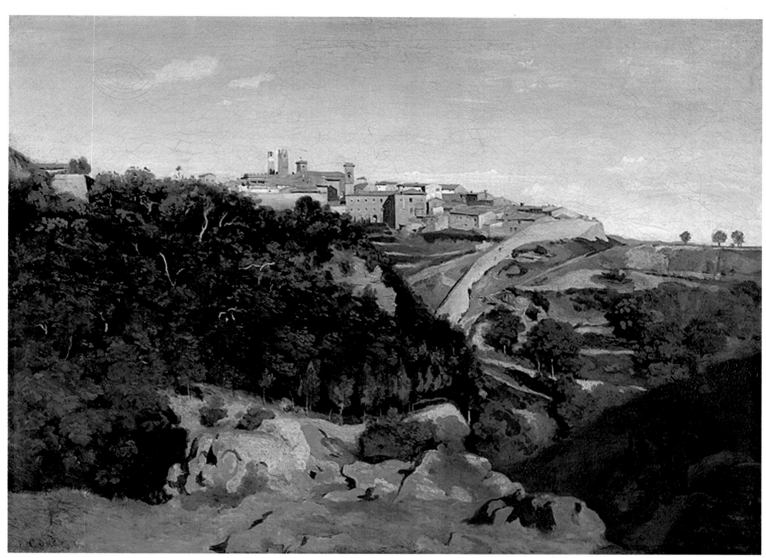

Camille Corot, Volterra: View of the Town. *Paris, Musée du Louvre.*

FÉLIX ZIEM (1821–1911)

Félix Ziem, Self-Portrait. *Martigues, Musée Ziem.*

André Gill, Presumed Portrait of Théodore Rousseau.
Paris, Musée d'Orsay.

Félix Ziem is best known for his views of Venice and the Bosporus, but the work he executed in Provence is also noteworthy. Here he tells Théodore Rousseau, whom he had met at Barbizon, about his settlement in the south of France, in Martigues.

The isolation of the site ("a promontory forgotten by civilizing men"), its authenticity and beauty ("this country is still virginal and antique like its inhabitants"), the proximity of the sea, and the light of Provence prompted Ziem to purchase property there the following year, which he proceeded to decorate in accordance with his tastes for the Orient. A contemporary article describes the result as follows: "Ziem had built, in the garden of his villa in Martigues, small artificial structures, pointed minarets surmounted by crescents, mosques skillfully decorated with bits of faïence simulating mosaic and capped by imitation domes, large oil jars turned upside down and painted white."

From this atelier, Ziem painted many views of the nearby lakes and, especially, of the fishing boats, known as *tartanes*, that plied the Mediterranean.

Although he kept an atelier in Paris and continued to travel, Ziem continued to spend time in Martigues until 1872, when he settled in Nice. Unfortunately, the decor of the Martigues atelier was destroyed in 1970, but a museum in the town continues to honor Ziem's memory.

To Théodore Rousseau

Martigues, Monday. [1860]

Claudes and Poussins at every step! My dear friend, it's now eight days since I left Barbizon. The most beautiful weather has not let up for a minute. It hasn't rained here since the month of May. The oleanders are in bloom and pomegranates are being harvested. These trees here are like the apple trees where you are: the field grass here consists of aromatic plants. The forests are of pine, cyprus, holm oak, cork trees, and plane trees.

I've rented a charming place three minutes outside of town: on the ground floor, salon, dining room, kitchen, service areas etc; on the first floor, a beautiful atelier, a magnificent bedroom, facing south, and a maid's room. The house is in the middle of an immense produce garden: artichokes, lettuce, etc., fig trees, apricot trees, medlar trees; a small corner of this garden has been allocated to me personally, and I have the run of the rest like everyone else; the peasants who cultivate it are quite amiable. The country is healthy and mild, apart from the north wind I hear such frightening things about: but I wonder if this wind is so terrible here, where there's a real palm tree right in the ground, right at my door. We bought a goat named Jeanne and a large ewe named Blanche. Later I intend to buy a *boquet corse*, a kind of wicker cabriolet with a small horse the size of a small donkey. A donkey for riding or for a conveyance is available to me whenever I want. My country seat costs me 300 francs per year: that's a squeeze for me, but the real price is 250 francs. . . .

(continued in the appendix, page 215)

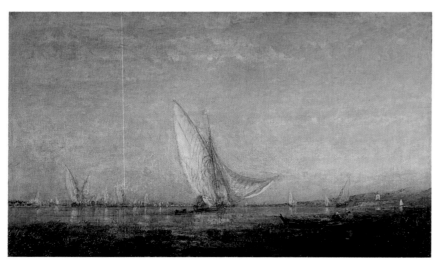

Félix Ziem, Tartanes. *Martigues, Musée Ziem.*

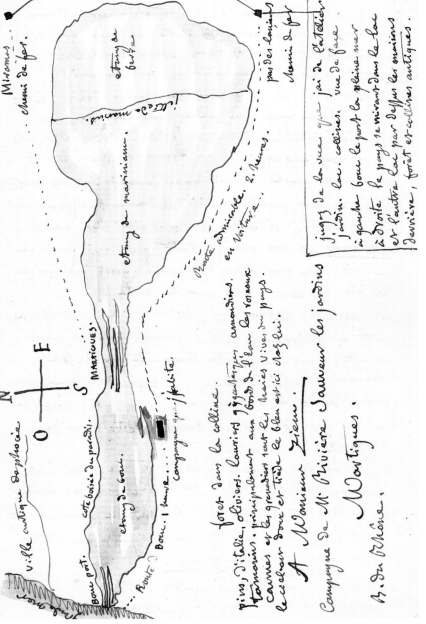

j'apelle Blanche, j'ai le projet d'acheter plutôt un boquet corse, espèce de cabriolet en osier avec un petit cheval gros comme un petit âne, j'ai quand je veux un âne à bât ou à voiture à ma disposition. ma campagne me coûte 300 f par an, je me suis pressé mais le prix réel est de 250 f. mon frère aura soin de mes animaux quand je serai dans le nord, j'aurais pu trouver une campagne d'un meilleur rapport au prix de 150 f. mais j'ai sacrifié à la beauté du local et à la vue dont voici le plan. ce pays est ce qu'on apelle mord. et sans ressources, c'est un pays terrible pour le progrès, imaginez la forêt de fontainebleau avec des lacs salés au bout d'un cap oublié des civilisateurs, néanmoins quoique la ville soit de 12,000 habitants on va faire une usine à gaz, et un projet de port de guerre dans le fameux étang de mariname port qui serait en effet le plus beau port du monde et le mieux soustrait aux coups de l'ennemi en temps de guerre et de paix. bref. le pays est encore Vierge et antique comme ses habitants, tous pêcheurs, le paysage ne le cède en rien aux beautés de la grèce c'est suffisament vous en faire l'éloge car vous connaissez ma passion pour ce pays, vous le verrez un jour et comme moi vous n'en reviendrez pas, les beaux torrents couverts d'arbres remplis de lièvre

je regrette bien mon chat !!!

forêt dans la colline.
Pins d'italie, oliviers. lauriers rosé admirable, amandiers ... romarins. principalement aux bords de l'eau les roseaux, cannes et des grandins tout les marais vivent ce pays. le couleur dure et tiède le bleu est ici chez lui.

A Monsieur Ziem.
Campagne de Mr Olivier Sauveur les jardins
Martigues.
B. du Rhône.

jusqu'à la vue que j'ai de l'atelier jardin. lac. collines. vue de face à gauche borre le port la pleine mer à droite le pays se mirant dans le lac et l'autre lac par dessus les maisons Marseille, forêt et collines antiques.

JOSÉPHIN SOULARY (1815–1891)

Portrait of Joséphin Soulary, *print from the first edition of Soulary's* Sonnets humouristiques, *1858. Paris, Private collection.*

"Everything that comes from Lyon is meticulous, slowly elaborated, and timorous," wrote Baudelaire, citing Soulary as one of his examples.

Here is a poet who spent all of his modest career in the offices of the Prefecture of Lyon and remained attached to his province. It was to the excellent Lyonnais printer Perrin that he entrusted his masterpiece, *Sonnets humouristiques* (1858), which was praised by the princes of contemporary criticism, Jules Janin and Sainte-Beuve. While perhaps overmeticulous, these sonnets often approach perfection. The volume's title harbors a pun (when spoken, these two words are indistinguishable from the French for "his humorous nose," and *humer* means "to inhale"). Soulary's virtuosic mastery of this difficult form was such that he could use it to evoke a dramatic situation, weave philosophical reflections, or paint word pictures of a landscape. Soulary also had a gift for drawing, as evidenced by this rapidly executed self-portrait. The agitated mane gives him something of a Romantic air, but any extravagant aspirations he may once have cultivated had since been stoically abandoned: "All happiness that escapes one's grasp is but a dream!"

To an unknown correspondent

Lyon, February 4, 1867

Dear Friend,

I saw M. Montretaigue [?], and I was enchanted with him: he has a face that inspires confidence, and he loves you, you and Babou. That's more than enough to seduce me.

Didn't he inform me that you're going to exhibit our faces at the Palais de l'Industrie? Do you have a photograph of me, then? I don't think so. He asks me for a few verses to place underneath. I am prepared to oblige, but I still need to know where to put the thing. Should I send them to you on the first scrap that comes to hand? Should I wait until you send me a successful image? I'll do whatever you like: speak.

Joséphin Soulary

Title page of the first edition of Sonnets Humouristiques, *1858, published by the author for a few of his friends. Private collection.*

Cher ami,

J'ai vu Mr Montvéraigu, et j'en suis enchanté: il a une figure qui revient, et il vous aime vous et Babou. C'est plus qu'il n'en faut pour me séduire.

Ne m'a-t-il pas annoncé que vous alliez exposer nos binettes dans le palais de l'Industrie? mais avez-vous donc une photographie de moi? je ne le crois pas. il me demande quelque vers pour mettre au bas. je suis tout prêt à m'exécuter, mais encore faut-il que je sache où placer la chose. Dois-je vous les envoyer sur le premier chiffon venu? Dois-je attendre que vous m'envoyiez une image bien réussie? je ferai ce que vous voudrez; parlez.

Henri Regnault (1843–1871)

Photograph of Henri Regnault.

Six years after entering the École des Beaux-Arts in 1860, Henri Regnault won the coveted Prix de Rome with a work depicting *Thetis Giving Achilles the Arms of Vulcan.* The young man's prospects were bright, and he set off for his study period at the Villa Médicis in Rome, an all but obligatory rite of passage for French artists of the period.

When he wrote this letter, in 1868, Regnault was preparing to embark from the eternal city on a series of travels. He hoped to bring along his friend Charles-Emmanuel Jadin, who frequented the Paris studio of the academic artist Cabanel and who that same year exhibited at the Salon for the first time. Regnault's letter, in which he tries to persuade Jadin, tells us much about the lifestyle and aspirations of young nineteenth-century painters. The author reveals himself to be ambitious and droll, expressing mock pity for his plight after an accident ("My intellectual faculties profited greatly from a constant bath of ice for forty hours. It refreshed my ideas") and hinting at the future projects with which his mind was teeming. For Regnault dreamed, above all, of distant lands, of the color and light of Spain, where he soon went to study Goya and Velázquez. There he painted a *Portrait of General Prim y Prats*, which the patron refused but which won the artist his first medal at the Salon of 1869. After Spain, Regnault went to Morocco (not Egypt, as projected in the letter), whence he returned with his most famous painting, *Salome*, now in The Metropolitan Museum of Art in New York.

This nascent career as a history and genre painter would have netted Regnault a prominent place among the official masters of the nineteenth century if it had not been brutally interrupted by his premature death. As a pensioner of the French Academy in Rome, Regnault was exempt from military service. But when the Franco-Prussian War broke out in 1870, his patriotism drove him to return immediately to France and enlist in the nineteenth Infantry Regiment. He fell at Buzenval, at the age of thirty-eight.

Henri Regnault, The Madrilène.
Paris, Musée du Louvre.

To Emmanuel Jadin

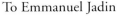

[Rome] June 25, 1868

So! Jadin, my friend,

You must be asking yourself what color my ink is. True! I'm worthless, I admit it. But it also must be said that I had quite a lot of work to do. And what's not consoling is that it's going to continue until my departure for Spain, which I can now set at around the 20th or 25th of July.

I like to think that in the month of December we'll be meeting up with one another in Rome, in God's name! With or without Gounod. Is this little project still in the works? Jadino mustn't let us down. I've been waiting for Jojotte and yourself to see the north of Italy. It's next summer that we'll take this little walking tour, in company I hope. If Blanche-muche deigns to honor us with his presence, that wouldn't make too many . . . We'll return to Rome for the winter, then the following spring head south: we'll begin with Naples, Sicily, Greece, Egypt, Egypt in God's name! where we'll arrive toward the month of November so as not to be totally cooked. You'll have understood that if you miss the train and don't arrive in Italy by December of this year, the line will be broken and you'll miss the tour.

And why don't you leave for Spain at the same time as Jojotte, we'd return to Italy together. I don't think the trip to Spain will be very expensive, we'll do it in the simplest possible way, and the cheapest.

It would be lovely to take the whole tour together: all in all, it's a matter of two years. One can certainly treat oneself to that. So send me a few heartfelt words by way of an answer.

Nothing new here, except that I smash myself up from time to time so I won't break the habit. Things are going rather well.

See for yourself. [Drawing of man with bandaged head]

I've been like this for eight days, but I'm none the less gay for that. My intellectual faculties profited greatly from a constant bath of ice for forty hours. It refreshed my ideas.

[Drawing of the accident with annotations:] cart-driver / horse pulling the cart / (bibi)

Here's how I push vehicles from behind and how, to make a cart-driver jump from his vehicle, I describe parables such as are seen only in the gospels.

So, Jadino mio, write me if there's any hope of seeing you soon.

And above all no jokes. There's no need for my father to know about my parables. Don't say a word to him, and try to keep the others from talking either, dammit.

On which I suck your eye. Yours.

Henri Regnault

Give big hugs to Camille, Madame Saint-Saëns, Mr and Mme Bussine. If you see Libon, thank him for the article he had the kindness to send me.

Rome ce 25 Juin 68.

Eh bien! Jadino mon ami,

Vous devez vous demander de quelle couleur est mon encre. Vrai! je suis rosse, j'en conviens. Mais il faut dire aussi que j'ai eu un dur coup de pioche à donner. Et ce qui n'est pas consolant, c'est que cela va recommencer jusqu'à mon départ pour l'Espagne, que je puis à peu près fixer maintenant au 20 ou 25 Juillet.

J'aime à croire qu'au mois de Décembre nous nous retrouverons à Rome, nom de Dieu! avec ou sans Gounod. Cela tient-il toujours ce petit projet? Faut pas nous lâcher, Jadino. Je vous ai attendu Jojote et toi pour aller dans le nord de l'Italie. C'est l'été prochain que nous ferons ce petit tour de ballade, de conserve j'espère. Si Blanche muche daigne nous honorer de sa présence, il ne sera pas de trop. —

nous repassons l'hiver à Rome, puis au printemps suivant, tournée vers le sud; nous commencions par Naples, la Sicile, la Grèce, l'Égypte. L'Égypte nom de Dieu! où nous arrivons vers le mois de Décembre pour ne pas y cuire tout à fait. Tu comprends bien que si tu manques le train et que tu n'arrives pas en Italie cette année au mois de Décembre, la filière est rompue et tu manques la tournée. —

Et pourquoi ne partirais-tu pas, en même temps que Jojote, pour l'Espagne, nous reviendrions ensemble en Italie. Je ne pense pas que le voyage d'Espagne soit très coûteux, nous le ferons de la façon la plus simple, et la plus économique.

Ce serait gentil de faire toute cette tournée là ensemble; ce serait une affaire de deux ans en tout. On peut bien se payer cela

Réponds-moi donc quelques paroles bien senties à ce sujet.

Ici, rien de neuf, si ce n'est que je me casse la gueule de temps en temps pour ne pas en perdre l'habitude. — Cela me réussit assez bien. Vois un peu.

me voilà depuis huit jours; ce qui n'entrave en rien ma gaîté. Mes facultés intellectuelles ont beaucoup gagné à un bain constant de glace pendant 40 heures. Cela m'a rafraîchi les idées. —

charrette

Cheval de la charrette

bibi

Voilà comment je pousse les voitures au cul, et comment pour faire sauter le charretier à bas de sa voiture, je décris

de paraboles, comme on n'en voit pas dans les évangiles. —

Donc, Jadino mio, écris-moi si on a l'espoir de te voir bientôt. —

Et surtout pas de blague, mon père n'a nullement besoin de connaître mes paraboles.

N'en parle pas; attache que les autres n'en parlent pas, foutre! —

Sur ce je te suce l'œil. —
Tout à toi
Henri Regnault

Embrasse bien Camille, Mme Saint Saëns Mr et Mme Bussine. Si tu vois Lebon remercie le de l'article qu'il a eu la gentillesse de m'envoyer. —

FÉLIX RÉGAMEY (1844–1907)

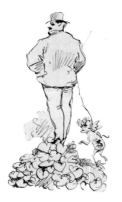

*Félix Régamey, Self-Portrait on a note declining an invitation,
1887. Paris, Musée du Louvre.*

Son and student of an admired draftsman who illustrated the Gospels, Félix Régamey turned toward a lighter style and became a caricaturist. A friend of Verlaine's, to whom he devoted a book, *Verlaine dessinateur*, Félix Régamey is best known for his sketch of Rimbaud and Verlaine in London in 1872. He founded the short-lived periodical *Salut Public* in 1870, but then sought refuge in England from the Franco-Prussian War. He contributed to numerous illustrated journals and revues and was also a professor of drawing. His trips to Japan with Émile Guimet made him a not insignificant representative of fin-de-siècle japonisme.

This little sketch, which was dashed off to serve as an invitation, intimates his considerable skill at rapid visual notation. The figure of the artist himself was laid in with a few quick pen strokes and then given volume by the addition of hatching and two touches of wash, while the receding buildings are summoned up with a few deft lines.

41, rue du Four St. Germain
Thursday, 7 April, 1870-2 o'clock.
Régamey

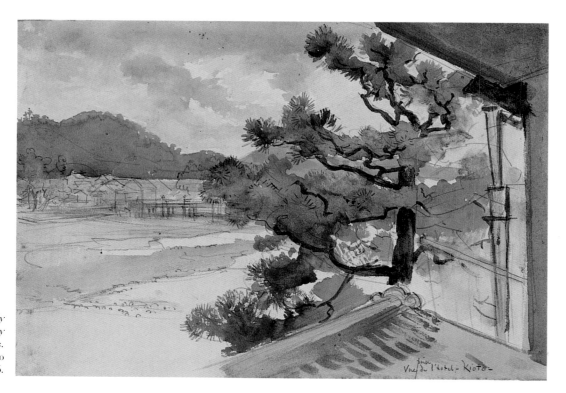

*Félix Régamey's sojourn in Japan greatly
influenced his work, inspiring many
sketches, watercolors, and paintings.
This* View of Arashiyama in Kyoto
dates from c. 1876.

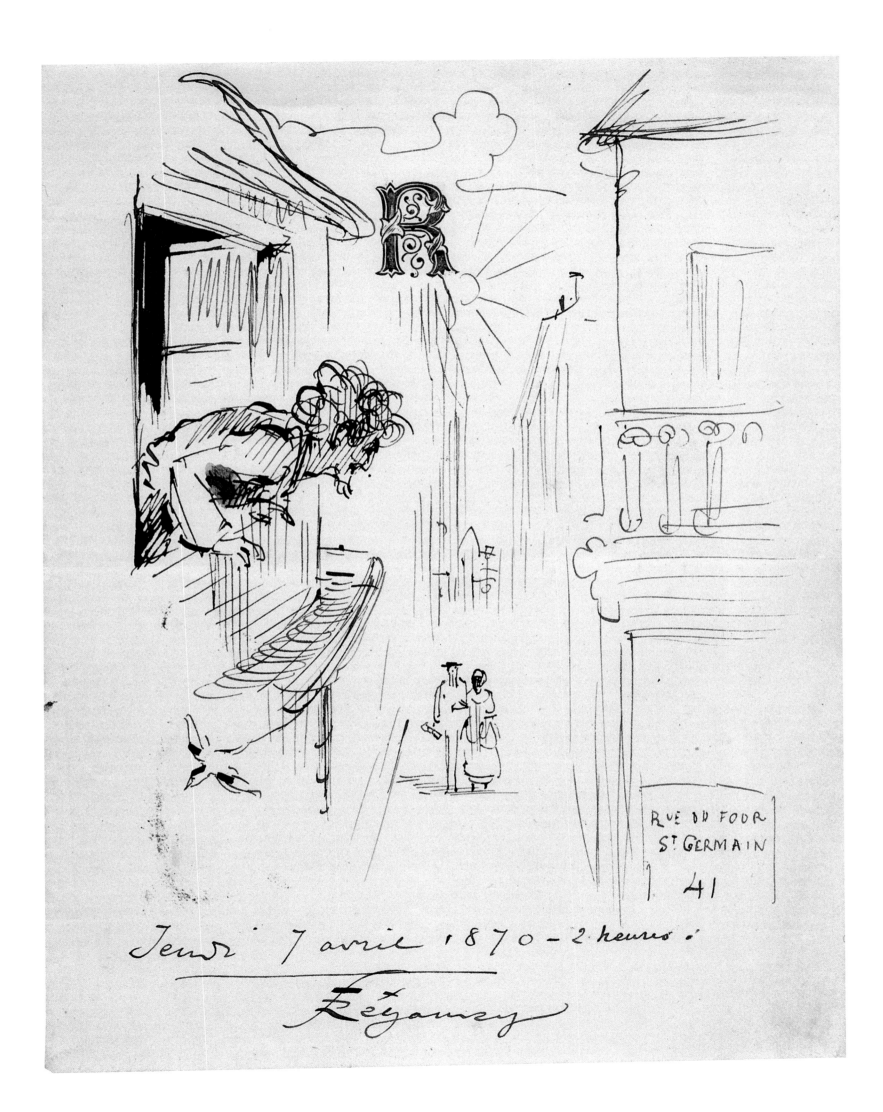

Jeudi 7 avril 1870 - 2 heures.

Zézaucy

GUSTAVE DORÉ (1832–1883)

Nadar, Portrait of Gustave Doré.
Paris, Musée d'Orsay.

Gustave Doré produced his first comic albums, *Les Brillantes Aventures de M. Fouilloux* and *Les Aventures de Mistenflûte et de Mirliflor*, at the age of eight. At age fifteen he was hired by the *Journal pour rire*, which regularly published his drawings. Comic verve would be a constant throughout his considerable career as an illustrator.

This letter, whose text is as hilarious as its drawings, is a good example. It was written by Gustave Doré and Baron Davillier during a trip to Spain in 1862. They had been commissioned by a travel periodical, *Le Tour du Monde*, to produce a complete and varied inventory of the races, costumes, and customs of Spain. Baron Davillier, a wealthy art collector, archaeologist, and author of several specialized works on earthenware and metalwork, was already familiar with Spain; he took the notes and kept the journal that was to serve as the basis for the text. Doré executed on-the-spot drawings that were to serve as the basis for the engraved illustrations. The two got along very well, as shown by this letter. The results of their collaboration first appeared between 1862 and 1869, as installments in *Le Tour du Monde*. In 1874 Hachette reissued them in a single volume entitled *L'Espagne*. The same trip also inspired Doré's *Don Quixote* illustrations, published in 1863, as well as several paintings exhibited at the Salon between 1863 and 1870.

It is worth noting that Gustave Doré—an artist of many gifts, for he made sculpture as well as paintings and illustrations—has greatly influenced contemporary French masters of the comic book such as Tardi and Druillet.

Gustave Doré, illustrations for Don Quixote de la Mancha, *vol. 2, Don Quixote arrives at the wedding of Gamache. Paris, Private collection.*

To M. Templier

Léon, October 30, 1862
[erroneously dated 1872]

. . .

[Passage in Spanish in the hand of Baron Davillier]

My dear Templier, I seize the pen from Davillier's hands, for I don't think you can take much pleasure in this unintelligible jargon: don't think he's drunk, he drinks only water, but since he's been in Spain he doesn't know two words of French. That causes me much trouble: the present is to inform you that the columns of *Le Tour du Monde* have only to remain standing: they're going to receive an excess of drawings that they'll scarcely be able to contain: moros, avieros, baratteros, mutchachas [sic], posaderos, sacristanos mayores etc. etc. . . . will fall into them in disorder. Forewarn M. Charton . . . (here we place a half-page woodcut.)

[drawing of a table set for a meal and three figures]

The scene represents your two friends settled in before a meal that would greatly displease them if it weren't for the amiability of the innkeeper, who keeps them company and distracts them with his stories.

At first encounter you'll be struck by his eagle-eye gaze. Pay no attention, he's quite stupid . . . I think he belongs to the [workers'] international . . . happily, instead of using oil to burn houses it's being used to season food.

Our first idea, my dear Templier, was to offer you a work entitled *Las siete plagas de Espana*, the seven plagues of Spain, but we've had to abandon it on account of the foreign editions of *Le Tour du Monde*. We don't, however, complain about this too much. One still finds here the marvels sung by our poets. So refrain from those knowing winks. It's the Marquesa d'Amagani in person, but where have my twenty years gone, and the castanets I used to have!

[at left: drawing of a veiled head of a Spanish woman]

[passage in Spanish written by Baron Davillier]

I had only to rise from my chair for Davillier to seize my pen and thus prevent me from continuing the story I was beginning and that would have interested you! So I postpone that until another day: especially as I freely admit to you that I'm extremely tired. I saw a great deal today, I ran all over the place and worked hard: I think if I don't go to sleep immediately my style will suffer. So goodnight, my dear Templier, a thousand cordialities and until next time.

[at left: Drawing of Doré and Davillier asleep in bed, with a giant pen and some sketchbooks]

S.S.S.
Q.S.M.B.
Baron Davillier G. Doré

Henri Meilhac (1831–1897)

Kastor, Henri Meilhac. *Private collection.*

Kastor, Ludovic Halévy. *Private collection.*

To Ludovic Halévy

La Belle Hélène, La vie parisienne, La Grande-Duchesse de Gérolstein, La Périchole . . . At the mention of these operettas one name springs to mind: Offenbach. Their librettists are less familiar: Ludovic Halévy and Henri Meilhac, whose considerable fame in their own day has not been recognized by posterity. The two men collaborated on opera librettos (notably that of *Carmen*, based on the novel by Prosper Mérimée), but they are best known for having written countless vaudevilles for the popular boulevard theaters in Paris—then in their hour of triumph—that enchanted not only the public and the critics but the Académie Française, which deigned to receive them among its number.

In 1874 they were at work on a new piece, *La Boule* (The ball), whose plot certainly posed no threat to the laws of dramaturgy: "If Monsieur deceives Madame, it is with a gaiety that precludes all reproach, and Madame, as womanly as if she were going all the way, nonetheless stops herself at the limits of the permissible." While they were writing, Meilhac gave free reign to both his imagination and his gifts as a draftsman (previously displayed in the pages of the *Journal pour rire*) by working infinite variations in his correspondence on the theme of the ball, already suggested by the monogram on his stationary bearing his initials (H. M.). A cup and ball, Sisyphus endlessly rolling his rock, a hoop frame, a giant head, a finish-line marker, a terrestrial globe: any- and everything characterized by rotundity was limned by the author's playful pencil.

The premiere of *La Boule* took place on October 24, 1874, at the Théâtre du Palais-Royal. Some suggested it was a masterpiece . . .

1

Tuesday

My dear friend.

Give me two seats in the orchestra. I'm working but you must be complaining a bit.

2

Thursday

Dear friend.

That's me. For my sake, don't ask me to give it to you tonight, for example. You can get really mad if you don't have it by Sunday night. Do you have somebody for the role of the concierge's son? If you don't, I have a little protégée, Croizelle, whom I got into the Variétés. I could tell her to go see you. She has a face that would do nicely. Yours.

H. Meilhac

3

Dear friend.

You know that I owe you a dinner.

Yours.
H. M.

4

My dear friend.

Send me a seat in the first loge all the same. And a good one—facing front. And rest assured that I'll be grateful for that and for the rest.

H. Meilhac

5

My dear friend.

That's me riding your piece. I'm almost finished. Everything that's done is at the copyist. I need a bath.

Yours
H. Meilhac

6

August 8

Here it is!

H. Meilhac

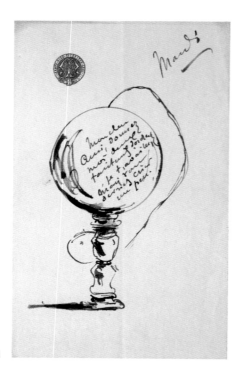

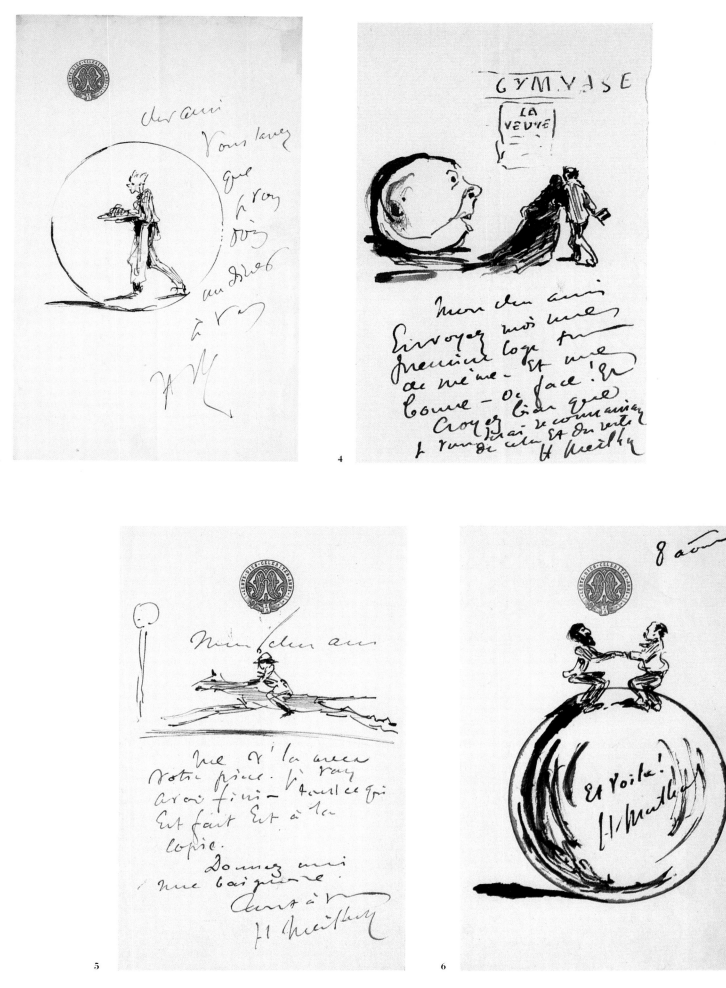

81

FÉLICIEN ROPS (1833–1898)

Paul Mathey, Félicien Rops *(detail)*, *Châteaux de Versailles et Trianon.*

The engravings of Félicien Rops are famous for their strange erotic and satanic imagery. Less well known are his talents as a writer, evidenced by an abundant correspondence much prized by his contemporaries for its literary qualities.

This letter addressed to Auguste Poulet-Malassis (see pages 54–57), the publisher of some thirty books illustrated by Rops, including Charles Baudelaire's *Les Épaves* (Odds and ends), is written on a proof of the etching *Russian Priest* and decorated with two pencil sketches.

Many characteristic features of Rops's epistolary writing are found on this sheet, where all manner of graphic marks are juxtaposed. Like many of his letters, this one is written on a print, with text and image intimately linked. The artist was quite fond of such verbal-visual interplay; he even envisioned a *Journal de Félicien Rops* consisting of etched letters and sketches, but the project came to nought.

So word and image are here closely interwoven. The letter doubles as the page of a sketchbook animated by the image of gamekeeper drawn from life and as a working laboratory in which the artist tried out an idea for his etching *Pallas*, published in 1875 in the *Album* of the Société Internationale des Aquafortistes founded by Rops.

The present letter incorporates several kinds of text. As often in his correspondence, Rops here inscribed a caption to be printed below one of his etchings. This one for the *Pallas* betrays his sources of inspiration: Théodore de Banville and Greco-Roman mythology, but also old French, which Rops used in several of his captions. Finally, there is the poem, whose counterintuitive coupling of Millevoye's *Chute des feuilles* with Baudelaire's *Fleurs du Mal* (here evoked with the phrase *pommes du mal*) reveals the originality of a writing style based on juxtaposition, irony, and incongruity.

To Auguste Poulet-Malassis

Coubroin (D. R.), after Alphonse Legros, Portrait of Poulet-Malassis in 1875.

[Thozée, 1874–75]

My dear publisher, I send you a proof of the *Russian Priest* after retouching. If it's possible, I'd like that amiable idiot Bauwens to execute some proofs in this coloration. Delâtre does that very well. I sketch in the margin a *Pallas* that I'm going to engrave for the Société des Aquafortistes de Bruxelles. I'd very much like, if it's possible without completely destroying the Société, to depart from to depart from [sic] "stereotypical" Simardiennes out of love for the gods of Banville.

We'll remain in Thozée for another week. I'm beginning to be fed up with this outcasting autumn: the falling fruit preoccupies me more than the falling leaves. It's also time to let Mr Millevoye & his sluggish ill young man rest:

> For me each fruit that falls
> Is an obstacle to my death
> Without remorse
> I let my tomb gape
> While devouring the fruit that falls . . .
> Apples of evil
> Dedicated to our Baudelaire
> (Infamy!)

Don't take too much trouble with this plate of the *Russian Priest*. I did it in Stockholm, and it's never satisfied me. The first state is wretched. I reworked the sketch & that improved it a bit but it's still "mediocre," which is worse. I'm determined to efface the plate.

Till Sunday

Quail are passing by.

> Yours
> Fély Rops

[sketch of a gamekeeper]

Don't forget your shoulder-arms Mr Malassis! It's Triquet who tells you so! Otherwise he'll be obliged to be severe!!

[drawing of Pallas]

I want to paint PALLAS who knows well how

> To take a military redoubt by assault
> Skilled at handling both lance and cutlass.
> Daughter of the Great Jupin Valorous in combat.

I'm going to engrave that below the etching

Don't forget that I'm expecting you on *Sunday.*

Félicien Rops, Sentimental Initiation. *1887. Paris, Musée du Louvre.*

Félicien Rops, Pornokratès, *1878. Namur, Musée Félicien-Rops.*

PALLAS

Je veux peindre PALLAS qui scait bien le manier
D'emporter par assaut une place, guerrière
Habile à manier et lance § Coutelas,
Fille du grand Jupin Valeureuse au combats

Je vais faire graver cela sur
l'eau forte

N'oubliez plus votre
port d'armes Mr
malassis! c'est
Triquet qui vous
le
dit!
Sans
cela il
sera
obligé
de
Sévir!!

À Dimanche
les écailles passent
vôtre

Félix Ropez

GUY DE MAUPASSANT (1850–1893)

Nadar, Portrait of Guy de Maupassant,
c. 1890. Private collection.

As a young man, Maupassant might have served as a model for one of the robust rowers painted by Renoir, muscles bulging below their striped jerseys, striking flattering poses on a balcony overlooking the Seine. In 1875, when he appeared much as in this photograph, he presided over a society of gay dogs who divided their time between floating cabarets and rowing practice; they christened themselves the "colony of Aspergopolis," a name inspired by Argenteuil (famous for its asparagus), where the companions met. Each member of the group had a moniker. Maupassant's was Joseph Prunier, a pseudonym he would use when he published his first novels; there followed La Toque (Robert Pinchon), Petit-Bleu (Léon Fontaine), Tomahawk (Henri Brainne), and N'a-qu'un-oeil ("One-eye"), also known as Le Monocle and Hadji, after his initials (Albert de Joinville, future inspector for the Compagnie des Chemins de Fer de l'Est). This particular year, Prunier and La Toque were writing a lewd vaudeville, entitled *À la feuille de rose, maison turque*, that was performed a few times before an invited audience. Reactions to the farce were mixed: Edmond de Goncourt found it repugnant, but Flaubert and Turgenev were convulsed with laughter. Albert de Joinville was cast as the brothel keeper, while Maupassant played one of the prostitutes *en travesti*. An as yet unknown young playwright by the name of Octave Mirbeau took the role of the husband . . .

The period was joyous, almost insouciant, save for the incessant need for funds that tormented Maupassant, whose salary as a bureaucrat in the Ministry of the Marine was insufficient. Debts accumulated, notably to the mother Poulin, the owner of an inn near the bridge at Bezons, where Maupassant spent much time

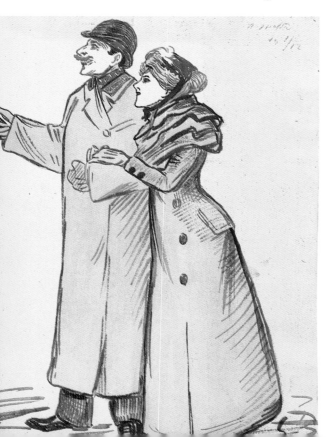

and which he evokes in *Une partie de campagne* with the enticing sign "Restaurant Poulin, fish stews and fries, rooms for sociability, arbors, and swings." As for the humorous drawings decorating his letter, they bear no relation to its content; depictions of a duel—doubtless imaginary—and the transport of a yawl, they recall two of the author's passions: the use of arms (foils as well as firearms) and boating.

In the letter's close, Maupassant takes leave of his companion by shaking his hand *crépitiennement*: Prunier was president of the Union des Crépitiens, named after Crepitus, the dwarf-god of flatulence imagined by Flaubert in *The Temptation of Saint Anthony*.

Guy de Maupassant, Couple no. 2 (man in bowler hat).
Private collection.

To Albert de Joinville

February 8, 1875

My dear Hadji

Here's the bill from last month that I hadn't found the other day. Please be so kind as to pay me back on Sunday, for it's essential that I pay mother Poulin, with whom I'm not on good terms.

Drinks at the barrage	0.25
dinner and share of wine	4 —
Cherry anisette evening	1.50
Chocolate wine morning	1.50
Bedroom candle	2.20
Received from Fidji	3 —
1 lunch	3 —
7 dinners at 2 F 50	17.50
Seltzer water	.80
absinthe—Fidji	.25
3 Bordeaux	6 —
additional wine	1.80
Champagne	5 —
billiards	.90
maid	1
	48.70
Paid for me	4.45
Balance	44.25

to which must be added the bill from Saturday night. Since Gaultier asked for it for himself, mother Poulin made it out for the full amount, and I told her there was no point entering it in her book because I would pay her on Sunday.

1 dinner	2 —
wine-Bordeaux	2 —
additional wine	— .30
Sweet rum and eggs (one portion)	.85
billiards	.50
Café au lait	.50
	6.15

Regarding this last bill, if you can't give it to me right away, I won't pay it until Sunday, but I count on you for the balance. I've just paid mother Poulin 200 F only 98 of which was for myself. I still owe her 130 and I don't even have a sou.

Till Sunday. I shake your hand
crépitiennement
Joseph Prunier

Ce 8 fer 1875

Mon Cher Hardÿ

Voici ta note du mois dernier que je n'avais
pas retrouvée l'autre jour. Sois assez aimable pour
me payer cela Dimanche car je tiens essentiellement
à payer la Mère Poulin avec laquelle je suis en froid.

Consom au barrage	—	0.25
dîner et pas d'Vin	—	4 —
anisette cerises	—	1.50
chocolat vin le matin	—	1.80
chambre bougie	—	2.20
Reçu de Fidji	—	3 —
1 déjeuner	—	3 —
7 dîners à 2f50	—	17.50
Eau de Seltz	—	40
absinthe — Fidji	—	25
3 bordeaux	—	6 —
vin ordinaire supplément	—	1.40
Champagne	—	5 —
billard	—	90
bonne	—	1 ..
		48.70
payé pour moi		4.45
reste		44.25

à ajouter la

comple d samedi soir. Comme Gauthier l'avait demandé
pour lui, la mère poulin l'a fait remplir et je lui
ai dit que ce n'était pas la peine de le porter sur son livre
que je le payerais dimanche

1 dîner	—	2 —
vin. bordeaux	—	2 —
supplém. d'Vin	—	20
Sucre Rhum et Œufs 1 part	—	85
billard	—	50
Café au lait	—	50
		6.15

Quant à cette dernière note si tu ne pouvais me la donner
de suite je ne la payerais que le Dimanche suivant, mais
je compte sur toi pour le reste. Je viens de payer 200 à
la mère poulin dont 98 seulement pour moi. J'en dois
encore 130 — et je n'ai plus le sou.

à Dimanche, je te serre la main
Crépiticreusement

Joseph Prunier

La pêche de nuit L'épagneul

à l'écluse !

ARTHUR RIMBAUD (1854–1891)

Print after a photograph by Carjat, Rimbaud.
Bibliothèque-Médiathèque de Charleville-Mézières.

To Ernest Delahaye

Photographie Raoul, Portrait of Ernest Delahaye,
Bibliothèque-Médiathèque de Charleville-Mézières.

[Stuttgart] February 5
[for March] [18]75

Verlaine arrived here the other day, gripping a rosary . . . Three hours later he'd renounced his god and made the 98 wounds of Our Lord bleed. He stayed two and a half days quite rational and at my protests returned to Paris, to finish studying *the other place on the island.*

I have only a week left at Wagner and I regret this money of hate, all this time wasted. The 15th I'll have Eine Freundliches Zimmer somewhere or other, and I'm whipping the language frantically, to such a degree that I'll be finished in two months at most.

Everything's inferior here, with one exception: Riesling, ayl ave a mug ryt now, anayl doast yur imperturbious 'ealth. It's sunny and frozen, quite annoying.

(After the 15th, Poste restante Stuttgart.)
Yours

Rimb.

On July 10, 1873, Arthur Rimbaud and Paul Verlaine, lovers who had broken up, reunited, separated, and reunited again, were face-to-face in a room in Brussels. Rimbaud wanted to leave. Verlaine begged him to stay and, losing control, threatened him and then fired two shots with a revolver. Rimbaud was wounded in the hand. At the railroad station, Verlaine's agitation was such as to suggest again to Rimbaud, who was about to return to Paris, that he might be in danger. Worried and exhausted, Rimbaud denounced him to the police.

This famous episode in the lives of the two poets ended, as is well known, in a severe reckoning: Verlaine spent almost two years in prison, a period during which a mystical crisis awakened in him an ardent Catholicism. Upon being released, he decided to revisit Rimbaud on the pretext of converting him. The result was the interview in Stuttgart on March 2, 1875, the last time the two men saw one another. It is this visit that Rimbaud briefly relates to his faithful high-school friend Ernest Delahaye in the present letter, where the author of *A Season in Hell* mocks his "pitiful brother," who, having become pious, arrived at Rimbaud's residence on Wagnerstrasse "gripping a rosary" (hence the sketch in the upper left corner, which shows Verlaine descending from the cab and bears the legend: "WAGNER[STRASSE] / DAMNED FOR ETERNITY"). Rimbaud simultaneously boasts and makes light of having demolished in a few hours the miserable convictions of the Pauvre Lélian, thereafter dispatched to Paris, passing without a beat to a discussion of his life in Germany, a country he held in contempt but where he had been sent, under the terms of the pension granted him by his mother, to serve briefly as preceptor in the house of one Dr. Lübner.

An astonishing document, this letter presents, in matter and drawings alike, a telling picture of Rimbaud's state of mind at the time. Insolence, irony, drunkenness, subversion, sexuality, profusion, lucidity, despair: this is the letter of a "seer" who, although "whipping" the German language, had already decided to abandon literature in favor of errant adventure, of "real life."

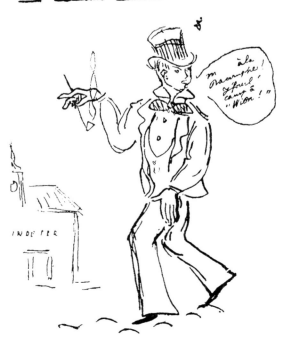

Paul Verlaine, "Travel shapes youth" drawing, 1876,
Private collection. Verlaine is playfully evoking the
"ludicrous trip" he had made to see Rimbaud,
who got the better of their last encounter.

WAGNER · IN EWIGKEIT!

VERDAMMT

RIESSLING

5 février 75

Verlaine est arrivé ici l'autre jour, un chapelet aux pinces.... Trois heures après on avait renié son dieu et fait saigner les 98 plaies de N.S. Il est resté deux jours et demi, fort raisonnable et sur ma remonstration s'en est retourné à Paris, pour, de suite, aller finir d'étudier là bas dans l'île

Je n'ai plus qu'une semaine de Wagner et je regrette cet argent payant de la haine, tout ce temps foutu à rien. Le 15 j'aurai une ein freundliches Zimmer n'importe où. et je fouaille la langue avec frénésie, tant et tant que j'aurai fini dans deux mois au plus.

Tout est assez inférieur ici. j'excepte un : Riessling, dont j'en vide un verre en vase de gôdeaux qui l'ont fu naître, à ta santé imperbédueuse. Il soleille et gèle, c'est tannant

(Après le 15 Poste restante Stuttgart

RIESSLING

VIEILLE VILLE

Jean-Baptiste Carpeaux (1827–1875)

Jean-Baptiste Carpeaux, Self-Portrait ("Carpeaux Crying Out in Pain"). *Valenciennes, Musée des Beaux-Arts.*

To Bruno Chérier

Jean-Baptiste Carpeaux, Portrait of Bruno Chérier. *Valenciennes, Musée des Beaux-Arts.*

[1875]

. . . The bust that Bernard made of me has been cast. It's a rough sketch made in two two-hour sittings. Blagny found it so beautiful that he wanted it cast without any further work. Bernard will give you a copy. Here's a sketch of it, judge for yourself. What do you say, my dear and old friend!

The pose is neither academic nor martial: it makes a sad impression, but what do you want, that's the way I am.

Please be so kind as to also tell my friend to continue writing; I'll answer her when I can.

Don't let Blanc forget to send me the address I asked for, as soon as he can, *right away*. . . .

(continued in the appendix, page 216)

Everything about this poignant page speaks of a man gravely ill and at his last breath: the sloppy hand, the ink blots, the lax spelling and syntax, and above all the drawing, a self-portrait. The sculptor was only forty-seven, but he depicted himself as an old man, his face consumed by his beard, his hair disheveled, his head drooping to one side like that of the expiring Christ.

And, indeed, in 1875, the year of his death, Carpeaux was approaching the end of a long Calvary of controversy and misfortune.

In 1869 his group *The Dance*—a paean to the joy of life, now regarded as the sculptor's masterpiece—commissioned for the new Opéra in Paris, had provoked scandal; many found its dancers lewd, and passions intensified until one day an unknown hand defiled the sculpture with a bottle of ink. More important, Carpeaux was bankrupt, for he had spent more than twice his contractual fee executing the piece. For a brief moment, it seemed as though his marriage that year to a young woman of impeccable breeding might bring him happiness, but their relations quickly deteriorated.

The war of 1870 sounded the death-knell of his career as a successful sculptor. Troubled by the violence of the Commune, he emigrated to London, where he received many commissions. But his private life was undermined by his nervous, unstable temperament: without cause, he erupted into violent scenes of jealousy with his wife. He grew so intractable that, despite their three children, a separation became necessary. His wife left him and used every judicial means at her disposal to win financial control over his work.

Upon returning to Paris in 1872, Carpeaux created a studio for reproductions that would have permitted him to capitalize on his production. But he was soon obliged to surrender management of the business, whose successive managers proceeded to exploit his oeuvre without restraint.

Then came the final blow: he contracted cancer of the bladder, a horribly painful illness. After two unsuccessful operations, Carpeaux sought refuge in the home of his friend the painter Bruno Chérier, the addressee of this letter, in Nice at the time with a wealthy art enthusiast, Prince Georges Stirbey. Between the bouts of pain, he reclined on a mattress at the seashore, indulging his gifts as a draftsman by reproducing what he saw there: "I draw at the seaside the movements of the fishermen. It's something to see." Back in Paris, he wrote long letters to Chérier in which he vented his pain and his sense of powerlessness. He died there on October 12, 1875.

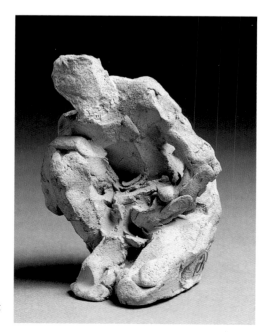

Jean-Baptiste Carpeaux, Man Kneeling on One Knee. *Paris, Musée d'Orsay.*

et les mouleurs vous y touchés
d'avantage. Braun [?] t'en donnera
une épreuve. voici le croquis, juge.

ayés la bonté de
dire aussi à l'ami
quel Messier toujours
je lui reprodrais quand
je prodrais [?]
que blanc mouflé [?]
que plus que [?]

qu'en dis tu mon cher et vieil ami [?]
ce n'est pas une pure académique
ni martiale. c'est bien triste
à voir mais que veux tu
je suis comme ça [?]

je lui demande le plus tôt qu'il
pourra tous de suite

Ivan Turgenev (1818–1883)

Nadar, Portrait of Turgenev *(detail).*
Paris, Private collection.

To Gustave Flaubert

Nadar, Portrait of Flaubert, *c. 1870.*
Paris, Private collection.

Of all the correspondences in French letters, that of Gustave Flaubert must be numbered among the richest and most fascinating. His list of respondents is peppered with famous names, most notably, perhaps, that of the French novelist George Sand (whom Flaubert addressed using the formal *vous* and greeted as "dear master," whereas she addressed him with the familiar *tu* and used the greeting "my old troubadour"). However, the correspondence of the Russian writer Ivan Turgenev is not far behind.

On June 8, 1876, Sand died in Nohant. Flaubert was devastated: "One had to know her as I knew her to understand all that was feminine in this great man, the immensity of tenderness to be found in this genius. She will remain one of the illustrious of France and a unique glory," he wrote on the seventeenth to Mademoiselle Leroyer de Chantepie. Inconsolable, the old troubadour confided his pain to Turgenev, who responded immediately, evoking Zola's article "George Sand et ses oeuvres," published in *Le Messager de l'Europe*, as well as, affectionately, the eyes and gaze of Sand's granddaughter, Aurora.

Turgenev then goes on to provide his friend with information he had requested about his "hermitage": the Russian estate at Spasskoye that he had inherited upon his mother's death in 1850. He not only describes his house in prose but provides a sketch, conforming to Napoleon's adage "that a good drawing is worth more than a long speech." He traces its horseshoe plan and its facade in pencil, providing written indications in pen with regard to the colors and general aspect of his residence. In Spasskoye, far from Paris and his mistress Pauline Viardot, Turgenev is unhappy. But when in Paris, he was often preoccupied with his native land. Such is the lot of the voluntary exile, a condition that Turgenev chose for himself and that obliged him to correspond with his famous friends throughout the world—to the great pleasure of contemporary readers.

Spasskoye
Gov-t of Orel
City of Mtsensk
June 23 / July 4
[18]76

My old friend,

I write you from here to Croisset, from one Patmos to another. I received your letter yesterday and, as you see, I answer without delay.

Yes, the life of Mme Sand was full, and yet speaking of her you say: poor mother—this epithet applies well to the dead, for in the end they have reason to complain, death being a hideous thing. I remember the eyes of little Aurora: they have an astonishing depth and goodness, and in effect resemble those of her grandmother. They are almost too good for the eyes of a child.

It seems Zola has written a long article on Mme Sand in his Russian review, the article is very beautiful but a bit harsh, they say. Zola cannot judge Mme S in a complete way. They are too unalike.

I can see you rolling your eyes ferociously in front of Mr. Adrien Marx. Mud of a very particular kind is required to make mushrooms like that spring up.

You're working at Croisset. Well, I'm going to astonish you, I've never worked like I have since I got here. I spend entire nights bent over my desk! I'm seized anew by the illusion that makes one think one can say, not something other than what's already been said (that doesn't interest me), but in another way! And note that at the same time I'm weighed down by problems, fiscal affairs, administration, farming, who knows what all! (In this regard, I can tell you that things aren't as bad as I thought at first—and, parenthetically, I'm delighted to learn that there are glimpses of blue sky in the affairs of your nephew.) But *St. Julien* suffers from this exuberant activity: my devil of a novel has taken invasive hold of me. Despite everything, you needn't worry: the translation is already promised for the October issue of the *Messager de l'Europe:* it will appear there— or I'll be dead. . . .

(continued in the appendix, page 216)

Anonymous, The Hermitage *in the park on the estate of Kuskovo, c. 1800s.*
Moscow, Ceramics Museum.

Vous travaillez à Croisset.. Eh bien,
je vais vous étonner — jamais je n'ai travaillé comme
je le fais depuis quelque temps ici. — Je passe des nuits
blanches, courbé sur mon bureau! Je suis repris
par l'illusion qui fait croire qu'on peut dire —
non pas autre chose que ce qui a jamais été dit —
(ça — ça m'est indifférent) — mais autrement! —
Et remarquez qu'avec cela je suis accablé
de besogne — d'affaires d'argent, d'administration,
de fermage, que sais-je! (A ce propos, je puis
vous dire que tout n'est pas aussi mauvais
que je l'avais cru au premier moment — et par paren-
thèse je suis enchanté de savoir qu'il y a
un peu d'argent dans les affaires de votre neveu.)
Mais St Julien souffre de cette exubérance d'ac-
tivité; mon diable de roman s'est emparé
de moi d'une façon envahissante.)
Malgré tout, vous pouvez être
tranquille: la traduction est déjà promise
au N° d'Octobre du "Messager d'Europe."
Elle y paraîtra — ou je serai mort. —

Je n'ai pas lu les articles de Tourgueneff,
je n'ai pas lu le livre de Renan: et je
ne puis rien lire à présent — si ce n'est

le journal que je reçois ici, qui me parle des affaires
d'Orient et qui me fait rêver. — Je crois que c'est
le commencement de la fin! — mais que de têtes
coupées, de femmes, de filles, d'enfants violés, é-
ventrés d'ici là! — Je crois aussi que nous (je
parle des Russes) — nous ne pourrons pas éviter
la guerre. —

Vous voudriez connaître l'aspect de mon
habitation? — C'est bien laid — Tenez — voici
quelque chose d'approchant:

Je ne sais si vous comprenez bien: c'est une maison en
bois, très vieille, recouverte de planches — peinte à la détrempe
d'une couleur lilas clair; il y a une véranda devant avec
du lierre qui grimpe; les deux toits (a et b) sont en

AUGUSTE RODIN (1840–1917)

Camille Claudel, Bust of Rodin, *1882.
Paris, Musée Rodin.*

Auguste Rodin, Young Woman in a Flowered Hat,
1865. Paris, Musée Rodin.

To Rose Beuret

[Paris, after
April 13, 1877]

My dear Rose,

I don't know how you're getting on in Brussels, I'll arrive in the first days of June so I can't send the *Monument to Lord Byron* to London myself Paul must do it with a base he deems suitable. I'm very annoyed god knows but the end's in sight I'm taking my cast to the exhibition but will anyone bother to compare them. I'm at wit's end I'm exhausted without money I'm going to look for an atelier that of Tournier is too small the caster wants 150 francs for having cast my *Ugolino* which I won't pay. But what vexation on all sides I'm happy on days when I go to bed and can sleep 8 hours for that doesn't happen often. Try to get money from M. Van Berkeleare sell the barrels.

ateliers cost 600 or 700 francs and I have to swallow this if I want one papa's doing well the brat too the monument has to be in London before June 1 you'll receive the case toward the end of the week for the base he should make a large rectangle in wood that he'll paint white to go underneath I'll send you a postcard with the address all this should be done quickly so when the case arrives it can be packed and sent off immediately Paul should put the good fellow [the figure of Byron] on top of the pedestal as I placed it before shifted slightly in three-quarters view he should lower the corner of the plinth so it tallies with the plinth of the good fellow on top if you need to clarify something write to me immediately guide marks will be needed for the detached figures to make sure they go in the right place since you'll pack the monument dismantled.

regularize the plinth by lowering the panel put the lower figures in the place where I put them and make a guide mark with enough notches clearly marked in red crayon.

on the base put as sign an anchor that I'll indicate in my letter.

use a rectangular base that suits you and pleases the eye that Paul finds appropriate

The design is paid for but England must be paid the monument should be there before June 1 try to get some money from Mr. Van Berkeleare the monument must be packed as soon as the case arrives toward the end of the week

Greetings to all my friends

write to me if there are any problems

The year 1877 was a turning point in the life of Auguste Rodin. After spending several years in Belgium working for Carrier-Belleuse, the sculptor, still unknown, returned to France, where a controversy was raging among the critics: his *Age of Bronze*, also known as *The Vanquished*, seemed so realistic that when it was exhibited in Brussels and then at the Paris Salon, the artist was accused of having realized it from a cast of a living model. Rodin, a victim of his own genius for animating matter, refused to endure this insult and proceeded to produce precisely such a life cast to reveal its differences from his sculpture. The controversy subsided, but all his life the artist retained bitter memories of this episode, to which he alludes in the present letter to Rose Beuret ("I'm taking my cast to the exhibition but will anyone bother to compare them").

In the same year, at the request of several English writers and the British Prime Minister Benjamin Disraeli, Rodin entered a competition organized in London for a monument to Lord Byron. Unfortunately, nothing survives of Rodin's design, but he must have been pleased with it, judging from his frantic instructions in this letter regarding its presentation. When he dashed off this breathless missive, the sculptor had no time for style, dispensing with capital letters and punctuation, displaying no qualms about crossing things out and making additions in the margins. But these features only increase the letter's historical interest—already considerable, given the information it provides about a lost work by the sculptor and about his private life. For it is addressed

to Rose Beuret, the young dressmaker who had modeled for him since 1864 and became—in quick succession—his mistress, his servant, and then the mother of his son Auguste, born in 1866. His confidante, she remained faithful to the sculptor her whole life, loving him with a devotion that withstood all trials. Rodin finally married her on January 29, 1917. Fifteen days later Rose died, followed by Rodin himself nine months later on November 18.

Auguste Rodin, The Age of Bronze. *1876. Paris, Musée Rodin.*

Vous emballerez le monument de mort...

regraloriez le plâtre en abattant le trou

que voulu

Bien mettre les figures d'en bas
à la place que je les avais mises
et faire un repaire avec des entailles
Portes marquées au Crayon rouge

sur le soubassement
on mettra comme
signe une ancre
que je reporterai dans
ma lettre

mettre un soubassement
Carré
à la volonté et
l'œil que peut le payeur Commenolle

M.R

1º Ce projet est payé mais il faudra payer
pour l'angleterre le monument doit jeter
avant le 1 juin. Tachez d'avoir de l'argent
Ton Barthélemy

Ma chère Bon...

Je ne sais comment tu
fais à Bruxelles, je
viendrai dans les premiers jours
de juin je ne pourrai donc pas
expédier moi même le Monument
de Lord Byron à Londres
il faut que Paul le fasse
avec un soubassement que le payeur
Commenolle. Je suis bien
ennuyé je te prie de tenter
le but presque tout. À moins
surtout le Monde et que je n'ai
obtienne le modèle... que je
porte mon modèle à l'exposition
mais voudras-tu les comparer
seulement. Je suis à bout je
suis fatigué l'argent me manque
je dois chercher un atelier Celui de
Tournisseux est trop petit

M.R

ÉDOUARD MANET (1832–1883)

Nadar, Portrait of Édouard Manet.
Private collection.

To Isabelle Lemonnier

*Édouard Manet, Isabelle in a string cap (detail of
a letter from Manet), 1880. Private collection.*

In 1880 Manet's health was deteriorating. He was subject to sudden pains, dizziness, and bouts of fatigue, indications of the illness (syphilis) that was to kill him three years later. For the second year in a row, he had to undergo a rest cure at a hydrotherapy clinic in Bellevue, not far from Paris, where he lived in a rented house with a large garden. There he painted still lifes of vegetables, flowers, and fish. Often this imagery found its way into the letters he sent to his friends to compensate for his isolation. These are short notes conveying news and, above all, soliciting it, and illustrated with delicate watercolors—flowers, fruit, animals, flags and paper lanterns celebrating Bastille Day, pairs of women's legs.

Bellevue [summer 1880]
to Isabelle
this mirabelle
and the most beautiful
is Isabelle.

Of the thirty-five such letters addressed to young women, sixteen were sent to Isabelle Lemonnier and two to Madame Guillemet.

Isabelle Lemonnier was the daughter of the jeweler to Napoleon III and sister-in-law of the publisher Gustave Charpentier, who, along with his wife, hosted a weekly salon frequented by artists, intellectuals, and politicians. It was there that Manet met the ravishing Isabelle, who around 1880 became one of his favorite models. In the present letter to her, Manet poetically rhymes her name with *mirabelle* (cherry plum) and *belle* (beautiful).

As for Madame Guillemet, she was a paragon of fashion whose portrait Manet painted in 1880 (*La Parisienne*). The preceding year Manet had represented her and her husband in the greenhouse in his garden (*The Conservatory*). She owned a shop that sold fashionable attire and trinkets at 19, rue du Faubourg Saint-Honoré, and we can be sure that its black stockings and gaiters were in the latest style—like those depicted here by Manet.

The beautiful sketches and elegant layouts of these brief communications make them much more than mere illustrated letters.

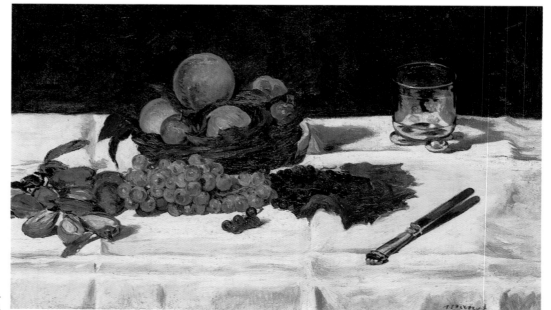

Édouard Manet, Still Life: Fruit on a Table.
Paris, Musée d'Orsay.

Bellevue

à Isabelle
cette mirabelle
et la plus belle
c'est Isabelle

Ed. Manet

This elegant letter addressed to the fashionable Madame Guillemet pays homage to Parisian chic.

Bellevue

Thursday

Madness if you like. dear madame, but it is a sweet madness that allows me to pass the time agreeably. I'm feeling better and better
 [upper left]
and a letter from you from time to time would foster my recovery; don't be too stingy.
 I haven't seen Mademoiselle L[emonnier], her mother is very sick
 [upper right]
and she is moving. I'm even surprised not to have had news of her. I'm afraid of tiring you with my letters; you'll tell me won't you,
 and soon some news of you; my warmest regards.

E. Manet

et à bientôt et vos
nouvelles — mes meilleures
amitiés É. Manet

EMMANUEL FRÉMIET (1824–1910)

It is tempting to surmise that this letter provoked as much scandal as the work on which Frémiet was working at the same moment, the famous *Gorilla Abducting a Negress*, exhibited for the first time at the Salon of 1859.

"I had the misfortune in 1854," wrote Frémiet, "to take on a gorilla. At a time when the notion was beginning to spread that man and the ape were brothers, this was quite audacious, and my endeavor was made worse by the gorilla's being the ugliest of all the apes, the comparison was not flattering to man."

To add to the scandal, the gorilla was shown abducting a young black woman. The work, having been judged "coarse and unseemly" by the Salon jury, was installed in a corner of the exhibition space behind a curtain. It was reported that when visitors opted to lift the curtain, many women screamed.

However, an interest in naturalist themes, and more specifically in prehistoric and "primitive" beings, was in the air. From the beginning of the nineteenth century, the French naturalist Jean-Baptiste de Monet, chevalier de Lamarck saw organic evolution as a fundamental fact of nature. Georges Cuvier, by contrast, underscored the radical differences separating fossil species from present ones. These opposing positions occasioned violent disagreements among paleontologists, archaeologists, and naturalists. The discovery of Cro-Magnon man in 1868 was the event of the century.

Frémiet was immersed in this scientific environment: at age sixteen he had been hired by the Musée d'histoire naturelle in Paris to make drawings of skeletal remains. For four years he measured tibias and vertebrae, an experience that heightened his sensitivity to animal forms, cultivating in him a gift for precise observation. This proved the foundation of his success, for after a period of study with François Rude (the sculptor of *La Marseillaise* on the Arc de Triomphe), he embarked on a career as an animal sculptor. His first commissions, in 1852, were for a plesiosaur and a pterodactyl. He subsequently represented a great variety of animals, often life-size, with a meticulous attention to detail—and with the sense of humor evident in this letter.

To a lady

Madame,

I beg you to accept this accurate portrait of Adam, reconstituted in accordance with precious documents found in nitrous shale in Monaco. It seems to me that Eve would be inexcusable.

Please permit me to offer all my respects.

E. Frémiet

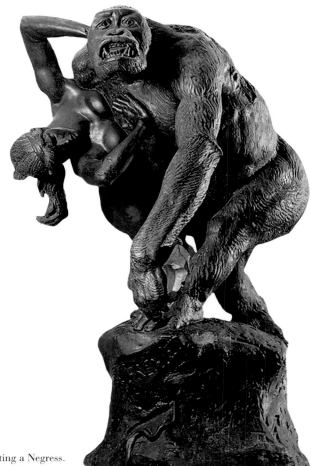

Emmanuel Frémiet, Gorilla Abducting a Negress.
Nantes, Musée des Beaux-Arts.

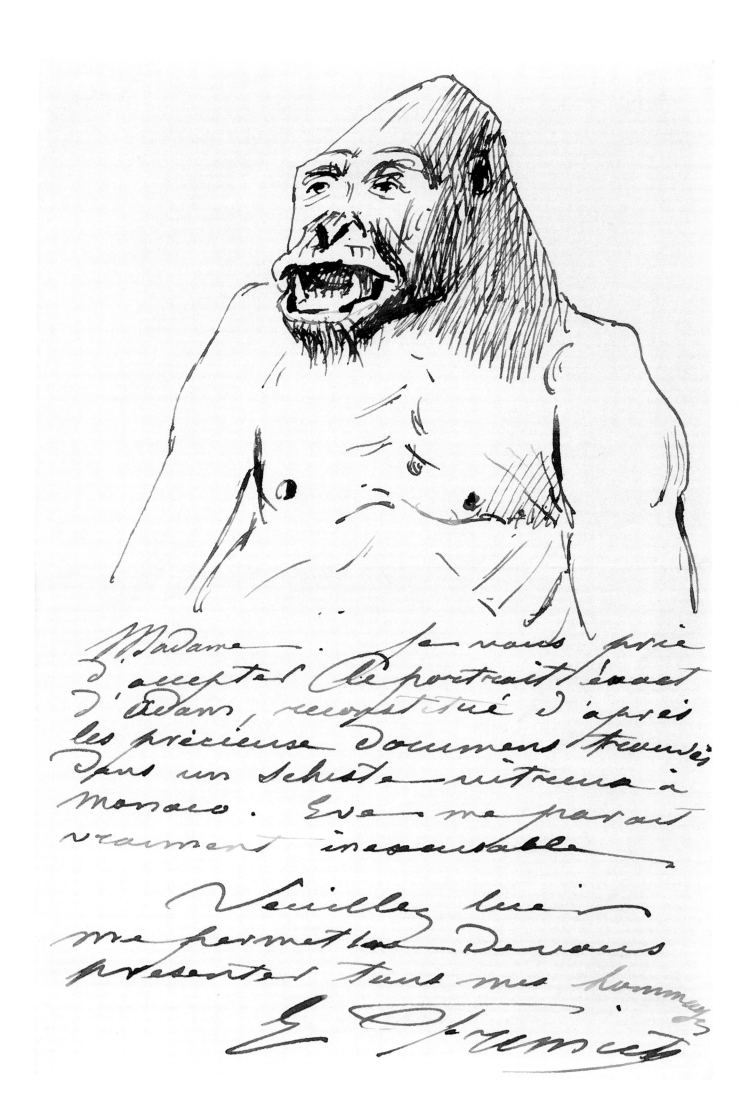

ERNEST DELAHAYE (1853–1930)

Ernest Delahaye, Self-Portrait at Age Twenty-Seven, *1880.*

To Paul Verlaine

Ernest Delahaye, a childhood friend of Arthur Rimbaud, first met Paul Verlaine in Paris in 1871 (see pages 86–87 and 112–13). The two men were destined to see and write one another often, Delahaye frequently providing Verlaine with news of Rimbaud, sometimes even serving as messenger between the two lovers, who met for the last time in 1875.

At the time, Verlaine had just decided on a title for the collection of poems he was writing reflecting his conversion to Catholicism, *Sagesse*, which Delahaye was helping him to get published. But the publisher Alphonse Lemerre, who had brought out *Poèmes saturniens*, *Fêtes galantes*, and *La Bonne Chanson*, refused it. Stock did likewise. In the end, Léon Palmier agreed to issue it, at the author's expense, for the Société Générale de Librairie Catholique. *Sagesse* appeared at the end of 1880. A total of eight copies were sold.

Delahaye, who consistently encouraged Verlaine, supported his friend by expressing good-natured enthusiasm—as in this letter, in which he refers to the recent appearance of a review. The press was generally unkind to the poet, dubbed by *Le Temps* "Paul Féval du Parnasse" (after a popular novelist of the day who similarly converted to Catholicism).

Ten years later, Verlaine devoted a poem in the collection *Dédicaces* to Ernest Delahaye. Its first lines testify eloquently to the close ties uniting the two companions: "God, wanting us to be perfect friends, made us both / Gay with the gaiety that laughs for itself, / With the absolute, colossal, supreme laughter / That guffaws at everyone and wounds no one." For his own part, Delahaye, a college professor who later became a bureaucrat in the Education Ministry, wrote a book evoking his friends and confidants that has proved immensely valuable to historians: *Souvenirs familiers à propos de Rimbaud, Verlaine et Germain Nouveau* (Paris: Meissen, 1925).

[mid-1881]

Dear friend,

I am so ashamed that I don't know where to hide. [to right of drawing:] That's me, I'm really ashamed.

Here it is three days that you must have been cursing me or thought me dead. In effect [*en nez fait*, a homonymous reworking of the phrase *en effet*, playfully incorporating *nez*, the French word for nose], I am very guilty but I have loads of excuses. First a frightful cold that played all sorts of tricks on me; then the funeral of Fffather Hugo; then a-, a-, a-frightful, a-, a-cold, just punishment—among other things!—for my rubbernecking. Finally, a heap of the most nullifying hindrances.

I've not yet been able to get to either the Patroupe or the Natismar, any more than to Dentu's. I've been told that *L'Univers* has just had something to say about *Sagesse*. I haven't been able to find out what issue. Did you get this article by Trocmé? If not I'll go to the *l'Univerpompe*, leaf through the collection and try to obtain the precious follicle [a dismissive pun playing on the consonance between follicle and fascicle—*follicule* and *fascicule* in French], if I dare call it that! . . .

You ask me to explain the word "accepted" ["*admis*"] that I used when talking about "Voyou." Trocmé showed me the manuscript in a gray paper folder, together with several others, and said to me: "All that is accepted." Now I "thank" ["*pinse*"] that these are things deemed suitable for insertion waiting in this limbo for their moment to arrive. I didn't want to press the matter with Trocmé for fear of being indiscreet and to avoid annoying him. One should always avoid seeming like a buttonholer, no? That's why I think it's better to be patient for a while.

I spoke to Nouveau about the rhythmic verses. He doesn't remember which ones. Do you remember the titles or subjects? Moreover I think that this Jansenist grows softer by the day. He still goes to d'Amécourt's where he just qualified as a second-class student-lecturer.

Your Delahaye

P.S. Thanks for the stamps, useless to send any more.

That's me celebrating your eightieth birthday.

[verso:] A crowd: That's me leading a claque at the celebration of Father Hugo.

Jean Béraud, The Funeral of Victor Hugo.

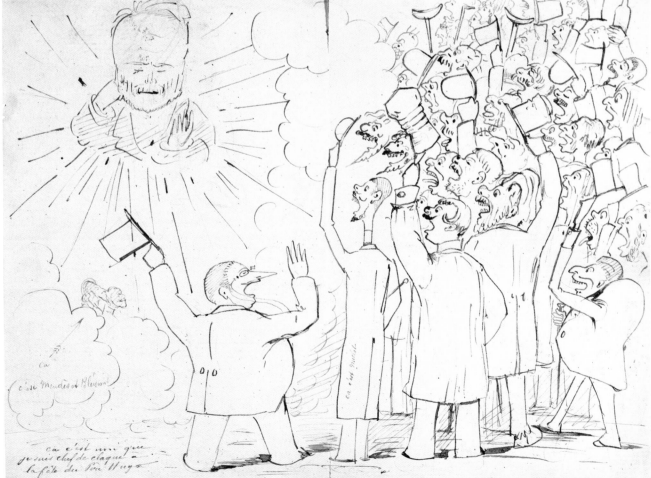

Henri Harpignies (1819–1916)

Léon Bonnat, Portrait of Henri Harpignies.
Valenciennes, Musée des Beaux-Arts.

A traveling salesman by profession, Henri Harpignies began his career as a painter only at age thirty-four, when, at the Salon of 1853, he exhibited *View of Capri*, the product of a trip to Italy and lessons with the landscape painter Jean-Alexis Achard. Thereafter, he devoted all his energies to his art, to cultivating his gift for rendering the varied landscape of France, from its coast to its mountains, from its plains to its thicketed forests. He cleared a broad path for the painters of the Barbizon School.

By the time he wrote this letter to his mother, Harpignies's gifts had been acknowledged by both his peers and the state. He had won several Salon medals, and two years earlier he had been made an officer of the Légion d'Honneur.

In this intimate missive, the painter details his wife's problems with her vision, speaks of daily anxieties, communicates his preoccupations and his envisioned trips to the Midi ("I work tremendously in the land of the sun"), mentions a student who is "mad for landscape but earns his living doing illustrations for books and newspapers" (a common enough quandary at the time): in sum, he conveys all the news of the day to his "good mama." The document would be considerably less charming without the sketch illustrating the artist's remarks about the bad weather. Falling somewhere between a comic strip and a genre scene, this string of little figures struggling against a squall—the wind has turned one umbrella inside out and swept another one away—presents a little-known aspect of this somewhat solemn painter, striking a playful note that the letter otherwise would have lacked.

To his mother

St. Privé
Tuesday, October 27, 1885

Dear good mama,

I don't say that I'll finish this evening, but for the moment here I am.

I thank you for your fine letter, my wife does likewise for the one you addressed to her.

We hope that your indisposition does not persist and that you are now recovered. Doubtless you don't know that for the last two months I've been very uneasy about Marguerite's health regarding her vision, which has been weakening for some time. She has been to Paris to consult one of my comrades, Dr. Desprez, for the first time (he's at the Charité); the outcome was not happy. I then advised her to see a renowned specialist, Dr. Galézoski, which she did about a month ago. She returned less uneasy since the doctor assured her that she wasn't losing her sight. At the moment she's of course being treated at St. Privé, and the problem has stabilized. They've ordered special glasses for her that seem to help. Finally, when we return to Paris in about a month we'll go to see the doctor again if need be.—Don't count on her writing you often for the reality is she has trouble seeing and that tires her greatly. —It's our beloved niece who undertook these little notes but she and her sister left the day before yesterday. Their parents came to get them and the whole lot left us the day before yesterday. I still have near me at the moment an old friend, Monsieur Berthier, who will be leaving us on Saturday to return to his small villa outside Chartres.

In the midst of all these anxieties, I've had some bad moments, but I trust in God and I hope that things will improve. For my part, at the moment I'm suffering from rheumatism. I'd even say in very inconvenient places but I console myself, for despite this wretched pain I can still hold my pencils and brushes. The day that's no longer possible I'll be damned annoyed.—. . .—

I've invited the usual musicians for All Saints' Day; I hope they'll come and that for a day or two we'll be able to play some quartets. It's a wonderful distraction in the country. . . .
(continued in the appendix, page 217)

Henri Harpignies, Evening Effect. *Dijon, Musée Magnin. Like so many of Harpignies' landscape paintings, this one is imbued with a melancholy nostalgia.*

(3) pourons pendant un jour ou deux — faire
quelques quatuors. C'est une fameuse
Distraction à la campagne. =

Nous pourons rentrer à Paris dans la dernière
huitaine de 9bre, et je terminerai alors un grand
tableau au quel j'ai travaillé tout cet Été et
puis nous penserons à retourner dans le
Midi pour un mois ou deux, comme l'an
Dernier. Cette Excursion sera nécessaire à la
Santé de ma femme. Elle s'en est très bien
trouvé l'an dernier. de mon côté je travaille
Enormement dans le Pays du Soleil et je t'avoue
que j'en suis fort aise.

Je te quitte à ce soir - tout ce qui précède
est bêtement raconté — je suis pas en train.
J'ai mon J. F. de Rhumatis me qui me fait souffrir
Bonsoir Bonne maman.

Chère Bonne maman. le 30 8bre 85 1r 9bre

Je clos cette lettre aujourd'hui jour de la Toussaint
Il fait un temps ignoble comme toujours †

Vincent van Gogh (1853–1890)

Vincent van Gogh, Self-Portrait, 1886. The Art Institute of Chicago.

To his brother Theo

Isaacson,
Portrait of Theo.

Raised in a Calvinist family, van Gogh attempted to follow in his father's footsteps and become a clergyman. After his religious training, he served as a missionary to coal miners in Belgium. This experience proved disastrous, prompting him to abandon his religious calling, but it provided him with a store of impressions that would later nourish his art.

Although he always suffered from being "in the eyes of most an eccentric and disagreeable man," van Gogh worked intensely. Influenced by the peasant scenes of Jean-François Millet, he painted landscapes with cottages and farms, still lifes, and frank portraits of male and female peasants, such as the ones in his first important painting, *The Potato Eaters*, of 1885. Written in the same year, the present letter depicts a female peasant from the Brabant region wearing her white cap. The sketch manifests little concern for conventional notions of beauty: as van Gogh wrote in another letter, his aim was "profound expression." Like Millet—and like Émile Zola portraying the bitter life of French miners in his novel *Germinal*, which van Gogh says he had just read—he set out to render poverty and backbreaking work as realistically as possible. To this end, he used dark, tawny colors and bitumen.

The following year, 1886, Vincent suddenly decided to go to Paris, where he lived with his brother Theo. There he discovered the light-filled painting of the Impressionists, which prompted him to change his own palette.

Throughout his life, van Gogh maintained an extended correspondence with his brother Theo, his prime morale booster and indispensable confidant. His epistolary production, which began in 1872 and ended only with his death in 1890, consists of 650 letters, many of them illustrated.

[May 1885]

Dear Theo,

I just received *Germinal* and started to read it at once.

I have read about fifty pages, which I think splendid; I once traveled through those same parts on foot.

Enclosed is a sketch of a head, which I just brought home.

There was the same one among the last studies I sent you, namely the largest of all. But painted smoothly.

Now I have not smoothed down the brush stroke and in fact the color is quite different too.

I haven't yet made a head so much "peint avec de la terre," and more will follow now.

If all goes well—if I earn a little more—so that I can travel more—then I hope to go and paint the miners' heads someday.

But I shall work on till I am absolute master of my hand, so that I can work even more quickly than now, and, for instance, bring home about thirty studies within a month. I do not know if we shall earn money, but if it is only enough to let me work terribly hard, I shall be satisfied; the main thing is to do what one wants to do.

Yes, we must do the miners someday.

What did Poriter say about the potato eaters? I know quite well it has its faults, but just because I see that the heads I am doing now are becoming more vigorous, I dare maintain that the potato eaters will keep its value in relation to future pictures, too.

Last year I often got desparate about the color, but now I work with more confidence. You must tell me what you think best, to keep my latest work for Antwerp or to send it as soon as possible to you and Portier. It's all the same to me, I have now finished seven heads and one water color, so I could send a small batch again. Good-by, once more thanks for *Germinal*, I am still reading it as I write this. It is splendid.

Ever yours,
Vincent.

Jean-François Millet, The Gleaners, 1857. Paris, Musée du Louvre.

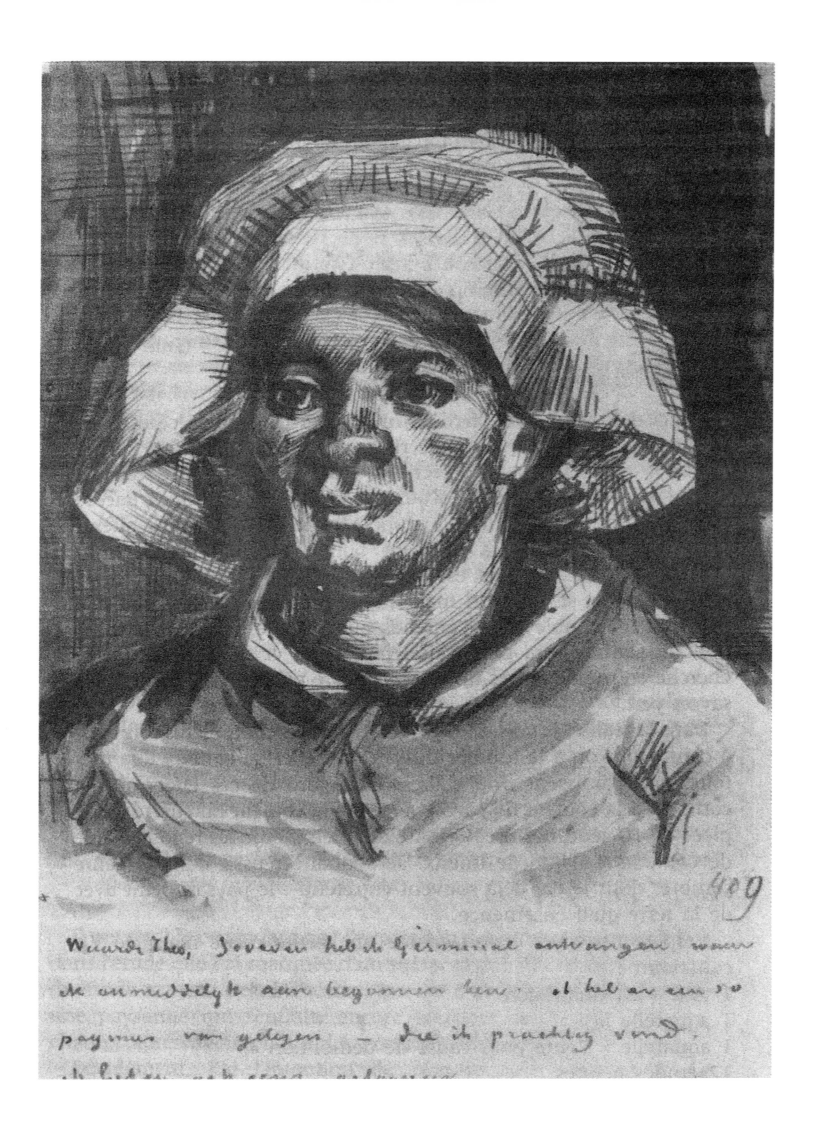

409

Waarde Theo, Zooeven heb ik Germinal ontvangen waar
ik onmiddellijk aan begonnen ben. ik heb er een 50
pagina's van gelezen — die ik prachtig vind.

Vincent van Gogh, Portrait of Gordina de Groot, March 1885. Amsterdam, Rijksmuseum Vincent van Gogh.

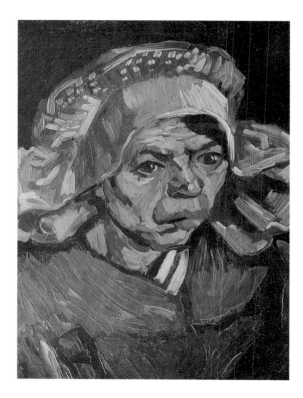

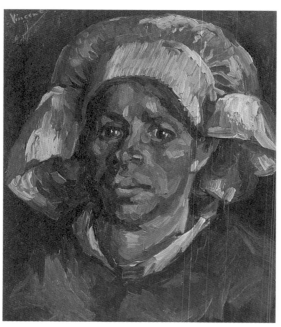

Above: Vincent van Gogh, Head of a Peasant Woman of Neunen, 1885. Amsterdam, Rijksmuseum Vincent van Gogh. Below: Vincent van Gogh, Portrait of Gordina de Groot, May 1885. Private collection.

Vincent van Gogh, The Potato Eaters, *April 1885. Amsterdam, Rijksmuseum Vincent van Gogh.*

"I intend to attack this week a canvas representing peasants around a plate of potatoes, in the evening—perhaps rather by daylight—or both at once, or neither—you'd say. I might succeed and I might not; however that may be, I'm going to begin making studies of the different figures," van Gogh wrote to Theo in April 1885. He did as he said, as evidenced by these three studies of peasant heads (facing page). The same month, after executing several compositional studies, he completed *The Potato Eaters* (above). It is the first canvas that he deemed a *tableau*, or considered a real painting, as opposed to the many studies he had produced previously. "What I think of my own work is that the tableau I made with peasants eating potatoes, which I made in Neunen, is in the end the best thing I've done," he confided to his sister Willemine in a letter written from Paris.

OCTAVE MIRBEAU (1848–1917)

Portrait of Octave Mirbeau.

From Père-Lachaise
December 11, 1886

My adored little tomb,

We'll come pick you up tomorrow at seven o'clock sharp. Make yourself beautiful, as for our burial. I've taken a box at the Variétés. I hope that this final trial will reclaim you for truth, along the path of *macabrisme*.
We embrace you.

Octave Mirbeau
Jean-Louis Forain

"And all these remains of human bodies, stripped fleshless by death, threw themselves on top of one another, all carried off by homicidal fever, all whipped by pleasure, and they wrangled amongst themselves over filthy carrion." So ends Octave Mirbeau's first novel *Le Calvaire*, which brought its author instant celebrity in November 1886. Blood, "immense and sterile fornication," and death pervade this exercise in realist symbolism, whose narrator confesses: "Neither virtue, nor goodness, nor misfortune, nor hallowed old age impede me, and, as settings for these frightful follies, my preference runs to sacred and consecrated places, church altars, tombs in cemeteries."

Mirbeau was already far along the path of *"macabrisme"* by the time his novel appeared, when he penned this letter to his "adored little tomb" with the aid of his friend, the painter Jean-Louis Forain (see pages 132–33). A small masterpiece of gallows humor, it deftly incorporates references to the Grand Siècle, the historical apex of French grandeur. Appropriating the emblem of Louis XIV—*Nec Pluribus Impar*, "none greater"—Mirbeau replaced its accompanying radiant sun with Death's head, while turns of phrase associated with the diction of repentance maliciously evoke the king's confessor Father Lachaise, after whom the great Parisian cemetery was named.

Addressing Death in the familiar *tu* form, this note inviting a tomb to the Théâtre des Variétés is consistent with the defiant project of all of Mirbeau's fiction: to effect a grating marriage of laughter and calamity. The cruelty that pervades *L'Abbé Jules* (1888), the monstrous rites at the center of *Le Jardin des supplices* (*Torture Garden*; 1899) were imagined by the same author who wrote the play *Les affaires sont les affaires* (*Business Is Business*; 1903), and who as a renowned art critic, a defender of Manet and Cézanne, was acutely aware of the strong effects that could result from juxtaposing images with text.

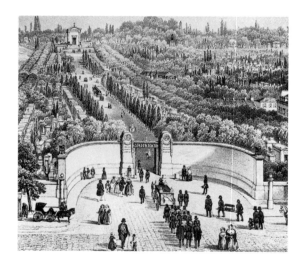

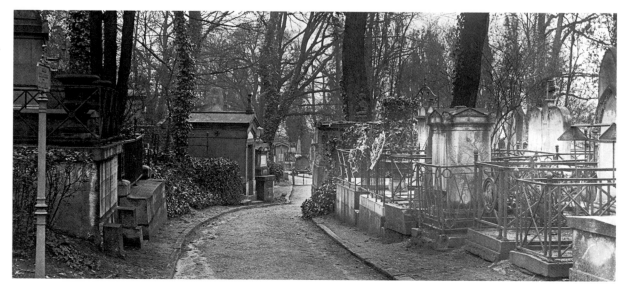

Above: 19th-century print representing the entrance to the Père-Lachaise Cemetery. Left: A path in the Père-Lachaise Cemetery, c. 1900.

NEC PLVRIBVS IMPAR

du père Lachaise, ce 11 décembre 1886.

Ma petite tombe adorée.

Nous irons demain, te prendre, à sept heures précises. Fais-toi belle, comme pour notre enterrement. J'ai pris aujourd'hui une loge pour les Variétés. J'espère que cette dernière épreuve te ramènera à la vérité, sur la voie du macabrisme.

Nous t. embrassons.

Octave Mirbeau
Jean Louis Toraig

Félix Buhot (1847–1892)

Photograph of Félix Buhot.
Valognes, Bibliothèque Municipale.

This splendid illustrated letter provides us with an occasion for rediscovering a nineteenth-century "little master" who is too little known. For some years now, there has been a renewal of interest in Félix Buhot, prompted by the originality and technical qualities of his work. A catalogue of his paintings recently appeared, and several exhibitions have been mounted of his prints.

Buhot is better known as an engraver than as a painter. He participated in a movement that sought to establish the print as a major creative medium, as opposed to one of merely technical or reproductive interest, and to this end he defined himself as a painter-engraver. He was encouraged by Philippe Burty, who published an article on him in *Harper's Magazine* and wrote the catalogue preface for an exhibition of his work in New York, thereby helping to establish his reputation in the United States. Buhot illustrated works by Barbey d'Aurevilly, Victor Hugo, and Charles Baudelaire, producing images whose fantastic qualities, nocturnal visions, and picturesque effects identify him as a Romantic. But he also executed views of Paris and London whose atmospheric effects—evocations of overcast skies, wet sidewalks, rainstorms, and fog—align him with Impressionism.

In this letter's illustration, one cannot help but admire the two banners flapping in the wind, the shield bearing Buhot's personal device ("free and faithful"), the little figure of a woman with an umbrella in the foreground, the freely rendered shadows of the trees, and, above all, the admirable bluish horizon with its view of sea and sky. Through the mist one can make out the small, seaside town of Saint-Malo.

Dinard—the Biarritz of the North, made fashionable by the English around 1850—appealed to Buhot, for it reminded him of La Manche, his native province. In 1892 he purchased a villa there, L'Abri, where he proceeded to expand the technical and aesthetic boundaries of his art, painting in the medium of *détrempe* (tempera), experimenting with printing techniques and papers, and refining his characteristic "symphonic margins." This last technique consists of adding little vignettes—based on drawings in his sketchbooks—to each proof, all relating to the central image, thereby producing a visual theme-and-variations effect and rendering each sheet unique. Similarly, he liked to illustrate his letters with drawings in ink and watercolor. He died in 1892 a disenchanted and solitary man, after confiding: "Proofs consumed me whole, time and brain."

To Philippe Burty

Manoir Blanc-Dinard, October 16, 1887

Dear Monsieur Burty,

Thanks for the gracious recollection that begins your letter and for all the good news you send me. I'm not surprised to learn that Mr. Fred Keppel did his best to make himself agreeable to you, for I'm convinced that he is very grateful to you for what you're doing for us.

Madame Buhot thanks you for your kind remembrance; she has just made a copy of the second edition of your manuscript.

For my part, I draw and paint from morning 'til night: I needn't go out to look for motifs. Here I have at my disposition four mansard windows facing the four points of the compass and thus see the sky in all its aspects, in its splendor and its melancholy. I'm still trying to master painting in *détrempe*.

While awaiting the pleasure of seeing you in three weeks or a month, if the weather remains fine, I am always, Dear Monsieur Burty
 Your affectionately devoted
 Félix Buhot

[verso]
P.S.—October 21. I received a letter from Mr. Frederick Keppel dated October 6 acknowledging receipt of a roll of proofs, sent by me on September 1. He had not received the manuscript. I await from day to day a letter informing me of its arrival.

In the course of his letter, Mr. Keppel writes (I translate): "It has always been my intention to publish the first article by Mr. Burty in my catalogue despite Harper's" [sic] . . . Doubtless he means to say, despite the article in *Harper's*.
Ever yours sincerely

 Félix Buhot

Félix Buhot, print with "symphonic margins." Paris,
Bibliothèque d'Art et d'Archéologie Jacques Doucet.

LIBRE

ET FIDELE

Manoir Blanc - Dinard

Cher Monsieur Burty

16 octo
bre
1887

Merci pour le gracieux souvenir
qui commence votre lettre et pour toutes les
bonnes nouvelles dont vous me faites part
Je ne suis pas étonné que d'apprendre que
Mr Fred. Keppel ait fait son
mieux pour vous être agréable, car je suis
convaincu qu'il vous est très reconnaissant
de ce que vous faites pour nous.

Madame Buhot vous remercie pour votre
bon souvenir; elle vient de faire une
copie de la seconde édition de votre manuscrit —
Pour moi je dessine et je peins du matin au soir; je n'ai pas
besoin de sortir pour chercher des motifs. Je jouis ici de 4 mansardes
orientées aux 4 points cardinaux et donc je vois le ciel dans
tous ses aspects, dans ses splendeurs ou ses mélancolies. — Je
cherche toujours la peinture à la détrempe
En attendant le plaisir de vous revoir (dans 3 semaines ou 1 mois, si le
temps reste beau) je suis toujours, Cher Monsieur Burty
Votre affectueusement dévoué
Félix Buhot

1920

PAUL VERLAINE (1844–1896)

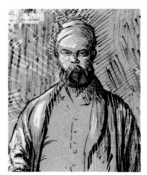

Cazals, Verlaine. *Paris, Bibliothèque Nationale Française.*

To Irénée Decroix

Paris January 24, 1889

Dear friend,

What's been happening to you all this time that we haven't exchanged news? Myself, still broken and sick, as proof, here I am again in the hospital. Even so, my health and my finances are going better; I even hope to leave soon and at last! live normally.

I'm still producing literature in bulk. Among other things I'm going to publish a collection of verse entitled *Les Amis*. One bit is dedicated to you and I'll send it to you. It touches on the good women from the Arras suburbs who come to market every week on their donkeys with their pipes in their mouths. Are they called *courbouillères* or *fourbouillières* and what is the precise meaning of this word of dialect?

Brief me about this as soon as possible. All information about yourself, too, alright?

A thousand compliments to you, and believe me always

Your
P Verlaine

Bed 1, Salle Parrot, hôpital Broussais
96 rue Didot

Delahaye and Nouveau, whom I just saw, send you their warmest regards

P.V.

Dark hotels, lugubrious jails, drunkards' cafés, and hospital rooms are constants in the sad geography of Verlaine's peregrinations. At the end of his life, confined to his sickbed, condemned to frequent hospital stays by rheumatoid arthritis in his knee that eventually spread to his entire left side, the poet with the head of an old faun tried to laugh at his lot and continue to write.

Witness this letter addressed to his friend Irénée Decroix, in which Verlaine confides that he is still producing "literature in bulk" and is preparing a new collection provisionally entitled *Les Amis* (the eventual *Dédicaces*). Despite his suffering, he sketched a droll self-portrait—he excelled at comic drawings—in which he wears the cap of a follower of General Boulanger (behind whom an unlikely coalition of Bonapartists, royalists, and workers had rallied in opposition to the Third Republic). Pen in hand, he puts a lexical question to Decroix, who, like himself, was a native of northern France. "*Four* or *Bour*?" asks the balloon: in other words, is *fourbouillères* or *courbouillères* the correct word to designate "the good women of the Arras suburbs who come to market every week"?

The collection of poems, published in 1890 by Éditions de La Plume, provides the answer, for it contains this verse dedicated to Irénée Decroix: "For we laughed in those days.—Tiles and bricks / Dusted by the plain in rather ugly hamlets; / The *fourboyères*, their pipes and their asses / Descended on Arras, the city with spritely roofs / Piercing, Spaniards, the overcast skies of Flanders." The volume's publication coincided with one of the rare moments when Verlaine was not bedridden. Some months later, however, he had to return to Cochin Hospital, which he left soon after to be admitted once more to Broussais. In all, more than twenty stays in Parisian hospitals punctuated the end of Verlaine's life.

Although initially unable to secure even a single vote for his Académie Française candidacy, he was consecrated a "Prince among Poets" only later, when, exhausted by poverty and illness, he had scarcely two years to live.

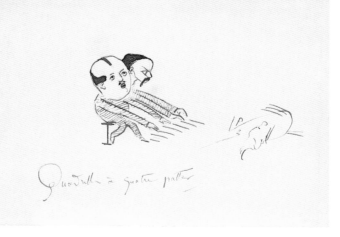

Paul Verlaine, Quadrille à quatre pattes *(Quadrille for Four Hands)*, c. 1870. Paris, Private collection.

Vous intitulé **Les Amis**. Une pièce vous y est dédiée que je vous enverrai. Il y est question des bonnes femmes de la banlieue d'Arras qui viennent toutes les semaines au marché pour leur rente et leur pipe à la bouche. Est-ce courbouillières ou fourbouillières qu'on les nomme et que signifie au juste ce mot patois?

Renseignez-moi sur ce sujet le plus tôt possible.

Vos renseignements aussi sur vous, n'est-ce pas?

Mille compliments chez vous et envoyez-moi toujours.
Votre P Verlaine

Lit 1, Salle Parrot, hôpital Broussais
96 rue Didot — Paris-Plaisance.

Delahaye et Nouveau, vus tout récemment, vous envoient leur meilleur souvenir.

P.V.

[croquis avec annotations:]
Foer... ou Boca?
Le 1 de la salle Parrot
Ça c'est un porte-plume
Ça c'est une cocarde avec Vive Boulanger! autour.

JOHN PETER RUSSELL (1858–1931)

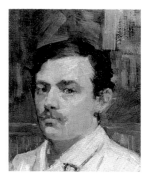

John Peter Russell, Self-Portrait, *c. 1886.*
Morlaix, Musée des Jacobins.

In this informal letter to Rodin, the Australian painter John Peter Russell—he studied at the Slade School of Fine Art in London and the Atelier Cormon in Paris, where he met Van Gogh—congratulates the sculptor on two counts: for his monument to Victor Hugo, commissioned in 1889 for the Panthéon (after many vicissitudes, it is now in the gardens of the Musée Rodin); and for the bust of Russell's wife Marianna (a model for several works by Rodin, notably the several versions of *Pallas*), which Russell plans to take back with him to Australia.

As luck would have it, Rodin's response survives. In it, the sculptor writes that the drawing in Russell's letter is "very much to his taste" (he even promises to "keep it in a little frame") and that he is flattered that one of his works is going to "Sidnez," and he specifies that the favor he has asked of his friend, namely, that he return the bust to him for a certain time, is for an exhibition at the Société Nationale des Beaux-Arts on the Champ-de-Mars. It was indeed shown there, along with *The Beautiful Helmet-Maker's Wife*, a *Danaïde*, and a torso. Rodin further informs us that "the bust was seen to ill advantage in Paris at Petit's, the patina being horrible like floor wax." The problem was soon corrected, for Rodin adds: "Now it is very beautiful," a judgment readily verifiable today by visitors to the museum devoted to the sculptor's work.

To Auguste Rodin

Photograph of Rodin, c. 1880.
Private collection.

Belle-Île /
Morbihan
[early 1890]

Perhaps two weeks ago, my dear Monsieur Rodin, we had a magnificent storm. In some places the sea jumped at least a hundred feet into the air. Impossible to work because of the wind. I congratulate you on the statue of Victor Hugo.

We are very happy with the bust of Madame R[ussell]. Patina very beautiful. [I will be happy] to send it whenever you like if it's still at my house for I plan to present it to the Museum in Sidney shortly. It's a work that will do much good for the painters and sculptors down there. Madame Russell has been sick for the last two weeks; now she's much better.

I have too many distractions to work as much as I'd like but I think I'm beginning to see nature more broadly and simply, [with] more colors and richness. That pleases me.

Our very sincere regards and sympathies [sic]

John P. Russell

John Peter Russell, The "Needles" at Belle-Île,
c. 1890. Morlaix, Musée des Jacobins.

pour les derniers deux semaines
maintenant elle va beaucoup
mieux. J'ai tâché de travailler de
travailler tant que je voulais
bien — mais je crois de commencer
de voir la nature plus simplement et
simple. plus de couleur et richesse.
Pour ça je suis content.

Mes bien sincère amitiés et sympathie

J'espère d'avoir le plaisir de vous voir
ce mois ou côté année

①

Morbihan

Il y a peut-être
deux semaines,
Mon cher
M. Rodin
que nous
avons vu
une tempête
magnifique.
Dans certains
endroits la
mer a sauté
100 pieds au moins

ROSA BONHEUR (1822–1899)

Édouard Louis Dubufe, Portrait of Marie-Rosalie, known as Rosa Bonheur. *Châteaux de Versailles et Trianon.*

The amusing little caricature at the end of this letter is the only known self-portrait by the animal painter Rosa Bonheur. She is shown holding an oversize brush and palette, wearing the comfortable attire that she customarily donned to paint: a chemise with narrow sleeves that would not get in her way, a Breton waistcoat, a long pleated skirt, and polished boots. An analogous relaxed quality characterizes both the diction and the handwriting of the letter, addressed to her old friend Pierre-Jules Mène, an animal sculptor who throughout her life provided Bonheur with the plaster models she needed to realize her paintings.

A century later, it is perhaps difficult for us to grasp the audacity of Bonheur's nonconformism, a quality that has prompted her to be nicknamed the George Sand of painting. Greatly admired by the French (she first exhibited at the Salon at age nineteen and later was awarded a first-class medal, occasioning congratulations from Louis Napoleon), her career unfolded on an international scale, but not without scandal. Raised by her father, the painter Raymond Bonheur, a society portraitist in Bordeaux who espoused Saint-Simonian ideas of social reform and advocated sexual equality ("Woman is the messiah of the future," he said), she was indifferent to the conventions of her day. Unmarried, financially independent, outspoken about her preference for the company of women (especially her beloved Nathalie Micas), she smoked cigars, road horseback male-style instead of sidesaddle, and dressed like a man so that she could freely study animal anatomy in the slaughterhouses in Le Roule and the horse markets at Ivry. Fascinated by the United States (she painted an equestrian portrait of Buffalo Bill), she saw several of her paintings purchased by Americans, for example Cornelius Vanderbilt, who acquired her immense *Horse Fair* (1853; New York, The Metropolitan Museum of Art). Possessed of exceptional energy, she worked prodigiously, producing canvases of vast dimensions in which she represented animals life-size. She entrusted all matters relating to their sale to a dealer.

Appreciated by the imperial family despite her eccentricities, she was protected since her youth by the duc de Morny, she served as director of the École Impériale de Dessin pour Jeunes Filles until 1860, and when she received the Légion d'Honneur, it was from the hands of Empress Eugénie herself.

She spent her final years in seclusion at the Château de By, near Fontainebleau, where she lived surrounded by her "menagerie": aviaries in her bedroom and a zoo in her garden that boasted cows, deer, foxes, and even a lion.

To the sculptor Pierre-Jules Mène

[undated, no place specified]

My good old P. J.:

You are a true friend and I thank you for the pleasure you have given me by responding so quickly to my request. Only, my dear friend, I asked not for three deer but for one; note that I'm not complaining about this, not at all, not at all, only I dare not think that the three deer were intended as gifts: you'll clear this up for me on my next visit. As for Cain, he, too is a good prince [?]; his willingness to lend me his Barye is very kind and I thank him, too.

But my heart prefers all the same my Mène, given that they'll ravish me more, and then for other reasons that I can't state here for fear of making my old P. J. blush.

As for little Henri Mène, yes, he's a fine fellow! And his exclamations touch me. Be sure to tell him so, and embrace him for his artist; I want to be his artist.

Monsieur Georges is becoming quite indifferent. I don't receive any letters from him: it's true that I'm careless about responding, but there shouldn't be any friction between old friends; I enclose an embrace for him, through you.

I hope to come and give all of you warm embraces one of these days: in the meantime, my male and female friends, I embrace you with all my heart and thank you again my old P. J. Mène.

Your friend
Rosa Bonheur

I'm working hard but there's lots to do today.

Rosa Bonheur, Eight Studies of a Hunting Dog. *Château de Fontainebleau.*

CHARLES FILIGER (1863–1928)

Photograph of Charles Filiger. Private collection.

To his friend Bois

Born in 1863 in Thann, Alsace, Charles Filliger—he later dropped the second "l"—was the son of a fabric designer who sent him to Paris to study painting in the atelier Colarossi. At an exhibition at the Café Volpini, he discovered lithographs by Paul Gauguin and Émile Bernard. He also developed ties with Alfred Jarry, Rémy de Gourmont, and Claude-Émile Schuffenecker, with whom he corresponded copiously.

Filiger visited Pont-Aven in July 1889, but the next year he effectively settled in Brittany, where he spent much time with Paul-Émile Colin, Gauguin, and Paul Sérusier. He became especially close to the latter two artists, who, together with Meyer de Haan and Maxime Maufra, had taken rooms in Marie Henry's modest inn at Le Pouldu, where Filiger was to remain something of a fixture until 1892.

Filiger was one of the many painters who lived the great, quasi-communal aesthetic adventure, so important in the history of modern art, now known as the school of Pont-Aven. This school, sometimes truantlike, a trifle dissident, was characterized by an infatuation with color and a free lifestyle. Filiger had a spiritual bent that led him to create a great deal of work known collectively as "chromatic notations." Constituting a third of his painted oeuvre, these productions evidence an extraordinary longing for the absolute, for perfect unity.

The focus of Filiger's life and work was the search for God. Mystical and secretive by nature, he led an unhappy existence, without resources, clouded by alcohol and illness, dependent on the generosity of those close to him and of his patron, Comte Antoine de La Rochefoucauld, a painter and art critic. As Filiger put it: "My painting resembles my life; both are strewn with crosses."

This assessment is echoed in a letter from La Rochefoucauld, who supported Filiger from 1893 until the two broke with one another "amiably" in 1900: "It is with devotion and pious respect that we must approach one of the few truly mystical painters of the day; in front of the Christs, Virgins, saints that Filiger has managed to create, prayer seems obligatory, all hatred vanishes from one's heart, all contrarian desires are extinguished: one must be ecstatic and dream only of the God of peace and forgiveness."

My very dear friend,

I indeed received your good and friendly letter yesterday—and I thank you for it. I don't want to waste a minute in responding to you. All I have—here—of my little kneeling fellow is a very incomplete proof, badly flawed and even more badly colored. Why don't you ask Mr. de Larochefoucauld for the rather good proof he has of the little thing: you could use it as you see fit. Or just tell me exactly what is needed, and how. Or look at the original at Schuffenecker's. In short, I am entirely at your service—and don't stand on ceremony with me about anything.

I still haven't received the Du Coeur nos.— but on the other hand the house of Berville in the Chausée d'Antin sent me a superb fan to paint. Provided I don't ruin the thing—such beautiful material makes me nervous.

I've already found my fan subject: it symbolizes music—a small Orpheus that a bodiless genius touches lightly or caresses; in the center, ornaments and flowers (roses, if you please!) to finish.

It was while playing, these last few days, *Armide* and *Orphée*, the two immortal masterpieces by Gluck, that the idea of painting Music came to me.

Now you'll allow me a little time to execute the thing, for I intend to do it at night—so as not to fall too far behind with my other large project—awaited with such impatience. As soon as your friend has given me some news about herself—I'll bring her up to date about the little project I'm preparing for her.

Above all, thanks to your friend and yourself, my dear Bois, for having responded so quickly to my desire. I won't neglect to write to Mr de Larochefoucauld—after the date you send me of their return.

I have a thousand agreeable things to tell you from Mr Seguin; as for my young friend, don't speak to me about him any more—he causes me infinite pain and I was much mistaken to have taken an interest in him. I don't know what all they've done—he and his friend—in Pont-Aven. It seems they're being retained for just what you thought. I wrote a very harsh letter to the little fellow, inviting him to leave me in peace one last time and to return as quickly as possible the studies I entrusted him with.

If I tell you the little story—it's to warn you about the little fellow—for it would be vexing if he went to pester you—when he returns to Paris.

My very dear friend Bois, I hope to have good news from you shortly. I cordially shake your hand in this expectation—and I remain very devoted to your frank and good friendship.

Ch. Filiger
Sunday morning
Kersulé par Moëlan
Finistère

[along left edge]
(The fan maquette has already been sent to you.)

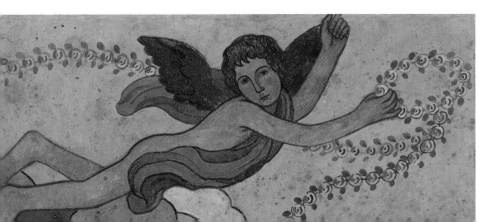

Charles Filiger, Genius of the Garland, *1892.*

Mon bien cher ami

J'ai eu votre si bonne et si amicale lettre hier — seulement
et je vous en remercie. Je ne veux pas perdre une minute
pour vous répondre de suite. Je n'ai ici de mon
petit bonhomme à genoux — qu'une épreuve fort
incomplète, mal venue et plus mal coloriée encore —
Pourquoi ne demanderiez vous pas à M. de la Rochefoucauld
l'épreuve assez bonne — qu'il a de la petite chose. vous
en userez comme vous l'entendrez — ou alors vous me
direz exactement ce qu'il faudra — et comment et
ou bien — voyez l'original chez Schuffenecker.
Enfin — je suis entièrement à votre service — et ne
vous gênez en rien avec moi.
Je n'ai pas encore reçu les n° du Cœur — mais
parût-il la maison Berville de la Chaussée
d'Antin m'a adressé un éventail à peindre
Superbe. Pourvu que je n'abîme pas l'affaire —
j'ai crainte devant si belle matière.
Mon sujet d'éventail est déjà trouvé : il symbolise
la Musique — un petit Orphée qu'un Génie sans
corps frôle ou caresse — au milieu des ornements
et des fleurs (des Roses s'il vous plaît!)
pour compléter —
C'est en jouant — ces derniers — Arme de et

Orphée — ces deux immortels chefs d'œuvre du
vieux Gluck — que m'est venue l'idée de
peindre la Musique.
Maintenant vous me donnerez un peu de temps pour
l'exécution de la chose. car je compte faire cela
à loisir afin de ne pas me mettre trop en retard
avec l'autre grand travail — si impatiemment
attendu. Sitôt que votre amie m'aura donné
de ses nouvelles — je la tiendrai au courant
du petit travail que je lui destine.
Avant tout. mes remerciements. à l'Amie et
à vous. mon cher Bois — pour avoir si vite
répondu à mon désir — Je ne manquerai
pas d'écrire à M. de la Rochefoucauld — après
la date que vous me fixerez pour leur retour.
J'ai mille choses aimables à vous dire de la
part de M. Seguin ; quant à mon jeune
ami. ne m'en parlez plus — il me fait infiniment
de peine et j'aime bien tôt de m'arrêter
à lui. Je ne sais tous les tours qu'ils ont
faits — lui et son ami — à Pont-Aven — Il paraît
qu'on les retient pour cause que vous
J'ai écrit au petit d'une manière très dure,
au petit. L'invitant à me laisser la paix une

(la Maquette de l'éventail est à l'envoie à vous)

dernière fois. et à me rendre le plus prestement possible
études que je lui ai confiées —
Si je vous conte la petite histoire c'est pour vous prévenir du
petit bonhomme — car il serait fâcheux qu'il aille vous
importuner. à votre retour à Paris —
Mon bien cher ami Bois. j'espère de vos bonnes nouvelles dans
peu de temps. Je vous serre cordialement la main dans cette
attente. et je demeure très. dévoué à votre franchise et
bonne amitié —

Ch. Filiger

Kersulé
par Moëlan
Finistère —

Dimanche matin

Yves-Marie Le Dravizédec (dates unknown)

*Detail of another letter from Le Dravizédec to Lamouche.
Paris, Musée de la Poste.*

To M. Lamouche

Plumangat (Côtes-du-Nord)
[February 3, 1890]

Dear Illustrious Sir,

The present letter is from one unknown to another. Its author, Yves-Marie Le Dravizédec, on regimental duty near Saint-Servant, is doing his military service, an obligation that lasted quite some time in the last years of nineteenth century, nourished as they were by ideas of revenge and victory over the German Empire. His correspondent, Monsieur Lamouche, remained in Paris, putting together packages of clothing and money, offering advice, providing news from the capital (one fellow is no longer a barber, the comrade who worked in a glove factory has quit his job, another fellow has taken off with so and so, the little empty apartment is being used for trysts, perhaps the unlucky soldier will be turning up soon), and participating in small socialist groups. The two men had clearly established a regular correspondence, and at least two of the letters are illustrated.

Our soldier, who perhaps intends to pursue a career as a painter, leads a quiet life in his garrison, counts the days between leaves, is invited to a wedding in the nearby town, evokes Saturday night binges (he made advances to "a fine old lady at least fifty years old") as well as extended flirtations with girls of easy virtue in Saint-Malo, whom he suspects might infect him with a contagious disease. He decorates his letters with appealing portraits and genre scenes whose details are redolent of contemporary Parisian life. He makes plans for the future and anticipates the pleasures awaiting him after his "liberation." All this in a playfully affected style, vulgar and a bit pretentious, peppered with coded allusions and politico-philosophical remarks, brought to a mock-solemn close with *"affectuosités quintessencielles."*

The sky of Saint-Malo is a pastel blue-gray; in front of me, the Rance seems like a tablecloth of liquid diamond, without the flashing rays of May sunlight that are surely quite surprised to have nothing to illuminate but trees without leaves and plants without flowers. Although it could be clearer, we've had magnificent weather the last few days, and doubtless it's this beautiful weather that prompted me to ponder the violet tableau above.

It is almost spring and I greet its early arrival with the enthusiasm of a man who will soon have seen his last winter in Brittany. Take note, ye who persist in regarding the army as the sanctuary of all that is good and agreeable. The day before yesterday, I broached with a feverish hand [sic] the seventh-to-last stint of my last year. As of now, 228 days to go. But enough lyricism. You're becoming the filthiest pimp I know. Not satisfied with letting your bed serve as a refuge for the legitimate passion of [our] buddy Léon [?], *you tolerate* as well the presence in your hacienda of young women whose vaginal concavities are scarcely brushed with down. Oh Ernest! Soon the Eros decorating your door will swap his crown of flowers and blond hair for the ignoble Desfons and the curls of Polyte. . . .

*These accurate depictions of the uniforms worn
at Saint-Servant illustrate another letter from
Le Dravizédec to Lamouche. Paris, Musée de la Poste.*

120

3 février 96

Cher Illustre Maître.

Le ciel de St Malo est d'un gris bleu de pastel; devant moi la Rance semble une nappe de hyguide diamant, sous les rayons fulgurants d'un soleil de Mai qui doit être très étonné de n'avoir à éclairer que des arbres sans feuilles & des plantes sans fleurs — Pour être tant soit peu clair, il fait un temps magnifique depuis quelques jours & c'est sans doute ce beau temps qui m'a incité a pondre le tableau Violet ci-dessus.

C'est presque le renouveau. et je salue son apparition hative avec l'enthousiasme d'un homme qui aura bientôt vu son dernier hiver en Bretagne lache le o homme qui persiste a croire que l'armée est le sanctuaire de tous les bonheurs & de tous les plaisirs. Avant hier j'ai entamé d'une main fébrile le Septième avant dernier cran de ma dernière année — Encore

P<small>AUL</small> K<small>LENCK</small> (1844–?)

Not much is known about Paul Klenck. A Swiss caricaturist born in Basel, he lived for many years in Paris, where he contributed to *Cricri* and *La Caricature pour tous*. One of the few surviving documents concerning him is this letter, in which he evokes with humor and vivacity his years at the École des Beaux–Arts in Paris. He studied under the painter Alexandre Cabanel, alongside the sculptor and gem engraver Henri-Michel-Antoine Chapu, to whom he addressed this letter. Chapu entered the École in 1849; a student of the sculptors James Pradier and Jean-François Duret, he won second place in the Prix de Rome competition of 1851. Klenck was twelve years his junior; he was surely a less brilliant student, and his work is now little known. Henri Gill, also mentioned by Klenck, was a sculptor and a student of Émile-César-Victor Perrin and Charles Jalabert who first exhibited at the Salon in 1868.

The present letter cast retrospective light on the *affaire Manet*, clearly still vivid in Klenck's mind after a quarter of a century. In 1865 artists, like many of their fellow Parisians, were likely to become agitated at the very mention of Manet's name. Why? Because his *Olympia* had just been exhibited at the Salon. Painted two years earlier (the same year as the *Déjeuner sur l'herbe*), this canvas prompted scandal; its eroticism, underscored by the presence of a black cat with a stiffened tail, was deemed intolerable. "What is this odalisque with a yellow belly, an ignoble model picked up I know not where, representing Olympia?" thundered Jules Claretie. An assessment echoed by Théophile Gautier: "Monsieur Manet has the honor of being dangerous." And by another critic: "Art as low as this is not even worth criticizing." But the canvas brought the painter to the attention of the public at large. "You're more famous than Garibaldi," Degas told him.

Twenty-five years later, the same year that Claude Monet, on behalf of eighty-four contributors to a public subscription campaign he had organized for the purpose, officially asked President Fallières to accept the *Olympia* as a donation to the Louvre, Paul Klenck revisited his youthful judgments, which retained much of their initial heat.

To Henri Chapu

March 23, 1890

My dear Henri, Michel, Antoine, and Chapu!

Do you remember the mischief we got into at the École in 1865, on the subject of Manet? I always ended up with black eyes and a bruised nose. But when I got up, I blurted out: "Manet is a fairground painter, unworthy of washing Sonthonax's brushes; first of all, he's a Couture student; and he looks like an Englishman; now if you're right, we might as well burn down the Louvre." Which provoked a new fight with another student in the atelier, for I was aggressive. Bah! I washed myself off at the basin and the next day it started all over again. Then Cabanel came in: "What's going on here?"—"Boss, it's Gill, who thinks Manet is talented." Our excellent master Gérôme happened by, every bit as caustic as we were; in all seriousness, he said to us: "Look here, Messieurs, why are you talking about Manet, you know very well it's forbidden."

When all these battles came to an end, Delrieu proposed a competition: everyone was to make a pastiche of Manet, *une figure*. As I thought myself the one most opposed to the controversial painter, I put all my artistic rage into it; I won the grand medal (a pastille of chocolate), a prize that the improvised jury decreed should go to me. This time, no favoritism was involved; my imitation was altogether worthy of the award bestowed. . . .

(continued in the appendix, page 218)

Four pages of Klenck's illustrated letter.

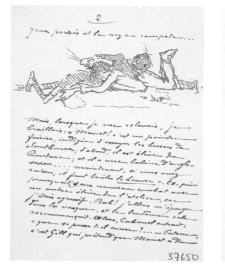

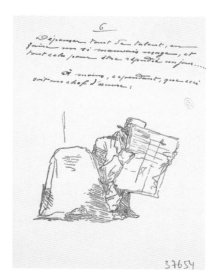

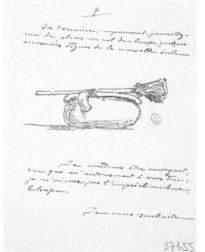

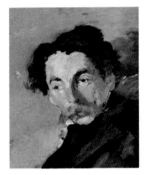

Stéphane Mallarmé (1842–1898)

Édouard Manet, Portrait of Stéphane Mallarmé
(detail), 1876. Paris, Musée d'Orsay.

Some months after a fifteen-year marriage with a grocer (who was a poor businessman) had ended in divorce, Suzanne Louviot, alias Méry Laurent, headed for Paris. She dreamed of being an actress but ended up instead as a *demi-mondaine*, thanks to the material advantages offered her by a dentist, Dr. Evans, who was sufficiently spendthrift to provide her with an apartment at 52, rue de Rome, and sufficiently philosophical to close his eyes to her dalliances. Méry dined out, received callers in her salon, and met Manet, for whom she modeled. It was in his atelier that she met Mallarmé, who soon began to write verses to her. The poet visited his "little peacock" on a regular basis for fifteen years (save for the summer he spent with his family in Valvins) and wrote her note after note, but scholars have never been able to determine whether their relationship remained platonic. While the present letter does not provide definitive proof either way, the familiarity, even intimacy, of the correspondence illustrates the closeness of their ties and, above all, the degree of fantasy Mallarmé lavished on this tender, joyous relationship.

In the form of little stories or captioned images, the author of *La Dernière Mode* becomes a recorder of ordinary events in the life of his friend, a teller of amusing tales. In the missive opposite, entitled "He [the peacock] is changing houses," Mallarmé anticipates the destruction of her country abode Les Talus, on boulevard Lannes, where he, a playful correspondent, sometimes sent her rhymes even on the envelopes: "Paris, chez Madame Méry / Laurent, who lives far from the profane / In her little house *very* / *Select* at 9, boulevard Lannes." (The many letters addressed in this oblique way reached their intended recipient, "evidence of the mailman's poetic acumen," according to Mallarmé.) On May 4, he respected postal conventions but decorated the address side of the postcard with a sketch of the house to be demolished the following November 9. Mallarmé consoled Méry with this quatrain: "To oblivion, tender challenge of wings / The instants they have vouchsafed us / Late, uneasy, faithful, / Flutter around Les Talus."

To Méry Laurent

To Madame Méry
Laurent
52 rue de Rome
[Paris, October 31,
1890]

[below drawing]
He is changing houses.
[below line]

All I have to hand is this postcard; and faithful to an old habit, before getting into a conveyance, I let fly beside the rue de Rome, a flock of [six *v*'s resembling birds] to serve as a signature to this beautiful drawing.
S. Mal.

Les dames, les fleurs, les courges
Se partagent les émois
De Monsieur Elémir Bourges
En Seine-et-Marne, à Samois.

Another envelope to Méry Laurent with an address in the form of a quatrain. "Ladies, flowers, gourds, / Share the sentiments / Of Monsieur Elémir Bourges / In Seine-et-Mearne, in Samois."

Il change de maison

Tu n'as que ce cartous, Pars
la main ; et, fidèle à une
vieille habitude, avant de mouler
en voiture, je lâche, du côté
de la rue de Rome, un vol
de ~~~~~ qui sert de
signature à ce beau dessin.

S. M.

125

Opposite:
The day of the 12th
The peacock leaves Les Talus at 8 o'clock
The peacock gets onto a train at 9:10
The peacock, still followed by Elisa, in the station at
Melun, leaves her baggage at the cloakroom, 9:57
M. Mallarmé and the *wagon-toilette* are ready at 8:57,
in the station at Melun.

*Proceed, messenger, whether by / Train, coach, or ferry it matters not, /
To rue, and 2, Gounod, at the door / Of our Georges Rodenbach.*

*Other envelopes with quatrain addresses, which Mallarmé copied into
an autograph album bearing the title* Loisirs de la Poste.

*May the lady with a gently victorious air, / Who dreams at nine Boulevard Lannes, /
Open my missive, like a heart, / With her diaphanous fingernails.*

"The day of the 12th" consists of a sequence of captioned images recounting a trip that Méry Laurent and Mallarmé took to Royat in 1888.

Norbert Goeneutte (1854–1894)

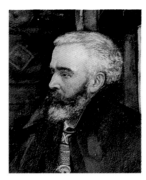

Norbert Goeneutte, Self-Portrait in the Atelier
(detail), 1893. Private collection.

To Murer

Dordrecht, Saturday
[September 17, 1891]

Although less seductive than the Orient or the regions bordering the Mediterranean, the countries of northern Europe attracted many nineteenth-century painters seized with a passion for travel. The present letter is a by-product of such a trip; written in Holland, it describes tourist episodes and evokes the beauty of the local landscape. Its author, Norbert Goeneutte, now better known abroad than in France, lived within the Impressionist orbit but followed his own way. A close friend of Manet and Renoir (he appears in the foreground of the latter's *Ball at the Moulin de la Galette*), he produced scenes of Parisian life, portraits of family and friends, and many landscapes picturing sites in Normandy and the environs of Paris. He also executed landscapes of the Netherlands and Venice intended for engraving.

Of fragile health, he retired to Auvers-sur-Oise in 1881 on the advice of Dr. Gachet. There he joined the recipient of this letter, one of the most picturesque figures of the Impressionist tendency, Murer (his real name was Eugène Meunier). Self-educated, a pastry chef by profession, he was smitten by the art of the Impressionists as early as 1872, when it was still widely disparaged. The first Wednesday of every month, he had painters and their admirers to dinner; he bought their canvases, assembling (without the slightest interest in their economic value) a superb collection of works by Cézanne, Renoir, Monet, Sisley, and Van Gogh. As his apprentice pastry chef put it, punning on a French word that can mean both "crust" and "bad painting": "I make the pastry, he buys the *croûtes*."

Meunier also retired to Auvers-sur-Oise in 1881, where he himself began to paint. The catalogue of his first exhibition was illustrated with a portrait of him by Goeneutte, who died shortly afterward in Auvers-sur-Oise at the age of forty. He is buried there beside Van Gogh.

My dear Murer, here I am on my return trip; we leave tomorrow for Antwerp, from there to Brussels and via Paris, I hope to be in Antwerp next Saturday.

Charles is in Amsterdam, he went to see the old folks (or the ancestors); I preferred to remain here, having many things to finish. I've scarcely painted, it's all but impossible, in the city. The kids are all over us, within five minutes there are fifty or so; the only viable remedy is one I've seen used by an Englishman, who had a policeman with him who kept the crowd at a respectful distance. Moreover no painters, aside from the Englishman in question, *3 ecstatic ladies* doing the same motif; the atelier Julian is enough to make one disgusted with painting. I nonetheless report five painted studies and a dozen watercolors, many documents, sketches, notes; I need only turn them to account.

The country is magnificent, the boats above all, with strange forms, and painted in loud colors to suit the boatman's whim; you see them with green, pink moustaches, the most surprising tones, crude, but everything is harmonized by the sun, add some beautiful red roofs, from time to time old violet tiles, it's truly very beautiful; the skies are extraordinary, they even possess a perspective that few painters have understood. . . .

Norbert Goeneutte, Morning Soup. *Paris,*
Musée d'Orsay, on loan to the French Senate.

Auguste Renoir, Ball at the Moulin de la Galette
(detail), 1876. Paris, Musée d'Orsay.
Goeneutte is the figure at right smoking a pipe.

Dordrecht. Samedi 17 (ce croix) Septembre 1893

Mon cher Maman, ne ... sur mon retour, nous partons demain matin pour Anvers, ... la Bruxelles et via Paris, j'espère bien être à Anvers, ... Samedi prochain.

Charles est à Amsterdam, il est allé voir les anglais, j'ai préféré rester ici, ayant beaucoup de choses à finir. Je n'ai guère peint, c'est à peu près impossible, dans la ville, les gosses vous tombent dessus en 5 minutes on a une cinquantaine, le seul moyen pratique que j'ai vu, (pratiqué par un anglais) c'est d'avoir avec lui un policeman qui fait respectueusement ranger la foule à distance, du reste pas d'peintres, hormis l'anglais en question, 3 esthetics ladies, faisant le même motif, l'atelier Julian, c'est assez vous dire le goût, de la peinture le rapport néanmoins cinq études peintes et une dizaine d'aquarelles, beaucoup de documents, croquis, notes, il ne reste plus qu'à en tirer parti.

Le pays est magnifique, les bateaux surtout, avec d'étranges formes, ... peinturlurés de toutes couleurs, à la fantaisie du batelier, on en voit avec des mâts verts, rose, les tons les plus inattendus, crus, mais tout

AUGUSTE VIMAR (1851–1916)

The painter Georges Clairin, who illustrated the incredible *Histoire de l'invalide à la tête de bois* (The story of an invalid with a wooden head) by Eugène Mouton, put the latter in contact with Auguste Vimar. A painter and sculptor from Marseilles who specialized in depicting animals, he produced illustrations for the *Fables* by Florian and *Le Roman de Renart* (a collection of medieval fables in verse). He envisioned an illustrated album of texts by Eugène Mouton (pseudonym Mérinos), who had previously published a *Zoologie morale* (the title here abbreviated as *Z.M.*). The final title of the book, published by Mame in 1894, was *Les Vertus et les grâces des bêtes* (The virtues and graces of animals). Vimar sent some of the proposed illustrations to the author so that he could show them to the publisher. He reassures him about the tone of the drawings, saying they will have none of the eroticism found in the work of Félicien Rops, despite the elephant's appearing without clothes.

In the drawing in the letter, Vimar pictures himself as a monkey-draftsman; the cynical Punchinello he is sketching has the side-whiskers and bloated face of Mouton—a "sheep" with the head of a dog! The scene is observed by another monkey, this one a photographer. Throughout, the pen is alert, precise, and deft, full of wit, expression, and life.

In another letter to Eugène Mouton, Auguste Vimar represents an elephant whose precarious posture was carefully calculated.

Thursday, February 22, 1894

My dear collaborator and excellent friend,

You can well imagine the joy I felt on receiving your letter.

I am enchanted that, thanks to your solicitude on my behalf, the MM. Mame found my modest drawings to their liking. I am, from today, entirely at your disposal to express as best I can, with my finest pencil, what you have painted so well with your charming pen.

I thank you for all your good advice, I took it seriously into account. Allow me to retain for a few days your joyous drawings, *have no fear*, I will take the greatest care with them. And now, please continue to be my powerful interpreter to the good MM. Mame. *What you produce will be, as always, well done, I approve and thank you in advance for everything.*

I await your decision with regard to the genre of the drawings and the format you prefer. It is a matter of complete indifference to me, I can do whatever kind of drawings you like, the essential thing for me is that I have access to your views and ideas; nonetheless I point out to you that line drawings like those of the fête d'Eu are the ones that are now most sought after. Tell me as well, in your next letter, how you imagine the illustrations for the *Z.M.* The poor samples that you've just seen, did you like them?

The MM. Mame need not worry about the morality of my future illustrations, rest assured, there will be nothing of "F. Rops" in them, and for many reasons, the main one being that the text does not lend itself to this. As for the elephant that you had before your eyes, I did it above all for the difficulty of the pose, it is in effect a bit . . . (how to put this) a bit *décolleté*—and yet! An elephant who makes like an ibis? Confounded . . . again!

I do not know, in closing this scribble, how to express all the gratitude I feel toward you for all your kindnesses. May Clairin again be blessed for having arranged a meeting with you along my poor path.

My two hands in yours, and very affectionately, your totally devoted collaborator and friend,

A. Vimar

Jeudi 22 février 1894.

Mon cher Collaborateur
et excellent Ami,

Vous ne doutez
pas de la joie que
me caus...
votre
lettre.

Je suis enchanté,
que grâce à votre sollicitude pour moi,
que M. Mame aient goûté mes modestes
dessins — Je suis dès aujourd'hui
entièrement à vos ordres pour

le texte ne s'y prêterait pas. Quant
à l'Éléphant que vous avez eu sous les
yeux, je l'ai fait ainsi, surtout pour la
difficulté de la pose, il est en effet un peu
.... (comment dirai-je) un peu décolleté —
et cependant! un éléphant qui fait
comme l'ibis?. Sacré ... encore!

Je ne sais, en terminant
ce griffonnage, comment m'exprimer
pour vous dire toute la reconnaissance
que je vous dois pour toutes vos
bontés — Que Claire soit encore
une fois bénie de m'avoir fait
vous remonter sur ma pauvre route

Mes deux mains dans les vôtres
et bien affectueusement votre
tout dévoué collaborateur et ami
A. Firmin [?]

Jean-Louis Forain (1852–1931)

Jean-Louis Forain, Self-Portrait.
Paris, Musée d'Orsay.

"No man, save Molière, managed to attain like Forain that sublime comedy that carries a degree of bitterness," declared Guillaume Apollinaire in 1914. This was quite a compliment for this artist, whose beginnings in Paris were difficult. He studied with Jean-Baptiste Carpeaux and then Jean-Léon Gérôme at the École des Beaux-Arts, living for quite some time off drawings that he sold wherever he could, sometimes peddling them to illustrated periodicals such as *Le Monde parisien*, the *Journal amusant*, and *L'Écho de Paris*.

Around 1875 he established ties with Manet, Degas, and Huysmans, illustrating the latter's first novel, *Marthe, histoire d'une fille*, the story of a prostitute about whom the author observes: "She had not yet been able to forget, in the dreary degradation of feasting, this terrible life that throws you, from eight in the evening until three in the morning, onto a divan; that obliges you to smile, whether you are sad or happy, sick or not; that obliges you to stretch yourself out beside a frightful drunk, to submit to him, to please him; a life more frightful than all the Gehennas imagined by poets, than all the galleys, than all the convict ships, for there exists no state, however degrading, however miserable, whose abject labors, whose grim fatigues equal those of the trade practiced by these wretches!" Did Forain remember these lines when he recounts in his letter sleeping in a bordello, whose scantily clad prostitutes he here depicts? True, the subject was common enough during a period that saw Toulouse-Lautrec spend so much of his time in *maisons closes* (licensed houses of prostitution), an experience that netted him notebooks full of drawings. Even so, the publishers opted for prudence. Forain's drawings for Huysmans's novel were refused, notably because of a frontispiece that showed a prostitute working the sidewalk wearing nothing but stockings and an umbrella.

Renowned for his witty, often caustic, remarks, Forain cut an original figure in the period. Huysmans remarked that he "had the unhoped-for luck to resemble no one, from the very beginning," an assessment more applicable to the illustrator than to the painter. Forain died in 1931, having been awarded the Légion d'Honneur and named to the Institut de France in 1923.

To Monsieur Marthe

[undated, no place of origin specified]

Here, my dear Marthe, is what I found on arriving in Lyon. It's enough to make you sick.

This dirty pig, no more beard! Shaved! Just a little mustache.

I was furious.

I had lunch at the home of his very charming father. Our best regards to you, and our hopes for good news soon.

We saw the exhibition. It was very sad, as *xaphalandreux* as possible.

All the hotels were jammed and *balaminesques*, I slept in a bordello.

And today I am high in the mountains, where I'm a bit bored. So it's not there that we'll meet on August 15.

Soon, my dear Marthe, I will have the pleasure of seeing you, in the meantime be cheerful.

Your old friend

Jean Forain

Jean-Louis Forain, Pink Dancer.
Paris, Musée d'Orsay.

Ce sale cochon, plus de
barbe! rasé! juste une petite
moustache.

J'étais furieux.

J'ai déjeuné chez son père
très charmant... à vous
notre meilleure pensée
et l'espoir des prochaines
réjouissances.

Nous avons vu
l'Exposition. C'était
bien triste et raphalandreux
au possible.

Tous les Hôtels étaient

Bondés et balaminesque,
j'ai couché au Bordel

Et je suis aujourd'hui
sur de hautes montagnes où je
m'ennuie quelque peu. aussi
ce n'est pas là qu'aura lieu
notre rencontre au 15 août.

À bientôt mon
cher Marthe le plaisir
de vous voir... et en
attendant soyez joyeux.

Le vieil ami
Jean Forain

HENRI-EDMOND CROSS (1856–1910)

To Paul Signac and Théo van Rysselberghe

Less well known than his friends Paul Signac and Georges Seurat, Cross spent the better part of his career as a painter—from 1891 to 1910—in the Midi, where he painted Mediterranean landscapes in the neo-Impressionist technique known as pointillism or divisionism.

So as not to be confused with Eugène Delacroix, whose last name he originally shared, he adopted the English equivalent "cross" as a pseudonym.

His early works are in an Impressionist mode, but in 1891 he adopted the pointillistic technique; that was the year he settled at Cabasson on the Varoise coast, where the climate mitigated his rheumatism, an affliction from which he had suffered since childhood and that continued to trouble him until his death in 1910.

Charmed by his adopted region, he sought to persuade other painters to join him there. Paul Signac, who remarked in a letter, "How I envy your dignified, simple, elevated existence far from Paris and its intellectual shit," himself settled in Saint-Tropez in 1897 (see pages 156–157). Théo van Rysselberghe and Maximilien Luce frequently visited Cross in the south.

All of these artists shared in a community of inspiration rooted in the enchanting landscape that surrounded them. In large compositions, such as Cross's *Evening Air* and Signac's *In the Time of Harmony*, they tried to represent an ideal world, an Epicurean "golden age" in which the figures—men, women, and children alike—engage in bucolic activities in an idyllic nature.

The motif of tall pines at the seaside appears in the present letter, which the painter illustrated "to compensate for the absence of a postcard." Here the little dots of the divisionist technique are supplanted by sinuous arabesques, whose forms have been reduced to simplified, flattened silhouettes, although the colored lyricism of pure, strong tones remains.

In 1990 an exhibition at the Musée de l'Annonciade in Saint-Tropez paid homage to this painter, who was plagued by illness his entire life and whose work, a hymn to the nature and light of the Mediterranean, celebrates the triumph of life over pain.

[early 1896]

Thanks, my good friends, for your charming little sketches. Happily, they arrived unharmed. The absence of a postcard obliges me to enclose one of my own.

Dordrecht, which I know only, by the way, through them (your sketches), seems to me an interesting center full of interest. Doubtless you'll remain there a while.

I've just stained a frame with aniline dye for that laundress in which the dominant color is (if you remember) yellow orange. The flat part of the frame is blue, within which there's a blue-green design that's lighter.

I left the "rail" band white. My canvas certainly looks better in it than it would have if everything were white, but the overall effect is commonplace and the frame too assertive.

Paul, when will you be back in Paris? It is without enthusiasm that I see rapidly approaching the day of your departure (March 30), for, as you know, the milieu in which we must live is rather aggravating. But I feel that this sojourn in Paris is absolutely necessary for me. Every year. You can't imagine how painful is this prolonged deprivation of . . . top hats, etc.

I plan to send my canvases to Luce, at his place or at the premises, according to his response.

Farewell, my dear friends, and good harvest for the future enchantment of our minds and our eyes.

My wife joins me in embracing you cordially,
Henri-Edmond Cross

Henri-Edmond Cross, Afternoon in Pardigan (Var). *Paris, Musée d'Orsay.*

Henri-Edmond Cross, Trees at the Seashore. *Paris, Musée d'Orsay.*

pénible cette longue
privation de ... chapeaux
hauts de forme, etc.

Je compte envoyer mes
toiles où Luce soit chez
lui soit au local, selon
sa réponse.

Au revoir, chers amis
et bonne récolte pour
les futurs enchantements
de nos esprits et de nos
yeux

Ma femme se joint
à moi pour vous embrasser
Cordialement

Henri Edmond Cross

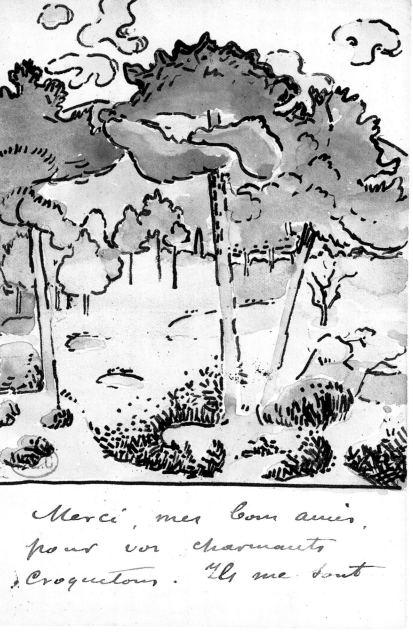

Merci, mes bons amis,
pour vos charmants
Croquetons. Ils me sont

PAUL GAUGUIN (1848–1903)

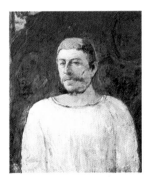

Paul Gauguin, Self-Portrait Near Golgotha.
1896. Museu de Arte, São Paulo.

In this letter, text and image are separated by the yawning chasm that distinguishes reality from dream. The same discrepancy is at the heart of Paul Gauguin's tragedy and was the cause of his miserable end.

During his two Tahitian sojourns (1891–93; 1896–1903), Gauguin corresponded with his friend Daniel de Monfreid, a fellow Synthetist painter, and his journals record the disappointments, vexations, and misfortunes that marked his residence in Oceania. The dream of a life of "escstasy, calm, and art" that prompted him to abandon Europe in favor of Polynesia was ultimately brought up short. In addition to being disappointed by his "paradise," he found himself penniless, ill, and alone. In the present letter, he complains that the recent auction of his work at Drouot (February 18, 1895), organized to raise money for his second trip, had been a "total defeat," so disastrous that the pictures had "induced vomiting."

Nonetheless, he never worked harder than during his second Tahitian sojourn, when he produced roughly a hundred paintings, four hundred woodcuts, and a considerable body of sculpture in wood. Although daily life in the tropics failed to meet his expectations, he imbued his art from this seven-year period with the "old splendor, primitive and myserious," that characterized it in his imagination. In his painting *Te arii vahine*, a sketch of which he includes in the present letter, he reimagines the theme of Paradise Lost, replete with a voluptuous nude Eve reclining in the foreground, an idyllic garden near the sea overflowing with nature's bounty, and, in the background, a Tree of Knowledge with a serpent coiled around its trunk.

To Daniel de Monfreid

April 1896

Since my arrival my health deteriorates every day. My broken foot is extremely painful; I have two wounds that the doctor hasn't managed to close and in a warm climate that is difficult. When night comes intense pain prevents me from sleeping until midnight. Admit that my life is very cruel. During my first sojourn in Tahiti I made unheard-of efforts the results of which you saw on rue Lafitte: which resulted in a *total defeat* for me. Enemies, that's all. Bad luck pursues me ceaselessly my whole existence: the more I advance, the deeper I sink. Perhaps I am without talent but (vanity aside) I don't think one makes an artistic movement without having at least a bit, or else there are quite a few crazies. In short, after the effort I've made, I can't do anything more, at least fruitfully. I have just finished a canvas of 1.30 by 1 meter that I believe to be better than anything I've done previously: A naked queen, reclining on a green rug, a female servant gathering fruit, two old men, near the big tree, discussing the tree of science; a shore in the background; this quivering light sketch will give you only a vague idea. I think I've never made anything of such grand grave sonority; the trees are in flower, the dog keeps guard, the two doves at right are cooing. What's the good of sending this canvas if there are others that don't sell and induce vomiting. This one will induce more vomiting. So I'm condemned to die from goodwill so as not to die from hunger.

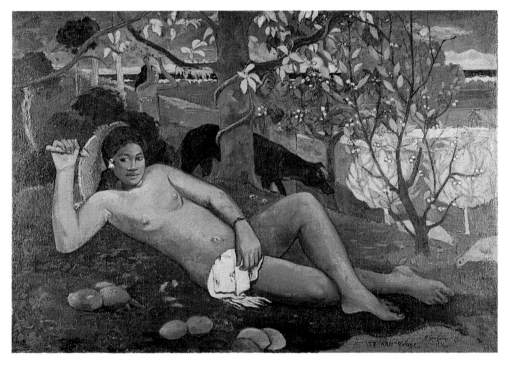

Paul Gauguin, Te arii vahine. *Pushkin State Museum of Fine Arts, Moscow.*

à faire sinon sans fruit. Je viens de faire une toile
de 1m.30 sur quatre que je crois encore meilleure que
tout auparavant ; une reine nue couchée sur un tapis
vert ; une servante cueille des fruits, deux vieillards près du

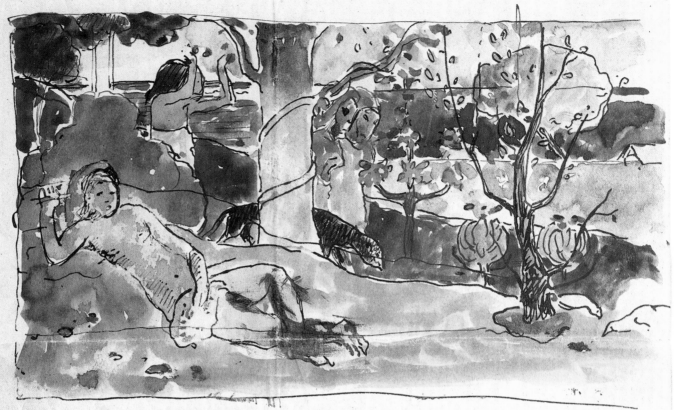

gros arbre discutent sur l'arbre de la science ; fond
de rivage ; ce léger croquis trembloté ne vous donnera
qu'une vague idée . Je crois qu'en couleur je n'ai
jamais fait une chose d'une aussi grande sonorité
grave . Les arbres sont en fleur, le chien son garde,
les deux colombes à droite roucoulent.
à quoi bon envoyer cette toile s'il y en a tant d'autres
qui ne se vendent pas et font hurler . Celle-là fera
hurler encore plus . Je suis donc condamné à mourir
de bonne volonté pour ne pas mourir de faim . Et dire
qu'il y a des hommes âgés qui agissent avec la plus
grande légèreté et que la vie d'un homme honnête
en dépend : je parle de Lévy . Sans lui je n'aurai

Édouard Manet, Olympia, 1863. Musée d'Orsay, Paris.
Gauguin, enraptured with this canvas, painted a copy of
it in 1891. It certainly influenced his Te arii vahine.

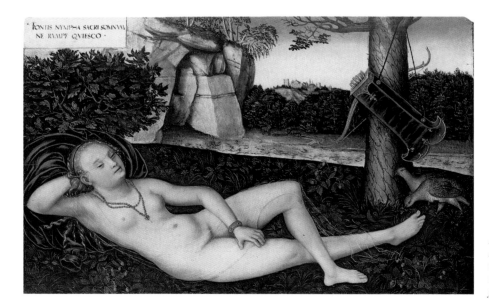

Lucas Cranach, Diana Reclining, c. 1537.
Besançon, Musée des Beaux-Arts.
Gauguin took a photographic reproduction of
this painting with him to Tahiti. This is the other
famous painting that influenced Te arii vahine.

Paul Gauguin, Be Mysterious,
*1890. Musée d'Orsay, Paris.
This wood-with-polychrome
panel decorated the
painter's house in Tahiti.*

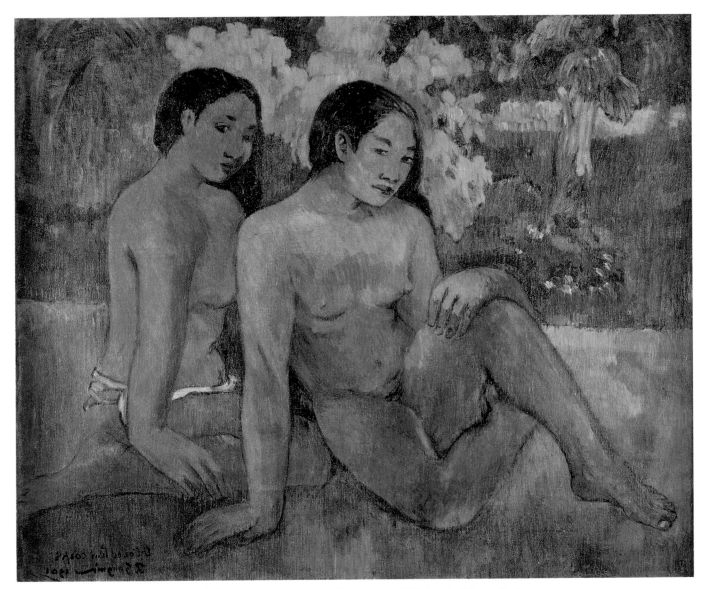

Paul Gauguin, And the Gold of Their Bodies. *1902, Musée d'Orsay, Paris.
Another painting in which Gauguin pays homage to Tahitian women.*

Henri de Toulouse-Lautrec (1864–1901)

Photograph of Henri de Toulouse-Lautrec,
detail of photomontage by Maurice Guibert,
c. 1890. Private collection.

"I was again duped by the concierge of the new premises, but in the end, I found for 1,600 francs, *you mustn't tell anyone*, a wonderful apartment. I hope to end my days there in peace. There's a kitchen, like in the country, some trees, and nine windows overlooking some gardens." It was in such terms that Henri de Toulouse-Lautrec told his mother, in the spring of 1896, about his latest discovery: the studio at 5, avenue Frochot, into which he moved early the next year.

Thereafter, between trips to Belgium, Holland, and England, the painter received visitors at home, as attested by this lithograph invitation, which shows him standing beside a cow and a magpie above a text suggesting that prospective guests come to take "a cup of milk." The irony of this proposal would have been obvious to members of his circle: Toulouse-Lautrec was a notorious alcoholic (he once famously declared: "I will drink milk when cows graze grapes") who delighted in ridiculing the milk bar that had recently opened in Paris. For the mock housewarming of his avenue Frochot "establishment," the jokester-bartender took the humorous conceit so far as to concoct cocktails dubbed (in English) the "maiden blush" and the "corpse revivers."

In the end, Toulouse-Lautrec's affair with alcohol got the better of him. From year to year, the situation worsened. Contemporary trends encouraged his abuse: alcohol consumption doubled in France during the 1890s. Toulouse-Lautrec preferred the strongest brews, cognac and absinthe, which he combined in equal portions to produce a cocktail he called "the earthquake."

At the end of February 1899, suffering from hallucinations and episodes of delirium tremens, Toulouse-Lautrec, apparently the kindest man on earth when sober, was obliged to enter a clinic in Neuilly to purge his system. He died in 1901, in his rooms on avenue Frochot. Apparently, his final words were directed to his father when the latter tried to shoo some flies away from his son's face with an elastic shoehorn. "You're as idiotic as ever," he told him.

[Paris, early May 1897]
5 avenue Frochot

Henri de Toulouse Lautrec would be very flattered [misspelled] if you would accept a cup of milk on Saturday, May 15 about 3:30 in the afternoon.

A poster-advertisement for Berthelot absinthe,
1895. Private collection.

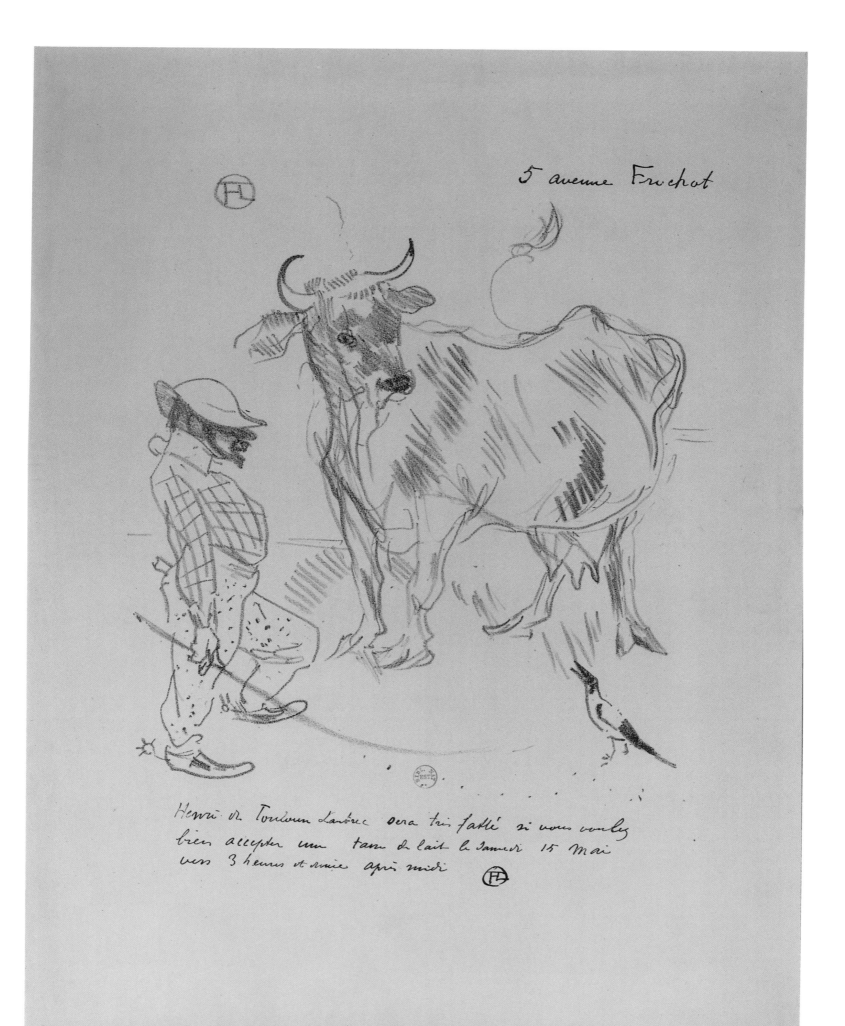

Frédéric Pioche (dates unknown)

Very little is known about Frédéric Pioche, a Paris postman who worked in the distribution center at 26, boulevard de l'Hôpital, where he was responsible for the fifth arrondissement. A member of a family residing in Sceaux, he sent one of his friends, Alphonse Perrault, who lived in Sceaux at 15, rue Florian, dozens of illustrated postcards and letters—the envelopes, too, are illustrated—between 1901 and 1910. Using ink, gouache, and colored crayon, he delighted in decorating his missives with silhouettes, landscapes, and anecdotal drawings, all happily preserved by their recipient. Now in the Musée de la Poste in Paris, these letters are both charming and touching.

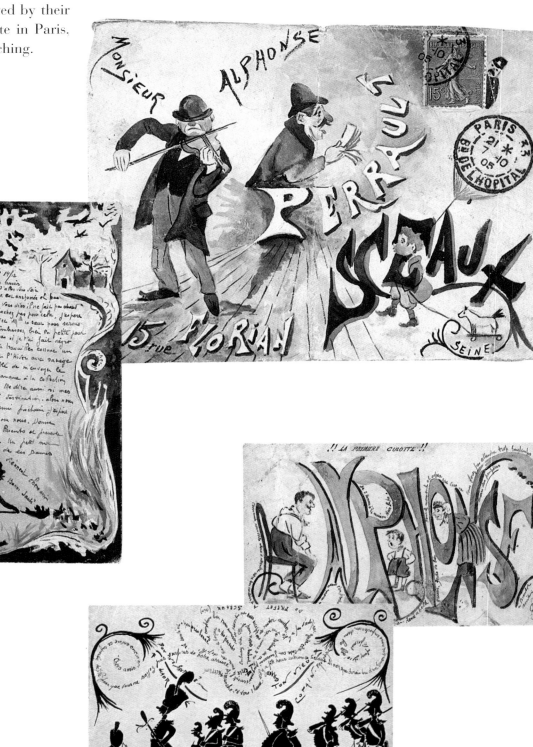

This page and opposite: A selection of Pioche's letters illustrated in pen and ink and watercolor.

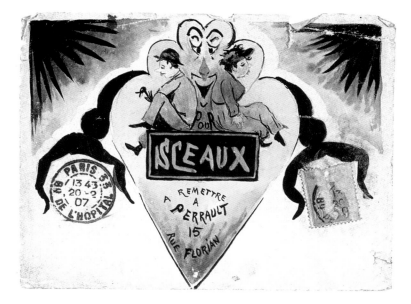

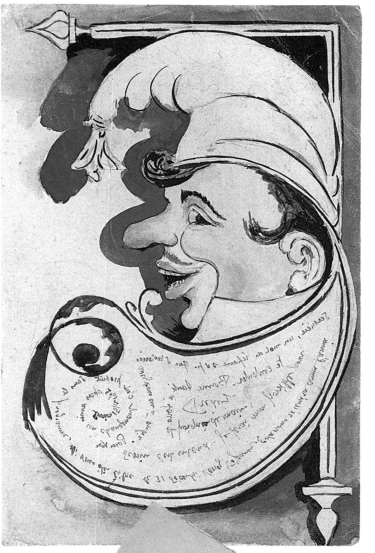

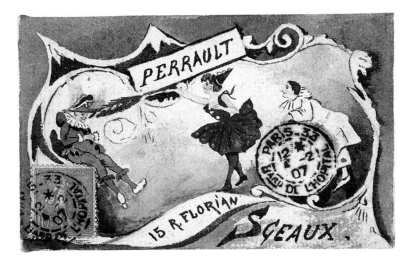

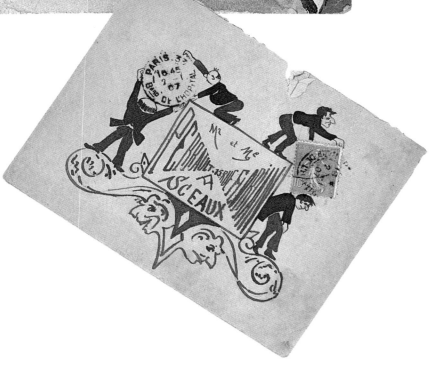

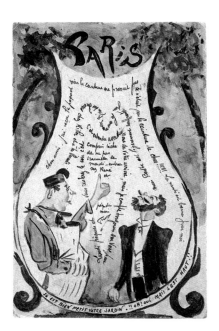

JUDITH GAUTIER (1850–1917)

"One has noted with reason the almost hostile indifference of Mme Judith Gautier not only toward her works of art, but even toward her beautiful literary works. M. Edmond de Goncourt recounts that one day he found, in the little house on the rue de Longchamp, the young Judith sculpting Ingres's *[Roger and] Angelica* in a turnip. This fragile masterpiece perished shortly thereafter. This was only an amusement, the game of a young fairy; but those who know of Mme Judith Gautier's indifference to glory are tempted to see in it a character trait." Thus did Anatole France pay homage to the obstinate modesty of the very gifted Judith, the eldest daughter of Théophile Gautier, whose artistic gifts she clearly inherited. Judith was a writer of great delicacy, a great music lover (she was one of the principal advocates in France of the music of Wagner, who fell passionately in love with her), and a deft watercolorist, as evidenced by the improvised image at the head of this letter of recommendation for the actress Renée Parny, engaged first by the Odéon and then, in 1901, by the Théâtre Sarah-Bernhardt.

From her father, Judith—nicknamed as a child "the Hurricane," an acknowledgment of her impetuous nature—likewise inherited a taste for the Orient. All of her books (*Le Livre de jade, Le Dragon impérial, Les parfums de la pagode*) bear the mark of this passion, into which she was early initiated by a Chinese teacher, Tin-Tun-Ling. In 1870, dispensing with parental approval, she married Catulle Mendès, from whom she separated some years later. Her *Souvenirs d'une Parisienne* remains an irreplaceable source of information about nineteenth-century literary and artistic society.

To an unknown correspondent

Dinard-St Enogat

Dear friend,

I place under your high protection Mlle Renée Parny, who next Tuesday will tremble before you in the guise of Iphigenia and Francillon. It is she who played Alix in *Une Larme du Diable* at the Petit Théâtre, but she has worked enormously since then. It is her last competition year and you know how serious: the Odéon of one's dreams goes up in smoke if one miscarries.

Renée had the mischance to draw No. 1. She must be tragic at 9 in the morning, which increases her distress.

I hope after all these obligations keeping you busy that you, too, will get some rest. I send you this little boat to conduct you to our shore.

Please give my warm regards to Mme Roujou.

I clasp your hand affectionately.

Judith Gautier

A thank-you note from Judith Gautier with watercolor illustration. Private collection.

Dinard. 1. Enogat.

Cher ami ———

Je mets sous votre haute
protection M^elle Renée
Parny — qui va, Mardi pro-
chain, trembler devant vous

PABLO PICASSO (1881–1973)

Pablo Picasso, Self-Portrait, *1902. Picasso Estate.*

To Guillaume Apollinaire

[July 23, 1905]
Saint Apollinaire

Happy name day
Picasso

A t the beginning of the century, three men met and immediately became fast friends: Pablo Picasso, Guillaume Apollinaire, and Max Jacob. They were an inseparable trio, a veritable trinity, according to Jean Cocteau, who once developed this idea as follows: "The father would be Picasso, the son Max, and the Holy Spirit Guillaume." The painter probably dedicated a painting to this tripartite allegiance: the *Three Musicians* of 1921, believed to represent Picasso in the center, dressed as Harlequin, flanked by a Pierrot to his right (this would be an homage to Apollinaire, who had died three years before) and a monk to his left (Max Jacob was then living in the presbytery of Saint-Benoît-sur-Loire).

The three friends quickly began to correspond with one another. Of the three, Picasso was the one who chose the most compact way of expressing his affection. Single words sufficed: "Bonjour" (June 29, 1905), "Salve" (September 24, 1907). Apollinaire seems to have been content with these communications. Max Jacob, who admitted to being touchy, sometimes regretted their extreme laconism. Most often, the cards remained virginal, augmented by a drawing and or a signature. In these years, Picasso, whose French spelling was largely phonetic, left it to his mistress Fernande Olivier to recount their travels and adventures, sometimes adding a phrase in fractured French at the bottom of the letter, for example: *Bonjour mon cher ami Guillaume ye te embrase et preciement sur ton nombril. Ye te envoi quelques petis desins* ("Hello my dear friend Guillaume I kiss you and precisely on your bellybutton. I send you some small drawings"; June 21, 1906).

A simple token, the card that Picasso and Max Jacob sent to Apollinaire on his name day—July 23 is indeed the feast of Saint Apollinaire of Ravenna—is one of these symbolic dispatches, often more telling indications of friendship than extended letters.

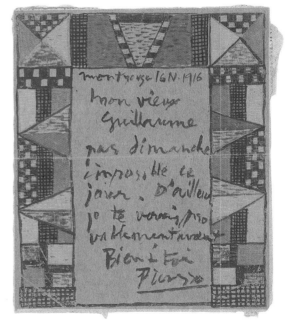

Montrouge, November 16, 1916
My old friend Guillaume / not Sunday /
impossible that / day. Furthermore / I will pro- /
bably see you [illegible] / yours / Picasso

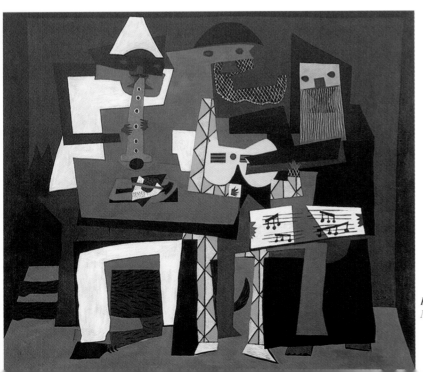

Pablo Picasso, The Three Musicians, *1921.*
New York, The Museum of Modern Art.

ANDRÉ DERAIN (1880–1954)

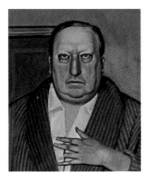

Balthus, Portrait of Derain, *1936.*
New York, The Museum of Modern Art.

André Derain and Maurice de Vlaminck first met in 1900, at the Académie Carrière. The first was twenty, the second twenty-four; both were just beginning to paint. Their friendship led them to rent an atelier together on the Île de Chatou that became a laboratory of the avant-garde.

In 1905 Derain left with Matisse for Collioure, just south of Perpignan on the Mediterranean coast, where they spent the summer. This was a decisive period during which Matisse, who was preparing his submissions to the Salon d'Automne of that year, resolved to "shake off the tyranny of pointillism." The exhibition itself was marked by scandal: in the "cage of wild beasts," to cite the critic Louis Vauxcelles, an "orgy of colors" upset both critics and the public, who did not understand these flamboyant paintings signed Matisse, Derain, Marquet, Van Dongen, and Vlaminck (the most radical member of the group, applying paint to the canvas directly from the tube). Thus was Fauvism born. The dealer Ambroise Vollard, sensing something important, bought Derain's entire production and encouraged him to go to London, where the artist produced some of his most beautiful canvases, such as *Westminster Bridge* and *Old Waterloo Bridge*.

In 1907 the situation began to change. Fauvism gradually expired in light of the birth of Cubism, invented by Braque and Picasso. Derain left Chatou and distanced himself from Vlaminck; he began to be influenced by the paintings of Cézanne, as well as by African sculpture, which prompted him to reorient his work. Was it at this moment that he wrote the present letter to his friend? It is difficult to date, for there is no known painting by Derain that includes a bull and a horse, the animals mentioned in the letter. But we do have these beautiful improvised drawings by Derain, a revolutionary who, little by little, as his career unfolded, shifted his sights to the past and a sober classicism.

To Maurice de Vlaminck

[undated]

My dear Vlaminck,

Nothing new to tell. Surely it isn't the same at your end. So send me some news. Give me some idea what's going on. I'm really fed up with myself. I'm stuck in my work. I'm on the verge of another bout of neurasthenia, I think. This damned painting is so nerve-wracking! The more I reflect, the more I find my horse and bull close to what I've always sought to achieve. Nothing about it surprises me. By reducing the inner proportions, I may just arrive at what's generally known as a painting.

In sum, in all the paintings we see, and God knows we see lots of them, even in the good ones, how many things there are that don't interest us, in addition to the one thing that does interest us, and how much better it would be if those things weren't there!

Finally, I shake your hand. Greetings to everyone.

A. Derain

André Derain, The Port, Collioure, *1905.*
Paris, Musée d'Art Moderne.

André Derain, The Turning Road, L'Estaque,
1906. Houston, The Museum of Fine Arts.

FERDINAND BAC (1859–1952)

Who better than Ferdinand Bac to produce illustrated correspondence? A draftsman of German origin who early became a naturalized French citizen (hence the name change from Bach to Bac), he wielded his weapons at the periodicals *La Caricature* and *La Vie parisienne*, then contributed to *Le Rire* and *Le Journal amusant*. Gifted at capturing the essence of the "modern woman," he was in demand as a poster designer, producing some remarkable examples for the singer Yvette Guilbert, whose profile was later immortalized by Toulouse-Lautrec. Before long he gathered his work into albums, to which he contributed the texts as well as the drawings. For Bac wielded the writer's pen as well as the draftsman's pencil, and in both cases the style is alert, lively, never boring. He published dozens of such volumes, including *La Volupté romaine, Jardins enchanté, Le Fantôme de Paris, Chez Louis II de Bavière, Souvenirs d'exil* (Roman voluptuousness, Enchanted gardens, The phantom of Paris, At home with Ludwig II of Bavaria, Memories of exile), titles evidencing the broad range of his interests and gifts.

Thus it was only natural for the artist to complement the texts of his letters with sketches in the margins or with separate drawings, pastels, and watercolors. For the comtesse de Béhague, a collector and patron who supported his work and appreciated his conversation, he exploited his proven gifts for caricature and pastiche: one immediately recognizes here the features of Voltaire, just as there is no mistaking the distinctly eighteenth-century music that wafts through the text. In the same spirit, one can easily imagine the costumed fêtes, improvised dinners, and intimate evenings that Madame de Béhague organized in her town house on the rue Saint-Dominique, at her villa Hyères, on her yacht *The Nirvana*, and in her Louis XIII château at Fleur-en-Bière, where Ferdinand Bac appeared dressed as Cardinal Richelieu. In these salons, Bac kept company with Marie-Laure de Noailles, Jacques-Émile Blanche, Paul Valéry (secretary and librarian to Madame de Béhague for three years), Gabriele D'Annunzio, Aldous Huxley, Count Primoli, Paul-César Helleu, and many others.

Paul-César Helleu, Homage to the Comtesse de Béhague. *Private collection.*

To Martine de Béhague

Photograph of the comtesse de Béhague.

Ferney,
December 25, 1773

Madame,

Report of your grace, your taste for the Beautiful and the Good, and your rare and incisive mind have not reached me in my solitude without making me tremble with pleasure and pride for my unfortunate country infested with invulnerable malefactors.

Permit an old man long since withdrawn from the ambitions and vanities of this world to place at your adorable feet a trustworthy image of his decrepitude. Be so kind as to see in it only the feeble reflections of the sentiments of very high regard and respectful emotion with which I persist in remaining eternally, of your renowned grace, the very faithful and very humble and very obedient servant.

Voltaire

The portrait was made by a mediocre dilettante who came to visit me today and who arrives from Provence, from an obscure little town called Le Launet near the Mediterranean Sea. He hasn't flattered me, but I'm satisfied with the likeness.

[signed and dated in upper right corner:]
Ferdinand Bac, 1912

Ferney le 25 Decembre
1773

Ferdinand Bac
1912

Madame

Le bruit de vostre grâce, de vostre gout pour le
Beau et le Bien et de vostre rare et incisif esprit
n'est point venu jusqu'à ma solitude sans qu'il
m'eut fait tressaillir d'aise et de fierté pour mon
malheureux pays infesté de malfaiteurs invulnerables.
Souffrez qu'un vieillard depuis longtemps
retiré des ambitions et des vanités de ce Monde
dépose à vos pieds adorables l'image certaine
de sa decrepitude. Veuillez n'y voir que les faibles
reflets des sentimens de très haute estime et
de respectueux émoi avec les quels je
persisterai de demeurer eternellement
de Vostre Grâce renommée le très fidèle
très humble et très obeïssant serviteur

Voltaire

Le portraict a été fait par un mediocre dilletante
qui est venu me visiter aujourd'hui et qui arrive
de Provence, d'une bourgade obscure nommée
Le Lannet près de la mer mediterrannéenne
Il ne m'a point flatté mais mon regard me satisfait.

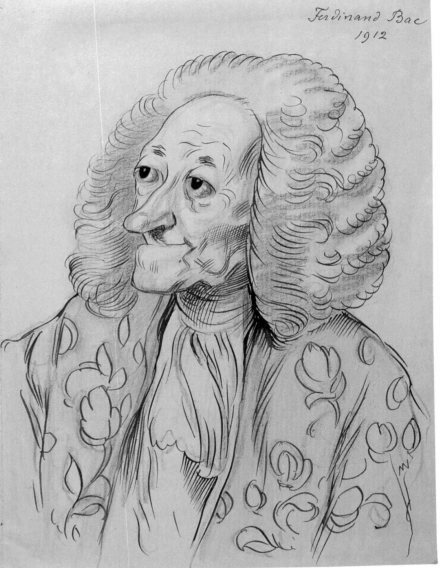

151

RAOUL DUFY (1877–1953)

Raoul Dufy, Self-Portrait as Harlequin (detail).
Private collection.

"A day of work is a day of astonishing adventure": such is Raoul Dufy's thumbnail characterization of his life as an artist in this letter to his friend the writer Fernand Fleuret. The two men had known one another for some time. In a text entitled *Comment j'ai illustré mon premier livre* (How I illustrated my first book), Dufy remarked: "In 1907 I engraved, for *Friperies* by my friend Fernand Fleuret, a few small vignettes, but at the time no publisher was willing to assume the modest costs of this pamphlet, which appeared only some fifteen years later in *La Nouvelle Revue Française*." In fact it was not until 1923 that this project, which introduced Dufy to textual illustration as well as to woodblock prints (a genre and a technique that he later exploited to marvelous effect, notably in an edition of Apollinaire's *Bestiare*), finally came to fruition. For his part, Fleuret, a sometime art critic, published in 1931 an *Éloge de Raoul Dufy* in which he recollects the painter as a "young man with fresh complexion, his nose in the air, with curly blond hair, protruding eyes the color of the sky, brisk, natty, preoccupied."

In June 1913, when Dufy wrote this letter, he was in Paris working full tilt, designing fabrics for Paul Poiret, submitting additional designs to the latter's employer, Jacques Doucet, engraving, drawing, imagining tapestry cartoons: in short, doing his best to earn a living and make a name for himself. It was, however, painting that most engrossed him. He continued preparatory studies, begun in 1909, for what was to become *La Grande Baigneuse*. As he informs Fleuret, Dufy, originally from Le Havre, decided to situate his model in a Sainte-Adresse landscape evocative of his childhood. "May those who love painting, the sea in summer, and women in bathing costume derive some pleasure from it," he remarked. His prayer was to be answered.

To Fernand Fleuret

Paris, June 8, 1913

My dear Fleuret,

This little Bulgarian horseman brings you at a gallop on his fast horse my friendly regards, to which I add my respects to Madame Réval. If my letter is late, blame this horseman, who perhaps lingered in the Balkans. As for myself, I'm a little late, too, but imagine what ten or twelve hours of work every day can do to a man like me who has all his parts: weight, height, and strength, who tumbles at the end of every evening from his work table into his bed and every morning from his bed to his work table, and I think that's not too idiotic, for a day of work is a day of astonishing adventure and exploration, so, my dear Fleuret, try my method and tumble every morning from your pillow to your penholder, which you'll abandon every evening only for your pens. As to your choice of work, don't worry about it, it's of no importance, you'll make a positive impression despite yourself in whatever you do. Recall that I've often asked you to do a big *realist* novel since your version of reality is always a fantasy so surprising and dramatic that you have only to copy your characters from nature. Forget everything you know, old friend, and think only of yourself, but work like the devil . . . if you don't want to think about your 29 pink and blond springs anymore, and of myself, who no longer knows where I am with my thirty and more springs. And don't fire at anymore pigeons with your beautiful flint rifle, which burns your right eyebrow without rustling a feather of the fowl you lust after, and then above all return to Paris, don't stay in the country, later . . . later, Fleuret . . . For the moment Paris is good work that drags you by the feet from your bed every morning. A little rain also and some dung and the bus, put your beautiful sun into your hat box and run. Thanks for everything you said to me in your letter and thanks also to Madame Réval. . . .

(continued in the appendix, page 217)

Raoul Dufy, Illustration of a young Provençal in regional costume, from another letter to Fleuret. Paris, Bibliothèque d'Art et d'Archéologie Jacques Doucet.

Raoul Dufy, La Grande Baigneuse, 1914.
The Hague, Private collection.

152

Paris 8 Juin 1913

Mon cher Fleuret

Le petit cavalier bulgare vous apporte au galop de son cheval rapide mes bonnes amitiés auxquelles je joindrai hommages pour Madame Réval. Si ma lettre est en retard n'accusez donc que ce cavalier qui a pu s'attarder dans les Balkans. Quant à moi je suis un peu en retard aussi mais

n° aut 707

GUILLAUME APOLLINAIRE (1880–1918)

Pablo Picasso, Caricature of Guillaume Apollinaire as an Academician, *1905. Paris, Musée Picasso.*

During the summer of 1914, Apollinaire wrote unceasingly: for himself, for the daily papers, for magazines. He had little time for private correspondence, which he reserved for a few friends such as Pablo Picasso, whom he met in 1905 and to whom that same year he devoted his first essay on art criticism in which he evoked, with visionary perspicacity, "the great revolution that [Picasso] has accomplished virtually alone." Thereafter the two men, who were fond of and fascinated by one another, corresponded regularly. Picasso, using cards and bits of torn paper, sent brief, affectionate notes to his friend (see pages 145–46). Apollinaire, for his part, sent Picasso longer, if more infrequent, missives telling him about his plans, current artistic and literary news, how his work was progressing, etc. In this letter of July 4, 1914, he tells his friend about an evening spent at Maurice de Vlaminck's in the company of two Russian avant-garde artists, Natalia Goncharova and Mikhail Larionov, whose works had been exhibited in June at Paul Guillaume's gallery in Paris.

But the exceptional literary interest of this letter lies elsewhere. In June 1914, Apollinaire's poem "Lettre-océan" appeared in the monthly *Les Soirées de Paris*. Introducing a new form of expression dubbed by its author the "lyric ideogram," it was an attempt to coordinate text and image, with the words arranged to create a drawing evoking the same object as the text. Later, Apollinaire preferred the word "calligramme" to designate his invention. He used it as the title of a poetry collection published by Mercure de France in 1918, originally to have been entitled, rather provocatively, *Et moi aussi je suis peintre!* (And I too am a painter!). On July 4, when Apollinaire wrote Picasso this pipe-and-brush letter, the calligramme was in its birth throes. "I think it's a great innovation," the poet rightly sensed.

To Pablo Picasso

[July 4, 1914]

My dear Pablo, I received your cards; I thank you for them, I didn't answer right away because I didn't have the time.

I also wanted to finish the article and thus time's been short.

Did you receive *Les Soirées* with the "Lettre-océan"?

Since then I've made some poems that are still more innovative, real ideograms that take their form not from prosody of any kind, but from their very subject.

Thus they're no longer free verse, but at the same time the poetic form is renewed.

I think it's a great innovation: here, I'll make you a little poem

The pipe and the brush
[text of the pipe calligramme]
I am the very form of meditation / And in the end I contain nothing but cinders / smoked too hard and that can only descend
[text of the brush calligramme]
But the hand that holds you contains the UNIVERSE it immobilizes all of life / here are born all aspects all faces and all landscapes

You'll see several of these in the next *Soirées de Paris*.

I think I'll finish the article about you next week and I want to do another one in the *Soirées* about your sculpture.

Max [Jacob] is still reading *Fantômas*, along with me and the rest of the world, but furious that Blaise Cendrars has already written a poem about *Fantômas*, he's preparing another intended to compete with the first.

In the way of news, there's nothing except that Goncharova and Larionov are brave people and that I took them to an evening at Vlaminck's.

In the way of pretty stories, there's the one about the Andalusian schoolteacher who never learned division. One day the school inspector showed up and the Andalusian teacher had to show how one did division.

"My dear students," he said, "let's divide 40 by 8. How many times does eight go into 40. Four times, I put 4 and 8 remains. How many 8's are there in 8? One, so I put 1. So 8 goes into 40 41 times. That's a lot. Let's prove it. We multiply 41 by 8, 4 times 8 = 32 I put 32. 8 times 1 = 8. I put 8. 32 plus 8 = 40.

The division is correct

```
40   8      41
 8   41   x  8
            32
             8
            40
```

The friendly hand of
Guillaume Apollinaire

Guillaume Apollinaire, Les oiseaux chantent avec les doigts *(Birds sing with their fingers). Paris, Musée Picasso.*

Je crois que c'est une grande
nouveauté : Ici je te fais un
petit poème

La pipe et le pinceau

Je suis la forme même
de la méditation
Et
na fi
meut le
ne je
tiens con

... plus que des cendres fumée
dre con des que plus peut ne qui et trop
de tour

Mais la main qui te prend contient L'U ici naissent
c'est immobiliser toute la vie N4 tous les aspects
VERS tous les visages
et tous les
paysages

PAUL SIGNAC (1863–1935)

Photograph of Paul Signac.

Urged by his friend Henri-Edmond Cross to flee Paris for the Midi (see pages 134–35), Paul Signac settled in Saint-Tropez in 1892. "There I have enough to keep me busy for the rest of my life. I've just discovered happiness," he declared. Over a period of two decades, he spent half of each year there, buying a house known as La Hune. Drawn to the sea, a passionate sailor (he acquired thirty-two boats in succession), he always liked to paint ports, notably La Rochelle, Antibes, and Marseilles. An exhibition mounted in 1992 at the Musée de l'Annonciade in Saint-Tropez revealed the degree to which he had been inspired by that town's port. He represented it from many points of view, in oil as well as watercolor. The present drawing, which represents the quay-front facades, the bell tower of the church, and two *tartanes* (from the Provençal *tartana*, a small Mediterranean vessel outfitted with a large mast and pivoting yardarm, a bowsprit, and occasionally a jigger, used for fishing and trade), does not correspond to any known canvas. When Signac wrote this letter, he no longer lived in Saint-Tropez, having abandoned it for Antibes, but he returned regularly to visit his first wife, Berthe Signac.

It was during his Saint-Tropez period, and at the suggestion of Camille Pissarro, that he had begun to work with watercolor. In a letter of 1888, Pissarro had written: "I recommend watercolor to you, it's very precious, very practical, one is able to take notes in a few minutes that would be impossible otherwise: the fluidity of a changing sky, certain transparencies, lots of information that slow work cannot provide." Signac was especially devoted to the medium during the tragic years of World War I, when he was so discouraged that he stopped painting in oils.

Marcel Sembat, a Socialist deputy, and his wife, Georgette Agutte, a painter and sculptor, were long faithful friends of the painter. The present letter is one of five illustrated ones from Signac to the Sembat couple that are now in the museum in Grenoble, to which they were donated in 1995 by the Sembats' nephew and heir, Pierre Collart.

To Georgette Agutte

[Saint-]Tropez, October 18, 1915

Dear Madame,

We were very happy to receive your good news; we think about the two of you so often in these trying days, in this violent tempest, when our friend is there, on the bridge, on duty, always keeping watch!

And do you see calm approaching! It seems to me that in the East, things are very dark . . . Will I still have to wait a long time before going to paint the *Entry of the Allies into Constantinople?*

It was painful for me to see the departure of my admiral, Bric de Lapeyrère. But truth to tell, I was less interested in the return of the "sacred carpet" on October 10 in Jidda. In the end, one has to have some distraction! And you must have smiled, no, Sembat?

But you know, dear madame, your reproaches for [my] silence are very unjust . . . For I'm the one who wrote last (didn't I discuss the painter Roustan in my last letter?); Did you not receive it, or did I not receive your response? But I protest against the accusation of neglect, clearly and firmly!

So it's tomorrow, your raffle drawing. I must congratulate you, madame, on the success of your enterprise and, thanks to you, a bit of gold will aid our poor painter chaps. If I weren't in such terrible straits myself, I'd have bought some tickets . . . for it also strikes me as a good deal: if only a collector could be found to buy all the tickets: for 20,000 [francs], he'd have a fine collection in one swoop!

My health is not robust enough for me to risk going to Paris. Events have not improved it: I've had serious bouts of suffocation lately, so bad that I couldn't walk. But how happy we would be to see you in the Midi this winter. Don't fail to let me know: if you can't come as far as Tropez, I would so gladly meet you halfway.

I'm doing a little work; I'm waiting for some beautiful colors from Block, whose factory—near Liège—was not destroyed—I'm sketching the ports . . . and like you, I dream of more important work . . . of peace. When? . . .

(continued in the appendix, page 219)

Paul Signac, Saint-Tropez, Houses at the Water's Edge. Paris, Musée du Louvre.

Tropez 18 Octobre 1915

Chere Madame.

Nous avons été très heureux de recevoir vos bonnes
nouvelles = nous pensons si souvent, à vous
deux, en ces dures journées d'épreuves, en cette
nuit de tempête, où notre ami, est là, sur le pont,
son devoir, tout le temps de quart !

CAMILLE SAINT-SAËNS (1835–1921)

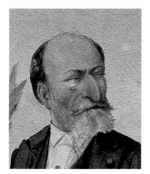

*Caricature of Saint-Saëns. Dieppe,
Médiathèque Jean Renoir.*

On November 13, 1915, Saint-Saëns wrote his old friend Charles Lecocq, author of *La Fille de Madame Ango*: "Imagine, this morning I was to leave for Calais, whence to La Panne, a small Belgian village where I was to figure in a concert before the king and queen of the Belgians; but then there was a counterorder and postponement for a week." Queen Elisabeth of Belgium, a fine violinist, had won the composer's affection by inviting him to the palace of Laeken, then, knowing his generosity, by soliciting his participation during the war in concerts organized to benefit Franco-Belgian armies.

The identity of the letter's recipient, who was aware of the scheduled trip, remains a mystery. Saint-Saëns rarely used the familiar "*tu*" form, which he reserved for a few intimate friends, all musicians: notably his publisher Jacques Durand, whom he had known since birth; his student Gabriel Fauré, then director of the conservatoire; and the pianist Louis Diémer, with whom he delighted in playing the four-hand piano. Or the recipient might have been Philippe Bellenot, the organist at Saint-Sulpice, to whom in 1889 Saint-Saëns had dedicated a scherzo for four hands, drawing the title page himself, and to whom he regularly sent decorated letters. Or, perhaps, it was the violinist Gabriel Willaume, with whom Saint-Saëns toured and with whom he made some recordings between 1915 and 1921.

Saint-Saëns took pleasure in decorating his letters: framed dates, illuminated letters, Greek and Latin words drawn in large script, ornamentally inscribed musical quotations, little colored drawings, and caricatures figure often in his correspondence, which was copious, for he was an inveterate traveler. He enjoyed rhyming (usually without pretension, although a collection of his poems, entitled *Rimes familières*, was published by Calmann-Lévy in 1890), and he also wrote a few short plays, not to mention the poems and librettos for his compositions. Saint-Saën's literary style often reflects his sly, satirical sensibility (he was, after all, creator of *The Carnival of the Animals*); here, the phrases "goblets of transparent crystal" and "the ebony and ivory of the sonorous instrument" are doubtless playful evocations of the high-flown diction of Symbolist and Decadent poets, for example, Stéphane Mallarmé (see pages 124–27), whom he disliked, and the comtesse de Noailles, whom he mocked even as he set her verse to music.

In any case, the virtuoso Saint-Saëns gave himself a fine lesson in humility: at age eighty, newly returned from an extended tour in the United States, he set about putting "into his fingers" a difficult piece by Liszt that he loved but had not played for thirty years.

*Pages two and three of the letter
reproduced on the opposite page.*

To an unknown correspondent

November 11, 1915

My dear friend,

Everything's changed!
The trip to Belgium has been postponed for a week!
So I'm free Sunday and I'll come fetch you for lunch.

You think, vile hypocrite,
You've gotten rid of me.
I'll remain in your orbit
Of that I here give you my word.

That will teach you to insult me, to feign being furious at my absence.
What relish I'd take in vengeance, armed with a fork with sharp prongs! How I'd relish it in a liquid state, in goblets of transparent crystal! How I'd relish it even by tormenting the ebony and ivory of the sonorous instrument with my indiscreet hands!
I'd even inflict on you *Les jeux d'eau de la Villa d'Este*, an abracadabrous piece by Liszt that I've just put back into my fingers; a piece with five sharps in the key signature and raining triplets. And what will become of you under this hail of sharps and triplets? . . .
So much the worse for you!
So until then, and my brotherly kiss.
C. Saint-Saëns

11 NOVEMBRE 1915

Mon cher ami

Tout est changé !

Le voyage en Belgique est remis à huitaine !

Je suis donc libre Dimanche et j'irai te demander à Déjeuner.

Tu croyais, ô vil hypocrite
Être débarrassé de moi ;
Je resterai dans ton orbite
Et je t'en donne ici ma foi.....

PASCAL-ADOLPHE DAGNAN-BOUVERET (1852–1929)

Charles-René de Paul de Saint-Marceaux,
Bust of Pascal Dagnan-Bouveret. *Paris, Musée d'Orsay.*

A few artists, at odds with the trends of early twentieth-century avant-garde painting, continued to work in a traditional figurative mode during this period, and Pascal-Adolphe Dagnan-Bouveret was of their number. A student of Jean-Leon Gérôme and Alexandre Cabanel, he was by inclination a naturalist painter, drawing much of his inspiration from the religious culture of Brittany, where he settled in 1885.

He liked to represent local peasants of both sexes, especially the women with their distinctive headdresses, both in individualized portraits, as here, and in groups figuring in processions and other religious ceremonies.

He shared with the letter's recipient, Alexis Vollon, a painter much honored in his own day but now obscure, a taste for technical virtuosity and meticulous detail (note the low chair back, opposite). He is known to have used photographs, which he had taken himself, while composing his paintings.

Several other painters of Dagnan-Bouveret's period shared his interest in academic depiction of the traditional cultures of provincial France, notably Alphonse Legros, Lucien Simon, and Charles Cottet.

To his friend the painter Alexis Vollon

November 14, 1916

It is extremely kind of you, my dear friend, to have found the little Breton chair that you'd promised me. It arrived just in time, for I'm being pressured to finish, as soon as possible, the little canvas that will probably go to the museum in Philadelphia.

Opposite, I trace for you a sketch of my little figure. You'll see that your low-back chair was just what was needed to explain the movement and at the same time set it off gracefully.

I thank you again for this sign of affection and beg you to have confidence, my dear Vollon, in my feelings of friendship.

Pas. Dagnan-B.

Respectful regards to Madame Vollon.

Pascal-Adolphe Dagnan-Bouveret,
Two Breton Women. *Paris, Musée du Louvre.*

JEAN GIONO (1895–1970)

Photograph of Jean Giono (detail of a photograph taken at the fort of La Pompelle during World War I).

"We'd 'seen' the Épagnes, Verdun, the taking of Noyon, the siege of Saint-Quentin, the Somme with the English, in other words without the English, and the butchery in full sunlight of the Nivelle, attacks on the Chemin des Dames . . . I'm twenty-two and I'm afraid. Since we were decimated at Verdun, I've refused to take part in the assaults." Enlisted in the 140th Infantry Regiment, then in the 8th Corps of Engineers, soldier Giono never left the battlefield between 1915 and 1918. At Verdun his company was almost completely annihilated by the "hospital artillery."

The front left an indelible mark on him. He saw all his friends die there. His eyes were burned by mustard gas in May 1918. It is fascinating to compare the texts Giono published after the war, in which he sought to convey the unspeakable horror he had experienced, with the letters he wrote to his parents in the heat of battle: soothing letters that scrupulously avoid communicating anything of the daily slaughter, so as not to upset the only beings in the world who could still remind him of his human roots. "My parents needed tenderness and tranquillity; I wrote them solely to reassure them," he noted after he was decommissioned. Only after a certain time had passed could Giono's traumatized mind and body give issue to the literary equivalent of Edvard Munch's *Scream* in the more harrowing passages of *Le Grand Troupeau*, *Refus d'obéissance*, and *Ivan Ivanovitch Kossiakoff*.

To his parents

With the army
March 30, [19]17

My two old dears

Yesterday evening I received your news in the "dispatch" mail. I'm happy that your cold is almost gone. Here the weather is dreadful. That doesn't prevent me from feeling quite well. We have a bit more to eat and are loosening our belts a bit. I hope to come see you sometime in April. The letters are reaching me just fine now. I hope you're not fretting any more on my account now that you know where I am. I'm well housed, warm and comfy. Let's hope that in April the weather will turn beautiful and that the almond trees will be in bloom to perfume my leave.

Big hugs from your kid, who loves you more than anything.

Jean

Jean Giono
Wireless Operator
140th Infantry Regiment

(See the appendix, page 219, for an excerpt from Recherche de la pureté.*)*

A page from a manuscript by Jean Giono discussing pacifism, excerpt from Recherche de la pureté. *Collection Jean Giono, Musée de Manosque.*

Aux Armées
le 30 Mars 7

Mes deux Vieux chéris,
 J'ai reçu
hier au soir de vos nouvelles sur
le coin de "La Dépêche". Je suis
heureux que votre Rhume ait
presque disparu. Ici le temps est
épouvantable, cela ne m'empêche
pas de me porter merveilleusement
nous avons un peu plus à bouffer
et nous devenons un peu la
ceinture. J'espère aller vous
voir dans le courant Avril
les lettres m'arrivent très bien
maintenant. J'espère bien que
vous ne vous faites pas de mauvais
sang à mon sujet maintenant
que vous savez où je suis. Je suis
bien abrité, au chaud et peinard

. Espérons que pendant Avril le
temps se mettra au beau et
que les amandiers seront fleuris
pour embaumer ma permission.

 Grosses Caresses de votre
fiston qui vous aime par
dessus Tout

 Jean

Jean Fons Radio Télégraphiste
140e R. Infanterie
 SP. 114

Raymond Renefer (1879–1957)

Born in the Marne, Jean-Constant-Raymond Fontanet is better known as Raymond Renefer. An excellent draftsman, he produced thousands of drawings that make the texture of turn-of-the-century Parisian life accessible to us. Executed on the spot—in cafés, on the street, in city parks—these drawings, usually in Conté crayon, evoke an era that, while long past, remains oddly familiar to us. Renefer also painted sweet, harmonious landscapes picturing motifs in the Île-de-France region that prompted critics of the day to christen him the Painter of Air and Water and to compare his work with that of Camille Corot and Albert Marquet.

Drafted in 1914 into the First Regiment of the Engineers Corps, Renefer recorded the life of his fellow soldiers in World War I in countless sketches. Despite the harsh conditions under which the combatants lived, described unblinkingly in his correspondence, he rendered his comrades in misfortune with humor and tenderness. Throughout the war, he dispatched to his wife drawings from the front, images that prompted the art publisher Boutité to commission from him several albums evoking life in the military. In one of his letters, Renefer explains that the next delivery of drawings will be delayed since "at the moment they're helping me in my relations with my officers, to whom I show them and who take more interest in me as a result." The year 1916 took him to the Somme, the Aisne (at the Chemin des Dames), the Oise, Les Woëvres, the Vosges, and the upper Rhine Valley. In 1917, the year of this note announcing his participation in a Parisian exhibition, Renefer was in Verdun and near the fort at Vaux. His conduct resulted in his being awarded the Croix de Guerre.

After the war he remained productive, notably in the field of book illustration, providing images for, among others, Barbusse's *Le Feu* (*Under Fire*), Henry Bordeaux's *La Fée de Port-Cros* (*The Fairy of Port-Cros*), Francis Jammes's *Les Nuits qui chantent* (Singing nights), Pierre Loti's *Mon frère Yves* (My brother Yves), and Colette's *La Vagabonde*.

"Renefer is scarcely interested in anything other than expressing what he saw, but he expresses it with a sincerity and loyalty that make his work valuable," wrote one critic. Works by him can be found in Paris (Musée Carnavalet; Musée des Deux-Guerres Mondiales), Châlons-en-Champagne, Le Havre, Strasbourg, and Vannes, as well as in Argentina, Spain, and Japan.

To Clément Janin

27-9-18

Dear Monsieur,

I would be happy to take part in your organization's upcoming exhibition. So you can count me in as of this moment. I tried to visit you at the Banque de France during my last leave, but you weren't there. I was very sorry.

Very cordially yours,

Renefer

Raymond Renefer, Two Soldiers on a Stoop. *Private collection.*

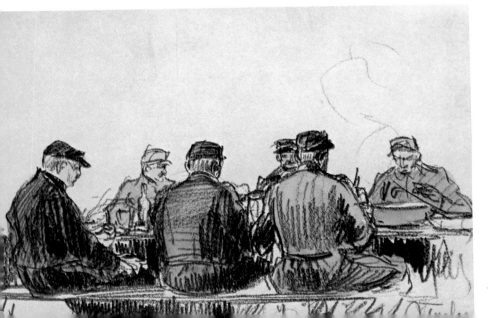

Raymond Renefer, The Meal. *Private collection.*

Raymond Renefer, Meal in Front of a House. *Private collection.*

Raymond Renefer, Game of Cards. *Private collection.*

MAX JACOB (1876–1944)

Pablo Picasso, Max Jacob.
Paris, Musée Picasso.

On September 22, 1909, Max Jacob's life was transformed: after returning home from the Bibliothèque Nationale, he suddenly had a vision of Christ, an event he recounts in *Saint Matorel* as well as in *Le Récit de ma conversion*, written thirty years later. "The host appeared on my wall. I fell to my knees, my eyes suddenly overflowed with tears. An ineffable well-being descended upon me, I remained motionless, without understanding. In a minute, I lived a century. It seemed to me that all had been revealed to me. I instantly had the notion that I had been nothing but an animal, that I was becoming a man. A timid animal. A free man." Over the years that followed he prepared to convert from Judaism to Catholicism, a process that culminated on February 18, 1915, in his baptism. He chose as his first name Cyprien (which, according to him, meant belief), and as his godfather Pablo Picasso, who, although not devout, was a believer, but, more important, had been his confidant and best friend for fifteen years.

Homosexual, Surrealist, Cubist, and a fervent Catholic, Max Jacob, whose behavior was often judged fantastic, which is to say that he was poorly understood, would divide his time between churches in the morning and cabarets in the evening. In January 1920, he was hit by a car in the Place Pigalle. The next year he published *Le Roi Boétie*, a book that resonates powerfully with his painful experiences in the Lariboisière hospital, where he contracted pneumonia. Upon his release, he decided to leave Paris and settle in a monastery at Saint-Benoît-sur-Loire, where he remained for seven years. When he left the capital, Jacob also left his friends, which is why he wrote his "dear godfather" these curious lines that, in their nostalgic tone, resemble a farewell. Seeing these words written on a piece of lace-paper unaware of the context, one might think they had been written by a child. They were, however, penned by a gifted poet who here seems, in some sense, to be withdrawing from the world. His relations with Picasso, while often distended, continued until Jacob's death in 1944: arrested by the Gestapo while leaving mass, he died a few days later in the camp at Drancy.

To Pablo Picasso

[June 1921]

My dear godfather,

You have figured in all the good and bad times of my life; you contributed to the first, you soothed my pain in the others. You encouraged my first artistic efforts, you put them on the right path. You were there for my first steps in the world of the arts. What am I saying? You alone were the world of the arts for me. It's you who had my first poems published and it was with you that I published my first volumes. If other occasions for publication should present themselves, they will again be with you or by you, directly or indirectly. Joyous, I found an echo in your heart; ill, it was you who cared for me. When God permitted me to come to Him, you were the first to know, and you were the only one who did not laugh at my repenting my faults. When baptism finally answered my prayers, you accompanied me toward this glory as I had accompanied you in yours. You are at my horizon and you are close to me, within me, and around me. I grew up through you, not only in my opinions, my vision, my understanding of the universe but also in my knowledge of geography and of people's customs. Never, in a word, was a godfather worthier of this title in relation to his godchild than you were to me. And I think that, without third parties, we would never have ceased for one hour being more than godfather and godchild, friends. Alas! So many third parties between us!

I hope that God will keep me worthy of you and keep you sufficiently in the light to know that I am as well. I hope that he will keep watch over you and give you the light one day to bring you to faith.

I embrace you.

Your devoted godson

Cyprien-Max

On Picasso's birthday in 1921, Max Jacob sent him a card on which he had drawn the image of a cigar.

Mon cher parrain,

été
Tu as démêlé à tous les bonheurs
et à tous les malheurs de ma
vie ; tu as participé aux uns
tu as pansé les douleurs des
autres. Tu as encouragé mes
premiers essais artistiques, tu
t'as mis dans de meilleures
voies. Tu étais là dans mes
premiers pas dans le monde des
art. Que dis-je ? tu as été à
toi seul le monde
des arts pour moi

Antoine de Saint-Exupéry (1900–1944)

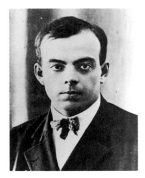

Photograph of Antoine de Saint-Exupéry in the 1920s.

The year 1921 marked a turning point in the life of the young Saint-Exupéry: although he had failed to qualify for enrollment in the prestigious military academies École Navale and the Centrale, in April he obtained his pilot's license and began his career in Strasbourg before leaving for Morocco. The future author of *Night Flight* (1931), *Wind, Sand, and Stars* (1939), and *Flight to Arras* (1942) was still something of a little prince when, in a clear, neatly perpendicular hand, he wrote this letter to his "adorable mama," thanking her for the package he had opened "as happy as a kid" and asking her opinion about the drawings he had sent her. For Saint-Exupéry devoted almost all of his free time to drawing, an activity he found endlessly fascinating. "I don't know what's taken hold of me," he stated elsewhere, "I draw all day and as a result the hours seem short. I've discovered one reason why: a Conté pencil with charcoal lead. I bought sketchbooks in which I express, as best I can, the day's events and gestures, my comrades' smiles, and the black dog's indiscretion." It is this animal that he chose to retain for his mother, a figure of which he was so proud that he cut it out and glued it to the letter.

These intimate letters also provided occasions for the pilot to recount the harsh conditions he had to endure during his apprenticeship: aviation was still in its beginnings, and while he "headed straight out, like a young god with a compass," he also bit his frozen fingers, crying from pain until landing delivered him from the cold. So great were the difficulties that Saint-Exupéry even considered dropping out, as he hints in the phrase "if I am failed or resign." He indeed left the army but returned to it in 1926 as a pilot in the Compagnie Aérienne Française, then with the Compagnie Latécoère, France's most ambitious mail service, where he was responsible for the first long-distance mail. Two years later, his novel *Courrier Sud* (*Southern Mail*) appeared. Another career had begun, inseparable from the first. Between 1934 and 1936, Saint-Exupéry again interrupted his activity as an aviator to work as a reporter, but the war prompted him to return to his passion. He died in July 1944, during a reconnaissance mission over occupied southern France.

To his mother

Photograph of Madame de Saint-Exupéry.

Casablanca [1921]

My little mama,

You're an adorable mama. I was as happy as a kid opening the package. It contained treasures . . .

But the papers say it's cold there! How are you getting by? Here, the weather's good. It's not raining and the sun shines softly.

For Christmas I sent you photos of myself and some sketches, but you never said a word to me about them. Were they lost? I beg you, tell me! And also, how are my sketches!

Yesterday I drew a dog from nature that's not bad, I cut it out and glued it. What do you think?

These days, splendid flights. Especially this morning. But no more trips.

Two weeks ago, I was in Kasbah Tadla, which is the frontier. Getting there all alone in my plane, I wept from the cold, wept! I was very high because of the mountains I had to cross, and despite my fur-lined overalls, fur-lined gloves, etc. I'd have landed anywhere if it had continued much longer. At a certain point it took me twenty minutes to put my hand in my pocket to pull out my map, which I thought I knew sufficiently and had neglected to install in the plane. I bit my fingers, they hurt me so much. And my feet . . .

I had no reflexes left and my plane was veering every which way. I was a pitiful thing, miserable and far away.

The return, by contrast, after a sumptuous lunch, was wondrous. Warm again and back in the air, contemptuous of landmarks, roads and towns, I headed straight out, like a young god with a compass. It took me two hours and forty minutes to get there, a little less to return. Violent turbulence found me like iron, and when I discerned Casablanca in the distance, I was as proud as the Crusaders when they saw Jerusalem. The weather was marvelous: I could see Casablanca from a distance of twenty-four kilometers! ([as far as] from Saint-Maurice to Bellegarde). . . .

(continued in the appendix, on page 220)

Les remous violents me trouvaient d'airain
et quand de loin j'ai découvert Casablanca
j'ai eu l'orgueil des Croisés quand ils virent
Jérusalem ... Le temps était merveilleux : j'ai
aperçu Casablanca à quatre-vingt kilomètres de
distance ! (de Saint Maurice à Bellegarde.)

Que veux dit Brault de mes écoles ?

Je vous arriverai probablement dans le
courant de Février, même si je suis recalé ou
si je démissionne, car dans ce cas j'irai faire
un mois ou deux de transport à Istres ≠ près de Marseille et
dès mon débarquement partirai en permission
de deux jours ou de un mois.

Vous tuerez le veau gras ...

Au revoir ma petite maman je
vous embrasse, écrivez-moi —
Votre fils respectueux
Antony

183 AP I d. VIII lettre 139

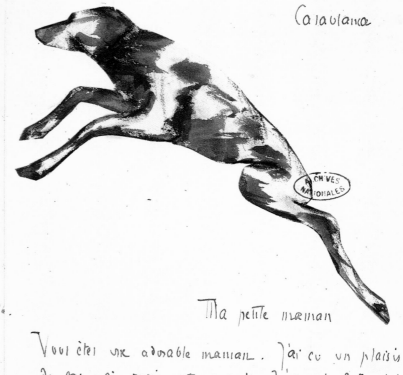

Casablanca

Ma petite maman

Vous êtes une adorable maman. J'ai eu un plaisir
de fou à ouvrir votre paquet. J'en ai sorti des
trésors ...

Seulement les journaux nous disent qu'il fait
froid là-bas ! Comment vivez-vous ? — Ici on

LE CORBUSIER (1887–1965)

Photograph of Le Corbusier. Paris,
Fondation Le Corbusier.

Charles-Édouard Jeanneret, who was born in La Chaux-de-Fonds, Switzerland, but settled in Paris in 1917, adopted the pseudonym Le Corbusier in 1920. In 1922 he began to build a series of private houses that first revealed the full extent of his genius. In his quest for commissions, he would first look for sites and then propose them to possible clients, trying to effect matches between the one and the other that did not always succeed: only a third of these projects came to fruition. In this letter, he is trying to interest a young couple in a plot of land he has ferreted out in Neuilly.

The architect presents his clients with a virtual architectural promenade: in the sequence of ten images with commentary that compose the letter, conceived like ten successive shots in a film storyboard, he has them "visit" the future house of his dreams. It is a series of "takes" in the course of which he stages his version of everyday domestic life, constantly relating interior to exterior, with all the images composed to resemble views through a wide-angle lens, evoking ideal spaces that are open and expansive, serene like the ateliers of Matisse.

The accompanying text is just as seductive as the images. The tone is playful, even coaxing: A commission hangs in the balance, and it is no accident that the architect addresses himself primarily to the wife.

He proposes a style of life that is altogether new, one privileging simplicity and openness to nature. All of his fundamental principles are here brought into play: the use of reinforced concrete posts as supports to liberate the plan, which is entirely open; the placement of service facilities on the ground floor, a two-story living space on the second floor, and the bedrooms on a mezzanine; a roof garden; a main staircase protruding from the main block, and a service stair rising through the building's center like an artery to irrigate the entire house. Nature is omnipresent: in the nearby park; in a greenhouse; and on the roof, which has a garden terrace, outfitted with a solarium and even a pool; leafy and luxuriant, it also safeguards the owners' privacy.

The project was never realized, having been deemed prohibitively expensive. There remains, however, this famous letter, worked up with such care that there is reason to suspect it may have been produced after the fact, for publication in the first volume of Le Corbusier's *Oeuvre complète, 1910–1929.*

To Madame Meyer

October 1925

Madame,

[1]
We have dreamed of building you a house that would be smooth and whole like a beautifully proportioned chest and would not be disrupted by multiple accidents that create an artificial and illusory picturesque effect and ring false in sunlight and only add confusion all around. We oppose the fashion raging in this country and abroad for houses that are complicated and cluttered. We think that unity is stronger than [an overemphasis on] parts. And don't think that this smoothness is an effect of laziness; it is on the contrary the result of plans pondered at length. Simplicity is not easy. In truth, this house rising against the foliage would make a noble impression . . .

[2]
The entry would be on the side, and not on the axis. Would we draw the Academy's thunderbolts?

[3]
The vestibule, broad, inundated with light . . . cloakroom, toilet are artfully hidden here. The servants are directly accessible. And if one ascends one floor, it is to reach the upper salon, above the shadow of the trees, and obtain a magnificent view of foliage. And see the sky better . . . If they are well lodged, the domestics, the house will be well maintained. Not at the top, for there we will place a garden, a solarium, and a swimming pool.

[4]
From the salon, then, one has an elevated view, light floods in. Between the double windows of the large bay we have installed a greenhouse that with one stroke neutralizes the chilling surface of the glass; there, large bizarre plants such as one sees in the greenhouses of châteaus and plant lovers; an aquarium, etc. Passing through the small door on the axis of the house, one heads toward the back of the garden on a footbridge, under the trees, to have lunch or dinner. . . .

(continued in the appendix, page 220)

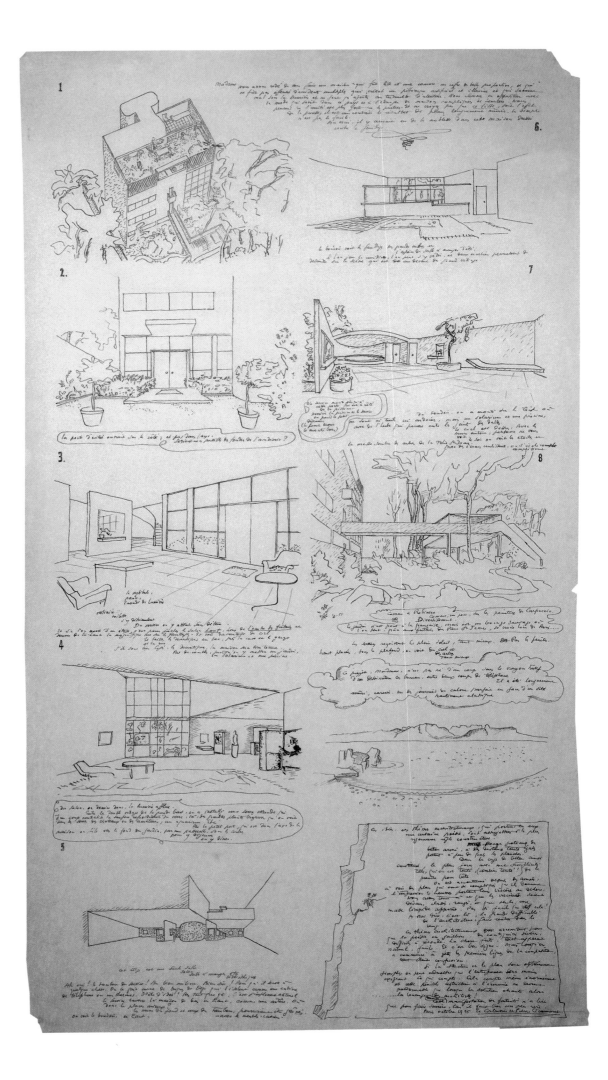

ANDRÉ BEUCLER (1898–1985)

Photograph of André Beucler.

André Beucler has all but disappeared from the reference books. A sensitive writer perhaps best known for his volumes recounting his impressions of the writers Jean Giraudoux and Léon-Paul Fargue, he was also a gifted novelist. Of his literary production—dominated by his output as a journalist, translator, and screenwriter—a few titles are worthy of interest, most notably *Gueule d'amour*, published in 1926.

Famous for the screen adaptation by director Jean Grémillon in 1937, *Gueule d'amour* remains indelibly linked to the name of Jean Gabin, who played the hero. Everyone is pulled into the web of intrigue with remarkable efficiency: Lucien Bourache, known as Gueule d'Amour (Love Face), conquers woman after woman in a garrison town until the day he falls in love with a femme fatale—played by Mireille Balin in the film—whom in the end he kills.

Beucler did not write the screenplay for the movie based on his novel. But did he want to illustrate his story? There are few writers who can themselves decorate their books. Thanks to this enigmatic sheet, we know that Beucler was one of them. Is it a letter? An attempt at a cover design? The care taken by the author in rendering this portrait of Gueule d'Amour, who is given blue eyes and a heart-shaped mouth that rhymes visually with the motifs on his collar, suggest that it was meant for eyes other than the author's, perhaps as a gift. Did the author send it to one of his correspondents at Gallimard? The initials NRF (Nouvelle Revue Française, an imprint of Gallimard) on the soldier's cap remind us that Beucler was published by this prestigious house, whose great authors had been introduced to him by Albert Thibaudet, one of his teachers in Besançon.

To an unknown correspondent

1926

One doesn't give nicknames lightly, but if anyone merited his, it was truly the hero of this story, who received it from his comrades before he even had any right to it, in the garrison town where he was to leave behind so many memories. If he hadn't acquired it, the talk about him would have attracted less attention, and the people who still remember him wouldn't think about him anymore. Not for quite some time. And when, after having seduced women because he fantasized himself a conqueror, and fulfilling his obligations according to his particular tastes, Gueule d'Amour was reclaimed by civilian life, a harsh destiny made him see that he should never have stopped playing the pretty boy.

In military costume, Gueule d'Amour showed himself to be so skilled at manipulating the hearts of his companions that he could outwit the severity of his superiors and the fury of his rivals. No one could resist him, and there was greater joy to be had in admiring him than in contending with him. For a year, he transformed provincial life into legend and won everybody over, even the hopeless ones, whose hearts he managed not to break too much.

But life held in store for him the surprise of a being whose affection was not easily won and who set out to make a victim of him. Gueule d'Amour understood that he was in love for the first time. He so accepted being in a woman's power that one would have had trouble recognizing him in civilian clothes and in a world where one was more likely to encounter murderers than exiles. Gueule d'Amour had become an exile, he had lost his name, forgotten his youth, and sacrificed his past. We then find him in a worker's colony, living from day to day with vagabonds and fearing the return of the only woman who ever managed to make him love her, without giving him anything but a taste for violent crime . . .

ANDRÉ BEUCLER

GUEULE D'AMOUR

Deuxième édition

nrf

PARIS
Librairie Gallimard
ÉDITIONS DE LA NOUVELLE REVUE FRANÇAISE
3, rue de Grenelle (VIIᵉ)

One of the first editions of Gueule d'amour, *with the famous white cover of the Nouvelle Revue Française imprint.*

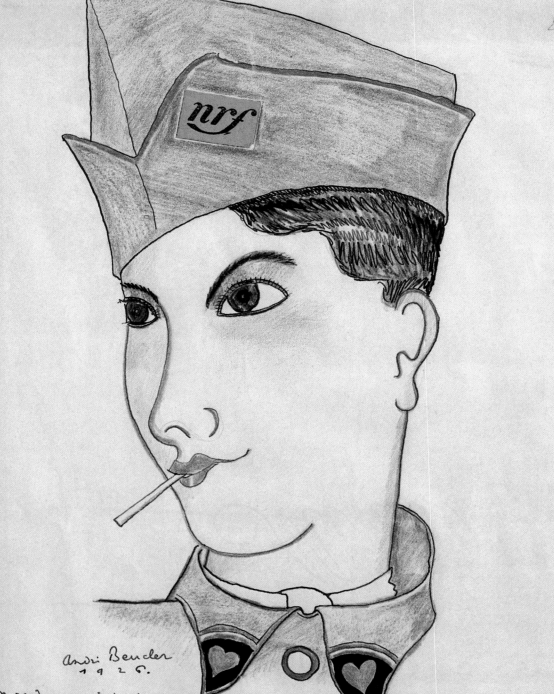

Andri Beucler
1 9 2 5.

On ne donne généralement pas les surnoms à la légère; mais si quelqu'un mérita bien le sien, ce fut vraiment le héros de cette histoire, qui le reçut de ses camarades avant même d'y avoir droit, dans cette ville de garnison où il devait laisser tant de souvenirs. S'il ne l'avait pas porté, le bruit qu'on fit autour de lui aurait été moins retentissant, et les personnes qui l'évoquent encore n'y penseraient plus depuis longtemps. Et quand, après avoir séduit les femmes par fantaisie de conquérant, et accompli son devoir selon des goûts bien à lui, Gueule d'Amour fut repris par la vie civile, un destin brutal lui fit bien voir qu'il n'avait jamais dû renoncer à faire le joli cœur.

Sous le costume militaire, Gueule d'Amour se montra si habile à jouer avec le cœur de ses semblables qu'il sut se rendre maître de la sévérité de ses chefs et de la fureur de ses rivaux. Nul ne pouvait lui résister, et l'on avait plus de joie à l'admirer qu'on aurait eu de plaisir à se mesurer avec lui. Pendant un an, il transforma la vie provinciale en légendes et mit tout le monde de son côté, même les désespérées dont il savait ne pas déchirer le cœur à l'excès.

Mais la vie lui réservait la surprise d'un être qui n'avait pas les sentiments faciles et qui se chargea de faire de lui une victime. Gueule d'Amour comprit qu'il aimait pour la première fois. Il accepta si bien d'être au pouvoir d'une femme qu'on eut de la peine à le reconnaître sous le vêtement civil et dans un milieu où l'on rencontre plutôt des assassins que des exilés. Gueule d'Amour était devenu un exilé, il avait perdu son nom, oublié sa jeunesse et sacrifié son passé. On le retrouve dans une colonie ouvrière, vivant au jour le jour avec des vagabonds et craignant le retour de la seule femme qui soit arrivée à se faire aimer de lui, sans d'ailleurs lui donner autrechose que le goût violent d'un crime....

600 xxxix

GEORGES AURIC (1899–1983)

Jean Cocteau, Portrait of George Auric.
Private collection.

"Everything that's liveliest, keenest, tenderest. Everything that's lightest and heaviest, quite serious yet without the earnestness that betrays the soul, that's Georges Auric," wrote Jean Cocteau. Of the musicians constituting the group known as Les Six, Auric was perhaps the most gifted. Albert Roussel saw in him, at age fifteen, "a kind of musical Rimbaud." His acute critical intelligence may have prevented him from fulfilling his full potential. In any event, he left behind a body of work that is rich and beautiful.

His letter brings to life the atmosphere of the 1920s, for it is addressed to one of those aristocrats of the period's "gilded bohemia" who divided their time between the Côte d'Azur and Paris partaking of drugs, alcohol, debauchery, and other worldly pleasures. Auric here refers to recent events relating to Serge Diaghilev's Ballets Russes: Henri Sauguet's score for *La Chatte* and Lord Berners's for *The Triumph of Neptune* (both choreographed by George Balanchine), and a private performance at the home of the princesse de Polignac of Stravinsky's *Oedipus Rex*, set to a text by Cocteau. Then he conveys news of his friends: Francis Poulenc (Poupoule) has just bought a house in Touraine. Valentine and Jean Hugo are working on costumes and sets for Carl Dreyer's film *The Passion of Joan of Arc*.

The curious illustration was perhaps inspired by medieval illuminated manuscripts, whose beauty Léon Bloy had revealed to the young Auric.

To François de Gouÿ

[late May 1927]

Dear François,

It rains and rains. Since my arrival, we're shivering with cold but so many social events! *La Chatte* pleases the crowd, but our masters don't like it much. The ballet by Lord Berners is perhaps *The Triumph of Neptune*, not that of music.

Last Sunday evening, a soirée Polignac with a read-through of *Oedipus Rex*!

—Jean Cocteau very brilliant, despite the inevitable turmoil of any collaboration with the Russians.

—Francis Poupoule, a happy property owner, very kind.

—Valentine, ridiculous, communist, and persuaded that with this gesture she has greatly upset the course of the world. Jean (her husband) rather sad working on a film from morning till night.

—And you? I wish you peace. Not too many domestic troubles and every possible happiness.

I retain memories from Clavery that I'd be incapable of expressing. Thanks for so many kindnesses. Tell Russell that I send him, as I do you, dear François, all my affection.

Georges

Much sugar from me to Mlles Zette, Mireille, and M. Petit, a bit of cream to M. Blanc-blanc known as Mine-Mine.

Photograph of Georges Auric (left) with Jean Cocteau and Francis Poulenc.

Cher François,

il pleut. il pleut.
Depuis mon arrivée.
On grelotte de froid.
mais que de monde! La
chatte plait aux foules,
mais nos maîtres ne
l'aiment guère. Le
Ballet de Lord B.
est peut être le
Triomphe de Neptune,
pas celui de sa
musique.

Ce soir dimanche,
soirée Polignac avec l'audition d'Oedipus Rex!

— Jean Cocteau très brillant, malgré les
placas inévitables de toute collaboration avec ces
Russes.
— Francis Rouppole, heureux propriétaire, très gentil
— Valentine, ridicule, communiste, et persuadée d'avoir
par ce geste fortement dérangé la marche de
monde. Je ne lui ai pas soufflé mot de son
tout de maître. Jean (son mari) assez triste,
travaille à un film de méstin en 1917.
— Et vous? Je vous souhaite du
calme. Pas trop d'ennuis domestiques et
tout le boulot possible.
Je garde un souvenir que je ne saurai
exprimer de Clavary. Merci de tou
d'amitié. Dites à Russell que j'aime que
je lui envoie ainsi à vous,
cher François, toute mon affection,

Georges
auric

ROBERT DESNOS (1900–1945)

Photograph of Robert Desnos.

To Youki and Foujita

Photograph of Youki.

"If God exists, the world is only his dream and every dreamer is God. I believe in the material reality of the imagination and likewise that two gazes encountering one another can suffice to alter the destiny of a city, a people, a race, the world; that imagining an ideal being can, somewhere in infinity, illuminate suns and initiate planetary gravitation, make nights and days, clouds and stars succeed one another," wrote Robert Desnos in 1928 (*Le Soir*, September 12). When he penned these lines, was he thinking of Youki, alias Lucie Badoud, a fickle woman, the model and wife of the artist Foujita, whom the poet had met that same year in a café in Montparnasse?

Desnos quickly became close to the couple. But they soon decamped for an extended sojourn in Japan, for Foujita was counting on the success of a huge exhibition he had organized there to settle a bill for back taxes levied by the French government. For several months, the friends corresponded regularly, with Desnos constantly voicing his friendly affection for the couple. "My dear friends, Paris without you seems empty to me," he complained on September 3, 1929. "My dear Youki, it is time you returned, for your absence is unlucky for Paris," he insisted on November 7. In the interim, on October 13, he sent them an astonishing letter in which decals scattered over the page, poetically integrated into sentences that they both ornament and illuminate, take the place of words. "There are no siren decals but my big bear is still doing well," he concludes. Youki, in her book *Confidences*, published many years later, provides the key to this enigmatic phrase: "Desnos had baptized me 'the Siren.' We joined in the game and Foujita tattooed a siren on my thigh. Robert decorated his arm with a big bear standing on its hind legs."

In 1931 Foujita and Youki separated and what had to happen happened: Desnos linked his destiny to the frivolous Youki, whom he loved until his death at the hands of the Nazis on June 8, 1945.

[first sheet, below left]
[Paris] Sunday,
October 13 [1929]

I hope that Foujita is content with his trip to the cradle of his ancestors and that you're not preoccupied by the French tax authorities. I received the proofs of the little book published by F[ranck]. I hope it will do well.

I'm not drinking any more . . . not too much. I'll play the [drum] when you return.
[within decal of a wreath] "Pleasant Memories"
Your friend Robert
Are you [baba] for this letter?
I'm like a [crab]. Life in Paris is too mediocre for one to be satisfied with it for very long, happily there are things to do. [within decal of triangle and three flowers] "think of me" both of you.
[second sheet, below right]
Have you seen the ["Sphinx" (moth)] in Egypt?
Have you learned to manipulate the [fan] in Japan?
Do the [elephant(s)] in Ceylon have red fires in their asses?
In the midst of ["Gala(s)"] don't forget us here.
[third sheet, opposite]
Will we see you before ["winter"]?
Will you return soon to the ["République Français"]?
Will you make the trip ["in a rowboat"] or in a ["balloon"]?
May the ["eight-pointed star"] protect you.
There are no siren decals but my big bear is still doing well.

Robert Desnos

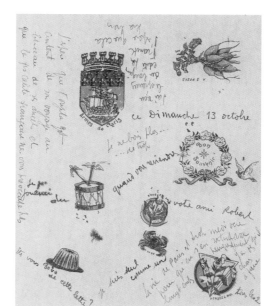

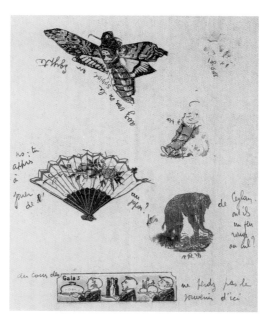

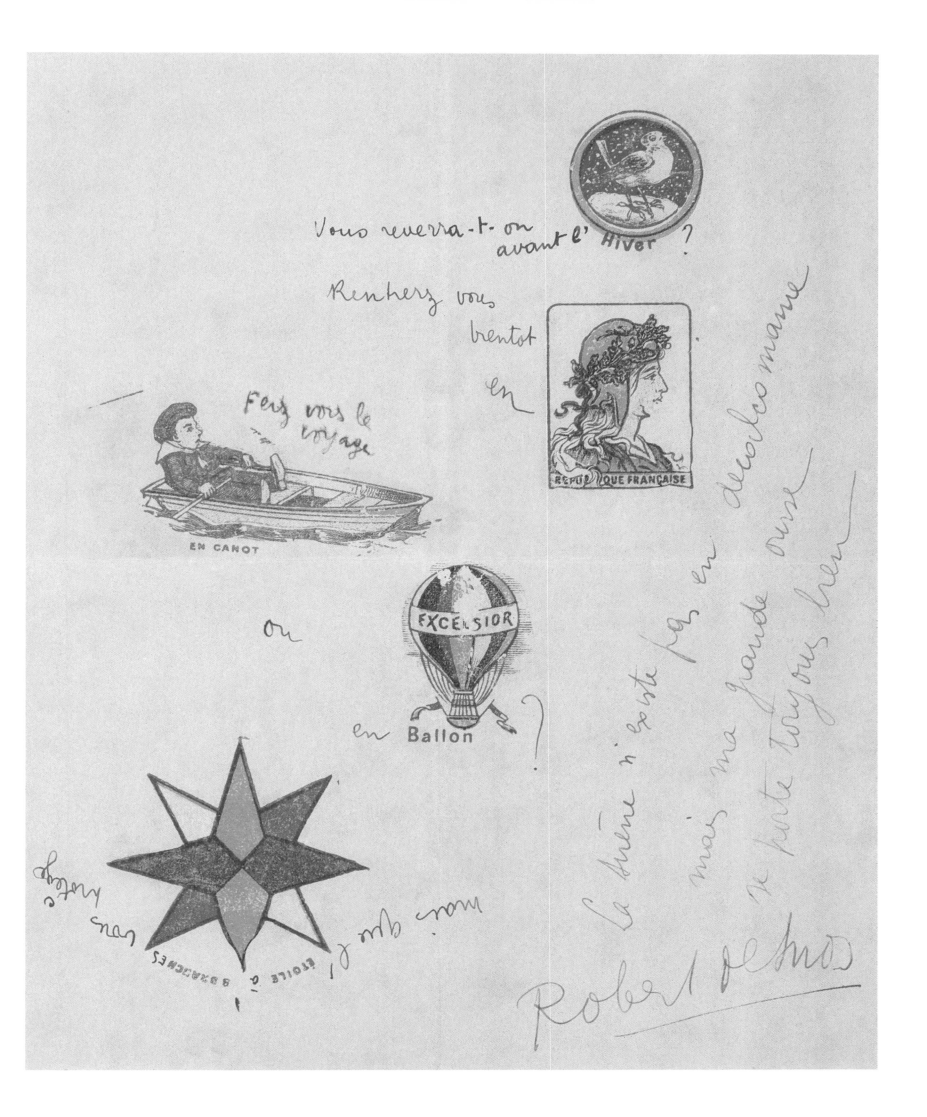

Francis Carcopino-Tusoli, known as Francis Carco (1886–1956)

Portrait of Francis Carco.

Quai d'Orléans, quai aux Fleurs, quai du Louvre, quai d'Orsay, quai de Béthune: Francis Carco never lived far from the Seine, the backbone of Paris, along which he walked ceaselessly. However, it is Montmartre with which his name is always associated, a turn-of-the-century Montmartre populated by Picasso, Apollinaire, Max Jacob, Roland Dorgelès, Pierre Mac Orlan . . . The writer made the most of this period that was simultaneously impoverished and gilded, one in which artists recast the world from the top of the Montmartre hill. In such volumes as *De Montmartre au quartier latin* (1927), *Montmartre à vingt ans* (1938), *Bohème d'artiste* (1940), and *Rendez-vous avec moi-même* (1957), Carco evokes this remarkable moment prior to World War I.

From a broader perspective, it is of Paris, always of Paris, that Carco speaks in his books, whose magical idiom encompasses both classical elegance and bantering *argot*. For there were indeed two Francis Carcos: the tough guy who emulated prostitutes and con men; and the respectable member of the Académie Goncourt, to which he was elected in 1937. Carco understood himself to be divided in this way, as evidenced by this illustrated letter sent to the writer and journalist Paul Reboux. Here he outlines his two profiles, which bring to mind the two faces of a medal, in incisive and assured strokes that border on caricature: at left, "Monsieur Carco" with bowler hat, wing collar, and cigar; at right, his "best friend," his "little pal Francis" wearing cap and foulard, a cigarette stub in his mouth.

This friend of painters—a phrase he used as one of his titles—who published several books on art (*Vlaminck, Maurice Utrillo, Le Nu dans la peinture moderne*) had himself tried his hand at painting but quickly gave it up. Although his vocation clearly lay elsewhere, Carco had "what might be called a graphic hand," in the words of his friend André Négis, who, in his book *Mon ami Carco* (1953), noted that Carco produced "countless manuscript poems very prettily illustrated by the same pen that wrote them" and that "the best profiles ever drawn of him were from his own hand."

To Paul Reboux

[undated]

My dear Reboux,

The "little pal Francis" and his best friend Monsieur Carco thank you warmly for your brilliant and amicable column in *Paris Soir*.

They send you their best regards and the usual expressions of gratitude.

F. Carco

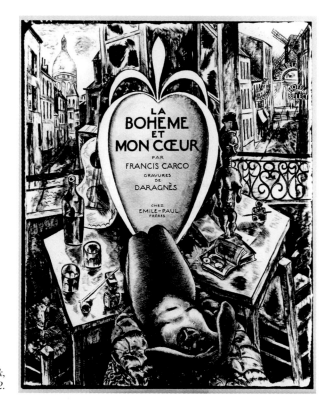

Daragnès, frontispiece for Francis Carco's book, La Bohème et mon coeur, *1912.*

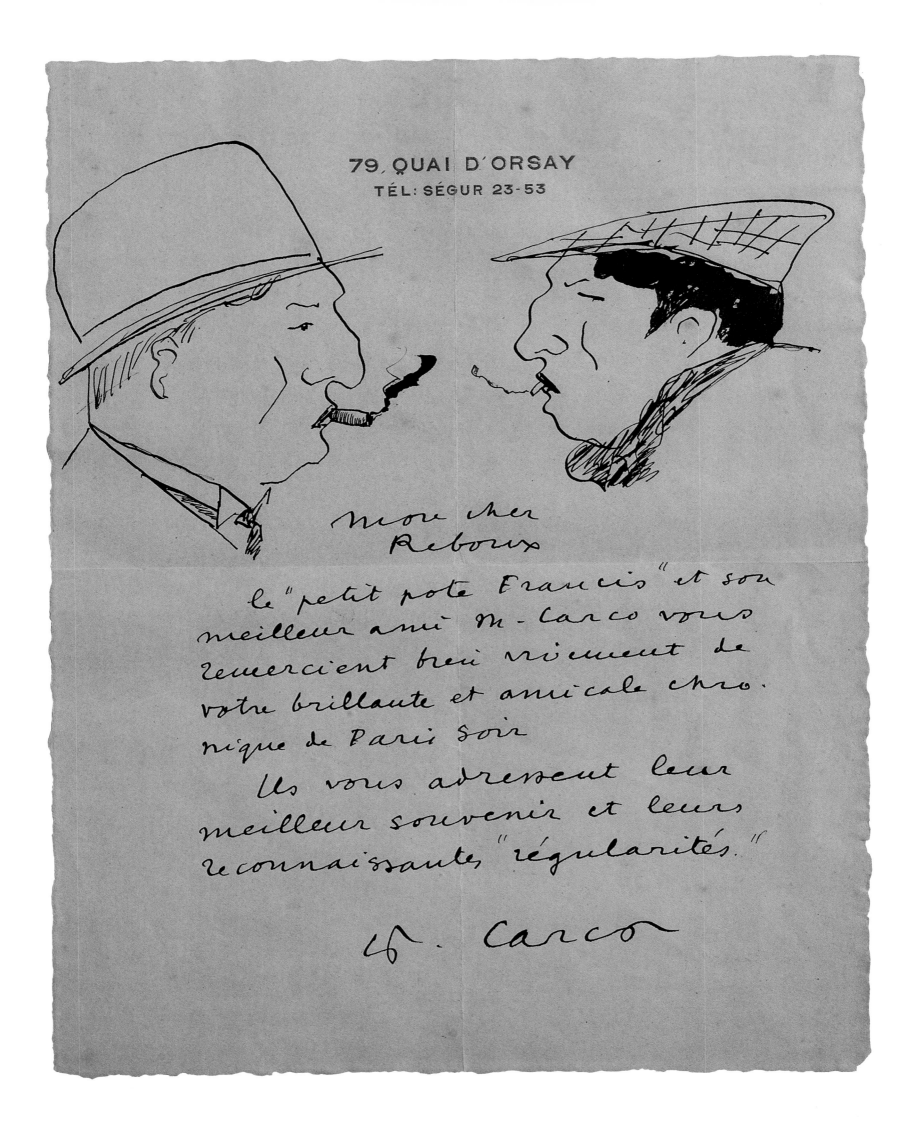

79, QUAI D'ORSAY
TÉL: SÉGUR 23-53

mon cher
Reboux

le "petit pote Francis" et son
meilleur ami M. Carco vous
remercient bien vivement de
votre brillante et amicale chro-
nique de Paris Soir

Ils vous adressent leur
meilleur souvenir et leurs
reconnaissantes "régularités."

fr. Carco

ANDRÉ BRETON (1896–1966)

Photograph of André Breton (above) and his daughter, Aube (below right), taken at the Château d'Airbel, Marseilles, in 1940. Private collection.

The Surrealists aimed, among other things, to reconcile dream and reality. In this respect, the present letter from Breton to his daughter, Aube, might be described as Surrealist, for it poetically imbricates word and image, drawing and statement, to achieve a combination that is both dreamlike and concrete. Those familiar with Breton's dictatorial comportment as head of the Surrealists will find it difficult to picture him as a tender father, but this document offers proof that he was indeed capable of paternal affection.

At this time, Breton, who was stationed in the fort at Sucy-en-Brie outside Paris as doctor-auxiliary of the 401st DCA (antiaircraft defense unit), then in the fort at nearby Noisy-le-Sec, sometimes managed to slip away from his military obligations and visit Paris. There he prepared, via correspondence with painters Wolfgang Paalen and Cesar Moro, an international Surrealist exhibition to be mounted in Mexico City; kept up with his friends; and frequented the Café Deux Magots. But he missed his wife, Jacqueline, and his daughter, Aube, barely four years old, for they were staying with friends in the Midi.

Between January and July of 1940, the situation changed. Breton became the head doctor at the basic pilot training school in Poitiers and henceforth could spend his leaves with his family, who were staying with Picasso and Dora Maar. The war did not prevent him from writing: his *Anthologie de l'humour noir* appeared in 1940—and was immediately banned. The following year he left France for the United States, where he devoted himself to travel and writing until the end of the war.

To his daughter, Aube

[below a fanciful composition with flowers, trellises, and two hands clasping, cut out and glued to the sheet (with the hands outlined in ink, one identified as Jacqueline and Aube, the other as ADA [Breton])]

the little finger [of Aube's drawn hand]
is tiny,
because
it's
like that
in reality

Noisy, October 9, 1939

Dear little fairy Aube,
It's still raining
[below: decal of a watering can]
I'm still with the [decal of a soldier]
(I still have my fine hat
currant jam
with as background
a three-leaf clover
in writing of sugar
of gingerbread pig)

le petit doigt
est minuscule,
parce qu'il
est
comme ça
en réalité

Noisy, le 9 octobre 1939.

D Chère petite fée Aube,

il pleut
encore

je
suis
toujours
avec
les
→

Arrosoir

(J'ai toujours mon beau chapeau
en confiture de groseille
avec au fond
un trèfle à quatre feuilles
en écriture de sucre
de cochon de pain d'épice)

ANDRÉ DIGNIMONT (1891–1965)

*Photograph of André Dignimont at his work table.
Private collection.*

To André Dunoyer de Segonzac

1939

Did you know, dear big boy? That we've received some quite beautiful things from Saint-Tropez? You are quite chic, my old friend. We too send you all kinds of best wishes for the New Year, which is already moving on. We embrace you and we love you very much.

Dignimont and Lucette

A watercolorist and illustrator, Dignimont had no equal when it came to evoking in a few vivid colored strokes a scene of gallantry or scantily clad women with ample buttocks and seductive breasts. He illustrated many books, notably several by Francis Carco and Colette in which *libertinage* is depicted with seductive grace and delicious wit. He also designed ravishing opera sets.

Like Colette, he enjoyed decorating pieces of lace paper with drawings and collages for his friends. In this 1939 New Year's card for the painter André Dunoyer de Segonzac, he used a chromolithographed image, two small figures of women from a set of cutouts, and some old photographs of prostitutes that recall the protagonists of *La Maison Philibert* by Jean Lorrain, one of Dignimont's finest illustrated books.

Above: Details of letter reproduced opposite.

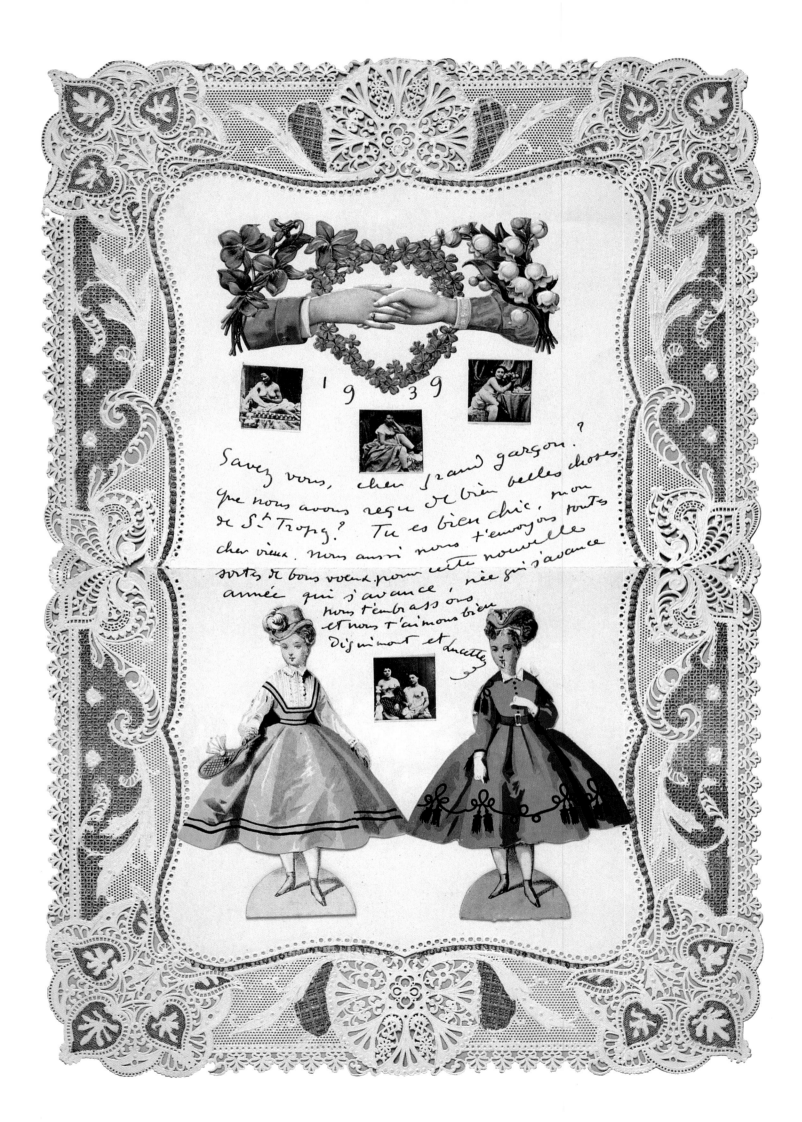

Colette (1873–1954)

Ferdinand Desnos, Portrait of Colette.

In 1913 a young film critic by the name of Louis Delluc wrote the following about a performance directed by Georges Wague in which Colette appeared nude beneath a large white veil: "We didn't know if we were troubled or simply full of admiration. For she means to be moving and perhaps perverse, and we allow ourselves to be dominated by her will, but we sense something within her that is inexplicable and very pure."

Scandalous at the time, more or less forgotten today, Colette's career as a pantomimist left an indelible mark on her, and she remained faithful to her "master" and friend Georges Wague. As early as 1910, she recounted her adventures on tour under the cover of fiction in *La Vagabonde*, in which the heroine, René Néré, "a woman of letters who had gone astray," performed pantomime with a certain Brague, transparently a portrait of Wague. It was the latter who nicknamed Colette "*la rate*," or the female rat (was it the curled-up resting pose she assumed during long rehearsals that occasioned this moniker?), and, naturally, it was in many letters to Wague—and to his wife—that she used an image of this animal as her signature. Following the birth of her daughter Bel-Gazou, she wrote him: "I have a little female rat, it cost me dearly: thirteen hours without any respite, chloroform and forceps." Sometimes she varied this signature: "*la rate affamée*" (the famished rat), "*la rate enflée*" (the swollen rat), "*la rate bien dodue*" (the very plump rat).

Although as disinclined to draw as she was attentive to animals, Colette did leave us, in these rebus-signatures, precious testimony of her humor and of her regard for Georges Wague. Their friendship was still intact in 1940, when the novelist, now a respected figure in the republic of letters who had obtained the Légion d'Honneur for her old professor, had been living in the Palais Royal for two years. Thus, when she mentions the hairdresser "on the other side of the garden," she is probably alluding to this enclosure in the heart of Paris. As for Luc-Albert, this can only be Luc-Albert Moreau, a painter and engraver with whom Colette had long been on friendly terms, who had been gravely wounded during World War I, and who had illustrated *La Naissance du jour* (1928).

To Georges Wague

[Paris, November 1940]

You see how you are! You look out with a detective's keenness for the moment when, disgusted with my hair in which dust, ladybirds, wild rabbits, wood louses, and nightingales have been settling for three weeks, and then you come. Your premeditation is perfectly clear, and all defense is futile. You simply must come back.

My hairdresser is on the other side of the garden, he's a friend and war buddy of Luc-Albert. His name is Porché. But since these days there's no pork anywhere, we call him Hé. (You see what's become of me since the earthquake in Budapest.) I embrace both of you, my dear

Pierrot-Sisters [image of a rat]

Colette, Female nude.

[Paris, novembre 1940] L. V

Tu vois comme tu es ! Tu as guetté
avec une âpreté de détective le moment
où, dégoûtée de mes cheveux dans
lesquels depuis trois semaines s'étaient
établis la poussière, les coccinelles,
le lapin sauvage, le cloporte et
le rossignol, et tu es venu. Ta
préméditation est nettement établie,
et tout système de défense est
inutile. Tu n'as qu'à revenir.

Mon coiffeur est de l'autre
côté du Jardin, et c'est un ami
et camarade de guerre de Luc-Albert.
Il s'appelle Porché. mais puisqu'il
n'y a plus de porc nulle part, nous
le nommerons Hé. (Voilà comment
je suis devenue, depuis le tremble-
ment de terre de Bucarest). Je vous
embrasse tous les deux, mes chers
Pierrot-Sisters

RENÉ MAGRITTE (1898–1967)

To Andrieu

April 29, [19]48

In May 1949, the first one-man show of work by Magritte opened at the Galerie du Faubourg in Paris. Considered the leading figure of Belgian Surrealism since 1945, he had nonetheless been excommunicated by André Breton (see pages 180–81) because of his idiosyncratic conception of the movement—Magritte indeed advocated a "sunlit Surrealism" based on "pleasure."

The exhibition consisted of twenty-five paintings and gouaches in a new idiom that he called his "*style vache*," presumably after the French expression "to speak French like a Spanish *vache* (archaic for Basque); in other words, very badly. The subject matter was jokey and provocative, and the deliberately crude technique recalled that of the Fauves: few precise lines but bright, even garish colors brusquely applied. Here we are very far from the meticulous, hyperrealist style usually associated with Magritte.

The catalogue contained a text by his friend Louis Scutenaire written in a slangy style and entitled "*Les pieds dans le plat*" (Putting one's foot in it). The show met with critical indignation and a chorus of jeers. Magritte decided to abandon this path, which remained a dead end.

Several of the works mentioned in this letter—*Famine, The Pebble, The Pope's Crime*—figured in the recent Magritte exhibition organized by the Musées Royaux des Beaux-Arts in Brussels to celebrate the centenary of the artist's birth.

My dear Andrieu,

I receive your letter at a moment when my work is finished (provisionally). I will have an exhibition at the Galerie du Faubourg, 47 rue du Faubourg Saint-Honoré, Paris 8ᵉ, which will open on May 11 and continue until June 5. Everything is ready, catalogues forthcoming at any moment, gouaches at the framer, etc. . . . I'll send you a few catalogues (as well as a few more from my exhibition in New York as soon as I receive my allotment). You'll see when you read Scutenaire's preface that we've prepared something remarkable for Paris. There are gouaches like this:
[three captioned drawings: "The Pope's Crime"; "Flûte"; "Les Démangeaisons"
Some of the paintings:
[four captioned drawings: "Famine"; "the Psychologist"; "Le Galet ["The Pebble"] (woman licking her shoulder)"; "Prince Charming (gouache)"]
etc. . . .

I plan to come to Paris on May 8 and doubtless I'll remain there a good week. I'll stay with my relative Monsieur Fumière [?], 15 rue Plisson (in Saint-Mandé-Paris). If you want to write me there during my stay I'd be happy to hear from you. It's not out of the question for me to "jump" up to Toulouse with my wife and my dog. That will depend on lots of things I can't foresee at this point. In any event, I'll let you know.

Have you read *Les Copains* by Jules Romains? It's a wonderful read, one of the most beautiful books in existence, to my mind.

See you soon, my dear Andrieu—my best to you and Douy.

Magritte

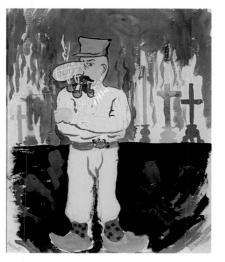

From left to right: The Psychologist *(1948);* Prince Charming *(above);* The Pebble *(1948);* The Pope's Crime *(1948). All in private collections.*

29 Avril 48

Mon cher Ondrien,

Je reçois votre lettre au moment où mes travaux sont terminés (provisoirement). J'aurai donc une exposition à la Galerie du Faubourg, 47, rue du Fg St Honoré Paris VIIIᵉ qui s'ouvrira le 11 Mai et durera jusqu'au 5 Juin. Tout est prêt, catalogues d'un moment à l'autre, gouaches chez l'encadreur - etc... Je vous ferai envoyer quelques catalogues. (ainsi que quelques autres de mon exposition de New York dès que j'en recevrai une provision). Vous verrez en lisant la préface de Soulenaire que l'on a préparé quelque chose de soigné pour Paris. Il y a des gouaches comme ceci:

Le crime du Pape.

Flûte!

Flûte!

Les Démangeaisons

Le Galet.
(femme se léchant l'épaule

le prince charmant
(gouache)

etc ----

Je compte aller à Paris le 8 mai et j'y resterai sans doute une bonne semaine - Je logerai chez mon parent. M⁻ Fumière - 15 rue Plisson (à S⁺ Mandé - Paris) Si vous voulez m'écrire là pendant mon séjour je serai heureux d'avoir encore de vos nouvelles - Il n'est pas exclu que je fasse "un saut" jusqu'à Toulouse avec ma femme et mon chien - Cela dépendra de toutes sortes de facteurs que je ne puis encore prévoir - De toute façon je vous préviendrais -

Avez vous déjà lu "Les Copains" de Jules Romains? c'est très très agréable à lire, c'est un des plus beaux livres qui existent. à mon avis.

à bientôt mon cher Andrieu - et recevez avec sous mes amitiés

Magritte

9726

189

GEORGES HUGNET (1906–1974)

Photograph of Georges Hugnet.

In 1957 Georges Hugnet bought his house L'Herbière on the Île de Ré, where henceforth he retired to work and write *L'Aventure Dada*, the first in a series of memoirs in which he functions as an archivist of Dada and Surrealism. In the 1920s, he committed himself to drawing and poetry (with the encouragement of Max Jacob, see pages 166–67), translated Gertrude Stein, and collaborated with the Surrealists: his works were illustrated by, among others, Miró, Dalí, and Duchamp, as well as his own collages and photomontages. He revolutionized the art of binding by fashioning veritable book-objects. Later, he collaborated with Picasso and Cocteau. He loved to surround himself with curious objects, precious books, and drawings, many of which were gifts from his artist-friends.

So it is not surprising that he delighted in decorating letters to those he loved with drawings and collages. This note to his friend the painter-poet Néjad features a bouquet of flowers drawn in colored pencil, into which he inserted the volutes of his hand, elegant and precise like the "thick and thin" strokes of his last book, *Pleins et Déliés: souvenirs et témoignages* (1972).

To his friend Néjad

L'Herbière, June 10, 1958

My dear Néjad,

Tomorrow I begin my fifty-second year. I'll never get used to it, being just as hardheaded as I was at twelve, twenty, thirty, and forty-five years. Here are some flowers for my birthday. I think of you, I work for you. A prose piece is singing in my head, it will be called: *The Allée of Swans* where scarcely pubescent loves pass and furtively define themselves. It is, I think, what you'd want from me. I hope in turn that this evocation won't disappoint you, that it's appropriate for your art and doesn't offend the publisher too much.

Embrace your wife for . . . (no, I'll do it myself, she is too nice) and know that you have a place in our triple heart.

Georges

P.S.: Our little property enchants us. If you're so inclined, come and judge its sweetness and grace for yourself.

Georges Hugnet, Untitled Collage. *1961. Private collection.*

L'Herbier le 10 Juillet 1958

Mon cher Néjad,
J'entrerai demain dans ma cinquante-deuxième année. Je ne m'y ferai jamais, étant toujours aussi peu conciliant qu'à douze, vingt, trente et quarante-cinq ans. Voici ces fleurs pour mon anniversaire, toi, pour toi, chante tête,

Je pense à Une je tra- vaille prose dans ma qui s'appellera:

L'Allée des Cygnes, où passent et se précisent

furtivement des amours à peine pubères.
C'est, je crois, ce que tu souhaitais de moi. Je souhaite à mon tour que cette évocation ne te déçoive pas, convienne à ton art et ne choque pas trop la bonhomie du publisher.

Embrasse ta femme pour... (non, je le ferai moi-même, elle est trop gentille) et sache que tu as ta place dans notre triple cœur.

GEORGES

P.S. - Notre petit domaine nous enchante. Si le cœur t'en dit, viens juger par toi-même sa douceur et sa grâce.

JEAN COCTEAU (1889–1963)

A self-portrait by Jean Cocteau, from a letter to his translator Mary Hoeck dated June 12, 1956. Private collection.

At the end of 1959, Cocteau finished editing his film *The Testament of Orpheus*, which he had first envisioned early in 1958. The figure of Orpheus accompanied Cocteau throughout the course of his life and work, thus it was only natural that he should charge this mythological hero, his double, with conveying news to his friend, the poet Yanette Delétang-Tardif. In Cocteau's drawing, Orpheus holds his lyre, and the play of colored pencils drawn over the irregular texture of the paper suggests the ancient poet's multicolored mantle. It is indeed poetry that is in question here, for the letter concerns the ballot for the Prix Apollinaire, a poetry prize, in 1960. He authorizes the recipient to cast his vote, in absentia, for Marcel Béalu, justifying his choice by elliptically evoking distant memories. In 1937 he had sojourned in Montargis with his companion, the actor Jean Marais, to write his play *Les Parents Terribles*, and Max Jacob, as well as the young hatseller and poet named Marcel Béalu, had also been there.

In *The Testament of Orpheus*, Cocteau appears in a robe and mortarboard cap just as he had drawn himself in a letter to his translator Mary Hoeck, written after he had been awarded an honorary doctorate by Oxford University. It was on this occasion that he presented his "Oxford Address," *Poetry, or Invisibility*, in which he described himself as a "modest worker who has never sought anything but to place himself at the service of the unknown force that inhabits poets."

To Yanette Delétang-Tardif

Saint-Jean-Cap-Ferrat
[late December] 1959
1960

My very dear Yanette,

It took me two years to give birth to a delicious monster unlike any other. The result is a frightful post-fatigue. I won't be among you and I cast my vote for Marcel Béalu in memory of Montargis and Max.

Jean
who embraces you and wishes you luck and happiness.

Madame Yanette Delétang-Tardif
31, rue de Bellechasse
Paris 7e
[the postmark on the envelope is dated December 29, 1959]

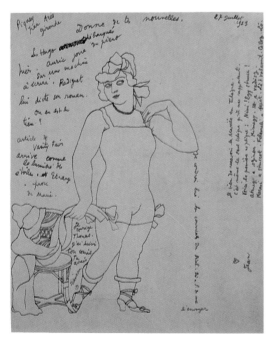

Another illustrated letter by Cocteau, one in which he reveals a very different inspiration and drawing style, dated July 27, 1923. Private collection.

"SANTO-SOSPIR"
St JEAN CAP-FERRAT
☎ 251-28

1959
1960

ma très chérie
Yanette — il m'a
fallu donc des
pour accrocher d'un
montre de licorne
et qui ne
ressemble à aucun
autre.
il a résulté
une
post-fatigue
effrayante
←

GASTON CHAISSAC (1910–1964)

An astonishing and unclassifiable figure, Gaston Chaissac was a self-taught peasant from the Yonne, in northeast France, who, after working as a chef's assistant, hardware salesman, harness maker, fairground hawker, and shoemaker, settled in Paris in 1937 to become an artist. Extremely creative and original, he was finally noticed after the war by the critic Jean Paulhan, the writer Raymond Queneau, and above all the avant-garde artist Jean Dubuffet.

Free of all cultural baggage and prejudices concerning art, Chaissac explored new creative domains: the use of rubbish and secondhand materials (in this he heralded Art Brut); sculpture made of bark and charcoal; totems made of folded and painted sheet metal; collages.

His copious correspondence, much of it written to his dealers, Aimé Maeght and Iris Clert, is in a "modern-rustic" style, a term he used to describe himself. It abounds in picturesque descriptions of the details of his daily life comically combined with reflections about art. His illustrations comment on the texts with extraordinary freedom.

In another letter to Iris Clert, which he signed "Gastonnet," he confided: "Dear friend, I have perhaps preposterous ideas for painting new pictures that are childish in conception . . . at every step, I ran the risk of looking so as to make fun of the world."

To Iris Clert

Dear friend,

Since the other day I'm the happy owner of cassocks intended for Jacqueline Derain (native of Montmartre), but Ekström has the wrong fellow. I must reckon, like him, with my asthenia, with my discomfiture with abstract art, and it becomes much more interesting to restrict oneself to relating the thing and to inciting writers to do the same.

I happily use my old gouaches in collages. In that way I obtain fetishes firsthand; I'm more and more decrepit and ready to sink into inertia by the force of things. And it will be difficult for me to finish in beauty as Dubuffet sanctioned. But perhaps I'll manage to make a decent impression by rigging myself out with a kind of halo, what's more, done to measure. I am more and more out of breath and panting, and my stomachache is getting worse . . .

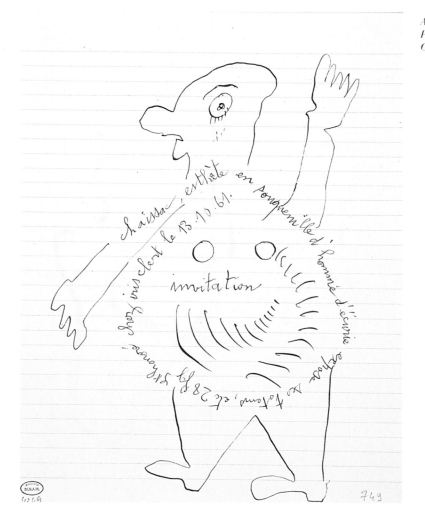

An illustrated invitation from Gaston Chaissac. Paris, Musée National d'Art Moderne/Centre Georges Pompidou.

Gaston Chaissac, Figure, 1961–62. Paris, Musée National d'Art Moderne/Centre Georges Pompidou.

194

Chère amie, Je suis depuis l'autre jour l'heureux possesseur de centaines dessinées par Jacqueline Deraison (native de Montmartre) mais Ekstrom se trompe de porte. J'ai à compter avec mon asténie comme lui avec la déconfiture de l'art abstrait et il devient bien plus intéressant de se borner à conter la chose et d'inciter des écrivains à en faire autant. J'utilise avec bonheur mes vieilles gouaches dans des collages. J'obtiens ainsi des fétiches de premières... mais me voilà de plus en plus caduc et près à ... m'enfuir dans l'inertie par la force des choses. Et il me sera difficile de finir en beauté comme Dubuffet le préconisant. Mais peut-être parviendrais-je à faire figure en m'affublant d'une espèce d'auréole du reste sur mesure. Je suis de plus en plus essouflé et haletant et ma colique prend de l'ampleur

JOAN MIRÓ (1893–1983)

Photograph of Miró in the 1970s. Private collection.

To Jacques Prévert

"Joan Miró, people today say he's somebody. I don't know if he's somebody, something, or some creature. In any case, he's not like anyone else, but the world resembles him. When he wants to be, he's a sorcerer: he can summon anything from anywhere: birds, plants, the sun, beauty, lucidity." So wrote Jacques Prévert about his friend, whom he had met in the 1920s, when Surrealism was at peak intensity.

In 1963 Prévert confided: "I've been working with Joan Miró for a long time. . . . We're doing a book. Myself, I've done everything by hand, my work is complete. He's working on top of it, my work. He says he's starting over, that he wants to do better." This prolonged gestation resulted in *Adonides*, a collection of poems and drawings signed Prévert-Miró that appeared in 1978, one year after the writer's death. It is undoubtedly to this project that the painter alludes in the present letter of November 1970: the book for which he thanks Prévert was probably *Imaginaires*, published in September of the same year. In this volume, the writer published some of his own collages, a technique of which he was especially fond and one at which he was gifted: beginning in the 1950s, he exhibited his work at Galerie Maeght, which brought together all the talents of the moment in its magazine *Derrière le miroir*, publishing the catalogues of its exhibitions and some of the Prévert-Miró productions. However, the fruits of this collaboration, although carefully prepared and long pondered, were to be rare. For example, a projected suite of illustrated texts often mentioned by them, entitled *On ne se voit pas dans la mer*, never saw light of day.

Testimony to a shared vision of the world and to a genuine artistic complicity, these collaborative productions are among the high points in the modern history of illustrated literature. Doubtless because Prévert was a bit of an artist and Miró a bit of a poet.

November 14, 1970

Thank you, my dear Jacques, for your book, which I found at the gallery and which is very beautiful. This spring I'll attack the one we're doing together. Embrace your wife. I embrace you as well.

Miró

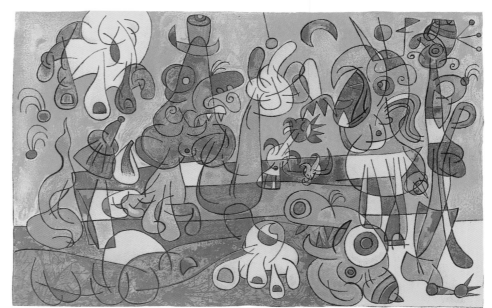

Joan Miró, Illustration for *Ubu Roi* by Alfred Jarry. *1966.*

que j'ai trouvé à la Galerie

et qui est très beau

Ce printemps on attaque
celui que nous faisons ensemble
Embrasse Ta
je t'embrasse
Miró aussi femme

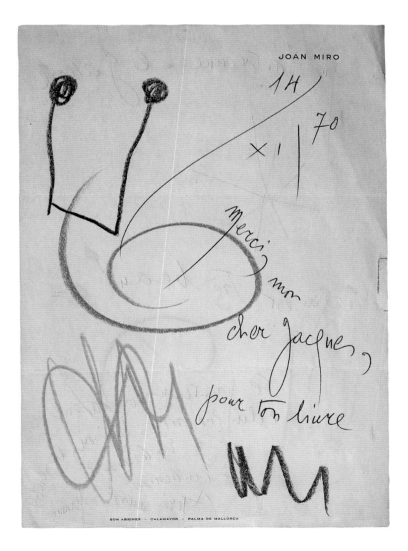

JOAN MIRO

14
XII / 70

Merci, mon
cher Jacques,
pour ton livre

SON ABRINES · CALAMAYOR · PALMA DE MALLORCA

PAUL DELVAUX (1897–1994)

Photograph of Paul Delvaux in the 1970s.
Private collection.

To Claude Lévi-Strauss

At the end of the preface to *The Naked Man*, in its first French edition, Claude Lévi-Strauss writes: "Finally, how to express my gratitude toward a painter in whose work I have always taken a special pleasure? Told by a mutual friend about my musings with regard to what I was pleased to consider the myth of reference painted by him, Paul Delvaux kindly agreed to decorate the cover of this book with an original composition, for which the publisher and myself are profoundly grateful." The fourth and final volume of *Mythologiques* (after *The Raw and the Cooked*, *From Honey to Ashes*, and *The Origin of Table Manners*), the book was published by Plon in 1971. Delvaux imagined a figure with long hair and of indeterminate sex climbing a tree. For the back cover, the publisher and the author selected a photograph of a bronze from the Amlash region representing a small figure sitting at the top of a ladder apparently—thanks to a photomontage—emerging from a mass of clouds.

To thank the author for having sent him several copies of the book, perhaps signed and dedicated, the Belgian Surrealist painter wrote a few simple lines on a sheet occupied for the most part by a large composition in ink and wash treating a theme that preoccupied him throughout his work: woman, primitive or otherwise. More elaborate than "the little vignette" used on the cover, which Delvaux thought "works well," this document was carefully framed by Lévi-Strauss, a member of the Académie Française and a passionate art lover, whose father, it is worth recalling, was a portrait painter and collector of curiosities.

Photograph of Claude Lévi-Strauss.

October 14, 1971

Dear Monsieur
Lévi-Strauss

Many thanks for the very beautiful books: *L'Homme nu*, which you were so kind as to send me. They are really superb, and the small vignette works well. All my best regards.
P. Delvaux

P.S.: I've already forwarded some copies to Paul De Bock and I'll send one to Paul Brien.

Paul Delvaux, Water Nymphs (detail), 1938. Private collection.

le 14-10-71 Cher Monsieur Levi Strauss
Un grand merci pour les très beaux
livres: L'Homme Nu " que vous avez
eu la gentillesse de m'envoyer.
Ils sont vraiment superbes et la petite
vignette donne bien.
Tous mes sentiments
les meilleurs
P. Delvaux
P.S. J'ai déjà
remis des
livres à Paul
De Bock et
je vais en
envoyer un
à Paul
Brien...

JULES MOUGIN (1912–)

To Christian Bernadac

According to Catherine Fricault, who published an article about him in September 1993, Jules Mougin is a "poet-postman." She writes: "He scatters his writings, drawings, dreams, and nightmares to the winds. He is a friend of little flowers, stars, and pretty rocks, but with him exaltation can quickly give way to rebellion. Like an archer, he sharpens his pen to lance the abscess of human absurdity."

Born in 1912 in the small town of Marchiennes, Mougin now lives in Anjou. From his little house there, he cultivates warm and friendly relations with his many correspondents—including Christian Bernadac—sustained by generous written conversation, a composite of texts, drawings, color, and poetry. The poet began his career in the postal service in 1926, as a telegraph operator on the rue Dupin in Paris. He was then transferred to the sorting office for the fifteenth arrondissement, whence to the Gare Saint-Lazare post office, Alençon, and Digne. When he retired, he was a postmaster at Écouflant, in Maine-et-Loire.

With wonderful tact, he has developed the habit of thanking the postman on the envelopes of his missives. "Writing, for me, has always been a great pleasure!" he says.

[opposite]

Every morning
channel 3
empties the abscess
the abscess of the world!

Misery
Despair
Stench
Numb sadness

I'm ashamed

Jules Mougin
March 19, 1991

[below left]

Thursday, March 26, 1992
noon

Dear Christian Bernadac
I know you're hard at work.
Writing requires application.
I understand, yes, the solitude of the writer!

Of course, I was thinking about you.

Your "postman" isn't sleeping well. He's re-reading Victor Hugo!
He memorized some of "Marjan" by Claude Billon and even "Gulls are born from the handkerchiefs that say farewell in ports." It's by Ramón Gómez de la Serna.

[bottom right]

France is voting, I'm not voting! This nationalist tendency in the world, the hothouse of future wars! I repeat myself! I'm about to turn eighty-one!
The world is always the same!
Men kill each other.
I hear—despite my deafness!
I see with glasses—it's true!
I "ruminate," I think, I doubt.
Men are redoubtable, yes.
Here, three hundred kilometers from the capital, a pal is dead. "They" cut him down, the last walnut tree in the neighborhood! A shock for me.
Mougin embraces you.

Pages two and three of the letter that begins on the opposite page.

chaque matin,
La chaîne 3,
vide les abcès
les abcès du monde !

misère
Désespoir
Puanteur
Tristesse figée.

J'ai honte.

[signature]
19 mars 1991

OLIVIER DEBRÉ [1920–]

Photographs of Olivier Debré (left) and Bernard Noël (below right) taken in 1984, on the occasion of Flammarion's publication of a monograph on Debré with a preface by Noël.

To Bernard Noël

"At a given moment," said Olivier Debré, "something congeals in the material itself, and it is the reality of the emotion, and it is in fact me—I who am alive only insofar as this emotion is within me . . . There's interpenetration of a kind between a mental atmosphere and real atmosphere, and setting out from that I am what I see, then vision turns back on itself inside of me . . . One is always inside of oneself and outside of oneself. Like steam. The encounter with a shape creates my own shape. I paint in the emotion of a reality that engenders me."

The following quote from Debré, taken from an article about him published a few years ago by Bernard Noël, clarifies his meaning: "At a time when Man made do with his own face to express his inner life, the painter could content himself with images. That time has passed, since the gesture of the painter is now more present than the art of painting. This gesture is not present narcissistically for himself; it means that outer space, where thought seeks truth, is no longer separate from the mental space where thought is real. Always launched from the inside toward the outside, always giving inner experience exterior expression, the gesture effaces the difference between them by effecting an emotional opening."

[1998]

[opposite]
Dear Bernard,

Since the Maison de la Poésie evening at the Théâtre Molière, having not heard from you, I
[page 204]
fear I annoyed you by enunciating my theories about the end of humanist humanity by opposing the search for signs to attempt to formulate the body.

By contrast, I didn't
[page 205]
sufficiently analyze your surprising but perfectly accurate formulation: "I no longer have a back" (which has a strange effect on me). In front of Matisse (*The Piano Lesson*), since there's no perspectival space.

You should be comfortable in front of *Las Meninas*. But how do you feel in front of the reverse perspective of Japanese prints, with their vanishing point in the zone of death? And with the formulation that I'm looking for progressive signs of our space.

I embrace you
Olivier D.

Details of the letter reproduced on the following pages.

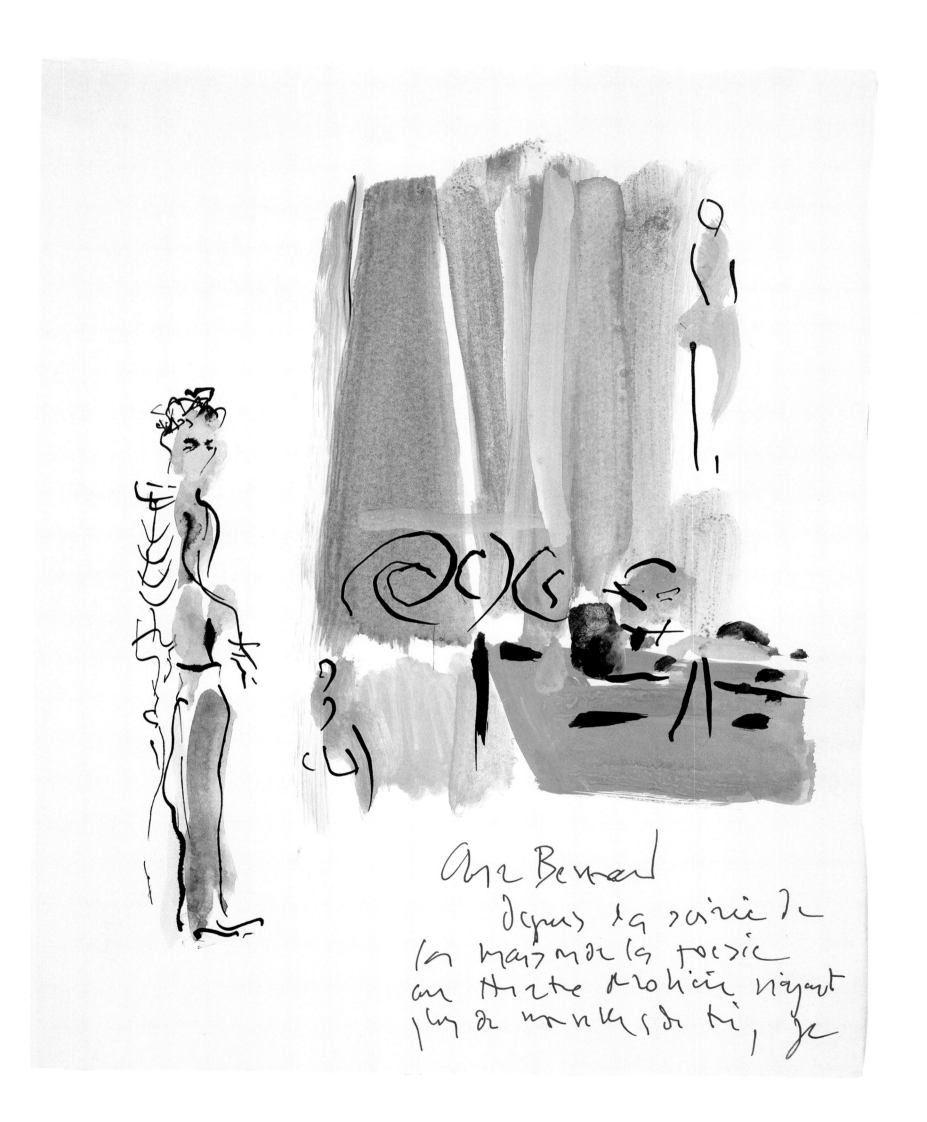

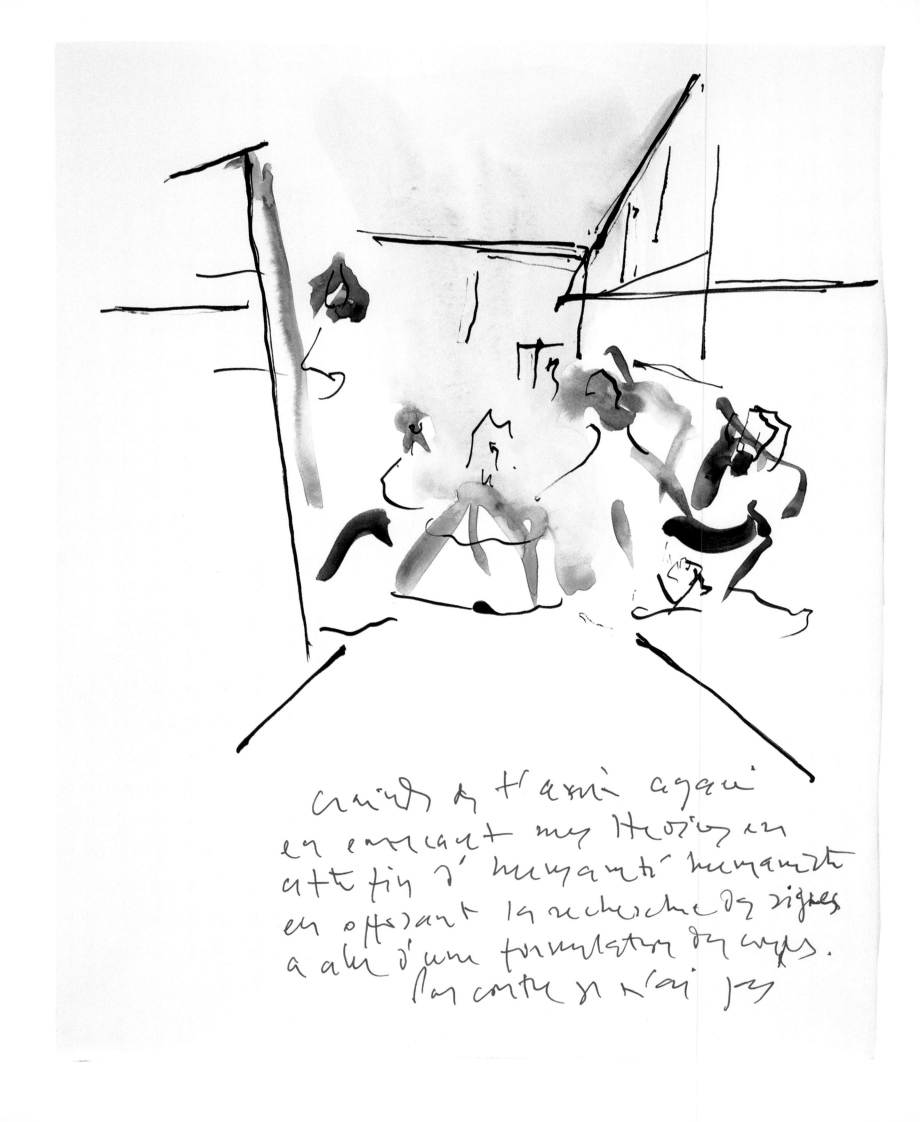

APPENDIX

COMPLETE TRANSCRIPTIONS OF SELECTED LETTERS

As it seemed desirable to publish the complete texts of certain letters that, for reasons of space, could not appear alongside the illustrations, we provide them in this appendix. Letters that are only partially transcribed in the main body of text—including those that do not have their complements published in the appendix—are marked by ellipses (. . .) indicating the missing text. The presence of a complementary passage in the appendix is announced by a note at the end of the letter. In the appendix, single brackets mark which portion of the letter was transcribed in the body of the text. As this volume is presenting all the letters in translation, punctuation and spelling have occasionally been adjusted from the original to facilitate comprehension for the English-speaking reader.

[It is very difficult, when writing you, to avoid the subject of *il troubadouro*, and you must have as many versions [of him] as you have letters. So lend me your pretty little ear: we've seen the whole family, even a niece who is charming. Let's proceed in proper order: the grandmother is a gaunt little old lady who is said to be quite amiable. Imagine a woman somewhere between Mme de Fétan and grandmama, with qualities of both, and you'll have a pretty good

idea of her. As for the mother, I didn't see her with my own eyes, but it seems she's a woman of the highest breeding, manner, etc., as live as gunpowder: she embraced Laurence with a cordiality rare for a mother-in-law. I would ask no more of my own. She told [her son], he said, that, while his accounts were flattering, she found [Laurence] above them. Judging from what I've been told, I'd say she's the nervous type, and, after nervous types, what I fear most, I dare say even more, are their intimates. There's a sister-in-law who is past the age of passion and who, by consequence, is pious up to her neck, and of whom it is said she is younger than she looks and quite amiable. There's a second one who married an auditor for the Council of State who one day will have a yearly income of thirty-thousand livres; who (the sister-in-law) is very pretty, amiable, not at all ill-natured.] I haven't seen her with my own eyes, but I saw the brother-in-law, who is a pretty little man with a plump face, finally if there's paradise on earth it is certainly the family into which Laurence will enter, if it please God. Yesterday we saw Laurence's future aunt, the second daughter of the fiancé's grandmother. You might have heard papa talking about her. She is Madame Cassière, wife of the director of the Provisions Accounting Office, and it is she who has such a pretty daughter, mentioned at the beginning of my letter. If you'd like—in your rascally Bayeux and in your vile rue Teinture, for how can

one call a town Bayeux and a street Teinture? If, as I was saying, you'd like to get some idea of her, you need only place two hands over your beautiful brown eyes and summon to mind that little lady at Monsieur Rousseau's—one of his nieces, so kind. I don't know what they call her. Imagine her with a divine smile and a bit taller, plumper and with a nicer figure, and you'll have a pretty good idea of her. There remains the future groom! . . . He's a bit taller than Surville; he's neither ugly nor handsome, his mouth is widowed of its upper teeth, and we must presume there will be no second marriage, for Mother Nature stands opposed: this widowhood ages him considerably. For the rest, he's rather better than acceptable, for a husband, you understand. He writes poetry and is an excellent marksman: hunting, he can fell twenty-six head of game with twenty shots. He's taken part in only two competitions and won both of them. He's excellent at billiards; he turns phrases, he hunts, he shoots, he supervises, he he he . . . And you know that all of these skills, pushed to the highest degree in a man, make him quite presumptuous—which he is to a certain point, and this certain point, I fear it might be the highest degree on the thermometer of self-regard, as in our celestial family we are all quite well provided for in that department, and as our own measure is quite high, we scarcely notice it: we make excuses for him, saying that when *one* does everything well, it is permissible to have *self-confidence*. He wants Laurence to be happy. Loss of the piano will be compensated by diamond studs, the wedding gifts will be the same, finally, everything advances as if on rollers —and the rollers are well aligned. Mama finds that the future son-in-law conducts himself quite well, quite well. He always embraces mama and as yet has embraced Laurence only on the day of their engagement. What's more, you will know that Laurence is as pretty as a picture, that she has the prettiest arm and the prettiest hand one could ever see, that she has very white skin, and two admirably well-placed t[its]: that, engaging with her, one finds her very intelligent; that one perceives quite clearly that it is natural intelligence, as yet undeveloped. She has very beautiful eyes; as to her pale complexion, throngs of men like such coloring. I don't doubt that marriage will do her considerable good. Grandmama is enraptured. Monsieur de Montzaigle is an eagle among eagles, an exemplary man, etc. etc. Papa is quite content, myself likewise, you as well. As for mama, recall the last days of your own maidenhood and you'll understand what Laurence and myself are going through. Nature always surrounds roses with thorns and pleasure with countless vexations. Mama follows nature's example. She wreaks havoc for five hours, then turns gay and agreeable. What's more, she can't get over it, she's almost as bad as grandmama, and what's most remarkable, she even has the same tic: losing her grip, she repeated to us a thousand times that she was stronger before her illness: Henri is unhappy; they spank the child, he'll amount to nothing, he must go to another school, they're hypocrites, his education is ruined; they're confined, severely punished for

nothing, etc. Dear sister, whenever I'm there, I imitate papa, I say nothing; but I have a resource that he doesn't, which is to live apart. I'm expecting to have a little room on the fifteenth of this month. I hope to sell a novel every month at 600 francs; that will be sufficient to get me out of my scrapes while waiting for the fortune that I'll share willingly with all of you, for it will come to me, I've no doubt about that.

I greatly pity my dear mother because of this and because of her illness; no one in the world will tell her this. She'd be the unhappiest of women if she suspected that, trying

to do everything to make those around her happy, she does nothing of the kind. Mama thinks that a financial sacrifice is worth more than a century of good humor.

Burn my letter, for I confess to you that I don't like it anymore.

Farewell. I embrace you with all my heart, recommending that you resist your nervous affections. My regards to Surville.

You told me you were reading *Clarissa* [by Samuel Richardson]. Afterwards try to read *Julie* [or, *the New Heloise* by Jean-Jacques Rousseau]. I greatly encourage you to read *Kenilworth*, [Sir Walter] Scott's last novel; it's the most beautiful thing in the world. Our novel is finished. I'm holding the last chapters. It will be sold for 600 francs for the first edition. I'll send it to you, on condition that you not lend it and that you proclaim it a masterpiece, of course. You understand that in the present circumstances I can't go to Payeux any more than to Touraine, and that if I separate myself from the paternal hearth [it's because] I'm obliged to work on novels, which require research and diligence.

My nose writes to yours to find out, after having duly sent its regards and good wishes, whether it's still filling handkerchiefs, and whether in Bayeux as in Paris it procures from its mistress the pleasure of rummaging for little snotballs.

I will inform you with manifest pleasure that I've become a bit handsomer than I was: my skin is paler, my pimples have dis-

appeared, and I'm a man that would turn the head of any woman who . . .

You didn't tell me whether there are any rich widows in Bayeux.

The Sallambier household has learned a great lesson about the danger of not creating an inner happiness, once a man has made the huge mistake of condemning himself to live his whole life with a chattering pious woman: despite this lesson, the little woman strikes me as having grown too accustomed to the vapors, to fits of bad temper, for her to give them up. Sallambier hasn't changed. My uncle has forgiven everything except Mama, who's again at daggers drawn with him, and Sédillot, the great schemer behind the intrigue. We still don't know what's to become of this alliance. Sallambier is in excellent spirits about Laurence's getting married. Mouillard is making dresses, Ravinet sheets, and myself bibs.

I pray a thousand times that I'll see you return to Paris to work on this Saint-Martin canal, for which I'll be damned if Surville isn't the engineer. I hope you'll tell me about everything that's going on in Bayeux, and above all [provide me with] a brief account of all the pretty women, of all those who are and aren't pious, and of all the husbands who are and aren't . . . For the rest, be informed that for ten long months I've been without love and without a mistress, yet I can say with Correggio: I, too, am a painter!

Adèle Bellanger the dark-complexioned has been so prudish as to refuse an English millionaire. But Élisa the redhead, my passion, is getting married to spite whom? I don't know. Gatien[ne] the malevolent is married. Honorine sings like an angel with the help of Romagnesi and is shaping up nicely with the help of her mother.

If I heeded only my desire to babble, I'd write you reams. I have to finish, for I have precious little time for all my enterprises. Farewell.

I embrace you absolutely as in my last letter. My regards to Surville, and to the bridge in Vée. It's been quite some time since we saw his mother, but I'll go soon.

So farewell.

Your brother who loves you,

H. Balzac

[Address]
Madame Surville
rue Teinture, in Bayeux
Calvados

It seems, dear friend, that my cursing the heat of this muggy country had some effect. As I closed my last letter the sky clouded over and gratified me with the worst of rains, the fine cold rain that extends as far as the horizon and lasts the whole day. To reach Antwerp and Ghent one must cross the Escaut. Since the polders are flooded, and have been for nine months, the trip by water is longer, the steamboat obliging one to take a transverse course that connects with the Ghent road half a league from the Tête-de-Flandre. You'll have guessed that I wasn't annoyed by this little promenade almost at sea. Despite the rain, I remained on the bridge, listening distractedly to the disappearing song of the sailors heading out to sea, and watching the high steeple of Antwerp disappear in the mist.

I only passed through Ghent, but I count on returning to it after I've seen Tournai and Kortrijk. It's a very beautiful city, Ghent. Ghent is to Antwerp as Caen is to Rouen: something beautiful near something admirable. Nonetheless, I took the time to visit Saint Bavo and of course climbed the tower. For myself, there are two mutually complementary ways to see a city: in detail first, street by street and house by house; as a whole afterwards, from the top of a bell tower. In this manner one obtains facial and profile views of a city. Viewed from the top of Saint Bavo, which is to say from [a perch] two hundred seventy-two feet high, and one must climb four hundred fifty steps to get there, Ghent has a Gothic configuration almost as well preserved as Antwerp's. The belfry tower, surmounted by an enormous gilded griffin, has for its roof an amusing jumble of bell turrets, dormer windows, and weathervanes. Next door is an old black church, St. Nicholas, whose almost Romanesque facade is admirable. It consists of a large severe ogive arch flanked by two crenelated turrets in the grandest style. A bit further along is St. Michael's, which, like St. Nicholas, presents its apse to me. Two or three other churches form a pyramid still farther along amidst stepped roofs. Coming back there's St. James, which has three spires, one of stone and two of slate. To the side, a beautiful square with high gables framed by two old stone buildings from the fourteenth century, with turrets and steep roofs. The one in the middle of the short side of the square was the house of the counts of Flanders. This square is the picture market; and then there are lots of other picturesque markets, convents, crooked little crossroads surrounded by crenelated houses in attitudes of all kinds, and cutting each other off in the most charming way; and then an immense roof that covers a large austere nave from the fourteenth century, without tower or bell tower, it's the Dominican church. At this moment several monks entered wearing their admirable costume, white robes with black scapulars. At my feet the town hall with its two facades, one from the age of Louis XIII, the other from the age of Charles VIII, the one austere, the other ravishing. Add to this outside the city a vast horizon of fields and within the city a multitude of little bridges and waterways that wet the foundations of the houses; and you'll have some idea of a bird's-eye view of Ghent.

It is truly a beautiful city; four rivers converge there, the Escaut, the Lièvre, the Moer, and the Lys. It's a network of flowing waterways, constantly twisting and untwisting between the houses, that divide the city into twenty-six islands; which means that with its boats, its countless bridges, its old facades fronting the water, Ghent is a kind of Venice of the north.

Just at the foot of the cathedral, within a dense block of oppressive Flemish houses,

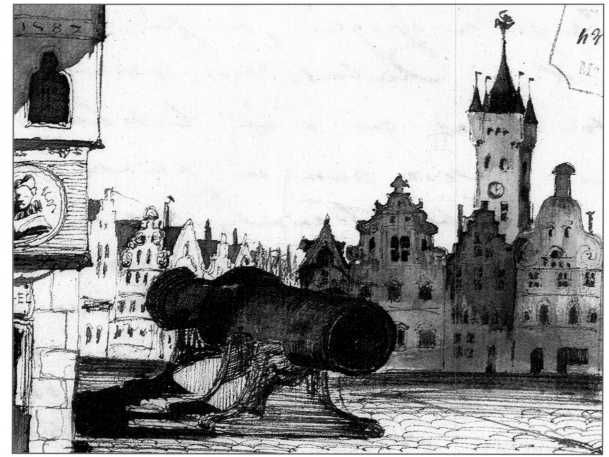

my guide pointed out to me a pretty garden courtyard, smart, green, and sanded, surrounded by a columned portico of the last century, all rocaille and curlicues, with a colonnade and statues made of blue marble. This house and garden couldn't be fresher or gayer. It was the residence of the old millionaire Maës who was so miserably assassinated two years ago and who filled his old hats with gold.—Now construction is under way at his house, they're adding another floor, joy and riches are there. I never begrudged this old man.

There are many rocaille facades in Ghent among the Gothic gables, as agitated as can be, which makes them pass muster. Rococo is bearable only when it is extravagant.

But is all this chatter boring you, my poor dear? I prattle on as though we were sitting by our fireplace in the Place Royale. I'm telling you everything. I'm passing on as much as I can. Let me know, my dear Adèle, if my account doesn't amuse you.

Now here's something that will make you laugh. Just now, leaving Ghent, between Ghent and Audenarde, I saw a tavern sign in a village painted with the figure of a man with his hair cut like Titus's, with large side-whiskers, gold epaulettes, a blue uniform with white lapels, and the Cross of Leopold around his neck. Below was this inscription: "Louis XIV, king of France." I report things just as they were. I've invented nothing.

In this country one encounters neither manor houses, nor keeps, nor castles. One sees that it's a country of communes and not of lords, of bourgeois rather than squires. By contrast, everywhere there are town halls, charming stone flowers that the fifteenth century especially made blossom splendidly everywhere in the middle of the towns.

Here, for example, in Audenarde, where I'm writing to you, and which is only a small town. I can see from my window in the Hôtel du Lion d'Or the profile of a ravishing town hall in the most florid Gothic style topped by a real stone crown, surmounted by an armed and gilded giant carrying the town's blazon. The whole of the square I have before my eyes is charming, although it retains too few of its old gables. In the middle of the town hall's facade

there's a small fountain from 1676. The duc de Saint-Simon was only a year old when it was built. Beside the fountain a beautiful poplar; and then, over there, below some houses, a beautiful bell tower in a severe Gothic style. The setting sun is casting beautiful angled shadows over all of this.

In Flanders they have the idiotic custom of closing all the churches at noon. After noon there is no praying. The good Lord can busy himself with other matters. This means that, of the two churches in Audenarde, I was able to visit only the smaller one, which was still quite remarkable, with a Romanesque apse.

It has two beautiful, scandalously mutilated tombs. To see them I had to brave a battalion of old women washing the church, and who advanced, grumbling, to scrub the pavement under my feet. I had the satisfaction of eliciting several Flemish curses from their mouths, which I let echo peaceably through the church.

These worthy Flemish ladies offer further justification of what I told you about them. They devote twenty-four hours of the day to washing their houses and the twenty-fifth to washing themselves. For the rest, they are for the most part quite pretty, almost all pale with dark hair, like yourself, my dear Adèle. On Sunday they don beautiful lace caps of charming shape. In Lier these are secured with sparkling ribbons that are quite distinctive and quite pretty.

It goes without saying that here I speak only of peasants. The women of Brussels wear Flemish silk mantles, almost mantillas, which drape them admirably.

[I saw the large cannon of Ghent, of which I provide you with a small drawing. It's an enormous tube made from sheets of cast iron, a real fifteenth-century machine. The inhabitants of Ghent take few pains with it. They've stuck rococo stonework with garlands on three sides, and the mouth of the bombard is just a trash receptacle. This cannon is eighteen feet long and weighs thirty-six thousand livres. One can readily make out on the inside the grooves made by the iron sheets. The mouth is two and a half feet in diameter. It fired large balls or tons of grape-shot. It's enormous. It's nothing, however, beside the bombards of Mohammed II, drawn by four thousand men and two thousand oxen and which vomited immense stone blocks. They were kinds of volcanoes that the Turk aimed at Constantinople.

There are beautiful paintings in Saint Bavo, especially two: one by Rubens, the other by Jan van Eyck, the inventor of oil painting. The one by Rubens, which represents the entry of Saint Amand into the monastery of Saint Bavo, is admirable. The group at the bottom is superb. The other, in a totally different style, is no less marvelous. Van Eyck is as calm as Rubens is violent. There is also a beautiful painting by a student of van Eyck, and another, likewise beautiful, by Rubens's master. In Paris we scarcely know this Otto-Venius [Otto van Veen] who was the master of Rubens. A remarkable thing! He, too, is a calm painter.

Moreover, all of these Flemish churches are museums.] I'd like to see our good and dear [Gustave] Boulanger* there.

That aside, I prefer our French churches. The ones here are much too clean. When it comes to monuments, excessive cleanliness is a great fault. First it entails whitewashing, that supreme obscenity, and then scraping, and then perpetual washing. Now the coloring of centuries is always beautiful, as is sometimes the dust of a day. One is the trace of generations, the other is the trace of man. Everything in Belgian churches is white, sparkling, polished, scrubbed, glistening. At every step, there's the harsh, shrill, unsparing contrast of white marble and black marble. Very few of those beautiful gray and mouldy tints of our old cathedrals. No stained-glass windows. Smash the stained-glass windows and whitewash the churches, often knock down their choir screens as well, such is the program of devastation favored by priests. They want to be seen at all costs, for which reason it is necessary to whitewash the windows, whitewash the walls, and knock down the choir screens. Oh affectation, who would expect to find you here?

Since I've been in Belgium I've seen only two or three choir screens, and those cruelly painted in loud colors, two or three stained-glass windows, only two churches that were not whitewashed, St. Waudru in Mons and the Chapel in Brussels.

In Belgium, none of those beautiful portals

*Gustave Boulanger (1824–88). French Romantic painter

encumbered with admirable statues, as at Chartres, as at Reims, as at Amiens. The portals of the most beautiful cathedrals have but a single sculpted figure. It's odd. True, a spire like the one in Antwerp compensates for many things. What a magnificent work! It's as much goldsmithery as architecture. And I'm talking about a piece of goldsmith work that's five hundred feet high.

September 15, 1846: Letter from Charles Giraud to Hardin

[My dear Hardin
It was very kind of you to think about the exile. Your letter found me in the middle of my garden: I was giving myself over to husbandry. I immediately dropped my pickax and rake to devour your letter beneath the shade of a palm tree. Its length didn't frighten me, quite the contrary. When I got to the end, I set about rereading it to make sure I hadn't forgotten anything. My brother persists in not sending me any news. Gibert has forgotten me. Only you think about me. Not only because I'm very grateful to you but because illustrations give you pleasure, I'll scatter some throughout my letter to strengthen my narrative.

Before telling you about myself, I must report the death of J. Bovy. Things are not going well in this family. Is Daniel, of whom you say nothing, doing better? Did

you replace Leleu with Gibert? This enchants me: we could enjoy ourselves together: you who love strolling would come and get me at my house and we'd have at one another until we got to your place, walking all the while (it's not far). So Élisa has gotten into preserves: what luck! I'd embrace her; are there sweeter circumstances? For her everything is milk and honey. How I'd like to be there to give her advice and encouragement! Remember, my dear Élisa, that there's no pleasure in life without a little work: it's Monsieur Florian who said that. Another prankster said: Work, exert yourself, the background [fond] is more finished than the rest (he said nothing about funds [fonds]). My advice to you is: Courage, perseverance: you already have my business, and you could put on your shop sign: Licensed by the Painter of Queen Pomaré. I'll make drawings for your candies and Hardin will make up some slogans for you. Isn't your fortune already assured? I'm annoyed that this poor Henriette sees you so rarely. You could give her some good advice. I'd like to know she's on the path of good fortune like you. I'd like to have heard a word from her as well, even a simple greeting. For a moment, I'd have thought I was surrounded by all my friends on the rue du Sabot. I haven't forgotten the wild times we had together and Henriette's laugh. It's all fresh in my memory, but that's over now. We've become grave, serious. We think about the future, fools that we are! Isn't life in the present? So you're painting. Good, all the better: but don't have the

vain desire to paint finished paintings, make studies, good and serious ones that you can exhibit.] When one embarks on finished paintings at too young an age, one inevitably becomes false. What's more, don't you have Corot to guide you, and he, better than I, will tell you what you should do. You couldn't have a better master for working from nature. Regarding Corot, I saw his name in the papers. The Salon reviews do nothing but list the names of the exhibitors. I'd prefer to have the Salon booklet. Let's return to Corot. He is reproached for his awkwardness, even as he is praised for his truth, but if he were more artful he would be less true. Facility is a slope that's difficult to avoid slipping down, it's like an excess of intelligence that makes you stupid.

You ask me for information about the landscape of this country. Have you by chance any desire to make a short voyage to Cythera? It's beautiful for the bourgeois, for the curious, for promenaders: it's new, but its colors are ugly. The sun at its zenith colors objects badly, everything's black. Only in the morning and evening is it tolerable. The trees have bizarre shapes. The palm tree is elegant, but it's not worth as much as an oak or any other tree: there are beautiful plants, but they're not worth a trip. In the way of landscape, I've done very little, some sketches, not a single oil study. I've given myself over completely to portraiture, which is to say that there are lots of painted head studies at my place. It's a veritable gallery of cartoons, all the great men of Tahiti are represented there in fancy dress. I paint out of vainglory.

I don't know if they're any good. When I get back to France I'll take stock. I need to get back, to see the Salon, sometimes it seems like I'm not a painter anymore. I hope to leave in the month of January on the *Meurthe*. For a moment I was tempted to leave on the *Seine* and go to New Zealand. It's a good thing I didn't. The *Seine* was lost. Happily, none of the crew perished. We expect them here in a few days. I'd have been able to add a new calamity to my conflagration. Saddest of all, I'd have returned to France after an absence of four years without a single drawing. After having done nothing for two years, I made up for lost time. I have a presentable collection. I could have had more, but the war prevented me. In truth, there are rifle shots everywhere, all you can see is smoke, there are no groups. The only episode where there was hand-to-hand combat was in Maohena, and I wasn't there. That's the only place I would have been able to do something. I note that in everything I write you, there's scarcely anything suitable for illustration. I see I'm obliged to recount my [military] campaigns in the manner of Monsieur de Norvins, illustrated by Horace Vernet. That will be for next time, for I leave tomorrow for Faaa where we have an outpost. I'll make a drawing of it and when I get back I'll continue my correspondence. Tomorrow I have to be ready to go at 4 o'clock, so I'm going to get ready for bed.

My trip went well. At four o'clock I unfurled the sail of my dugout canoe and the Giraud family was off. At about the halfway point we had lunch on the small island of Mota Taiti. From there, we went

to Faaa, and I was back in Papeete by evening. Here's how we live here. Every Sunday I take a similar trip. During the week I work. I spend most mornings caring for my garden.

Around nine o'clock I go to breakfast, at ten I return. I prepare my palette while smoking my pipe. At noon a second pipe. At four o'clock dinner, then a pipe, a pipe, and a pipe—on average a dozen pipes every twenty-four hours. But I promised you an account of my campaigns: I must keep my word. Would you believe that toward the end of 1845, I came down with dysentery while returning (it's an effect of the war) from a tour of the island of Tahiti. For my recovery, the doctor advised me to go to Bora Bora, one of the Leeward Islands. So to recover I packed my bag and embarked on a steamer. After a day at sea we put in at Huahine, the prettiest of the Society Islands before the war. We remained there a day, then the next day we set sail, or rather steam, for Bora Bora, where the frigate *Uranie* was having difficulty with the rebellious Indians. Instead of remaining on board where I'd never have managed to do anything, I preferred to settle in on land where I had plenty of models. I'd already been working for about a fortnight when the frigate received orders to head for Mahina, to demand reparation for I know not what. So it left, leaving me with a schooner and thirteen crewmen, the defensive works incomplete—which is to say that the year before we had built a fort, but the *Uranie* had wanted to perfect it by adding to it, and the added part compromised the defenses of the old work: perhaps the plan on the next page will give you some idea of

the thing, the new work being made of sand and thus ineffective as protection against bullets, as we subsequently saw—in short, we had to fend for ourselves with meager resources, thirteen men, some sixty Indians on our side, in all seventy-three men capable of defending themselves without counting women and children. At first everything seemed calm. I even visited the rebels, who received me well. One fine day, news of our disastrous victory at Nuahine reached the rebels' camp along with orders, doubtless from Pomaré, forbidding them to communicate with us, for we received a messenger who forbade us the Faanui district, where the rebels lived. Being the only one who understood Tahitian and was able to speak with him, I found myself second in command, minister of indigenous affairs. So we drafted, the captain of the schooner and myself, a vigorous protest, in conformity with orders from the Commander of the *Uranie*. I took it upon myself to take it to the camp. When I arrived in their camp, they threatened to fire on us if I didn't leave immediately. Three times I sent messages to the chief that I needed to speak with him. I had the letter of protest carried to him, which he refused to read, so I set it up in the middle of the camp and left in all haste, my mission accomplished. Three days passed without our hearing a word from them, on the fourth we saw two armed men in the brush who doubtless had come to spy. The next day an individual came to inform us that Pomaré's people were planning to attack us at daybreak. Having anticipated this for some time, we had taken precautions, defensive trenches had been exca-

vated, we'd made use of all our meager resources, the Indians even seemed confident. At first light we discovered on the headland—at about a thousand—the fires of the Indians making their breakfast. We were on our guard. At about six o'clock, the first gunshots were fired. We sent out a reconnaissance party that got into trouble. We had to send in back-ups. We lost one man and two were wounded. We shot at each other all morning, until noon. There had been no fire for two hours when a messenger came to tell us that the next day people newly arrived from the Jaiatea and people from the Anao district would join forces with them to attack, after which the messenger recounted the losses: to his knowledge, one man had been killed, but we learned afterwards that seven persons had been killed or wounded. Throughout the commotion, I cheered on [our] Indians. I directed their blows, a sabre under my arm as sign of command, with bare feet because I had no more shoes. The captain commanded the blockhouse.

The messenger's news upset all our Indians. Chief Tefaova wrote to the chief of Elnao asking for his help the next day. The latter answered that instead of being for us he would be against and would come to augment with his men the people of Baiatea and Faanui. Dismay was at its height. The captain of the *Sultane* and I, we fortified them. They seemed to prepare themselves anew for the next day. The camp was again barricaded. We moved everything inside that we could. On the other hand, our thirteen men had resolved to put up a vigorous defense. I went to bed anticipating the day that would follow. Around midnight, chief Tefaova sought me out to tell me that he was alone, that all the Indians had been seized by terror and fled. I got up immediately and it was only too true. I then sent word to captain of the *Sultane*. I proposed to him that we burn the whole camp and then rejoin the *Uranie* at Huahine. As this was the only option, he didn't hesitate. Thirteen men to defend a fort able to contain five hundred combatants in addition to the schooner with a student and a cook on board. So we burned our entire settlement as quickly as possible and during this operation were extremely uneasy, for we no longer had any defenses. Everything turned out well. We were not disturbed and our vessel was able to set sail only the next morning. While we were preparing to embark, all of our Indians accompanied by their families came on board and when the vessel set sail we were full up, without a single man having defected to the insurgents. Imagine three hundred people on board a thirty-foot vessel, women as well as children, the wounded, etc., all without water during extreme heat, and you still won't have an accurate idea of our suffering. After three days of navigation we reached Huahine. At our entry we had the spectacle of a little skirmish. To enter the roads, we had to hug a little point where the Indians were accustomed to lie in wait to fire on entering vessels. This time we were ahead of them and they took much fire, leaving one man behind

and ourselves, we took some hits broadside. The Bora Borans were settled on shore, we took away their arms and, next day, we set out to reconnoiter the enemy from the mountains above their camp, where fifteen days before we had proved unsuccessful. When we were discovered by the insurgents, we withdrew. Not a single shot was fired during this excursion. Huahine, where I had previously spent six weeks and which I had found the most beautiful spot in the Society Islands, is now nothing but rubble. Everything's been razed as far as the mountain. All the cabins burned, the trees cut down. If I could paint with the pen as well as I can with the brush, this would be the moment to display my skill, but I give your imagination free rein. When I return I'll give you a more detailed verbal account. In the several days I remained at Huahine, the enemy Indians fired on our camp from close range without managing to wound anyone. Unable to do anything, I profited from the departure of a steamer to return to Papeete. The *Uranie* received orders to return. I forgot to tell you that the Indians had hoisted a cannon onto the top of a mountain and that, from there, they fired half a dozen balls that all hit the frigate without wounding anyone. One fine night when it was pouring, Tefaova and a few men climbed the mountain and rolled the canon back down. This was the finest act of the Bora Boran monarch, whose portrait adorns my collection. Although his courage and composure have been much praised, he was the cause of our fleeing Bora Bora, and I was able to judge him under different circumstances at Nuaciena [?], for example, where he was constantly at odds with his people. Whew! Writing a whole treatise like this certainly is exhausting. I hope the reader's response isn't the same as mine. I'm smoking a cigar to recover.

[We had not expected, my very dear Bilboquet, to hear from you so soon. It is charming of the head of the troupe to be so thoughtful of his friends and to profit from the slightest moment to send them news: we are enchanted to know that your vases will soon be in Paris and I hope that you'll be satisfied with the way your saltimbanques carried out your instructions. How did you reach Paris? Not too tired? Write us about all this quickly, for we [are] uneasy and very impatient to know that you are already comfortably installed in the rich apartments of Hôtel Bilboquet, surrounded by all the masterpieces of indigenous and exotic art and magnificently attired in a beautiful housecoat of white cashmere while holding your morning cup of chocolate, after having spent the whole night writing masterpieces like the wicked old cousin, or the friends Pons and Schmucke who went "prickapracking" together. I've made some magnificent purchases here in the way of sphinxes, which as you know are my great passion in butterflies. I bought one, above all, that's the rarest in Europe and comes from Crete. We will remain here until Wednesday because of the mail-boats. The conveyance that will transport the brave saltimbanques to Dresden is magnificent and causes riots in our hotel, which, as you can imagine, makes us quite proud

May 2, 1843: Letter from Gérard de Nerval to Théophile Gautier

[My poor cat. I am indeed in Cairo, in the great Cairo and nowhere else, near the Nile and the pyramids. I say, that's not bad, but the place's charms aren't inexhaustible, and it's two months now that I've missed you terribly. Since the consul's departure, I've stopped seeing *La Presse*, where you spoke to me a little, very little, yourself; and I haven't received any letters; I count on finding some in Beirut. It's true that here you have to write three before one arrives; it's probably the same at the other end. I want to try not to describe the landscape to you, as you'll surely come here and probably talk about it much more than I, it's important that you not have ideas in advance that are too precise. The city of the Thousand and One Nights is a bit dilapidated, a bit dusty, yet something can still be done with it. You're right to do a ballet about Cairo before seeing it. Set it in the period of the Mamluks instead of in the present, otherwise you'll have to have extras at the Opéra dressed as Englishmen in mackintoshes, with cotton piqué hats and green veils, marvelous Frenchmen proudly wearing the fashions of 1816 in tatters, ridiculous Turks decked out in the uniforms of Istanbul, etc. You mustn't neglect [gap] [seen from?] Mokattam, a mountain that [gap] if you need gardens, there are some on the banks of the Nile and those in Rodda [are?] delicious: Arab gardens are quite distinctive and you probably won't find any prints of them.

[drawing]

I'd like to paint for you a kiosk that's in Rodda but I can't; it's a stairway of terraces with green arbors one surmounting the other, culminating in a pavilion on top, a bit like the Isola Bella in Lago Maggiore but lighter, then lots of cypresses to sad and charming effect with doves perching on their tips. But what's marvelous and what I'm even less capable of rendering [drawing] are the plant beds tracing carpet patterns, flowers, patterns of very tall tamarind trees. There's something funereal about this that makes one feel women should be strolling about in the moonlight, around the pools.] There are arbors of jasmine, [drawing] and myrtles pruned like this or circular, lemon trees [drawing] pruned identically like distaffs, orange trees heavy with fruit, but not pruned—large painted galleries forming bird cages, a marble pavilion with

columns] where women bathe with the master looking on. I regret not being able to send you my daguerreotype proof of the latter, which is in Shubrâ; some painter will provide you with a design; there are crocodiles and lions spouting water, everything's illuminated during fêtes. The whole thing, in effect, could be set at night with the moon. I greatly regret not being nearby to explain everything to you, but by taking the Shubrâ gardens as your motif you could do something ravishing. In the way of mores I've seen some very curious things—the Easter of the Copts and the feast of the birth of the Prophet, then the return of the pilgrims, when the emir of the hadjis rides on horseback over the *backs* of a crowd of the faithful—then the marriages, an exact description of which you will find in two volumes by an Englishman named *Lane*, entitled *Moeurs des Égyptiens*.* There's a very good dance for the Opéra in which the Nubians do [gap] almahs while others strike [gap] clay that they carry on the shoulder of a [gap] male soloist leading the dance and doing [gap] and a woman, her head covered with a black silk veil with an ample striped robe, directs everything with a curved sabre, performing a kind of Pyrrhic dance, advancing, withdrawing in front of the procession; there, as in the marriages, everyone holds a candle if it's night and they carry bundles of candles and fire-pots. The woman fellahs wear very gracious costumes—the Opéra could easily manage some. Perhaps you'll be seeing a deaf painter who left before us and whom I told to go see you.

My friend, I'm a scoundrel. I always write you when the mail's about to be sent off, and what's more today. I'm leaving myself. Fonfride is a rather decent fellow. He bought me an Indian slave and wanted me to fuck with her, but since I didn't want to, he didn't fuck her either, and there we are. This woman was very expensive and we haven't any idea what to do with her. Other women are easy to come by. One can get married in the Coptic way, the Greek way, and it's much less expensive than buying women, as my companion was beastly enough to do. They've been trained in the ways of the harem and they must be served, it's exhausting.

So here's the thing. We leave today for Damiette with the woman

*Edward William Lane, *Manners and Customs of the Modern Egyptians*, 1836

and a whole party; from there we go to Beirut. The trip will come to an end this fall. I often think of you; I dream of you; I do nothing. One is very sluggish in this climate. I've read a great deal. I'll do no more than one or two articles on mores that I'll send you, but there'd be an enormous amount for you to do. You must absolutely write to me in Beirut; try to join me there this summer, leave after the ballet, without you, I'm like an idiot. Time is short, farewell. Tell me if Henrietta had a success and what you decided to do. Give my regards to Pierrot, to [gap] where there were thirteen of us, the [gap] is finished. I'm the one who risked the most. But the pestilence spared me. I'm as fit as could be and find the weather cool rather than hot. I embrace you with all my heart my poor friend, and I'll write you when I arrive.

Farewell.
Gérard

of this distinction. Farewell, my very dear Bilboquet, write us soon, for we think of you always, and the question "What's dear Bilboquet doing?" is on our agenda morning and evening and every hour of the day. Farewell, then, hoping that we will soon be seeing, dear and good Bilboquet, our excellent and unique friend.

[Gringelet]

[on the verso, a note from Madame Mniszech]

Dear and good Bilboquet, I had just gone to bed when Mama sent us your note announcing that you had arrived in Fosbach unfatigued and without a cold, and we await with great impatience the letter from Paris promised for the next day. I'm writing everything askew, for I have a bad cold and it's already quite late, but I know the good, dear Bilboquet will forgive me. What do you say to the monstrous sphinx that dominates the first page of our letter and that Georges has just christened so pompously! He's made some superb acquisitions here in the sphinx way, and has been quite busy all day today, with a long visit paid him by the burgomaster of the city Monsieur de Heyden, who busies himself greatly with etymology and possesses a superb collection of microlepidotera. Mama, thanks be to God, is doing quite well, she was a bit tired this morning but a long nap in the afternoon completely restored her. Au revoir, good, dear, excellent Bilboquet, work well but try not to abuse your strength too much and not to exhaust your dear health which is so precious to your friends.

The very happy
Anna Zéphirine Mniszech

[Note from Madame Hanska]

Since I wrote you this morning I think you'll allow me to dispense with repeating to you that I was very touched by your remembrance and by your fine letter from Forbach, this new proof of affection that you've given me, for it's the dominant thought of the moment—imagine, at the very moment I was writing you the children sat down in the same chair in accordance with the usages and customs of a honeymoon, which I hope for them will be unending, and fell, the both of them, as far as the other end of the room, you can imagine how apprehensive I was. Happily, all ended in laughter, but I'm still a bit distressed. Farewell, my dear, au revoir.

[Atala]

[Address]
To Monsieur
Monsieur de Balzac
poste restante
in Passy near Paris

[Around the address]
From professeur
doctor and *Kaulèopeutherien*
Georges Wandalin Gringelet Mniszech

December 15, 1848: Letter from Adolphe Armand to his friend Délègue

[My dear Délègue,

Doubtless you're quite surprised to receive, unexpectedly, news from a poor philosopher who's been carried 150 leagues from his stomping ground by the political hurricane of June. I've long reflected in my *ponton* as to what course I should pursue regarding this letter, and you would have already received it if I hadn't judged it appropriate to begin it over again to cut short any grounds for delay. So I address myself to you, to your old friendship for the family, to beg you to give me some news of it as well as of yourself, and a short word about the quarter, and above all about the family. When I was in the faubourg or in Paris, I had it when I wanted it, but distanced as I am and always uncertain of going or coming I know not where, to Algeria, they say, all that I've suffered has not completely stifled in me the feelings of natural interest I bear toward persons who are so far from returning them, and it seems to me, of course, very cruel to be the *only one* deprived of all ties with his relations. There are people of all sorts among us, and there's not a single one even among the most destitute of the lowest class who doesn't receive, almost as often as the most distinguished men in the *ponton*, their share of consolation and solace. This last item is, to be sure, the one that least concerns me, but a line, a word from someone in the family or from a friendly hand telling me about them—I'd pay for it with anything that might be inflicted on me. It is difficult to imagine the joy and eagerness with which everyone on the *ponton* rushes forward at the signal of the distribution of mail, and myself, I follow suit only to witness the contentment of others.] As for letters from comrades, I've received two, much surprised that they were able to ferret me out at such a distance. That's good but cannot be compared to a line from another quarter. At the fort of Romainville, I received with as much pleasure as surprise a visit from Mr. Nublat that I was far from expecting, for he had heard where I was only indirectly. So this initiative on his part touched me very much. It was above all after his departure that I felt, in my solitude, all the evil that can be done to someone naturally inclined to affection by breaking all the ties that attach him to his family, itself generally inclined to benevolent feelings. But cunning, audacity, and influence deriving from one's position can do many things, especially in certain cases . . . But let's move on, that's no longer in question. I was happy, then, to receive a visit from Monsieur Nublat, but some time after I was among those included in a departure that took place November 1, at ten o'clock in the evening. As we were still unaware of what might become of us in such circumstances, a statue maker who remained with the others in our cabin promised me, at the door, when they were beginning to secure us, to write to Monsieur Nublat's address to apprise him of my removal.

Having arrived at the Fort de L'Est during the night, at six o'clock the next morning I left a word written in haste, as did all the others, but our sudden departure, despite the promise of seeing our families, meant that only a few could say good-bye to their relatives, who'd had the idea of rushing [to see them] without losing an instant; the others were able to see their own and make their farewells only from a distance at the exit of the fort in the glimmer of thousands of candles, some 500 people tied together and restrained by four rows of bayonets. This picture, which I described since, in my last letter of September 10, was one of the most extraordinary that's ever been seen and would certainly merit depiction by some famous brush. Reaching the vast harbor of Brest on the fourth, we were taken to our *ponton* the next day, and only on the tenth did I address a letter to Monsieur Nublat, then another one a few days later to Cousin Duchon. Since then, I've continued to wait, in vain, for even a word, not of consolation, I've absolutely no need of such on the one hand, but a friendly word that might provide me with some news. It's true that our correspondence is subject to many difficulties. A great many letters have been delayed; some letters from Paris were even distributed on board long after others bearing more recent dates had already been

answered, but finally they arrived and myself . . . I climbed up to the bridge like sister Anne to her tower, but there was nothing for me. I admit that no one is obliged to answer me, but I thought some [hope] had been warranted by Monsieur Nublat, whose visit had been all benevolence, even though I had not prompted it. The silence pained me all the more because on February 26, Monsieur Nublat recognized the gist of my thought and learned, doubtless for the first time, the true cause of my misfortune and my misery, even as his good heart prompted him to allay it. Finally, Monsieur Nublat is a man too independent and with too firm a character for me to suppose that he has changed his mind without cause. So I absolutely don't understand. On the other hand, I'll tell you that I'm not without uneasiness [for his sake]. Scarcely a day has passed when I haven't thought about what he told me of the losses he has suffered. I try to convince myself that the blows against his position were not strong enough to subvert it completely. However, I don't know what might have happened to him in the meantime, and I'm all the more uneasy about this as I've never been uneasy about myself. So I'd be very grateful to you if you could reassure me as much as possible about all these things. Above all don't forget, beginning with mama, of course, to give me news, news of my nephews and nieces, etc. etc., the whole clan. For the reasons that have separated me from all these people I loved, I had to stop pestering them on my own account some time ago, but if I've alienated their affections, even incited their contempt, I still manage to love them because I'm sure they would still love me if they still knew me. This conviction has almost always been enough to compensate my heart for everything that it has suffered unjustly. That is why, my dear Délègue, I entreat you to give me news as promptly as possible; I await your response with confidence, and I will bless it a thousand times especially if it answers to my wishes. With regards to myself, I'm still doing well; captivity on the *ponton*, like all events of the same kind, won't be able to influence someone as used to vicissitudes as I am. The health of the detainees on our ship, as on the three other ships in the harbor, is generally good; the weather, at first rather fine, has of course grown worse because of the season, and the sea doesn't always make it easy for us to stand up straight, but by now we're sufficiently used to it to be able to walk with an occasional stumble, something from which the sailors themselves are not exempt. The days have grown so short that we must abandon the bridge around four o'clock and return to the inside of the ship and pitch our hammocks, which, once they're hung, oblige us to move around on our hands and knees. Thus most of those who go to sleep immediately remain until reveille, in other words from four in the evening until eight in the morning.

For myself, I don't go to sleep until rather late, given that I always manage to occupy my time reading or chatting in groups that gather to pass the time. During the day, many who've managed to buy tools pass the time making little objects out of bone, etc. etc. Tailors keep themselves quite busy, shoemakers, artist-painters, draftsmen earn money; myself, if I'd been able to obtain what was necessary I'd have been able to improve my situation considerably. Sometimes I've profited from the good-will of a painter of flowers on porcelain to make little drawings with his colors like the ones you see, and I'd have more orders than I could meet, but it's impossible to take advantage of this without abusing what was only lent to me in passing, as a favor. After the punishment of being separated from their families, which is the worst part for most, it's the uncertainty and idleness that's most unbearable. The food invariably consists of dry vegetables for lunch, small beans, peas, and string beans for lunch [sic]. The beans are small favas, most of which we throw out because we can't get used to them. For dinner, we have greasy beef soup and twenty-three liters of wine. The bread is not the best but isn't bad. Between the two meals, those who don't want to eat their dry bread can buy various fare (even roast chickens), such as fruit, butter, charcuterie, etc., which are sold at very high prices by a sailor authorized to operate a little market where one also finds spices, haberdashery, etc., and tobacco at roughly normal prices. Tobacco is what sells best, and by means of a little permanent subscription it's even provided to those momentarily lacking cash. As for myself, thanks to my brave Héry, my respectable friend, I've not yet lacked for anything. This brave Héry, my comrade in arrest, is one of the oldest foremen at the Choisy factory. This factory sent him a hundred francs, the yield of a collection to which Monsieur Fauler himself contributed a substantial sum. They also sent him a pouch containing a veritable trousseau of winter clothes, all new. Regarding clothes, the maritime prefecture in Brest expressly delayed their distribution as long as possible so they wouldn't have to give any to those who'd received them from their families. Many foresaw this and arranged for nothing to be sent. For my part, I got a good linen chemise, a kind of smock, and some pants of the same fabric, a wool cap, and a pair of sabots with some socks. This outfit makes one look like a rower in his Sunday duds. But the tailors got involved, and by means of some rather elegant alterations this ridiculous aspect has disappeared, at least for a great many. In general, the 500 or so [men] on our *ponton* come from just about every class of society. There are journalists, professors, artists of all kinds, lawyers, students, *property owners*, merchants, shopkeepers, and workers from all industries. Agewise, the range is from boys of 13, 14, 15 years to old men of 70 and 77 years. We have three hunchbacks, three one-eyeds, four or five who limp or are bandy-legged, two who completely lack one arm, one of whom was no less than an officer in the Garde Nationale. The Garde Nationale it-

of our life on the *pontons*. I imagine it's much the same on the others we see in the distance, and whose prisoners are only recognizable with telescopes, which happens often when they come to the front of the ship, onto the long overhanging point called the prow. It's an area where we often meet one another during the day. A commission has just arrived from Brest with new instructions regarding the *pontons*. We await our turn. There is talk of return on foot for a great many who are to be given their liberty; I have my doubts. In any case, if it should be true and I'm among their number, I will certainly make my way on foot, which I'd find agreeable, but I'm not much of a walker and the rest stops along the way would be very brief, but without them I'd never persist. In the meantime, my good Débègue, I shake your hand. Embrace Madame Débègue for me.

Your entirely devoted Adolphe Armand

self is represented by all ranks, including that of captain. We have three recipients of the Légion d'Honneur, including the captain, we have musicians, artillerymen, and linesmen from the Garde Républicaine and the [Garde] Mobile. The prevailing mood is always calm and quite resigned, in the midst of uncertainty, we are constantly mocked by a thousand contradictory bits of information gleaned from letters or from the few newspapers that happen to reach us. Thus the days pass in conjectures of all kinds that get us more or less excited, and that center in turn and unceasingly on partial liberties, general amnesty, transport to Africa, the presidency, Cavaignac, Bonaparte, Ledru-Rollin, the famous decree of June 27, so cruelly sustained by the orders of the day due to [?] despite the eloquent words of Ledru-Rollin. I will conclude by telling you that the navy guards, which change often, behave quite well toward us the sailors are good kids, generally gay and affable. As for the good people of Brest, they now hear talk of us without their hair standing up straight. So, my good Délègue, that should give you some idea

Please send me a response.

There are four people on board from quartier I of the Gobelins: a wine merchant, a furniture merchant, a currier, and a lawn tender (Bonnefoi).

[Address on the letter]
To citizen Armand Adolphe
imprisoned on board the *Uranie*

Place in an envelope and send to
Monsieur Cornevin
President of the Commission des Détenus Politiques
in Paris
It's at 12, rue Caumartin.

December 24, 1854: Letter from Théodule Devéria to François Chabas

Ministry of the Maison de l'Empereur
Direction Générale des Musées Impériaux

[Palais du Louvre, December 24, 1854

[My dear Monsieur,

As the copy of Rossellini in the library of the institute was at the bindery, I had to wait until today to answer you. The word placed next to a fisherman is [hieroglyphics], at the indicated place: in the explanatory text, Rossellini breaks it down into [hieroglyphics], which he doesn't translate, and [hieroglyphics], analogous to [hieroglyphics]—which strikes me as highly problematic! It seems to me the bas-relief is better reproduced in Lepsius, II, bl. I send you a sketch:

[sketch of two young fishermen alongside a stream] + [hieroglyphics]

Fish, and perhaps fishing and fishermen, are in question in several places in the *Select Papyri* of the British Museum, particularly in *Anastasia* III and IV. I have unfortunately not had time to study them deeply but I find the word to be plural [hieroglyphics]. I think it's the same as

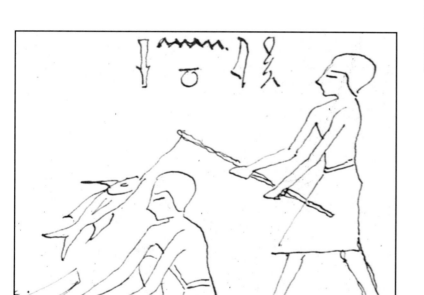

the one in M. Cailliaud's pottery fragment, which he also interprets as "fishermen." It's in a passage that is analyzed but not translated by Mr. Heath, perhaps I'll find other examples in the rest of his book, for looking through I noticed that fishermen are discussed in several passages. But lacking precise indications, I was unable to find the portions of the text he was talking about: this could be done only by following his translation with the text, the one beside the other. In

any case, I nowhere saw the word [hieroglyphics] used to mean fisherman. I totally agree with you about the phrase that you cite: your translation is much more literal and consequently better than that of Mr. Birch. In his dictionary, Champollion gives the sign [hieroglyphics] as expressing the general idea "shepherd, driver of a herd of quadrupeds, of whatever species." But he doesn't give its true phonetics [hieroglyphics], and he cites the word [hieroglyphics] "doorkeeper, guardian of a door." Furthermore, the verb *ari* is used, I think, in the sense of "to guard, to conserve, to reserve," whatever the object *cf.* T 81.1. "I am the Lotus pure issue of a splendid [?] reserved for the nostril of the sun god, reserved for the nose of the goddess Hathor" (the variants give [hieroglyphics]). This meaning has no relation to a herd of quadrupeds, and I see no example where this word used substantively and in isolation would obviously mean "shepherd," but wouldn't other examples be needed before advancing that of "prisoner"?]

If Monsieur Pernet passes this way, I'd take the greatest pleasure in seeing him and I'll give him the copy of the Prisse papyrus, in which I found, on seeing it again, many more gaps than I'd thought to have left. It would be possible, I think, to fill in some of them, providing a [more]

fluent translation.

Please accept, my dear Monsieur, the warmest compliments from your very affectionate

T. Devéria

[in the margin] answered December 27, 1854

October 28, 1857: Letter from Charles-François Daubigny to Geoffroy Dechaume

[My old friend,

Good evening. I waited to write you about the regular progress of *Le Bottin*, I could say irregular, for now that we know the country better, it's a bit by whim. But we're beginning to get used to this nautical voyage and we really encounter only good people. You must know from my wife that I returned to L'Afferte. Unfortunately, you

took the good weather away with you, such that we haven't seen the Herblay countryside in anything but gray weather. We went by the islands, and we had a bit of a scare getting past the two fragments of the bridge that we saw together. We no longer sleep on the boat. We even made a gift of our two bales of hay to Neptune so he'll look kindly on us. However, this old beggar made us break an oar in the middle of the water below Triel, such that we returned to father Creté and a wheelwright repaired it for us. We consoled ourselves by drinking some new wine with father Creté, who gave us some very good information. He's a very brave man with scads of medals for having saved eleven people from the water. He told us not to navigate when the water's high, but until now the water has been rather low and I'm instead afraid of rocks in the currents. We've already sailed twice in the dark of night but we knew the way: once going to Triel, the other time returning to Meudan. We hung our lantern, which lit up the whole Seine: the effect was very amusing. As you see, we're moving in short stages, the days are so short now, especially when you want to make sketches along the way. You have to see the grrreat sketching commotion on board *Le Bottin*, what diligence. All that's lacking is the teacher!!!

Alas, cabin boy No. 1 performs his duty well since I bought him a dishcloth. We're

very lucky, for the weather this morning, October 29, is superb. As you see, we're in Mantes. If I'm not afraid of wasting too much time, I'll seek out a man named Félix Cartier whom I haven't seen for thirty-nine years and who's supposed to be established as a clock-maker here. In Meulan I met a certain Bignon, an actor. He's supposed to come to see me in Paris. I refused to have lunch with him to avoid losing time, for the good weather might not last long.] I'm going to head toward Vernon. You should profit from this to come and see us at M. Lettre's, who I'll go to see. I'll also visit the little Epte river. I don't plan to go farther than Les Andelys. The weather will decide, but up to now it hasn't been cold and one can work; the only disturbance comes from steamers, which come and go rarely. I'll tell you [about it] when I'm in Vernon. You can write me there, if you like, *bureau restant*. But if you come I'll be ready for you. You left your sketchbook in the boat. Adieu, old fellow. I'll drink a share for you to your health. A good handshake.

Your friend
C. Daubigny

Embrace your wife and all your children for me.

February 7, 1859: Letter from Théophile Gautier to Jean-Auguste-Dominique Ingres

[Dear and venerated master,

I have just discovered in St. Petersburg a miraculous painting that can only be by you or by Raphael. It is not by Raphael, as indicated by its too-perfect state of preservation, yet I haven't seen this sub-

lime composition among the line engravings of your work. Is it one of the three or four paintings that, gone astray, lost, passed into the hands of unknown owners, have regrettably been lost track of? I have recourse to your benevolence to find out. This canvas represents the Virgin and the infant Jesus life-size. The celestial mother presents to the world her divine infant, whose little arms and perpendicular body simulate the resemblance of a cross as if in anticipation of the Passion. The Virgin, with her beautiful hands, holds the bambino by the armpits as if she wanted to have him take his first step on her knees and this first step presaged Calvary. The expression of maternal tenderness on Mary's face is tinged with a prophetic melancholy, she vaguely foresees the anguish of Golgotha. The little Jesus, too, is serious, sad, his head inclined to one shoulder already suggesting his agonized movement on the cross, recalling the . . . *ponant caput expiravit.* The two heads of the child and the Virgin touch one another; with a boldness that is pleasing and charming, the halo of Jesus traces its gold circle over the cheek of Mary, whose nimbus entwines with her son's rather like the rings of an open wedding ring. The Virgin's tunic is red, her mantle an intense blue. The drawing is yours, enough said, the modeling is of a strength and finesse that belongs to you alone, the color of a powerful harmony, a veiled warmth in the gilded and brown register of the Roman school.] The back-

ground consists of architecture representing a rounded niche flanked by two pilasters with arabesques. According to the present owner, there were several heads of saints or monks on either side of the Virgin, filling symmetrically the corners that are now empty. According to him, they were badly damaged and had to be covered by extending the architecture. Since the canvas has been cropped at the bottom, there is no signature for the common [viewer]. If we buy this masterpiece and if you admit to being its father, doubtless you will be so good as to affix, upon my return to France, that sovereign name that signifies sublimity, style, supreme ideal beauty, and perhaps you'll find the sacrificed heads underneath the restorer's overlay. I'd find my lifelong devotion to your glory well recompensed by this obliging act. M[onsieur] Carolus de Raäy [?] my friend and the publisher of *La Russie ancienne et moderne,* the large work on which I am now at work and in which your painting will have a prominent place, has made efforts to acquire it that I hope will be crowned by success. Deign, dear master, to leave your pencil and brush for a moment to take up the pen and send me by return mail the solution to my doubts. If you are not the author of this divine group, then I will have found an unknown work by the young Raphael in inexplicably good condition. Ingres and [Raphael] Sanzio are the only two names that might be inscribed on the panel of this masterpiece.

Your very humble and very fervent admirer.

Théophile Gautier

St. Petersburg, February 7, 1859

M. Théophile Gautier
chez M. Varlet
Dom Smuroff
Maya Norskaya no. 15
St. Petersburg
Russia
P.S.: It is with the deepest shame that I enclose with my letter this base sketch made from memory after having viewed the painting for five minutes. It corresponds roughly to the composition, and, however misshapen, might jostle your memory.

1860: Letter from Félix Ziem to Théodore Rousseau

[Claudes and Poussins at every step! My dear friend, it's now eight days since I left Barbizon. The most beautiful weather has not let up for a minute. It hasn't rained here since the month of May. The oleanders are in bloom and pomegranates are being harvested. These trees are here like the apple trees where you are: the field grass here consists of aromatic plants. The forests are of pine, cyprus, holm oak, cork trees, and plane trees.

I've rented a charming place three minutes outside of town: on the ground floor, salon, dining room, kitchen, service areas etc. On the first floor, a beautiful atelier, a magnificent bedroom, facing south, and

a maid's room. The house is in the middle of an immense produce garden: artichokes, lettuce, etc., fig trees, apricot trees, medlar trees, a small corner of this garden has been allocated to me personally, and I have the run of the rest like everyone else, the peasants who cultivate it are quite amiable. The country is healthy and mild, apart from the north wind I hear such frightening things about; but I wonder if this wind is so terrible here, where there's a real palm tree right in the ground, right at my door. We bought a goat named Jeanne and a large ewe named Blanche. Later I intend to buy a *boquet corse,* a kind of wicker cabriolet with a small horse the size of a small donkey. A donkey for riding or for a conveyance is available to me whenever I want. My country seat costs me 300 francs per year: that's a squeeze for me, but the real price is 250 francs.]

My brother will take care of my animals when I'm in the north. I could have found a less expensive country house, at a price of 150 francs, but I sacrificed to the beauty of the location and to the view; here's a plan of it. The region is one of those said to be dead and without resources, it's a terrible area for progress, imagine the forest of Fontainebleau with salt lakes at the tip of a promontory forgotten by civilization, even though, despite the town's having 12,000 inhabitants, they're going to build a gas-works, and [there's] a project for a naval station in the famous Lake Marignane, which will surely be the most beautiful port in the world and the most protected from enemy attack in time of war or peace. In short the country is still untouched and ancient like the inhabitants, all fishermen, the landscape lacks nothing in the way of graceful beauty. That's enough praise, for you know my passion for this region, you'll see it one day and like me you won't want to leave the beautiful streams overhung by trees full of ivy of extraordinary freshness, and the aromatic steppes in rocky hills as far as the eye can see.

[. . .] [text in box in the upper right corner of the letter]
Imagine the view I have from my atelier: garden, lake, hills, just opposite
at left the port opens into the sea
at right the country mirrored in the lake
and the other lake above the houses
behind, forests and ancient hills.
[indications on map]
Forested hill.
Italian pines, olive trees, gigantic laurels, almond trees
tamarind trees, reeds bordering much of the lake
pomegranate trees are the region's hedgerows.
the sky is blue and warm blue is at home here.

To monsieur Ziem
Campagne de M. Rivière Sauveur les
jardins
Martigues
B.-du-Rhône.

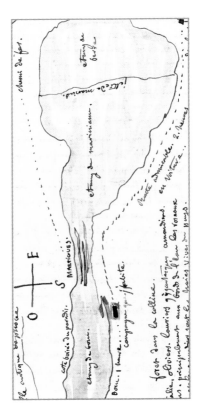

1875: Letter from Jean-Baptiste Carpeaux to Bruno Chérier

Dear Friend,

Immediately upon receiving your letter, I wrote to Monsieur de Chennevières. I would like your wish to be granted, but you know the whims and favor[itism] of this boutique, one must never expect anything and wait for a surprise.

I drag out here my very restless life. Constant pain, abominable weather, icy wind, absence of sun, gray, gray every-

where. Nice has never seen its like, torrential rains, storms, in sum natural disorder, all of which hurts me. The result on which Dr. Kanural [?] was counting from exposure to the sun was not attained. We were to return to Paris on April 14. Dr. Kanural objects to this, he wants me to remain in Nice until May 15! Bernard is in a panic about staying away from his daughter, his business, his usual life for so long. He wants to be replaced. By whom, that's the question, it won't be easy to find someone. In the end I remain with my ailment, which continues to devour my insides. I'm still losing blood. The infection [illegible] doesn't change. The stiff spells are terrible, it's as though I were paralyzed. I can't stay on my poor legs a second, so gripped is my left side by the pain brought on by the stiff spells, [it's] impossible to lay down on it.

All I have left is my right side but my loins give me frightful pain, my stomach can't support any weight due to the state of my poor bladder, my left side being completely useless. It's likely that the trochanter will soon push through the skin. Then my only option will be to put my . . . on my head, my legs, the devil take it.

I've no hope left. If Charles hadn't commissioned a real wheelchair for me from Lanuy [?] and made sure the stairways were wide enough and that there was a fine ramp so I don't hurt myself descending when he comes to get me in Nice, I'd surrender to despair, but the dear child breaks my heart when I hear him talk like that. I'd really like to remove him from this environment where he receives such sad lessons.

Madame Fould overwhelms me with her kindnesses. Every day she writes me consoling letters in superb style. She approaches all questions in a superior manner, what soul, what heart. She is cruelly disheartened to see that I'm not getting better, that the elements are against me, and that nothing promises a happy issue.

[The bust that Bernard made of me has been cast. It's a rough sketch made in two two-hour sittings. Blagny found it so beautiful that he wanted it cast without any further work. Bernard will give you a copy. Here's a sketch of it, judge for yourself. What do you say, my dear and old friend!

The pose is neither academic nor martial: it makes a sad impression, but what do you want, that's the way I am.

Please be so kind as to also tell my friend to continue writing: I'll answer her when I can.

Don't let Blanc forget to send me the address I asked for, as soon as he can, *right away.*]

[in the margin of the letter]

No matter how hard one tries to do good, there's always someone who's dissatisfied. I didn't want I resisted as best I could, I had to be told that without me he wouldn't leave before I agreed to it, no one would have traded places with me, believe me, it's no joke; now there are jealous people, unfortunate people. I've at least arrived at a result [word lined out], he'll profit [from it], you know Chérier what I think about it, we discussed it fully before the departure.

June 23/July 4, 1876: Letter from Ivan Turgenev to Gustave Flaubert

Spasskoye
Gov-t of Orel
City of Mtsensk
June 23 / July 4
[18]76

[My old friend,

I write you from here to Croisset, from one Patmos to another. I received your letter yesterday and, as you see, I answer without delay.

Yes, the life of Mme Sand was full, and yet speaking of her you say: poor mother—this epithet applies well to the dead,

for in the end they have reason to complain, death being a hideous thing. I remember the eyes of little Aurora: they have an astonishing depth and goodness, and in effect resemble those of her grandmother. They are almost too good for the eyes of a child.

It seems Zola has written a long article on Mme Sand in his Russian review, the article is very beautiful but a bit harsh, they say. Zola cannot judge Mme S in a complete way. They are too unalike.

I can see you rolling your eyes ferociously in front of Mr Adrien Marx. Mud of a very particular kind is required to make mushrooms like that spring up.

You're working at Croisset. Well, I'm going to astonish you, I've never worked like I have since I got here. I spend entire nights bent over my desk! I'm seized anew by the illusion that makes one think one can say, not something other than what's already been said (that doesn't interest me), but in another way! And note that at the same time I'm weighed down by problems, fiscal affairs, administration, farming, who knows what all! (In this regard, I can tell you that things aren't as bad as I thought at first—and, parenthetically, I'm delighted to learn that there are glimpses of blue sky in the affairs of your nephew.) But *St. Julien* suffers from this exuberant activity: my devil of a novel has taken invasive hold of me. Despite everything, you needn't worry: the translation is already promised for the October issue of the *Messager de l'Europe*: it will appear there —or I'll be dead.]

I haven't read Fromentin's articles, I haven't read Renan's book: I can't read anything at present—unless its the newspaper I receive here, which tells me about affairs in the Orient and makes me dream.—I think it's the beginning of the end!—Nothing but severed heads, women, daughters, children raped, disemboweled from here to there!—I also think that we (I speak of the Russians)—we cannot avoid war.

You want to know what my habitation looks like?—It's quite ugly—here—this will give you a rough idea:

[drawing]

I don't know if you'll understand properly: it's a wooden house, very old, covered with planks—painted in distemper a light lilac color; there's a veranda with

creeping ivy; the two roofs (a and b) are iron and painted *green*; the top is uninhabitable and the windows are nailed shut.—This little house is all that remains of a vast horseshoe-shaped habitation—thus:

[drawing]

that burned in 1840; the x—that's the house I live in.—Yesterday evening, with your letter in my pocket, I was sitting on the veranda—and in front of me some sixty peasants, almost all dressed in red and quite ugly—(except one: a new bride of *16* years who had just discovered true exultation—and resembled to a surprising degree the *Sistine Madonna* in Dresden) —danced like marmots or bears—and sang with voices very harsh and rough—but on pitch. It was a little celebration they had asked me to organize—which was very easy to do: two pails of brandy—cakes and hazelnuts—and there you are.—They bustled about, I watched them and felt terribly sad.

The little *Sistine Madonna* is named Marie, which is apt.

And that's enough.—I'll write you again before leaving here. Until then, I give you a big embrace.

Your old
J. Turgenev

P.S. I find that the color of the landscape—everything is pale here—the sky, the greenery, the earth—a paleness rather warm and gilded—would only make for prettiness if the grand lines, the grand uniform spaces, didn't introduce grandeur.

November 1, 1885: Letter from Henri Harpignies to his mother

St. Privé
Tuesday, October 27, 1885

[Dear good mama,

I don't say that I'll finish this evening, but for the moment here I am.

I thank you for your fine letter, my wife does likewise for the one you addressed to her.

We hope that your indisposition does not persist and that you are now recovered. Doubtless you don't know that for the last two months I've been very uneasy about Marguerite's health regarding her vision, which has been weakening for some time. She has been to Paris to consult one of my comrades, Dr. Desprez, for the first time (he's at the Charité); the

outcome was not happy. I then advised her to see a renowned specialist, Dr. Galézoski, which she did about a month ago. She returned less uneasy since the doctor assured her that she wasn't losing her sight. At the moment she's of course being treated at St. Privé, and the problem has stabilized. They've ordered special glasses for her that seem to help. Finally, when we return to Paris in about a month we'll go to see the doctor again if need be.—Don't count on her writing you often for the reality is she has trouble seeing and that tires her greatly.—It's our beloved niece who undertook these little notes but she and her sister left the day before yesterday. Their parents came to get them and the whole lot left us the day before yesterday. I still have near me at the moment an old friend, Monsieur Berthier, who will be leaving us on Saturday to return to his small villa outside Chartres.

In the midst of all these anxieties, I've had some bad moments, but I trust in God and I hope that things will improve. For my part, at the moment I'm suffering from rheumatism. I'd even say in very inconvenient places but I console myself, for despite this wretched pain I can still hold my pencils and brushes. The day that's no longer possible I'll be damned annoyed.—. . .—

I've invited the usual musicians for All Saints' Day; I hope they'll come and that for a day or two we'll be able to play some quartets. It's a wonderful distraction in the country.]

We could return to Paris the last week of November. Then I'll finish a large painting on which I've been working all this summer, and then we'll think about returning to the Midi for a month or two like last year. This excursion will be necessary for the health of my wife. It did her much good last year. For my part, I'm working enormously in the land of the sun and I admit to you that I'm very comfortable here.

I leave you for this evening—all the preceding is poorly recounted—I'm not in the mood. I have my damned rheumatism that makes me suffer.

Goodnight, good mama

October 8, 85 [lined out] November 1
Dear good mama,

I seal this letter today, All Saints' Day. The weather is dreadful as always.

Yesterday I received a letter from one of my students, Pépin, who is mad about landscape and earns his living making illustrations for books and periodicals. I send you this letter but on condition that you acknowledge having received it (which will procure me the pleasure of having news of you) and that *you send it back to me* because I collect these charming autographs and am quite attached to them.— Then I will send you something else, too.

Pépin is from Moulins: he knows Hérisson and the little country of Cosnes [illegible].

I'm in a bit of pain and am not profiting from my good luck today in having my whole string quartet. These youngsters came to spend All Saints' Day with me and return to the capital tomorrow. Last night we played music until 11:00.

It's quite rare in the country to have this pleasure.

I close by embracing you from the bottom of my heart along with the whole family—my wife, who's doing so-so, joins with me.

Your devoted son

H. Harpignies

Don't forget to send me back my paper.

I plan to return to Paris around the 20th or 25th of this month.

I hope you find that my student Pépin is not lacking in spirit.

March 23, 1890: Letter from Paul Klenck to Henri Chapu

March 23, 1890

[My dear Henri, Michel, Antoine, and Chapu!

Do you remember the mischief we got into at the École in 1865, on the subject of Manet? I always ended up with black eyes and a bruised nose. But when I got up, I blurted out: "Manet is a fairground painter, unworthy of washing Sonthonax's brushes; first of all, he's a Couture student; and he looks like an Englishman; now if you're right, we might as well burn down the Louvre." Which provoked a new fight with another student in the atelier, for I was aggressive. Bah! I washed myself off at the basin and the next day it started all over again. Then Cabanel came in: "What's going on here?"—"Boss, it's Gill, who thinks Manet is talented." Our excellent master Gérôme happened by, every bit as caustic as we were; in all seriousness, he said to us: "Look here, Messieurs, why are you talking about Manet, you know very well it's forbidden."

When all these battles came to an end, Delrieu proposed a competition: everyone was to make a pastiche of Manet, *une figure*. As I thought myself the one most opposed to the controversial painter, I put all my artistic rage into it; I won the grand medal (a pastille of chocolate), a prize that the improvised jury decreed should go to me. This time, no favoritism was involved; my imitation was altogether worthy of the award bestowed.]

But, my dear Chapu, you won't say to me, like these wretches did, that if one likes Courbet one should adore Manet; in good faith, can there be any rapprochement between these two painters; I ask you?

In effect, if Courbet didn't want to interpret anything except what he saw, at least he painted with accepted means; he did not seek to make use of things other than colors; he was even unable to free himself from bitumen, which he declared to be warm and necessary, and he never dreamed of suppressing green. He simply used an extraordinary power of touch, and above all, a robustness unknown until then. Moreover, he didn't want to draw himself up under the pediment: Realism! "No banners," he shouted.

Manet, by contrast, imagined saving us from the studio painting; so he invented the painting en plein air; he replaced bitumen with ink and, in his delirium, green became violet; he even strangely abused blue, a nasty shade. He set himself up against the slow and laborious efforts of the work produced over a year, he proposed in exchange a sketch flatly applied and polished off in three weeks. But he needed a label for this formula, he called it *Impressionism!*

In reality, yes, he started a school, he discovered this: *the art of the lazy.*

One of his biographers says that he was "the first to oppose the traditions of Romanticism." A fine affair, in truth, and should one brag about it?

To expend so much talent, to make such poor use of it, and all that to be repudiated one day . . .

Unless, however, this is a masterpiece:

[drawing of a man defecating and reading the newspaper]

I finish; beforehand, permit me to provide, as an end piece, some accessories worthy of the new school.

[drawing of a broom and a chamber pot]

I'd like to be from Auvergne, for then I could say to you: Chapu, I don't like *l'impréchionichme.*

I wish you with all my heart a rapid recovery; in advance, I tear you to pieces with joy, my dear Henri.

Your irascible but sincere friend; "honest and upright in his art," that's what an old critic said . . . How stupid they are, those people . . .

P. Klenck

June 8, 1913: Letter from Raoul Dufy to Fernand Fleuret

Paris, June 8, 1913

[My dear Fleuret,

This little Bulgarian horseman brings you at a gallop on his fast horse my friendly regards, to which I add my respects to Madame Réval. If my letter is late, blame this horseman, who perhaps lingered in the Balkans. As for myself, I'm a little late, too, but imagine what ten or twelve hours of work every day can do to a man like me who has all his parts: weight, height, and strength, who tumbles at the end of every evening from his work table into his bed and every morning from his bed to his work table, and I think that's not too idiotic, for a day of work is a day of astonishing adventure and exploration, so, my dear Fleuret, try my method and tumble every morning from your pillow to your penholder, which you'll abandon every evening only for your pens. As to your choice of work, don't worry about it, it's of no importance, you'll make a positive impression despite yourself in whatever you do. Recall that I've often asked you to do a big *realist* novel since your version of reality is always a fantasy so surprising and dramatic that you have only to copy your characters from nature. Forget everything you know, old friend, and think only of yourself, but work like the devil . . . if you don't want to think about your 29 pink and blond springs any more, and of myself, who no longer knows where I am with my thirty and more springs. And don't fire at anymore pigeons with your beautiful flint rifle, which burns your right eyebrow without rustling a feather of the fowl you lust after, and then above all return to Paris, don't stay in the country, later . . . later, Fleuret . . . For the moment Paris is good work that drags you by the feet from your bed every morning. A little rain also and some dung and the bus, put your beautiful sun into your hat box and run. Thanks for everything you said to me in your letter and thanks also to Madame Réval.] I saw J. Doucet again several times. The sketch I submitted was accepted. So you see everything is going well, and in effect, as you say, I'm famous. But you

know, celebrity, I'm beginning to see just a bit what it can be, and I'm afraid it might create lots of problems, and then in the end I think it's not all that useful; but for the world it's something else again, it's absolutely indispensable. You think this attitude is less disagreeable for a painter than for a poet! Poets are irritable but not regarded with contempt as you say, even the true ones, but painters! Imagine, I'm almost the upholsterer of Jacques Doucet and of anyone else who'll have me! But I will never be as honored as I would be to be yours. As for the painter: I'm yoked to my big canvas totally covered by a female bather in a modern bathing costume with white cord trim and embroidered anchors on the collar, and wearing a classic little waterproof Scottish bonnet. At her feet, the net of a shrimp fisherman and a little straw basket embroidered in red wool with "Souvenir du Havre." For a frame, the charming slope of Sainte-Adresse with its tiered greenery and its red brick houses with round and square towers, and there you have, on a four-square-meter canvas, the first spectacle to ravish my eyes when I was a young boy, and which I'm fixing for posterity almost twenty years later, having enjoyed this thing known as a beach. May those who love painting, the sea in summer, and women in bathing costume derive some pleasure from it.

My Ingresque and Clouetian desires, as you put it, persist, but would you recognize them in the form I've given them since I better understand the admirable art of the "Far-Easterners," perhaps closer to us than that of the Greeks? In Paris recently, there have been beautiful exhibitions of Chinese painting that were revelations, and any Chinese statue makes one forget the Gothic.

I will go to see Nijinsky. I'm sure your play will be mounted, but you're beginning a new career, and you know well that a playwright's is particularly difficult; it's not as simple as hanging one's canvas at the Indépendants every year. But take courage. Remember La Ciotat, of the Kneipp malt and the [illegible] in the stuffed artichoke sauce? Everything comes, with heaven's help . . . You won't be prosecuted for your *Enfer*, the three-year law puts the moralists in the wrong. You understand that a people reverting to such militarism is easier to embarrass, so you won't have your scandal, all that you could gain from it would be a further reduction of esteem in the eyes of F. James. I admire those who admire me, including Simon Bussi, whom I'll provide with all the instructions he needs for the woodblock engraving. Thanks for your intended articles on my woodcuts, certainly the collectors across the Channel are lucrative and sensitive, I think, to the beauties of woodblock engravings. I still have a thousand things to tell you, old friend, allow me to stop here. Have a good trip to [illegible] look hard at the painters. My wife appreciates your regards; she's doing well and grows sad thinking about the sun, which is absent here. Give my regards to Madame Réval, and as for you, old friend, my best handshake.

Raoul Dufy

October 18, 1915: Letter from Paul Signac to Georgette Agutte

[Saint-]Tropez, October 18, 1915

[Dear Madame,

We were very happy to receive your good news; we think about the two of you so often in these trying days, in this violent tempest, when our friend is there, on the bridge, on duty, always keeping watch!

And do you see calm approaching! It seems to me that in the East, things are very dark . . . Will I still have to wait a long time before going to paint the *Entry of the Allies into Constantinople?*

It was painful for me to see the departure of my admiral, Bric de Lapeyrère. But truth to tell, I was less interested in the return of the "sacred carpet" on October 10 in Jidda. In the end, one has to have some distraction! And you must have smiled, no, Sembat?

But you know, dear madame, your reproaches for [my] silence are very unjust . . . For I'm the one who wrote last (didn't I discuss the painter Roustan in my last letter?); Did you not receive it, or did I not receive your response? But I protest against the accusation of neglect, clearly and firmly!

So it's tomorrow, your raffle drawing. I

must congratulate you, madame, on the success of your enterprise and, thanks to you, a bit of gold will aid our poor painter chaps. If I weren't in such terrible straits myself, I'd have bought some tickets . . . for it also strikes me as a good deal: if only a collector could be found to buy all the tickets: for 20,000 [francs], he'd have a fine collection in one swoop!

My health is not robust enough for me to risk going to Paris. Events have not improved it: I've had serious bouts of suffocation lately, so bad that I couldn't walk. But how happy we would be to see you in the Midi this winter. Don't fail to let me know: if you can't come as far as Tropez, I would so gladly meet you halfway.

I'm doing a little work: I'm waiting for some beautiful colors from Block, whose factory—near Liège—was not destroyed —I'm sketching the ports . . . and like you, I dream of more important work . . . of peace. When?]

Madame Couturier gardens ferociously; she is proud of her digger's hands. She's having a hard time defending herself against the too enterprising Senegalese in the camp at Fréjus. She scorns painting (only her own, poor dear), the bourgeoisie, and lives with the humblest of peasants, admiring their charm, lightheartedness, and politeness, so delicate by comparison with the affected kind found in salons.

Of our good friendship, from the two of us to the two of you, our best and most devoted recollections.

Affectionately,

P. Signac

And since, dear friend, you give my little images such a warm welcome, here's another one, it's not much.

P.

Passage from Jean Giono, *Recherche de la pureté* (1953), included to complement the letter of March 30, 1917, from Giono to his parents.

The Weakness of the Fighting Man

Be a good soldier, that's the thing, surely. There's no better commission; a hot-

head, but a good soldier: magnificent! A skunk, but a good soldier: admirable! Then there's the simple soldier, neither good nor bad, who enlisted because he didn't feel strongly against it. He'll suffer without fuss the lot of the fighting man until the day when, like Faulkner's hero, he discovers that "anybody can fall inadvertently, blindly, into heroism just as one tumbles into the gaping manhole of a sewer in the middle of the sidewalk." In this plight of the fighting man there's also a moment that might be called the individual moment. In that particular place, he has to be alone. He's withdrawn so he can have this confrontation with solitude. He's been in a herd, in company, in the army, but now he's there, he's alone. Like a pacifist. It's the moment in accounts of battle when the fighting man usually pronounces historic words, or when he calls tenderly to his mother, and is very sad for a whole paragraph.

It's the moment when he's just been gutted by a bayonet thick with weapon grease, when he sees smoking guts being delivered from his belly that want to try to live outside of him like a separate god; it's the moment when a shell blast has made hash of his thigh and when, from the middle of the marsh that is his body, he sees the luminous spring of his femoral artery gush and feels his spirit slipping into this fountain's sticky hands. Suddenly, in the midst of battle, he's caught up in his private drama. If you try to avoid confronting it alone, immediately, you are likely to end up one day like he did.

Then, whether he says it or sees it in vivid images in his head, which is emptying out like a basin, at that moment he knows the truth. But that's no longer of any consequence for the game; this man can no longer retreat. He is already approaching a place from which there is no return; the hand has been played. The game of war is wholly dependent on the weakness of the fighting man.

1921: Letter from Antoine de Saint-Exupéry to his mother

[My little mama,

You're an adorable mama. I was as happy as a kid opening the package. It contained treasures . . .

But the papers say it's cold there! How are you getting by? Here, the weather's good. It's not raining and the sun shines softly.

For Christmas I sent you photos of myself and some sketches, but you never said a word to me about them. Were they lost? I beg you, tell me! And also, how are my sketches!

Yesterday I drew a dog from nature that's not bad, I cut it out and glued it. What do you think?

These days, splendid flights. Especially this morning. But no more trips.

Two weeks ago, I was in Kasbah Tadla, which is the frontier. Getting there all alone in my plane, I wept from the cold, wept! I was very high because of the mountains I had to cross, and despite my fur-lined overalls, fur-lined gloves, etc. I'd have landed anywhere if it had continued much longer. At a certain point it took me twenty minutes to put my hand in my pocket to pull out my map, which I thought I knew sufficiently and had neglected to install in the plane. I bit my fingers, they hurt me so much. And my feet . . .

I had no reflexes left and my plane was veering every which way. I was a pitiful thing, miserable and far away.

The return, by contrast, after a sumptuous lunch, was wondrous. Warm again and back in the air, contemptuous of landmarks, roads and towns, I headed straight out, like a young god with a compass. It took me two hours and forty minutes to get there, a little less to return. Violent turbulence found me again, and when I discerned Casablanca in the distance, I was as proud as the Crusaders when they saw Jerusalem. The weather was marvelous: I could see Casablanca from a distance of twenty-four kilometers! ([as far as] from Saint-Maurice to Bellegarde).]

What did Brault tell you about my schools?

I'll probably come to see you during February, even if I'm failed or resign, for in that case I'll do a month or two at Nieuport in Istres, near Marseille, and I'll have a twenty-day or a month's leave as soon as I land.

You'll slaughter the fatted calf . . .

Farewell, my little mama, I embrace you, write to me.

Your respectful son,

Antoine

October 1925: Letter from Le Corbusier to Madame Meyer

October 1925

[Madame,
[1]
We have dreamed of building you a house that would be smooth and whole like a beautifully proportioned chest and would not be disrupted by multiple accidents that create an artificial and illusory picturesque effect and ring false in sunlight and only add confusion all around. We oppose the fashion raging in this country and abroad for houses that are complicated and cluttered. We think that unity is stronger than [an overemphasis on] parts. And don't think that this smoothness is an effect of laziness; it is on the contrary the result of plans pondered at length. Simplicity is not easy. In truth, this house rising against the foliage would make a noble impression . . .

[2]
The entry would be on the side, and not on the axis. Would we draw the Academy's thunderbolts?

[3]
The vestibule, broad, inundated with light . . . cloakroom, toilet are artfully hidden here. The servants are directly accessible. And if one ascends one floor, it is to reach the upper salon, above the shadow of the trees, and obtain a magnificent view of foliage. And see the sky better . . . If they are well lodged, the domestics, the house will be well maintained. Not at the top, for there we will place a garden, a solarium, and a swimming pool.

[4]
From the salon, then, one has an elevated view, light floods in. Between the double windows of the large bay we have installed a greenhouse that with one stroke neutralizes the chilling surface of the glass; there, large bizarre plants such as one sees in the greenhouses of châteaus and plant lovers; an aquarium, etc. Passing through the small door on the axis of the house, one heads toward the back of the garden on a footbridge, under the trees, to have lunch or dinner.]

[5]
This floor is a single room, salon, dining

room, etc., library. Ah yes, the service stair! Right in the middle. Of course! So it will function properly. It is lined with cork bricks that isolate it like a telephone booth or a thermos. Curious idea! Not really . . . It's simply natural. The service stair rises through the house from bottom to top like an artery. Where better to place it? The back wall and that of the stair drum could be faced. One sees the boudoir with its built-in furniture [on the mezzanine].

[6]
The boudoir overlooks the foliage of the large trees and the space of the dining room. If you wanted to mount theatricals, you could dress here, and two stairways make it possible to descend to the stage, which is in front of the large window.

[7]
The service stair leads to this door, which is beside the swimming pool, and behind the pool and the service stair one can have breakfast.

From the boudoir, we have ascended to the roof where there are neither tiles nor slate, but a solarium and a swimming pool with grass growing between the joints of the flagstones. The sky is above. With walls all around, no one can see you. In the evening you can see the stars and the dark mass of the trees of the Folie Saint-James. With sliding screens you can isolate yourself completely.

[8]
As in [the treehouse in Swiss Family] Robinson, as in a few paintings by Carpaccio. Divertissement. This garden is not in the French style but a wild grove where, thanks to the trees in the Parc Saint-James, one can imagine oneself far from Paris . . .

The servants' quarters receive direct sunlight. All the better. Through these high windows, just below the ceiling, you can see sky and stars. All the better.

[within cloud]
This design, madame, was not born instantaneously from the hasty pencil of a staff draftsman, working between two telephone calls. It was considered at length, caressed, in days of perfect calm opposite a resolutely classical site.

[drawing of a rocky bay]
[on drawing of a crumbling wall]
These ideas, these architectural themes that carry within them a certain poetry have been subjected to the most rigorous constructive rules.

A dozen reinforced concrete posts spaced at equal distances support the floors at little cost.

Within the cage of concrete thus constituted, the plans unfold with such simplicity that one is tempted (how tempted!) to regard them as idiotic.

For years we've been accustomed to seeing plans so complicated that they create the impression of men carrying their vital organs outside of themselves. We were determined to put the vital organs inside, organized, tidy, and that only a single liquid mass should appear. Not so easy! To tell the truth, that is the great difficulty in architecture: to keep everything in its place.

These architectural themes necessitate, if poetry is to be released, severe contiguities difficult to resolve. Once the thing's been done, everything seems natural, easy. And that's a good sign. But when one began to fling down the first lines of the composition everything was confusion.

If the structure and the plan are extremely simple, it must be admitted that the contractor will be less demanding. Which matters. It matters quite a lot, and the painful economic limitations become forgivable only when the solution still sings. Then . . . praise for the architects! This last fatuous observation is included only to make you laugh. For it's important to laugh a bit . . .

Paris, October 1945
Le Corbusier and Pierre Jeanneret

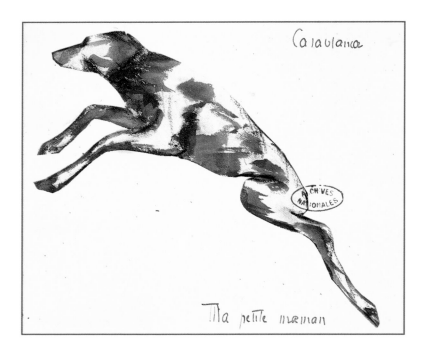

Casablanca

Ma petite maman

11

cher docteur, parfait ami,
j'ai reçu votre lettre avec beaucoup de joie. Vous.
vous avez la bonté de me dire quand je pourrai
vous rencontrer, après que vos regardions ensemble
ces précieux documents?
L'hiver est dur à porter.
Mes grandes amitiés.
audiberti

19 boulevard du
Temple

BIBLIOGRAPHY

General Works

Helen Osterman Borowitz. *The Impact of Art on French Literature: From De Scudery to Proust.* Wilmington: University of Delaware Press, 1985.

Richard R. Brettell. *French Salon Artists, 1800–1900.* (Chicago: Art Institute of Chicago, 1987; distributed in U.S. by Harry N. Abrams, Inc.).

Scott Carpenter. *Acts of Fiction: Resistance and Resolution from Sade to Baudelaire*, Penn State Studies in Romance Literature. University Park: Pennsylvania State University Press, 1995.

Jean Clay. *De l'impressionnisme à l'art moderne.* Paris: Hachette Réalités, 1975.

Christine Dixon and Cathy Leahy. *Manet to Matisse: French Illustrated Books.* Canberra, ACT: Australian National Gallery, 1991.

Serge Fauchereau. *Peintures et dessins d'écrivains.* Paris: Belfond, 1986.

L'Aventure de l'art au XXe siècle, edited by Jean-Louis Ferrier and Yann Le Pichon. Paris: Éditions du Chêne, 1992.

Le Nouveau Dictionnaire des auteurs, 3 volumes. Paris: Robert Lafont (coll. "Bouquins"), 1994.

Le Nouveau Dictionnaire des oeuvres, 7 volumes. Paris: Robert Lafont (coll. "Bouquins"), 1994.

"Les écrivains-dessinateurs," special issue of *La Revue de l'Art*, no. 44, 1979.

Les Plus Belles Lettres manuscrites de la langue française, La Mémoire de l'encre. Paris: Bibliothèque Nationale (Robert Laffont), 1992.

My Dear Mother: Letters of Luminaries in the Arts, edited by Karen Elizabeth Gordon and Holly Johnson. Chapel Hill, N.C.: Algonquin Books, 1997.

New Oxford Companion to Literature in French, edited by Peter France. New York: Oxford University Press, 1995.

Plis d'excellence: l'extraordinaire créativité de la correspondance, exhibition catalogue. Paris: Musée de la Poste, 1994.

Kenneth E. Silver and Romy Golan. *The Circle of Montparnasse: Jewish Artists in Paris, 1905–1945*, with contributions by Arthur A. Cohen, Billy Kluver, and Julie Martin. New York: Universe Books, 1985.

Joseph C. Sloane. *French Painting between the Past and the Present: Artists, Critics, and Traditions, from 1848 to 1870.* Princeton, N.J.: Princeton University Press, 1973.

For Each Author

Guillaume Apollinaire

Album Apollinaire. Paris: Gallimard (Bibliothèque de la Pléiade), 1971.

Pablo Picasso and Guillaume Apollinaire. *Correspondance*, edited by Pierre Caizergues and Hélène Seckel. Paris: Gallimard (coll. "Art et Artistes"), 1992.

Roger Shattuck. *The Banquet Years: The Origins of the Avant-Garde in France, 1885 to World War I: Alfred Jarry, Henri Rousseau, Erik Satie, Guillaume Apollinaire.* New York: Random House, 1968.

Adolphe Armand

Accounts of the political turmoil of 1848 in:

Maurice Agulhon. *Les quarante-huitards.* Paris: Gallimard, 1992.

Georges Auric

Éveline Hurard-Viltard. *Le Groupe des Six ou le matin d'un jour de fête.* Paris: Méridiens-Klinksieck, 1987.

Jean-Noël Von Der Weid. *La Musique du XXe siècle.* Paris: Hachette (coll. "Pluriel"), 1997.

Ferdinand Bac

Gieslain de Diesbach. *Ferdinand Bac.* Paris, 1979.

Laure Murat. "L'appel des chimères," *L'Objet d'art*, no. 5, March 1988.

Honoré de Balzac

Album Baudelaire, edited by Claude Pichois. Paris: Gallimard (Bibliothèque de la Pléiade), 1974.

Honoré de Balzac. *Lettres à Madame Hanska*, edited by Roger Pierrot, 2 volumes. Paris: Robert Lafont (coll. "Bouquins"), 1990.

Roger Pierrot. *Honoré de Balzac.* Paris: Fayard, 1994.

Graham Robb. *Honoré de Balzac: A Biography.* New York: W. W. Norton & Co., 1996.

Charles Baudelaire

Charles Baudelaire. *Correspondance*, edited by Claude Pichois, 2 volumes. Paris: Gallimard (Bibliothèque de la Pléiade), 1996.

Claude Pichois and Jean Ziegler. *Charles Baudelaire*. Paris: Fayard, 1996.

Selected Letters of Charles Baudelaire: The Conquest of Solitude, edited by Rosemary Lloyd. Chicago: University of Chicago Press, 1986.

Roger de Beauvoir (Eugène Roger)

Max Milner. *Le Romantisme I (1820–1843)*. Paris: Arthaud, 1973.

Bertall (Charles-Albert D'Arnoux)

Marcus Osterwalder. *Dictionnaire des illustrateurs (1800–1914)*. Paris: Hubschmid et Bouret, 1983.

André Beucler

Gueule d'amour. Paris: EJL, 1994.

Rosa Bonheur

Dore Ashton and D. Browne Hare. *Rosa Bonheur: A Life and a Legend*. New York: Viking, 1981.

Rosa Bonheur (1822–1899), exhibition catalogue. Bordeaux, Galeries des Beaux-Arts, 1997.

Danielle Digne. *Rosa Bonheur ou l'insolence: l'histoire d'une vie, 1822–1899*. Paris: Denoël-Gonthier, 1980.

André Breton

Anna Elizabeth Balakian. *André Breton: Magus of Surrealism*. Hawkshead Book Distribution Co., 1971.

André Breton. *Conversations: The Autobiography of Surrealism*, translated by Mark Polizzotti. New York: Marlowe & Co., 1995.

André Breton. *Manifestoes of Surrealism*. Ann Arbor: University of Michigan Press, 1972.

André Breton: la beauté convulsive, exhibition catalogue. Paris, Musée National d'Art Moderne–Centre National d'Art et de Culture Georges Pompidou, 1991.

Félix Buhot

Félix Buhot, 1847–1898, exhibition catalogue. Caen, Musée des Beaux-Arts, 1981.

André Fontaine. *Félix Buhot, 1847–1898*. Paris, 1982.

Francis Carco

André Négis. *Mon ami Carco*. Paris, 1953.

Jean-Baptiste Carpeaux

Claude Jeancolas. *Carpeaux, le farouche volonté d'être*. Lausanne: Edita-Lazarus, 1987.

Ann Middleton Wagner. *Jean-Baptiste Carpeaux: Sculptor of the Second Empire*. New Haven and London: Yale University Press, 1986.

Gaston Chaissac

Gaston Chaissac: puzzle pour un homme seul, anthology edited by Dominique Allan Michaud. Paris: Gallimard, 1992.

Très amicalement vôtre: lettres et textes inédits. La Louvière: Daily-Bul, 1982.

Jean Cocteau

Roger Lannes. *Jean Cocteau*. Paris: Seghers (coll. "Poètes d'aujourd'hui"), 1989.

Arthur King Peters. *Jean Cocteau and His World*. London: Vendôme, 1987.

Roger Stéphane, *Portrait-souvenir de Jean Cocteau*. Paris: Tallandier, 1989.

Jean Touzot. *Jean Cocteau*. Lyon: La Manufacture, 1989.

Colette

Album Colette, a collection of images chosen and captioned by Claude and Vincenette Pichois. Paris: Gallimard (Bibliothèque de la Pléiade), 1984.

Jean Chalon. *Colette, l'éternelle apprentie*. Paris: Flammarion, 1998.

Geneviève Dormann. *Amoureuse Colette*. Paris: Herscher, 1984.

Lettres de la vagabonde. Edited by Claude Pichois and Roberte Forbin. Paris: Flammarion, 1994.

Joan Hinde Stewart. *Colette*. Twayne's World Author Series, No. 679. New York: Twayne Publishers, 1996.

Camille Corot

Corot, 1796–1875, exhibition catalogue. (New York: The Metropolitan Museum of Art, 1996; distributed in U.S. by Harry N. Abrams, Inc.).

Henri-Edmond Cross

Isabelle Compin. *H.-E. Cross*. Paris: Quatre Chemins-Editart, 1964.

Paysages méditerranéens d'Henri-Edmond Cross, exhibition catalogue. Saint-Tropez, Musée de l'Annonciade, 1990.

Charles Daubigny

Madeleine Fidell Beaufort and Janine Bailly-Herzberg. *Daubigny*. Paris, 1975.

Olivier Debré

Pierre Cabanne. *Olivier Debré*. Paris: Cercle d'art, 1991.

Bernard Noël. *Debré*. Paris: Flammarion, 1984.

Eugène Delacroix

Eugène Delacroix. *The Journal of Eugène Delacroix: A Selection (Arts & Letters)*, edited by Hubert Wellington; translated by Lucy Norton. London: Phaidon Press Inc., 1995.

Eugène Delacroix. *Lettres intimes*, preface and notes by Alfred Dupont. Paris: Gallimard, 1995.

Guy Dumur. *Delacroix et le Maroc*. Paris: Herscher, 1988.

Maurice Sérullaz. *Delacroix*. Paris: Fayard, 1989.

Ernest Delahaye

Verlaine: étude biographique: documents relatifs à Paul Verlaine. Geneva-Paris: Slatkine, 1982.

Paul Delvaux

Claude Lévi-Strauss. *Mythologiques*, vol. IV: *L'Homme nu*. Paris: Plon, 1971.

Marc Rombaut. *Paul Delvaux*. Albin Michel, 1990.

Marc Rombaut. *Paul Delvaux*. London: Rizzoli, 1991.

Jacques Sojcher. *Paul Delvaux ou la passion puérile*. Paris: Cercle d'art, 1991.

André Derain

André Derain. *Lettres à Vlaminck*, edited by Philippe Dagen. Paris: Flammarion, 1994.

Robert Desnos

Pierre Berger. *Robert Desnos*. Paris: Seghers, 1970.

Théodule Devéria

Théodule Devéria. *Mémoires et fragments*, 2 volumes (volume V in the "Bibliothèque égyptienne"). Paris: Maspero, 1897.

Musée du Louvre. *Catalogue des manuscrits égyptiens écrits sur papyrus, toile, tablettes et ostraca, en caractères hiéroglyphiques, hiératiques, démotiques, grecs, coptes, arabes et latins qui sont conservés au Musée égyptien du Louvre, par feu Théodule Devéria*. Paris: C. de Mourgues frères, 1881.

Notice biographique sur Théodule Devéria (1831–1871). Paris: Ernest Leroux Éditeur, 1895.

André Dignimont

André Dignimont illustrateur, 1891–1965, exhibition catalogue. Paris, Bibliothèque Nationale, 1967.

André Dignimont illustrateur, 1891–1965, exhibition catalogue. Nogent-sur-Marne and Paris, Fondation Nationale des Arts Graphiques et Plastiques, 1982.

Francis Carco. *Dignimont*. Monte-Carlo: Sauret, 1946.

Femmes, fleurs et branches. Paris: M. Trinckvel, 1968.

Gustave Doré

Philippe Kaenel. *Le Métier d'illustrateur, 1830–1880: Rodolphe Töpffer, J.-J. Grandville, Gustave Doré*. Paris: Editions Messene, 1996.

Annie Renonciat. *La Vie et l'oeuvre de Gustave Doré*. Paris: ACR Éditions et Bibliothèque des Arts, 1983.

Raoul Dufy

Raoul Dufy with Lucovic Massé. *Correspondances*. Céret: Éditions de l'Aphélie, 1991.

Dora Perez-Tibi. *Dufy*. Paris: Flammarion, 1989.

Charles Filiger

Charles Filiger, 1863–1928, exhibition catalogue. Plagoustel-Daoulas and Penne du Tarn, Société des Amis d'Alfred Jarry, 1988.

Filiger: dessins, gouaches, aquarelles, exhibition catalogue. Saint-Germain-en-Laye, Musée du Prieuré, 1991.

Antoine Terrasse. *Pont-Aven, l'école buissonière*. Paris: Gallimard (coll. "Découvertes"). 1992.

Jean-Louis Forain

Jean-Louis Forain: les années impressionistes et post-impressionistes, exhibition catalogue. Paris. Bibliothèque des Arts. 1995.

Léandre Vaillat. *En écoutant Forain*. Paris: Flammarion. 1931.

Emmanuel Frémiet

Emmanuel Frémiet, 1824–1910, la main et le multiple, exhibition catalogue. Musée des Beaux-Arts de Dijon and Musée de Grenoble. 1988–89.

Paul Gauguin

Françoise Cachin. *Gauguin*. Paris: Flammarion. 1988.

Paul Gauguin. *Gauguin's Letters from the South Seas*. Mineola. N.Y.: Dover Publications. 1992.

M. Hoog. *Paul Gauguin: Life and Work*. New York: Rizzoli. 1987.

Lettres de Paul Gauguin à Daniel de Monfreid, revised edition. Paris. 1960.

Judith Gauthier

Anne Danclos. *La Vie de Judith Gautier: égérie de Victor Hugo et de Richard Wagner*. Paris: F. Lanore. 1996.

Joanna Richardson. *Judith Gautier*. Paris: Seghers. 1989.

Théophile Gautier

Théophile Gautier. *Correspondance générale*, edited by Claudine Lacoste-Veysseyre. 11 volumes. Paris: Droz. 1987–96.

Anne Ubersfeld. *Théophile Gautier*. Paris: Stock. 1992.

Jean Giono

Album Giono, volume of illustrations edited by Henri Godard. Paris: Gallimard (Bibliothèque de la Pléiade). 1980.

Jean Giono. *Le Refus d'obéissance*. N.p., 1937.

Jean Giono. *Oeuvres romanesques complètes*, 3 volumes. Paris: Gallimard (Bibliothèque de la Pléiade). 1971–74.

Charles Giraud

Marius-Ary Leblond. "Un peintre français sous Louis-Philippe. Charles Giraud." *Gazette des Beaux-Arts*, March 1937.

"Un prédécesseur de Gauguin à Tahiti: Charles Giraud." *Bulletin de la Société de l'Histoire de l'Art français*, 1969.

Norbert Goeneutte

Norbert Goeneutte. Sa vie et son oeuvre ou l'Art Libre au XIXe siècle. Paris: Mayer, 1979.

Vincent van Gogh

Lettres illustrées de Vincent Van Gogh, edited by Martin Bailey. Paris: Herscher, 1992.

Vincent van Gogh. *The Complete Letters of Vincent van Gogh: With Reproductions of All the Drawings in the Correspondence*, 3 volumes. Boston: New York Graphic Society. 1958.

Vincent van Gogh. *Correspondance générale*, 3 volumes. Paris: Gallimard et Grasset. 1960.

Van Gogh: A Retrospective, edited by Susan Alyson Stein. (New York: Hugh Lauter Levin Ass., 1986; distributed by Macmillan).

Vincent van Gogh: With an Introduction and Notes Selected from the Letters of the Artist, edited by Alfred H. Barr. Jr. North Stratford. N.H.: Ayer Company Publishers. 1966.

Henri Harpignies

Paul Gosset. *Harpignies, peintre paysagiste français, 1819–1916*. Valenciennes. 1982.

Harpignies, exhibition catalogue. Maubeuge. Musée de Maubeuge. 1977.

Georges Hugnet

James Phillips. *Georges Hugnet (1906–1974), "Le pantalon de la fauvette," étude et choix de textes*. Paris: Lettres Modernes. 1991.

Gaëton Picon. *Journal du surréalisme, 1919–1939*. Geneva: Skira. 1976.

Victor Hugo

Victor Hugo. *Correspondance familiale et écrits intimes*, introduction by Jean Gaudon. 2 volumes. Paris: Robert Laffont (coll. "Bouquins"). 1991.

Victor Hugo. *Oeuvres complètes*, chronological edition edited by Jean Massin, 18 volumes. Paris, Le Club Français du Livre, 1967–69.

André Maurois, *Olympia ou la vie de Victor Hugo.* Paris: Robert Laffont (coll. "Bouquins"), 1993.

Graham Robb. *Victor Hugo: A Biography.* New York: W. W. Norton & Co., 1998.

Soleil d'encre, Manuscrits et dessins de Victor Hugo, exhibition catalogue. Paris, Petit Palais, 1985.

Eugène Isabey

Pierre Miquel. *Eugène Isabey, 1803–1886, la marine au XIXe siècle*, 2 volumes. Maurs-La-Jolie: La Martinelle, 1980.

Max Jacob

Max Jacob et Picasso, exhibition catalogue. Paris, Musée Picasso. Réunion des Musées Nationaux, 1994.

Max Jacob. *Souvenirs sur Picasso.* Paris: Cahiers d'Art, 1927.

Le Corbusier

Geoffrey H. Baker. *Le Corbusier: An Analysis of Form.* New York and London: John Wiley & Sons, 1983.

Le Corbusier. *Vers une architecture*, revised edition. Paris: Arthaud, 1977.

Le Corbusier. *L'Art décoratif d'aujourd'hui*, revised edition. Paris: Arthaud, 1980.

René Magritte

René Magritte. *Écrits complets*, edited by André Blavier. Paris: Flammarion, 1979.

Magritte, catalogue du centenaire. Brussels: Musées Royaux des Beaux-Arts de Belgique, 1998.

Magritte—La Période vache: "Les Pieds dans le Plat." Réunion des Musées Nationaux. Musées de Marseilles, Ludion, 1998.

Magritte: 1898–1967, edited by Gisèle Ollinger-Zinque and Frederik Leen. (Brussels: Royal Museums of Fine Arts of Belgium, 1998: distributed by Harry N. Abrams, Inc., New York).

Stéphane Mallarmé

Stéphane Mallarmé. *Lettres à Méry Laurent*, edited by Bertrand Marchal. Paris: Gallimard, 1996.

Édouard Manet

Françoise Cachin. *Manet. Lettres à Isabelle, Méry et autres dames.* Geneva, 1985.

T. J. Clarke. *The Painting of Modern Life: Paris in the Art of Manet and His Followers.* Princeton, N.J.: Princeton University Press, 1986.

Guy de Maupassant

Album Maupassant, album of images edited by Jacques Réda. Paris: Gallimard (Bibliothèque de la Pléiade), 1987.

Guy de Maupassant Revisited. Twayne's World Author Series. New York: Twayne Publishers, 1999.

Henri Meilhac

Philippe Goninet. *Meilhac, Halévy, Offenbach.* Paris, 1992.

Théâtre de Meilhac et Halévy, 8 volumes. Paris: Calmann-Lévy, c. 1900–1902.

Octave Mirbeau

Pierre Michel. *Octave Mirbeau, l'imprécateur au coeur fidèle.* Paris: Séguier, 1990.

Octave Mirbeau. *Correspondance avec Auguste Rodin*, edited by Pierre Michel and Jean-François Nivet. Du Lérot Éditeur, 1988.

Martin Schwartz. *Octave Mirbeau. Vie et oeuvre.* The Hague: Mouton, 1966.

Georges Mniszech

Honoré de Balzac. *Lettres à Madame Hanska*, edited by Roger Pierrot, 2 volumes. Paris: Robert Laffont (coll. "Bouquins"), 1990.

Gérard Gengembre. *Balzac, "Le Napoléon des lettres."* Paris: Gallimard (coll. "Découvertes"), 1992.

Jules Mougin

Plis d'excellence: l'extraordinaire créativité de la correspondance, exhibition catalogue. Paris, Musée de la Poste, 1994.

Alfred de Musset

Alfred de Musset. *Correspondance (1826–1839)*, edited by Loïc Chotard, Roger Pierrot, and Marie Cordroc'h. Paris: Presse Univérsitaire de France, 1985.

Alfred de Musset, exhibition catalogue. Paris: Bibliothèque Nationale, 1957.

Madame Jaubert née Caroline d'Alton. *Souvenirs de Mme C. Jaubert, lettres et correspondances*. Paris: Hetzel, 1881.

Célestin Nanteuil

Célestin Nanteuil, peintre-graveur de l'époque romantique, 1813–1873. Dijon, Musée des Beaux-Arts, 1973.

Gérard de Nerval

Album Nerval, volume of images edited by Éric Buffetaud and Claude Pichois. Paris: Gallimard (Bibliothèque de la Pléiade), 1993.

Gérard de Nerval. *Oeuvres complètes*, volume II, edited by Jean Guillaume and Claude Pichois. Paris: Gallimard (Bibliothèque de la Pléiade), 1984.

Pablo Picasso

Piere Daix. *Picasso*. Paris: Éditions du Chêne (coll. "Profils de l'art"), 1991.

Picasso/Apollinaire, *Correspondance*, edited by Pierre Caizergues and Hélène Seckel. Paris: Gallimard (coll. "Art et Artistes"), 1992.

Christian Zervos. *Pablo Picasso*, 33 volumes. Paris, 1932–78.

Frédéric Pioche

Correspondence and other documents at the Musée de la Poste, Paris.

Jacques Prévert

Album Prévert. Paris: Gallimard (Bibliothèque de la Pléiade), 1993.

Jacques Prévert. *Oeuvres complètes*, volumes I and II, edited by Danièle Gasiglia-Laster and Arnaud Laster. Paris: Gallimard (Bibliothèque de la Pléiade), 1996.

Félix Régamey

Émile Guimet. *Promenades japonaises: Tokio-Nikko*. Drawings by Félix Régamey. Paris: Institut des Langues et Civilisations Orientales, n.d.

Félix Régamey. *Horace Lecoq de Boisbaudran et ses élèves: notes et souvenirs*. Paris: H. Champion, 1903.

Félix Régamey. *Verlaine dessinateur*. Paris: Slatkine, 1983.

Henri Regnault

Henri Regnault, exhibition catalogue. Saint-Cloud, Musée Municipal, 1992.

Raymond Renefer

Oeuvre de guerre, 1914–1918, exhibition catalogue. Paris, Hôtel des Invalides and Galerie Bruno Martin-Caillé, 1979.

Arthur Rimbaud

Arthur Rimbaud. *Oeuvres complètes*, edited by Antoine Adam. Paris: Gallimard (Bibliothèque de la Pléiade), 1996.

Arthur Rimbaud. *Oeuvre-vie*, edited by Alain Borer. Arléa, 1991.

Auguste Rodin

Ruth Butler. *The Shape of Genius: A Biography*. New Haven: Yale University Press, 1993.

F. V. Grunfeld. *Rodin: A Biography*. New York: Holt, 1987.

Auguste Rodin. *Correspondance*, 4 volumes. Paris: Musée Rodin.

Félicien Rops

Félicien Rops, aquarelles, dessins, gravures, exhibition catalogue. Paris, Centre Culturel de la Communauté Française de Belgique, 1980.

Roger Pierard. *Félicien Rops, quelques aspects de sa personnalité*. Namur, 1983.

John H. Russell

Several letters from Auguste Rodin's correspondence (see Rodin).

Donatien Alphonse François, marquis de Sade

Francine du Plessix Gray. *At Home with Marquis de Sade: A Life*. New York: Simon & Schuster, 1998.

Maurice Lever. *Donatien Alphonse François, marquis de Sade*. Paris: Fayard. 1991. [*Sade: A Biography*, translated by Arthur Goldhammer (footnotes omitted). New York: Farrar. Strauss and Giroux. 1993].

Donatien Alphonse François. marquis de Sade. *Correspondance. Lettres inédites et documents*, edited by Jean-Louis Debauve. Paris: Ramsay-Pauvert. 1990.

Donatien Alphonse François. marquis de Sade. *Les 120 journées de Sodome ou l'école du libertinage*. Paris: U.G.E.. 1993.

Donatien Alphonse François, marquis de Sade. *Lettres à sa femme*, selection edited by Marc Buffat. Arles: Actes Sud. 1997.

Donatien Alphonse François, marquis de Sade. *Oeuvres*, edited by Michel Delon. 2 volumes. Paris: Gallimard (Bibliothèque de la Pléiade). 1992–95.

Antoine de Saint-Exupéry

Album Saint-Exupéry, volume of images edited by Jean-Daniel Pariset and Frédéric d'Agay. Paris: Gallimard (Bibliothèque de la Pléiade). 1997.

Antoine de Saint-Exupéry. *Lettres à sa mère*. Paris: Gallimard. 1997.

Paul Webster. *Antoine de Saint-Exupéry: The Life and Death of the Little Prince*. London: Macmillan. 1993.

Camille Saint-Saëns

Correspondance Camille Saint-Saëns / Gabriel Fauré, edited by Jean-Michel Nectoux. Paris: Klincksieck. 1994.

Camille Saint-Saëns. *Correspondance inédite*. Paris: La Revue Musicale, 1983.

Camille Saint-Saëns. *Regards sur mes contemporains*, edited by Yves Gérard. Arles: B. Coutaz, 1990.

Un maître de musique à Dieppe: Camille Saint-Saëns, exhibition catalogue. Dieppe, Médiathèque Jean Renoir. 1997.

George Sand

George Sand. *Correspondance*, 24 volumes, edited by Georges Lubin. Classiques Garnier. 1964–94.

George Sand, Visages du Romantisme, exhibition catalogue. Paris, Bibliothèque Nationale. 1977.

Anatole de Sègur

Hortense Dufour. *Comtesse de Ségur, née Sophie Rostopchine*. Paris: Flammarion. 1990.

Paul Signac

Françoise Cachin. *Paul Signac*. Paris: Bibliothèque des Arts, 1971.

Signac et Saint-Tropez (1892–1913), exhibition catalogue. Saint-Tropez. Musée de l'Annonciade. 1992.

Joséphin Soulary

Claude Pichois. *Le Romantisme II (1843–1869)*. Paris: Arthaud. 1979.

Henri de Toulouse-Lautrec

Bernard Denvir. *Toulouse-Lautrec*. Paris: Thames & Hudson (coll. "L'Univers de l'art"), 1992.

Henri de Toulouse-Lautrec. *The Letters of Henri de Toulouse-Lautrec*. edited by Herbert Schimmel. Oxford: Oxford University Press, 1991.

Ivan Turgenev

Correspondance Gustave Flaubert/Ivan Tourgueniev, edited by Alexandre Zviguilsky. Paris: Flammarion, 1989.

Henri Troyat. *Tourgeniev*, translated by Nancy Amphoux. Paris: Flammarion, 1985.

Paul Verlaine

Paul Verlaine. *Oeuvres poétiques complètes*, edited by Yves-Alain Favre. Paris: Robert Laffont (coll. "Bouquins"), 1992.

Auguste Vimar

Marcus Osterwalder. *Dictionnaire des illustrateurs (1800–1914)*. Paris: Hubschmid et Bouret. 1983.

Félix Ziem

Félix Ziem, peintre voyageur, 1821–1911. Martigues, Musée Ziem. 1994.

Pierre Miquel. *Félix Ziem, 1821–1911*. Maurs-La-Jolie, La Martinelle. 1978.

LIST OF ILLUSTRATIONS AND PHOTOGRAPH CREDITS

Abbreviations:
BNF = Bibliothèque Nationale
 Française
RMN = Réunion des Musées
 Nationaux

Title page: Egyptian pottery fragment bearing an inscription. Terracotta potsherd. Egypt, New Kingdom. Paris, Musée du Louvre. Photo: RMN–R.G. Ojeda.

p. 4: Paul Gauguin, signed autograph letter with sketch (ink and watercolor) of Gauguin's painting *Te Arii Vahine*. Bérès collection. Photo: Flammarion.

p. 5: Top right: Charles Giraud, signed autograph letter dated September 15, 1846, sheet with sketch of two Tahitian women. Paris, Musée du Louvre, Département des Arts Graphiques. Aut. 990. Cote BC. b5. L11. Photo: RMN–Michèle Bellot. Bottom left: envelope from the postman Frédéric Pioche to Alphonse Perrault, 1901. Paris, Musée de la Poste. Photo: Musée de la Poste.

p. 6: André Dignimont, signed autograph letter, one page. Paris, Librairie "Les Autographes." Photo: Georges Fessy.

p. 7: Félix Buhot, print with "symphonic margins." Paris, Bibliothèque d'Art et d'Archéologie Jacques Doucet.

p. 8: Gaston Chaissac, signed autograph letter, 2 pages, illustrated with a color drawing (magic marker). Paris, Musée National d'Art Moderne–Centre Georges Pompidou. Doc MNAM-CCI. Photo: Jacques Faujour. © ADAGP, Paris 1998.

p. 9: Card from Pablo Picasso and Max Jacob to Guillaume Apollinaire. Paris, Musée Picasso. Photo: RMN–R.G. Ojeda. © Picasso Estate, 1998.

Preface:
p. 10: Letter from Avisse, February 21, 1890. Collection Édouard and Christian Bernadac, Paris. Photo: Georges Fessy.

p. 12: Letter from Codogna, Italy, with a colored drawing, 1811. Paris, Musée de la Poste. Photo: Musée de la Poste.

p. 14: Letter from Mariano Fortuny, May 5, 1912. Collection Édouard and Christian Bernadac, Paris. Photo: Georges Fessy.

p. 16: Letter from Marie Laurencin to Carmen Tessier. Librairie "Les Autographes." Photo: Bulloz. © ADAGP, Paris, 1998.

June 21, 1787: Letter from the abbé de La Haye to the Académie Royale des Sciences
p. 18: "Coral plant" (bottom left) and "prickly aerostat"(bottom right), extracts from letter whose first page is reproduced on page 19. Photos: Muséum National d'Histoire Naturelle.
p. 19: Signed autograph letter from the abbé de La Haye, parson at Le Dondon, Cap district, Island of Saint-Domingue [now Haiti], to the Académie des Sciences in Paris, with descriptions and drawings of indigenous plants. Bibliothèque Centrale du Muséum National d'Histoire Naturelle, Ms 1289. Photo: Muséum National d'Histoire Naturelle.

Letter from the marquis de Sade to God
p. 20: top left: Man Ray, *Portrait of the Marquis de Sade*, © Man Ray Trust-ADAGP, Paris, 1998. Houston, De Menil Museum. Photo: Roger-Viollet. Bottom, left to right: envelope with seal; text of the prayer; identifying note on the front of the envelope: "Papers concerning the late / Demoiselle de Launai / which is to say: family matters / to be burned without being read if / found after my death," 18 x 21 cm. Collection Édouard and Christian Bernadac, Paris. Photos: Georges Fessy.
p. 21: The same document, with two drawings enclosed in the same envelope. Collection Édouard and Christian Bernadac, Paris. Photos: Georges Fessy.

July 1821: Letter from Honoré de Balzac to his sister Laure Surville
p. 22: top left: Achille Devéria, *Portrait of the Young Balzac*, Paris, Bibliothèque de l'Institut, fonds Loevenjoul; top right: *Portrait of Laure de Balzac as a Child*, anonymous painting, Paris, Maison de Balzac. Photothèque des Musées de la Ville de Paris; bottom: Bertall, poster for *Les Petites Misères de la vie conjugale*, Paris, Maison de Balzac.
p. 23: Signed autograph letter. Paris, Bibliothèque de l'Institut, fonds Loevenjoul, Honoré de Balzac, Letters to his family, A 276, fols. 36–38, several pen-and-ink drawings on fol. 38v.; one of these drawings, mutilated

by tears from the seal, represents the author with the caption: "Honoré ogling Laurence"; the other drawings are caricatures captioned as follows: "The Ultra in despair"; "The Liberal after the session." Photos: Jean-Louis Charmet.

March 10–23, 1832: Letter from Eugène Delacroix to Jean-Baptiste Pierret
p. 24: top left: Eugène Delacroix, *Self-Portrait with Green Vest*, 1837. Paris, Musée du Louvre; bottom left: Eugène Delacroix, *Arab Fantasia in Front of a Gate in Meknès*, watercolor and pencil. 1832. Paris, Musée du Louvre, Département des Arts Graphiques. Photo: RMN–J.G. Berizzi.
p. 25: Signed autograph letter, 4 pages, in 8°, illustrated with a pen-and-ink sketch representing a gate and ramparts. Paris, Musée du Louvre, Département des Arts Graphiques. Aut. 558 p. 3. Cote AR18L43. Photo: RMN.
pp. 26–7: Five pages from Eugène Delacroix, *North African and Spanish Album*, ink and watercolor, 1832. Paris, Musée du Louvre, Département des Arts Graphiques. 1756: p. 26 top: fol. 23v.–24r.; bottom right: fol. 25v; p. 27: fol. 24v.–25r. Photos: RMN.

August 28, 1832: Letter from Eugène Isabey to M. Porte
p. 28: bottom left: Eugène Isabey, *The Bay of Saint-Énogat*, watercolor and gouache, 23.2 x 35.1 cm. Paris, Musée du Louvre. Photo: RMN; bottom right: Eugène Isabey, *Marine at Étretat*, watercolor, Musée du Louvre, Département des Arts Graphiques. Photo: RMN–J.G. Berizzi.
p. 29: Signed autograph letter, illustrated with a pen-and-ink drawing of beached boats. Collection Frits Lugt, Institut Néerlandais, Paris. Inv. no. 1995-A 630. Photo: Pascal Faligot / Seventh Square.

May 24, 1836: Letter from Alfred de Musset to Mme Jaubert
p. 30: top left: Charles Lancelle, *Portrait of Alfred de Musset*, pastel, 1854. Paris. Musée d'Orsay; top right: address of the letter to Madame Jaubert. Collection Édouard and Christian Bernadac, Paris. Photo: Georges Fessy; bottom right: Honoré Daumier, *The Théâtre-Français* (detail), 1857–60. Washington, D.C., The National Gallery of Art. Photo: Archives Snark-Édimédia.
p. 31: Signed autograph letter illustrated in pen and ink. 4 pages. in-4°.

Collection Édouard and Christian Bernadac, Paris. Photo: Georges Fessy.

December 13, 1836: Letter from George Sand to François Buloz
p. 32: top left: Alfred de Musset, *Portrait of George Sand*, 1833. Paris, Bibliothèque de l'Institut, fonds Loevenjoul; top right: Maurice Dudevant, *Caricature of François Buloz*, 1834. Private collection: bottom: *George Sand and Her Friends*, watercolor (on fan) by Auguste Charpentier and George Sand. Paris, Musée de la Vie Romantique. Photothèque des Musées de la Ville de Paris. Photo: Ph. Ladet.
p. 33: Signed autograph letter with a pen drawing. Paris, Bibliothèque de l'Institut, fonds Loevenjoul, George Sand correspondance, Ms 937, fols. 218–19 (facsimile). Photo: Jean-Loup Charmet.

April 18, 1837: Letter from Anatole de Ségur to his mother, the comtesse de Ségur
p. 34: top left: Portrait of the young Anatole de Ségur, detail of *The Ségur Children on a Boating Party*. Paris, Musée Carnavalet. Photothèque des Musées de la Ville de Paris. Photo: Joffre; top right: *The Comtesse de Ségur*, watercolor by Oreste Kiprensky. Paris, Musée Carnavalet (Roger-Viollet); bottom: *The Ségur Children on a Boating Party*. Paris, Musée Carnavalet. Photothèque des Musées de la Ville de Paris. Photo: Joffre.
p. 35: Signed autograph letter illustrated with pen drawings. 2 pages. Paris, BNF, Département des Manuscrits, N.A.F. 22830, fol. 48r. & v. Photo: BNF.

Auguste 24, 1837: Letter from Victor Hugo to Adèle Hugo
p. 36: top left: Auguste de Chatillon, *Victor Hugo and His Son Victor* (detail), 1836. Paris. Musée Victor Hugo; top right: Louis Boulanger, *Adèle Hugo*, 1839. Paris, Musée Victor Hugo; bottom: Jan Van Eyck, *The Ghent Altarpiece: The Mystic Lamb* (detail of central panel) and two side panels. Ghent, Cathedral of Saint Bavo.
p. 37: Signed autograph letter illustrated with a pen drawing. Paris, BNF, Département des Manuscrits, N.A.F. 13391, fol. 121. Photo: BNF.

May 2, 1843: Letter from Gérard de Nerval to Théophile Gautier
p. 38: top left: Portrait of Gérard de Nerval by Nadar, 1855. Private collection. Paris: top right: Jean-Baptiste

Clésinger, *Portrait of Théophile Gautier*. Châteaux de Versailles et de Trianon. Photo: RMN: bottom left: Gérard de Nerval: *Cairo Notebook*, drawing in ink and watercolor representing the island of Shubrâ. Paris. BNF. Département des Manuscrits. N.A.F. 14282. Photo: BNF.

p. 39: Signed autograph letter illustrated with several pen drawings. Private collection. Paris.

September 15, 1846: Letter from Charles Giraud to Hardin

p. 40: top left: detail of illustration on page 41: bottom left: Charles Giraud. *Portrait of Queen Pomaré*. Oil on canvas. Paris. Musée des Arts d'Afrique et d'Océanie. Photo: RMN: C. Jean.

p. 41: Signed autograph letter (21 pages in-4°, illustrated with seven sketches in pen, brown ink wash, and watercolor): first page, with drawing of Charles Giraud reading the letter from his friend Hardin in the shade of a coconut palm. Paris, Musée du Louvre, Département des Arts Graphiques. Aut. 990. Cote BC. b5. L.11. Photo: RMN-Gérard Blot.

pp. 42–3: Seven sheets from the same letter, illustrated with eight drawings in pen-and-brown-ink wash representing: Page 42, top row, right to left: Charles Giraud leaving on a Sunday excursion with three Tahitians: Giraud suffering from dysentery: Giraud overseeing the defense of the fort in Bora Bora. Bottom row: two native soldiers: two soldiers keeping watch. Page 43: Two Tahitian women. Photos: RMN-Michèle Bellot.

October 18, 1846: Letters from Georges Mniszech, Anna Mniszech, and Madame Hanska to Honoré de Balzac

p. 44: top left: Portrait of *Count Mniszech*. Paris, Maison de Balzac. Top right: Louis Boulanger. *Portrait of Balzac*, 1842, oil on canvas. Tours, Musée des Beaux-Arts: bottom: Signed autograph letter, 4 pages, illustrated. Bibliothèque de l'Institut de France, fonds Loevenjoul. Honoré de Balzac. Letters from Georges Mniszech to Honoré de Balzac. A 317, fol. 9r. & v. fol.10r. & v., pen drawing in colored ink on fol. 9r. Photo: Jean-Loup Charmet.

p. 45: Drawing by Mniszech representing himself "dazzled by a Sphinx moth from the planet Leverrier." From another letter from Mniszech to Balzac dated January 3, 1837. Paris. Bibliothèque de l'Institut de France. fonds Loevenjoul. Honoré de Balzac. Letters from Georges Mniszech to Honoré de Balzac. A 317, fol. 14 (detail). Photo: Jean-Louis Charmet.

December 15, 1848: Letter from Adolphe Armand to his friend Délègue

pp. 46–7: Signed autograph letter with watercolor illustrations, five pages. Paris. Musée de la Poste. Photos: Musée de la Poste.

August 12, 1852: Letter from Roger de Beauvoir to his friend Asseline

p. 48: top left: Roger de Beauvoir, photograph by Nadar. Paris, Musée d'Orsay. Photo: RMN; bottom left: Roger de Beauvoir. "Hommage to M. Charles Vincent," signed autograph letter with illustrations. 1865. Collection Édouard and Christian Bernadac. Paris. Photo: Georges Fessy.

p. 49: Signed autograph letter, 3 pages, illustrated with several pen drawings. Collection Thierry Bodin. Photo: Georges Fessy.

December 24, 1854: Letter from Théodule Devéria to François Chabas

p. 50: top left: *Portrait of Théodule Devéria*, engraving. Paris, Bibliothèque de l'Institut. Photo: Bulloz: bottom left: Théodule Devéria, *Edfu, Facade of the Great Hall of the Temple of Horus*, photograph, 1859. Paris, Musée d'Orsay. Photo: RMN-Béatrice Hatala.

p. 51: Signed autograph letter, three sheets. Paris. Bibliothèque de l'Institut, Correspondance de François Chabas, volume 1, M.S. 2572, fol. 116. Photo: Jean-Louis Charmet.

June 8, 1856: Letter from Bertall to M. Émile Pereire

p. 52: top left: Photograph of Bertall. Collection Thierry Bodin. Photo: Georges Fessy.

p. 53: Signed autograph letter, 1 sheet. Collection Thierry Bodin. Photo: Georges Fessy.

February 1857: Letter from Charles Baudelaire to Auguste Poulet-Malassis

p. 54: top left: *Portrait of Baudelaire*, colored drawing by Nadar. Photo: Édimédia. Top right: photograph of Poulet-Malassis by Nadar (detail). c. 1857. Private collection: bottom: publishing emblem of Auguste Poulet-Malassis. Private collection.

p. 55: Signed autograph letter, 2 sheets, illustrated with a row of exclamation marks and a musical staff on which exclamation marks are arrayed like notes. The latter signed "Ch. Assel[ineau]" and encompassed by a balloon, within which is also inscribed: "Letter written at Asselineau's." Paris. Bibliothèque Littéraire Jacques Doucet, no. B I 1 7216 17. Photo: Jean-Loup Charmet.

pp. 56–7: Page proofs of *Les Fleurs du Mal* with autograph corrections and notes, sent by Baudelaire to

Poulet-Malassis with the indication "approved for printing." Paris. BNF. Photos: Laurin-Guillaux-Buffetaud.

October 28, 1857: Letter from Charles-François Daubigny to Geoffroy Dechaume

p. 58: top left: Photograph of Charles Daubigny by Nadar. Private collection: bottom left: Charles Daubigny, *The Seine at Bezons, Val d'Oise*, oil on panel. Paris, Musée d'Orsay. Photo: RMN.

p. 59: Signed autograph letter, 3 sheets, illustrated with 4 ink sketches representing: Steamboats passing: Daubigny at work in his boat-atelier; Daubigny fishing from his boat-atelier; the boat advancing in the dark. Preserved in the form of a photograph and a copy made by Étienne Moreau-Nélaton. Paris, Musée du Louvre. Département des Arts Graphiques. Aut. 342, Cote AR13, p. 3. Photo: RMN-Gérard-Blot.

pp. 60–1: Charles Daubigny, *Barges*, oil on panel. Paris, Musée du Louvre. Photo: RMN-J. G. Berizzi.

p. 60: bottom left: Charles Daubigny, *Luncheon on the Floating Atelier*, pen-and-ink drawing. Paris, Musée d'Orsay. Département des Arts Graphiques. Photo: RMN-J.-G. Berizzi.

p. 61: top right: Charles Daubigny, *The Floating Atelier*, pen and ink drawing. Paris. Musée d'Orsay. Département des Arts Graphiques. Photo: RMN-J.-G. Berizzi; bottom right: Charles Daubigny, *Rising Sun, Banks of the Oise*, oil on canvas. Lille, Musée des Beaux-Arts. Photo: RMN-Quecq d'Henripret.

Letter from Célestin Nanteuil to a lady

p. 62: Célestin Nanteuil. *The Ray of Sunlight*, oil on canvas. Valenciennes. Musée des Beaux-Arts. Photo: RMN-K. El Madj/R.G.

p. 63: Signed autograph letter (incomplete) illustrated with several pen drawings. Collection Édouard and Christian Bernadac. Photo: Georges Fessy.

February 7, 1859: Letter from Théophile Gautier to Jean-Auguste-Dominique Ingres

p. 64: top left: photograph of Théophile Gautier by Nadar (detail). Private collection. Jean-Auguste-Dominique Ingres, *Self-Portrait*, oil on canvas. Cambridge, Mass., The Fogg Museum. Photo: RMN: bottom left: *Carlotta Grisi in "Giselle,"* pastel and pen and ink, 1841. Private collection. Photo: Édimédia.

p. 65: Signed autograph letter, 4 pages, illustrated with a pencil drawing on a separate piece of paper glued to one page. Paris, Bibliothèque de l'Institut. Fonds Loevenjoul.

Théophile Gautier. Cote C 484, fols. 297 and 298. Photo: Jean-Loup Charmet.

September 21, 1860: Letter from Camille Corot to Madame X

p. 66: top left: photograph of Camille Corot by Nadar (detail). Paris, Musée d'Orsay. Photo: RMN-Pascale Néri: bottom right: Camille Corot, *Rider on a Sunken Road* (detail). c. 1870. Paris. Musée du Louvre, Département des Arts Graphiques. Photo: RMN: J.-G. Berizzi.

p. 67: Signed autograph letter, 2 pages, illustrated with a pen-and-sepia-wash drawing. Geneva. Musée d'Art et de l'Histoire de Genève, Inv. 1977–193. Photo: B. Jacot-Descombes.

p. 68: top: Camille Corot, *The Roman Campagna*, also called *La Cervara*. Paris, Musée du Louvre. Photo: RMN-R.G. Ojeda; center: Camille Corot, *Souvenir de Mortefontaine*, oil on canvas. Paris, Musée du Louvre. Photo: RMN-R.G. Ojeda; bottom: Camille Corot, *Volterra: The Citadel*, oil on canvas. Paris. Musée du Louvre. Photo: RMN-Hervé Lewandowski.

p. 69: Camille Corot, *Volterra: View of the Town*, oil on canvas. Paris, Musée du Louvre. Photo: RMN-Hervé Lewandowski.

1860: Letter from Félix Ziem to Théodore Rousseau

p. 70: top left: Félix Ziem. *Self-Portrait*. Musée Ziem, Martigues: top right: André Gill, *Presumed Portrait of Théodore Rousseau*. Paris, Musée d'Orsay. Photo: RMN: bottom left: Félix Ziem, *Tartanes*, 1865. Musée Ziem. Martigues.

p. 71: Signed autograph letter, illustrated with an annotated pen-and-wash map of the Berre and Marignane Lakes at Martigues. Paris, Musée du Louvre. Département des Arts Graphiques. Aut. 3962. Cote BC b8 L 51. Photo: RMN.

February 4, 1867: Letter from Joséphin Soulary to an unknown correspondent

p. 72: top left: *Portrait of Joséphin Soulary*, print from the first edition of Soulary's *Sonnets humouristiques*, illustrated with drawings by the author, 1858. Collection Édouard and Christian Bernadac, Paris. Photo: Georges Fessy; bottom left: title page of the first edition of the *Sonnets humouristiques*, 1858. Collection Édouard and Christian Bernadac, Paris. Photo: Georges Fessy.

p. 73: Letter on stationary of the "Préfecture du Rhône-Division," illustrated with a pen-and-ink self-portrait. Collection Thierry Bodin, Paris. Photo: Georges Fessy.

June 25, 1868: Letter from Henri Regnault to Emmanuel Jadin
p. 74: top left: photograph of Henri Regnault. Collection Harlingue-Viollet. Bottom left: Henri Regnault. *The Madrilène*. Paris, Musée du Louvre, Département des Arts Graphiques. Photo: RMN.
p. 75: Signed autograph letter, 4 pages, pen-and-ink illustrations. Paris, BNF, Département des Manuscrits, Fonds Vaudoyer, classification in progress. Photo: BNF.

1870: Invitation from Félix Régamey
p. 76: top left: Félix Régamey, *Self-Portrait* on a note declining an invitation, 1887. Paris, Musée du Louvre, Département des Arts Graphiques, Aut. 3568, Cote BC b7 L36bis. Photo: RMN-Michèle Bellot; bottom: *View of Arashiyama in Kyoto*, watercolor, c. 1876. Photo: RMN.
p. 77: Drawn invitation with author's monogram, pen and ink. Collection Thierry Bodin, Paris. Photo: Georges Fessy.

October 30, 1872: Letter from Gustave Doré and baron Davillier to M. Templier
p. 78: top left: photograph of Gustave Doré by Nadar. Paris, Musée d'Orsay. Photo: RMN; Michèle Bellot; bottom left: Gustave Doré, illustration for Miguel de Cervantes, *Don Quixote de la Mancha*, vol. 2, Don Quixote arrives at the wedding of Gamache. Paris, Collection Jean-Claude Carrière. Photo: Édimédia.
p. 79: Signed autograph letter, 3 pages, illustrated with three pen-and-ink sketches representing: G. Doré and Baron Davillier at the dinner table, the inn-keeper looking on (page 2); head of a woman wearing a mantilla (page 3): G. Doré and Baron Davillier in their bed (page 3). Photo: RMN.

1874: Letters from Henri Meilhac to Ludovic Halévy
p. 80: top left: Kastor, *Henri Meilhac*, etching. Photo: H. Roger-Viollet; top right: Kastor, *Ludovic Halévy*, etching. Photo: H. Roger-Viollet; bottom and p. 81: six notes with pen-and-ink drawings relating to the genesis of the operetta *La Boule*. Collection Thierry Bodin, Paris. Photos: Georges Fessy.

1874–75: Letter from Félicien Rops to Auguste Poulet-Malassis
p. 82: top left: Paul Mathey, *Félicien Rops* (detail). Châteaux de Versailles et Trianon. Photo: RMN-Gérard Blot; top right: Coubroin (D.R.) after Alphonse Legros, *Portrait of Poulet-Malassis in 1875*; bottom left: Félicien Rops, *Sentimental Initiation*, 1887, black pencil and watercolor with highlights in gouache and pastel. Paris, Musée du Louvre, Département

des Arts Graphiques; bottom right: Félicien Rops. *Pornokratès*, 1878, gouache and watercolor. Namur, Musée Félicien-Rops.
p. 83: Letter from Félicien Rops to Auguste Poulet-Malassis on a proof pull of *Russian Priest*, illustrated with two drawings in pencil, *Game-Keeper* and *Pallas*; 31.5 x 24.5 cm. Namur, Musée Félicien-Rops.

February 8, 1875: Letter from Guy de Maupassant to Alfred de Joinville
p. 84: top left: photograph of Guy de Maupassant by Nadar, c. 1890. Private collection; bottom left: *Couple no. 2 (man in bowler hat)*, charcoal drawing, 22 x 16 cm. Private collection. Photo: Édimédia.
p. 85: Signed autograph letter, 2 pages, illustrated with four ink drawings. Collection Édouard and Christian Bernadac, Paris. Photo: Georges Fessy.

March 5, 1875: Letter from Arthur Rimbaud to Ernest Delahaye
p. 86: top left: *Rimbaud*, print after a photograph by Carjat. Bibliothèque-Médiathèque de Charleville-Mézières; top right: photograph of Ernest Delahaye. Photographie Raoul. Bibliothèque-Médiathèque de Charleville-Mézières; bottom right: Paul Verlaine, "Les Voyages forment la jeunesse," drawing, a876. Private collection.
p. 87: Autograph letter, one page, illustrated with pen drawings. Paris, BNF, Département des Manuscrits. Photo: Paul Renaud-Ph. Sebert.

1875: Letter from Jean-Baptiste Carpeaux to Bruno Chérier
p. 88: Jean-Baptiste Carpeau, *Self-Portrait ("Carpeaux Crying Out in Pain")*. Valenciennes, Musée des Beaux-Arts. Photo: RMN-R.G. Ojeda/Le Mage; top right: J.-B. Carpeaux, *Portrait of Bruno Chérier*. Valenciennes, Musée des Beaux-Arts. Photo: RMN-R.G. Ojeda; bottom right: J. B. Carpeaux, *Man Kneeling on One Knee*, terracotta model. Paris, Musée d'Orsay. Photo: RMN-H. Lewandowski.
p. 89: Autograph letter, 8 pages, illustrated with a pen drawing representing a bust of the dying artist. Paris, Musée du Louvre, Département des Arts Graphiques, sheet 4. Photo: RMN-Michèle Bellot.

June 23/July 4, 1876: Letter from Ivan Turgenev to Gustave Flaubert
p. 90: Portrait of Turgenev by Nadar (detail). Private collection, Paris. Top right: photograph of Flaubert by Nadar, c. 1870. Private collection, Paris; bottom: "The Hermitage" in the park on the estate of Kuskovo, oil on canvas, 70.5 x 39 cm, anonymous (eighteenth-century). Moscow, Ceramics Museum. Photo: Édimédia.

p. 91: Signed autograph letter, 4 pages, illustrated with two pen sketches. Paris, Bibliothèque de l'Institut. Fonds Loevenjoul, H 1366 (B VI), fol. 165v.–166r. Photo: Bulloz.

April 13, 1877: Letter from Auguste Rodin to Rose Beuret
p. 92: top left: Camille Claudel, *Bust of Rodin*, 1882, terracotta, 10.5 x 37.3 cm. Paris, Musée Rodin; top right: Auguste Rodin, *Young Woman in a Flowered Hat*, 1865. Paris, Musée Rodin; bottom left: *The Age of Bronze*, 1876, bronze, 180 x 80 x 60 cm. Paris, Musée Rodin.
p. 93: Signed autograph letter, illustrated with a pen drawing. Paris, Musée Rodin, Inv. L. 12. Photo: Jean de Calan.

1880: Letters from Édouard Manet to Isabelle Lemonnier and Madame Guillemet
p. 94: top left: Portrait of Édouard Manet by Nadar. Private collection; top right: *Isabelle in a String Cap* (detail of a letter from Manet), 1880; bottom right: Manet, *Still Life: Fruit on a Table*, oil on canvas. Paris, Musée d'Orsay. Photo: RMN-Hervé Lewandowski.
p. 95: Letter to Isabelle Lemonnier. Paris, Musée du Louvre, Département des Arts Graphiques. Photo: RMN-Gérard Blot.
pp. 96–97: Letters to Mme Guillemet. Paris: Musée du Louvre, Département des Arts Graphiques. Photos: RMN-Hervé Lewandowski.

Letter from Emmanuel Frémiet to a lady
p. 98: bottom right: Emmanuel Frémiet, *Gorilla Abducting a Negress*. Nantes, Musée des Beaux-Arts. Photo: Hugo Maertens.
p. 99: Signed autograph letter, one page, illustrated with a pen sketch of a gorilla. Institut Néerlandais. Paris, Collection Frits Lugt, Inv. no. 1978 - A. 2768. Photo: Pascal Faligot/ Seventh Square.

1881: Letter from Ernest Delahaye to Paul Verlaine
p. 100: top left: Ernest Delahaye, *Self-Portrait at Age Twenty-Seven*. Photo: Viollet; top right: Paul Verlaine, *Self-Portrait* in a letter sent to his brother-in-law Charles de Sivry, September 30, 1877. Collection Édouard and Christian Bernadac, Paris; bottom left: Jean Béraud, *The Funeral of Victor Hugo*. Photo: Photothèque des Musées de la Ville de Paris, Ph. Ladet. © ADAGP, Paris 1998.
p. 101: Signed autograph letter from Ernest Delahaye, illustrated with pen drawings. Paris, Bibliothèque Littéraire Jacques Doucet, Cote A 10-IV 7203–232. Photos: Jean-Loup Charmet.

November 1, 1885: Letter from Henri Harpignies to his mother
p. 102: top left: Léon Bonnat, *Portrait of Henri Harpignies*. Valenciennes, Musée des Beaux-Arts. Photo: RMN-R.G. Ojeda; bottom left: Henri Harpignies, *Evening Effect*. Dijon, Musée Magnin. Photo: RMN-R.G. Ojeda.
p. 103: Signed autograph letter, illustrated with pen drawings. Institut Néerlandais, Paris. Collection Frits Lugt, Inv. no. 1989 - A 773. Photo: Pascal Faligot/Seventh Square.

1885: Letter from Vincent van Gogh to his brother Theo
p. 104: top left: Vincent van Gogh, *Self-Portrait*, 1886, oil on canvas. The Art Institute of Chicago; top right: Isaacson, *Portrait of Theo*; bottom left: Jean-François Millet, *The Gleaners*, 1857, oil on canvas. Paris, Musée du Louvre. Translation of letter from *The Complete Letters of Vincent van Gogh* by Vincent van Gogh. By Permission of Little, Brown and Company (Inc.) in conjunction with The New York Graphic Society. All Rights Reserved. By permission of Little, Brown and Company (Inc.)
p. 105: Signed autograph letter, illustrated with a portrait in pen and ink and charcoal. Amsterdam, Rijksmuseum Vincent van Gogh.
p. 106: top left: Vincent van Gogh, *Portrait of Gordina de Groot*, March 1885, painting. Amsterdam, Rijksmuseum Vincent van Gogh; top right: *Head of a Peasant Woman of Neunen*, 1885, painting. Amsterdam, Rijksmuseum Vincent van Gogh; bottom right: *Portrait of Gordina de Groot*, May 1885, painting. Private collection.
p. 107: Vincent van Gogh, *The Potato Eaters*, April 1885, painting. Amsterdam, Rijksmuseum Vincent van Gogh.

December 11, 1886: Letter from Octave Mirbeau (and Jean-Louis Forain) to his tomb
p. 108: top left: Portrait of Octave Mirbeau. Photo: H. Roger-Viollet: center right: nineteenth-century print representing the entrance to the Cemetery of Père-Lachaise. Photo: Roger-Viollet; bottom: a path in Père-Lachaise c. 1900. Photo: H. Roger-Viollet.
p. 109: Signed autograph letter from Mirbeau and Forain, illustrated with a pen drawing of a skull with the legend "*Nec pluribus impar.*" Collection Édouard and Christian Bernadac, Paris. Photo: Georges Fessy.

October 16, 1887: Letter from Félix Buhot to Philippe Burty
p. 110: top left: Photograph of Félix Buhot. Valognes, Bibliothèque Municipale; bottom right: Félix Buhot, print with "symphonic margins." Paris, Bibliothèque d'Art et d'Archéologie Jacques Doucet.
p. 111: Signed autograph letter.

2 pages, illustrated with a drawing in pen and watercolor. Paris, Bibliothèque d'Art et d'Archéologie Jacques Doucet.

January 24, 1889: Letter from Paul Verlaine to Irénée Decroix
p. 112: top left: Cazals, *Verlaine*. Paris, BNF, Département des Manuscrits, N.A.F. 14677 fol. 230: bottom right: Paul Verlaine, *Quadrille à quatre pattes*, c. 1870, pen and ink, 20.3 x 25.9 cm. Collection Édouard and Christian Bernadac, Paris. Photo: Georges Fessy.
p. 113: Signed autograph letter, 2 pages, illustrated on verso with pen-and-ink drawing of Verlaine in his hospital bed. Collection Édouard and Christian Bernadac, Paris. Photo: Georges Fessy.

Early 1890: Letter from John Peter Russell to Auguste Rodin
p. 114: top left: John Peter Russell, *Self-Portrait*, c. 1886, oil on canvas, 27.5 x 22.5 cm. Musée G.P.O. Morlaix, inv. D997 1–1–1. © Musée des Jacobins, Morlaix: top right: photograph of Rodin, c. 1880. Private collection: bottom: John Peter Russell, *Les Aiguilles àt Belle-Île*, c. 1890. Oil on canvas, 65.5 x 81.5 cm. Musée G.P.O. Morlaix, inv. D997 1–1–12. © Musée des Jacobins, Morlaix.
p. 115: Signed autograph letter, illustrated with a pen-and-wash drawing. Paris, Musée Rodin, inv. Ma 1070. Photo: Jean de Calan.

Letter from Rosa Bonheur to the sculptor Pierre-Jules Mène
p. 116: top left: Édouard Louis Dubufe, *Portrait of Marie-Rosalie, known as Rosa Bonheur*. Châteaux de Versailles et Trianon. Photo: RMN-Gérard Blot: bottom right: Rosa Bonheur, *Eight Studies of a Hunting Dog*, oil on canvas. Château de Fontainebleau. Photo: RMN-Lagiewski.
p. 117: Signed autograph letter, illustrated with a pen drawing. Institute Néerlandais, Paris, Collection Frits Lugt, inv. no. 6118 C. Photo: Pascal Faligot/Seventh Square.

Letter from Charles Filiger to his friend Bois
p. 118: top left: photograph of Charles Filiger. Private collection; bottom left: Charles Filiger, *The Genius of the Garland*, 1892, oil on wood. Photo: Édiméa.
p. 119: Signed autograph letter, 3 pages, illustrated with pen-and-watercolor drawings of a Breton Calvary, a chapel, a heart, and some flowers. Paris, private collection.

February 3, 1890: Letter from Yves-Marie Le Dravizédec to M. Lamouche
p. 120: top left: detail from another letter from the same correspondent to the same recipient. Paris, Musée de la Poste; bottom right: colored drawing at the beginning of another letter from the same correspondent to the same recipient. Paris, Musée de la Poste.
p. 121: Signed autograph letter, 4 pages, illustrated with drawings, one of them colored. Paris, Musée de la Poste.

March 23, 1890: Letter from Paul Klenck to Henri Chapu
pp. 122–23: Signed autograph letter, 7 pages, illustrated with several pen drawings. Paris, Bibliothèque d'Art et d'Archéologie Jacques Doucet.

May 24, 1890: Letter from Stéphane Mallarmé to Méry Laurent
p. 124: top left: Édouard Manet, *Portrait of Stéphane Mallarmé* (detail), 1876, oil on canvas. Paris, Musée d'Orsay: top right: stamped envelope of a letter to Méry Laurent. Collection Édouard and Christian Bernadac, Paris. Photo: Georges Fessy; bottom right: another envelope from Mallarmé to Méry Laurent, with quatrain address. Paris, Bibliothèque Littéraire Jacques Doucet.
p. 125: Signed autograph letter, one page, illustrated with a drawing in pen and ink. Collection Édouard and Christian Bernadac, Paris. Photo: Georges Fessy.
p. 126: two envelopes with quatrain addresses, both of which were copied into the autograph album *Loisirs de la Poste*. Paris, Bibliothèque Littéraire Jacques Doucet.
p. 127: "La journée du 12," 1888. Drawing by Mallarmé in pen and ink and wash, 11.3 x 9.1 cm. Paris, Bibliothèque Littéraire Jacques Doucet. Photo: Édiméa.

September 17, 1891: Letter from Norbert Goeneutte to Murer
p. 128: top left: Norbert Goeneutte, *Self-Portrait in the Atelier* (detail), 1893, oil on panel, 65 x 76 cm. Private collection; bottom left: *Morning Soup*, Paris, Musée d'Orsay, on loan to the French Senate. Photo: RMN-C. Jean; bottom right: Auguste Renoir, *Ball at the Moulin de la Galette* (detail), 1876. Oil on canvas, 131 x 175 cm. Paris, Musée d'Orsay.
p. 129: Signed autograph letter, 2 pages, illustrated with a watercolor sketch representing a view of Papendrecht. Paris, Musée du Louvre, Département des Arts Graphiques, Aut. 993, cote BC. b5. L.14. Photo: RMN-Michèle Bellot.

February 22, 1894: Letter from Auguste Vimar to Eugène Mouton
p. 130: bottom left: Signed autograph letter from Auguste Vimar to Eugène Mouton dated March 29, 1894, 4 pages. Institut Néerlandais, Paris, Collection Frits Lugt, L.A.S. 1977-A. 648. Photo: Pascal Faligot/Seventh Square.
p. 131: Signed autograph letter dated February 22, 1894, with pen drawing. Institut Néerlandais, Paris, Collection Frits Lugt, L.A.S. 1977-A. 644. Photo: Pascal Faligot/Seventh Square.

Letter from Jean-Louis Forain to M. Marthe
p. 132: top left: Jean-Louis Forain, *Self-Portrait*, oil on canvas. Paris, Musée d'Orsay. Photo: RMN-Jean Schormans © ADAGP, Paris 1998. bottom right: Jean-Louis Forain, *Pink Dancer*, pastel on gray paper. Paris, Musée d'Orsay. © ADAGP, Paris, 1998. Photo: RMN-H. Lewandowski.
p. 133: Signed autograph letter, 4 pages, illustrated with several drawings in pen and ink. Collection Édouard and Christian Bernadac, Paris. Photo: Georges Fessy.

Early 1896: Letter from Henri-Edmond Cross to Paul Signac and Théo van Rysselberghe
p. 134: bottom left: Henri-Edmond Cross, *Trees at the Seashore*, watercolor. Paris, Musée d'Orsay, Département des Arts Graphiques. Photo: RMN-M. Bellot; bottom right: Henri-Edmond Cross, *Afternoon in Paridgan (var)*, Paris, Musée d'Orsay. Photo: RMN-R.G. Ojeda.
p. 135: Signed autograph letter, 4 pages, illustrated with watercolor sketch of a pine forest at the seashore. Institut Néerlandais, Paris, Collection Frits Lugt, inv. no. 1991-A. 1995. Photo: Pascal Faligot/Seventh Square.

April 1896: Letter from Paul Gauguin to Daniel de Monfreid
p. 136: top left: Paul Gauguin, *Self-Portrait Near Golgotha*, 1896, oil on canvas. São Paulo, Museu de Arte; bottom left: Paul Gauguin, *Te Arii Vahine*. Moscow. Pushkin State Museum of Fine Arts. Photo: Artephot/Cercle d'Art.
p. 137: Signed autograph letter illustrated with a sketch in ink and watercolor of the painting *Te Arii Vahine*. Bérès collection. Photo: Flammarion.
p. 138: Édouard Manet, *Olympia*, oil on canvas, 1863. Paris, Musée d'Orsay. Photo: RMN-Gérard Blot; bottom: Lucas Cranach, *Diana Resting*. Besançon, Musée des Beaux-Arts. Photo: Chauffier.
p. 139: Paul Gauguin, *Be Mysterious*. Polychrome wood. Paris, Musée d'Orsay. Photo: RMN-Jean Schormans; bottom: Paul Gauguin, *And the Gold of Their Bodies*. Paris, Musée d'Orsay. Photo: RMN.

May 1897: Invitation from Henri de Toulouse-Lautrec
p. 140: photograph of Henri de Toulouse-Lautrec, detail of photomontage by Maurice Guibert, c. 1890; bottom right: poster-advertisement for Berthelot absinthe, 1895. Private collection.

p. 141: Invitation from Toulouse-Lautrec, lithograph. 1897. Paris, BNF. Département des Estampes.

1901–1910: Letters from Frédéric Pioche to Alphonse Perrault
pp. 142–43: Selection of letters from the postman Frédéric Pioche, illustrated in pen and ink, many in watercolor as well. Paris, Musée de la Poste.

Letter from Judith Gautier to an unknown correspondent
p. 144: Thank-you note from Judith Gautier with watercolor illustration (detail). Collection Édouard and Christian Bernadac, Paris. Photo: Georges Fessy.
p. 145: Signed autograph letter, 2 pages, illustrated with a watercolor with gouache highlights. Collection Thierry Bodin. Paris. Photo: Georges Fessy.

July 23, 1905: Card from Pablo Picasso to Guillaume Apollinaire
p. 146: top left: Pablo Picasso, *Self-Portrait*, drawing, 1902. Photo: © Picasso Estate 1998: bottom left: Pablo Picasso, *The Three Musicians*, oil on canvas, 1921. New York, The Museum of Modern Art. Photo: © Picasso Estate 1998: bottom right: card from Pablo Picasso to Apollinaire with watercolor illustration. Paris, Musée Picasso. Photo: RMN-R.G. Ojeda. © Picasso Estate 1998.
p. 147: Card from Pablo Picasso and Max Jacob to Guillaume Apollinaire. Paris, Musée Picasso. Photo: RMN-R.G. Ojeda. © Picasso Estate 1998.

Letter from André Derain to Maurice de Vlaminck
p. 148: top left: Balthus, *Portrait of Derain*, 1936, oil on panel. 112.5 x 72.6 cm. New York, The Museum of Modern Art. Photo: Édiméa. Bottom left: André Derain, *The Port, Collioure*, 1905, oil on canvas. Paris, Musée National d'Art Moderne–Centre Georges Pompidou. Photo: Roger-Viollet; bottom right: André Derain, *The Turning Road, L'Estaque*, 1906, oil on canvas. Houston, The Museum of Fine Arts. Photo: Roger-Viollet. © ADAGP, Paris 1998.

1912: Letter from Ferdinand Bac to Martine de Béhague
p. 150: top right: photograph of the comtesse de Béhague. Private collection; bottom left: Paul-César Helleu. *Homage to the Comtesse de Béhague*. Private collection. © ADAGP, Paris 1998.

June 8, 1913: Letter from Raoul Dufy to Fernand Fleuret
p. 152: top left: Raoul Dufy, *Self-Portrait as Harlequin* (detail), oil on canvas, 14.5 x 28 cm. Private collection. Photo: Édiméa: bottom left: Raoul Dufy, *La Grande Baigneuse*,

1914. oil on canvas. 245 x 182 cm. Private collection. Photo: Édimédia: bottom right: young Provençal, illustration from another letter from Raoul Dufy. Paris. Bibliothèque d'Art et d'Archéologie Jacques Doucet. © ADAGP. Paris 1998.

p. 153: Signed autograph letter. 8 pages, illustrated with a pen drawing. Paris. Bibliothèque d'Art et d'Archéologie Jacques Doucet. © ADAGP. Paris 1998.

July 4, 1914: Letter from Guillaume Apollinaire to Pablo Picasso
p. 154: top left: Pablo Picasso, *Caricature of Guillaume Apollinaire as an Academician*, 1905. Paris. Musée Picasso. © Picasso Estate 1998; bottom: Guillaume Apollinaire, "Birds Sing with Their Fingers." watercolor over graphite. Paris. Musée Picasso. Photo: RMN-J.C. Berizzi.
p. 155: Signed autograph letter, one page, illustrated with a calligram. "The pipe and the brush" (detail). Paris. Musée Picasso. Photo: RMN-Daniel Arnaudet.

October 18, 1915: Letter from Paul Signac to Georgette Agutte.
p. 156: top left: photograph of Paul Signac. Photo: H. Roger-Viollet: bottom left: Paul Signac, *Saint-Tropez, Houses at the Water's Edge*. watercolor over lithograph. Paris. Musée du Louvre, Département des Arts Graphiques. Photo: RMN. © ADAGP, Paris 1998.
p. 157: Signed autograph letter. 4 pages, illustrated in pen and ink. watercolor, and pencil. Grenoble, Musée de Grenoble.

November 11, 1915: letter from Camille Saint-Saëns to an unknown correspondent
p. 158: top left: caricature of Saint-Saëns. Médiathèque Jean Renoir, Dieppe: bottom right: balance of letter whose first page is reproduced opposite.
p. 159: Signed autograph letter. 3 pages, illustrated with two drawings of flowers, one of them colored. Private collection. Photos: Georges Fessy.

November 14, 1916: Letter from Pascal-Adolphe Dagnan-Bouveret to Alexis Vollon
p. 160: top left: Charles-René de Paul de Saint-Marceaux, *Bust of Pascal Dagnan-Bouveret*, bronze. Paris. Musée d'Orsay. Photo: RMN-Hervé Lewandowski: bottom: Pascal Dagnan-Bouveret, *Two Breton Women*. Paris. Musée du Louvre. Département des Arts Graphiques, R.F. 23 360. Photo: RMN-Michèle Bellot.
p. 161: Signed autograph letter. 4 pages, illustrated with sketch in pen-and-brown-ink wash of a young Breton woman, shown in profile and sitting on a chair. Institut Néerlandais. Paris, Col-

lection Frits Lugt. inv. no. 8341 k./l. Photo: Pascal Faligot/Seventh Square.

March 30, 1917: Letter from Jean Giono to his parents
p. 162: top left: Jean Giono, detail of a photograph taken at the fort of La Pompelle during World War One. Photo: Roger-Viollet: bottom: a manuscript by Giono discussing pacifism, excerpt from *Recherche sur la pureté*, collection Jean Giono-Musée de Manosque.
p. 163: Signed autograph letter. 2 pages, illustrated with pencil drawing. Collection Jean Giono-Musée de Manosque.

September 27, 1918: Letter from Raymond Renefer to Clément Janin
p. 164: bottom left: Raymond Renefer, *The Meal*, crayon and watercolor. Private collection. © ADAGP. Paris 1998: bottom right: *Two Soldiers on a Stoop*, crayon and watercolor. Private collection. © ADAGP. Paris 1998.
p. 165: top: signed autograph letter, one page. illustrated with a drawing in pen and ink wash. Paris. Bibliothèque d'Art et d'Archéologie Jacques Doucet. © ADAGP. Paris 1998: bottom left: Raymond Renefer, *Meal in Front of a House*, crayon and watercolor. Private collection. © ADAGP. Paris 1998: bottom right: *Game of Cards*, drawing in colored crayon. Private collection. © ADAGP. Paris 1998.

June 1921: Letter from Max Jacob to Pablo Picasso
p. 166: Pablo Picasso, *Max Jacob*. Paris. Musée Picasso. © Picasso Estate 1998: bottom left: postcard from Max Jacob to Pablo Picasso. Paris. Musée Picasso. Photo: RMN. © ADAGP, Paris 1998.
p. 167: Signed autograph letter, one page, written on a piece of lacepaper with an illustration of a bird. Paris. Musée Picasso. Photo RMN. © ADAGP. Paris 1998.

Letter from Antoine de Saint-Exupéry to his mother
p. 168: top left: photograph of Antoine de Saint-Exupéry in the 1920s. Photo: Harlingue-Viollet: top right: photograph of Madame de Saint-Exupéry. Photo: Roger-Viollet.
p. 169: Signed autograph letter, one page, illustrated with a drawing of a dog in pen and wash. Paris. Archives Nationales.

October 1925: Letter from Le Corbusier to Madame Meyer
p. 170: top left: photograph of Le Corbusier. Paris, Fondation Le Corbusier. © ADAGP. Paris 1998.
p. 171: Signed autograph letter, one

page. large format. illustrated with several drawings in pen and pencil relating to the projected Villa Meyer in Neuilly. 1925. Paris. Fondation Le Corbusier. © ADAGP. Paris 1998.

1926: Letter from André Beucler to an unknown correspondent
p. 172: top left: photograph of André Beucler. Photo: Roger-Viollet: bottom: cover of *Gueule d'Amour*. 1926. © Librairie Gallimard. 1926.
p. 173: Signed autograph letter. illustrated with a drawing in pen and colored pencil. Collection Édouard and Christian Bernadac. Paris. Photo: Georges Fessy.

May 1927: Letter from Georges Auric to François de Gouÿ
p. 174: Jean Cocteau, *Portrait of Georges Auric*. Collection Thierry Bodin. Photo: Bulloz. © ADAGP. Paris 1998: bottom: photograph of (left to right) Georges Auric. Jean Cocteau. and Francis Poulenc. Photo: Roger-Viollet.
p. 175: Signed autograph letter, one page, illustrated with a pen drawing. Collection Thierry Bodin. Paris. Photo: Georges Fessy.

October 13, 1929: Letter from Robert Desnos to Foujita and Youki
p. 176: top left: photograph of Robert Desnos. Photo: Roger-Viollet: top right: photograph of Youki Foujita. Photo: Larlingue-Viollet: bottom: sheets 2 and 3 of letter reproduced on page 177.
p. 177: Signed autograph letter. 3 pages, illustrated with decals. Paris. Bibliothèque Littéraire Jacques Doucet. Photo: Musée de la Poste. © ADAGP. Paris 1998.

Letter from Francis Carco to Paul Reboux
p. 178: top left: portrait of Francis Carco, engraving. Photo: Roger-Viollet: bottom: frontispiece by Daragnès for Francis Carco. *La Bohème et mon coeur*. 1912. Photo: Roger-Viollet.
p. 179: Signed autograph letter, one page. illustrated with pen drawings. Collection Édouard and Christian Bernadac, Paris. Photo: Georges Fessy.

October 9, 1939: Letter from André Breton to his daughter Aube
p. 180: top left: photograph of André Breton: center right: photograph of his daughter Aube. Both taken at the château d'Airbel, Marseilles, in 1940. Photos: Collection Aube Elléouët: bottom: detail of letter reproduced on page 181. © ADAGP. Paris 1998.
p. 181: Signed autograph letter. illustrated with drawings and cutouts. Paris. Bibliothèque Littéraire Jacques Doucet. Photo: Jean-Loup Charmet. © ADAGP. Paris 1998.

1939: Letter from André Dignimont to André Dunoyer de Segonzac
p. 182: top left: photograph of André Dignimont at his work table (detail). Photo: Roger-Viollet: bottom: details of letter reproduced on page 183. © ADAGP. Paris 1998.
p. 183: Signed autograph letter, one page. Paris, Librairie "Les Autographs." Photo: Georges Fessy. © ADAGP. Paris 1998.

November 1940: Letter from Colette to Georges Wague
p. 184: top left: Ferdinand Desnos, *Portrait of Colette*. Photo: Édimédia © ADAGP. Paris 1998. bottom: Colette, *Female Nude*, charcoal drawing. Photo: Édimédia.
p. 185: Autograph letter with drawing of a rat as signature. Paris. BNF. Département des Manuscrits. N.A.F. 18708. Varia III, fol. 166.

April 29, 1948: Letter from René Magritte to Andrieu
p. 186: bottom left: René Magritte. *The Psychologist*, gouache. Private collection: bottom center, top: René Magritte. *Prince Charming*, gouache. Private collection: bottom center. bottom: *The Pebble*, gouache. Private collection: bottom right: *The Pope's Crime*, gouache. Private collection. All photos: © ADAGP. Paris 1998.
pp. 187–89: Signed autograph letter. 3 pages. illustrated with several pen drawings. Paris. Musée National d'Art Moderne/Centre Georges-Pompidou. Doc MNAM-CCI. Photo: Jacques Faujour. © ADAGP. Paris 1998.

February 10, 1958: Letter from Georges Hugnet to Néjad
p. 190: top left: photograph of Georges Hugnet. Photo: Roger-Viollet: bottom: Georges Hugnet. *Untitled Collage*. 1961. 305 x 25 cm. Private collection. Photo: Édimédia. © ADAGP. Paris 1998.
p. 191: Signed autograph letter. illustrated with a color drawing of a bouquet of flowers. Collection Thierry Bodin. Paris. Photo: Georges Fessy. © ADAGP. Paris 1998.

1959–60: Letter from Jean Cocteau to Yanette Delétang-Tardif
p. 192: top left: Jean Cocteau, *Self-Portrait*, from a letter to Mary Hoeck. Collection Thierry Bodin. Paris; center right: envelope of the letter reproduced on page 193. Collection Thierry Bodin. Paris. Photo: Georges Fessy: bottom left: illustrated letter from Jean Cocteau. Collection Édouard and Christian Bernadac. Paris. Photo: Georges Fessy. © ADAGP. Paris 1998.
p. 193: Signed autograph letter. one page. illustrated with a drawing in pen and colored pencil. Collection Thierry Bodin. Paris. Photo: Georges Fessy. © ADAGP. Paris 1998.

Letter from Gaston Chaissac to Iris Clert

p. 194: bottom left: illustrated invitation from Gaston Chaissac. Paris, Musée National d'Art Moderne/ Centre Georges Pompidou. © ADAGP, Paris 1998: bottom right: Gaston Chaissac, *Figure*, 1961–62. Paris. Musée National d'Art Moderne– Centre Georges Pompidou, Doc MNAM-CCI. Photo: Jacques Faujour. © ADAGP, Paris 1998.

p. 195: Signed autograph letter. 2 pages, illustrated with a color drawing (magic marker). Paris, Musée National d'Art Moderne–Centre Georges Pompidou, Doc MNAM-CCI. Photo: Jacques Faujour. © ADAGP, Paris 1998.

November 14, 1970: Letter from Joan Miró to Jacques Prévert

p. 196: top left: photograph of Miró in the 1970s. Private collection: top right: photograph of Jacques Prévert, June 1954. Photo: Roger-Viollet: bottom right: Joan Miró, illustration for *Ubu Roi* by Alfred Jarry, litho-

graph, 1966. Photo: Roger-Viollet. © ADAGP, Paris 1998.

p. 197: Signed autograph letter, 2 pages, illustrated with drawings in colored pencil. Collection Fatras, Estate of Jacques Prévert. © ADAGP, Paris 1998.

October 14, 1971: Letter from Paul Delvaux to Claude Lévi-Strauss

p. 198: top left: photograph of Paul Delvaux in the 1970s. Private collection: top right: photograph of Claude Lévi-Strauss. All rights reserved: bottom: Paul Delvaux, *The Water Nymphs* (detail), 1938. Colothèque/Private collection. Photo: Édimédia. © Fondation Paul Delvaux, St Idesbad, Belgium/ADAGP, Paris 1998.

p. 199: Signed autograph letter, one page, illustrated with a drawing in pen and watercolor. Private collection, Paris. Photo: Georges Fessy. © Fondation Paul Delvaux. St Idesbad, Belgium/ADAGP, Paris 1998.

March 19, 1991: Letter from Jules Mougin to Christian Bernadac

p. 200: Letter from Jules Mougin to Christian Bernadac and its envelope. Collection Édouard and Christian Bernadac, Paris. Photos: Georges Fessy.

p. 201: Signed autograph letter, one page, illustrated with several drawings. Collection Édouard and Christian Bernadac, Paris. Photos: Georges Fessy.

1998: Letter from Olivier Debré to Bernard Noël

p. 202: top left: photograph of Olivier Debré: top right: photograph of Bernard Noël. Both taken in 1984, on the occasion of the publication by Flammarion of a monograph on the painter with a preface by Bernard Noël. All rights reserved: bottom: details of letter reproduced on pages 203–5. © ADAGP. Paris 1998.

pp. 203–5: Signed autograph letter, 3 pages, illustrated with drawings in gouache. Private collection. Photos: Georges Fessy. © ADAGP, Paris 1998.

p. 221: Letter from Audiberti, undated, without indication of place of origin, to an unknown corre- spondent. Collection Édouard and Christian Bernadac, Paris. Photo: Georges Fessy.

p. 235: Envelope from Erik Satie illustrated with drawn stamp. Collection Thierry Bodin, Paris. Photo: Georges Fessy. All rights reserved.

With regard to letters reproduced here that are not in the public domain, every effort was made to contact their authors, recipients, or other parties to whom their reproduction rights had reverted. We were unable to reach some of these parties and would welcome their making themselves known to us.

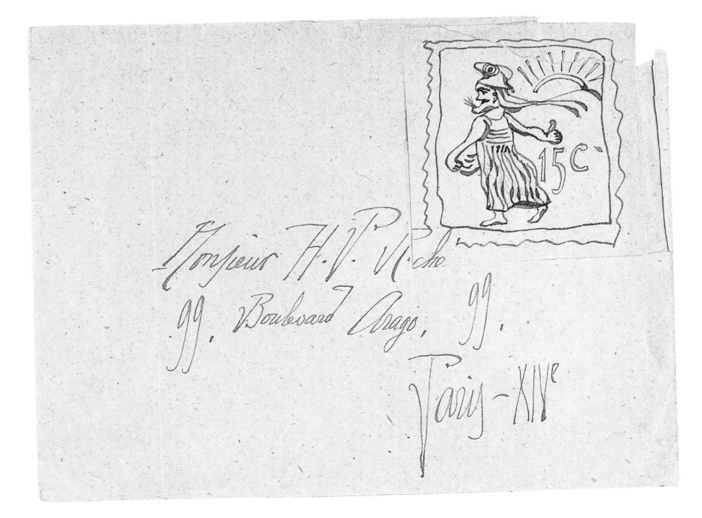

KEY TO AUTHORSHIP OF THE ENTRIES

Thierry Bodin, bookseller and bibliophile

Valentine de Chillaz, chargé de mission, Musée d'Orsay

Marie-Laure Crosnier-Leconte, chargé de mission, Musée d'Orsay

Yves Gérard, honorary professor of history of music and musicology, Conservatoire de Paris

Pascale Heurtel, curator of manuscripts, Bibliothèque Centrale du Musée National d'Histoire Naturelle

Laure Murat, writer and journalist

Francine Prose, novelist and essayist

Hélène Védrine, lecturer in comparative literature, University of Mulhouse

Undated: Letter from Emmanuel Frémiet
Valentine de Chillaz

1881: Letter from Ernest Delahaye
Laure Murat

November 1, 1885: Letter from Henri Harpignies
Laure Murat

1885: Letter from Vincent van Gogh
Valentine de Chillaz

December 11, 1886: Letter from Octave Mirbeau
Laure Murat

October 16, 1887: Letter from Félix Buhot
Valentine de Chillaz

January 24, 1889: Letter from Paul Verlaine
Laure Murat

Early 1890: Letter from John Peter Russell
Laure Murat

Undated: Letter from Rosa Bonheur
Valentine de Chillaz

Undated: Letter from Charles Filiger
Roselyne de Ayala

February 3, 1890: Letter from Yves-Marie Le
Dravizédec
Roselyne de Ayala

March 23, 1890: Letter from Paul Klenck
Roselyne de Ayala

May 24, 1890: Letter from Stéphane Mallarmé
Laure Murat

September 17, 1891: Letter from Norbert
Goeneutte
Valentine de Chillaz

February 22, 1894: Letter from Auguste Vimar
Thierry Bodin

Undated: Letter from Jean-Louis Forain
Laure Murat

Early 1896: Letter from Henri-Edmond Cross
Valentine de Chillaz

April 1896: Letter from Paul Gauguin
Valentine de Chillaz

May 1897: Invitation from Henri de Toulouse-
Lautrec
Laure Murat

1901–10: Letters from Frédéric Pioche
Roselyne de Ayala

Undated: Letter from Judith Gautier
Laure Murat

July 23, 1905: Card from Pablo Picasso
Laure Murat

Undated: Letter from André Derain
Laure Murat

1912: Letter from Ferdinand Bac
Laure Murat

June 8, 1913: Letter from Raoul Dufy
Laure Murat

July 4, 1914: Letter from Guillaume Apollinaire
Laure Murat

October 18, 1915: Letter from Paul Signac
Valentine de Chillaz

November 11, 1915: Letter from Camille
Saint-Saëns
Yves Gérard

November 14, 1916: Letter from Pascal
Dagnan-Bouveret
Valentine de Chillaz

March 30, 1917: Letter from Jean Giono
Jean-Pierre Guéno

September 27, 1918: Letter from Raymond
Renefer
Roselyne de Ayala

June 1921: Letter from Max Jacob
Laure Murat

1921: Letter from Antoine de Saint-Exupéry
Laure Murat

October 1925: Letter from Le Corbusier
Marie-Laure Crosnier-Leconte

1926: Letter from André Beucler
Laure Murat

May 1927: Letter from Georges Auric
Thierry Bodin

October 13, 1929: Letter from Robert Desnos
Laure Murat

Undated: Letter from Francis Carco
Laure Murat

October 9, 1939: Letter from André Breton
Laure Murat

1939: Letter from André Dignimont
Thierry Bodin

November 1940: Letter from Colette
Laure Murat

April 29, 1948: Letter from René Magritte
Valentine de Chillaz

February 10, 1958: Letter from Georges Hugnet
Thierry Bodin

1959–60: Letter from Jean Cocteau
Thierry Bodin

Undated: Letter from Gaston Chaissac
Valentine de Chillaz

November 14, 1970: Letter from Joan Miró
Laure Murat

October 14, 1971: Letter from Paul Delvaux
Laure Murat

March 19, 1991: Letter from Jules Mougin
Roselyne de Ayala

1998: Letter from Olivier Debré
various

INDEX OF AUTHORS AND RECIPIENTS OF THE LETTERS